Skin

Skin

The Complete Guide to Digitally Lighting, Photographing, and Retouching Faces and Bodies

Lee Varis

WILEY PUBLISHING, INC.

Acquisitions and Development Editor: Pete Gaughan
Technical Editor: Glen Martin
Copy Editor: Kathy Carlyle
Production Manager: Tim Tate
Vice President and Executive Group Publisher: Richard Swadley
Vice President and Executive Publisher: Joseph B. Wikert
Vice President and Publisher: Dan Brodnitz
Permissions Editor: Shannon Walters
Media Development Specialist: Kit Malone
Designers: Franz Baumhackl and Lori Barra
Compositor: Kate Kaminski, Happenstance Type-O-Rama
Proofreader: Nancy Riddiough
Indexer: Ted Laux
Cover Designer: Ryan Sneed
Cover Images: Lee Varis, Ken Chernus (water polo player),
 Anthony Nex (boy on rope and swimmer)

Dear Reader

Thank you for choosing *Skin: The Complete Guide to Digitally Lighting, Photographing, and Retouching Faces and Bodies.* This book is part of a family of premium-quality Sybex graphics books, all written by outstanding authors who combine practical experience with a gift for teaching.

Sybex was founded in 1976. Thirty years later, we're still committed to producing consistently exceptional books. With each of our graphics titles, we're working hard to set a new standard for the industry. From the writers and artists we work with to the paper we print on, our goal is to bring you the best graphics books available.

I hope you see all that reflected in these pages. I'd be very interested to hear your comments and get your feedback on how we're doing. To let us know what you think about this or any other Sybex book, please send me an email at sybex_publisher @wiley.com. Please also visit us at www.sybex.com to learn more about the rest of our growing graphics line.

Best regards,

DAN BRODNITZ
Vice President and Publisher
Sybex, an Imprint of Wiley

Acknowledgments

I could not have written this book without the help and support of many people. First, I need to thank my wife, Gila, for putting up with me these past several months—she is always ready to listen to and encourage me. Thanks also to my kids, Aaron and Erika, for being an inspiration to me and for being such great subjects for my example images. A special thanks also goes to my sister Oraea, who besides being a gracious subject for the retouching chapter has provided many years of creative inspiration through her music.

I must also thank my contributors—Aaron Rapoport, Ken Chernus, Anthony Nex, and Erin Manning; Erin was also the subject for the basic portrait-lighting examples. This book would not be anywhere near as good as it is without the great photographs contributed by these fine artists.

Another fine artist, whose influence was felt in every page, was my technical editor, Glen Martin. Glen made sure I didn't slip up, and he caught the tiniest errors in screenshots, captions, and descriptive text. He made numerous suggestions for clarifying technically dense text and pushed me to go further than I might otherwise have gone. I can't forget to thank the many subjects of all the photos whose humanity is on display in these pages; few of them are mentioned by name, but all are deeply appreciated for their contributions.

Of course, this book wouldn't be possible without the Sybex team: acquisitions and developmental editor Pete Gaughan, copyeditor Kathy Carlyle, and the compositors at Happenstance Type-O-Rama.

A special thanks goes to my agent, Matt Wagner, who has been watching my back in more ways than one (thanks for the insights on tattoos).

I could not have accomplished anything in digital photography without the many teachers I have had over the years: Tony Redhead, Kai Kraus, Ed Manning, Dan Margulis, David Biedney, Al Edgar, Daniel Clark, Jeff Schewe, Bruce Fraser, Chris Murphy, Katrin Eismann, Eric Magnusen, Bryan Allen, and many others who have helped me surf the bleeding edge of digital imaging technology.

Of course, no book on digital photography should fail to acknowledge the Knoll brothers, Thomas and John, who created Photoshop and let the genie out of the bottle to the delight of digital artists everywhere. And no book on photography techniques could begin to repay the debt owed to Ansel Adams, who established the great technical foundation for the art and craft of photography. I stand on the shoulders of giants to make my very modest contribution to the vast world of digital imaging.

About the Author

Lee Varis, who has been involved in commercial photography for the past 30 years, is a photo-illustrator working in Hollywood. He began working with computer imaging almost two decades ago, after one of his clients took him to see what they were doing to his photography on the Quantel Paintbox. Lee was hooked and spent many hours hanging out at Electric Paint, one of the first creative imaging services to utilize the new technology for movie posters and album covers. His first imaging computer was a Macintosh SE—a tiny computer with a B+W monitor that could process RGB color files. Lee began exploring digital photography using some of the earliest systems available, and he helped Dave Etchells (of Imaging Resource) conduct the very first comprehensive tests of digital camera systems in his photo studio back in 1990. Lee currently works with digital as well as conventional photography in conjunction with computer graphics to create images for print advertising.

Lee's work has been featured on movie posters, video box covers, CD covers, and numerous brochures and catalogs. His creative imaging has been featured in *National Geographic, Newsweek,* and *Fortune* magazines as well as trade journals such as *PDN, New Media, Micro Publishing News, Rangefinder, Design Graphics, Photo Electronic Imaging,* and *PC Photo.*

Lee has also been involved with consulting and training activities for numerous corporate clients. He conducted two series of imaging seminars for Apple Computer that took him to most of the major metropolitan areas in the United States. He is currently active in seminar programs with APA, ASMP, PPA, and Julia Dean Photographic Workshops as well as ongoing "Photoshop for Digital Photographers" workshops in Los Angeles. He is one of the founding fathers and current president of the Los Angeles Digital Imaging Group (LADIG, a chapter of the USDIG). Lee also serves on the board of the Digital Image Marketing Association (DIMA), a division of PMA, the Photo Marketing Association.

Besides his work in digital photography, Lee is an amateur musician with a passion for collecting and playing unusual instruments. His current favorite instrument is the *oud,* a Middle Eastern lute that was popular with his Greek ancestors. You can usually find him playing music while his computer is processing multiple RAW digital camera files.

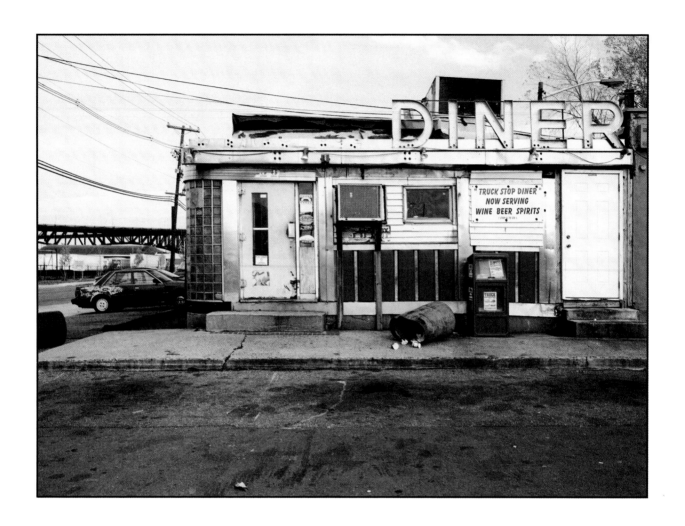

Foreword by Katrin Eismann

Recently I was on a flight, and the passenger next to me started a conversation with the usual, "What do you do?" I told him that I write books on digital photography, to which he immediately said, "I have a digital camera, and I've taken at least 3,000 pictures with it, but only three or four are any good." His comment took me by surprise, as the quality and ease of use of digital cameras and especially digital SLRs have skyrocketed in recent years. But upon further consideration, I realized that this man was letting the camera make critical decisions, and, more important, he wasn't aware that "cameras don't take pictures... people do."

If you're serious about digital photography—and who isn't after spending thousands of dollars on computer and camera equipment—you have found a true mentor in Lee Varis, who with this book will guide you through the entire process of creating better digital photographs. Lee is a successful commercial photographer who has developed valuable insights into the process of digital photography that he generously shares in these beautifully produced pages—from setting up your computer software, to lighting a portrait, to processing and retouching the file with Adobe Photoshop, and finally to making the best print possible. For photographers, the truth is when the ink hits the paper, and throughout this book, Lee shows you how to capture and process digital files that print exactly as you need them to.

The days of "You Push the Button; We Do the Rest" are long gone. With Lee's to-the-point writing and real-world examples, your photography sessions and image processing time will be both more satisfying and successful. Now I just wish I could tell that man on the plane about Lee's book; he and many of us, including me, can learn a great deal from these pages. As Lee says, "The only way to stay competitive is to keep on learning." I can sincerely say that this book will give you a valuable head start in creating better images and enjoying digital photography a lot more.

Please fasten your seat belts and enjoy the journey!

KATRIN EISMANN
Chair, Masters in Professional Studies in Digital Photography
School of Visual Arts, New York City

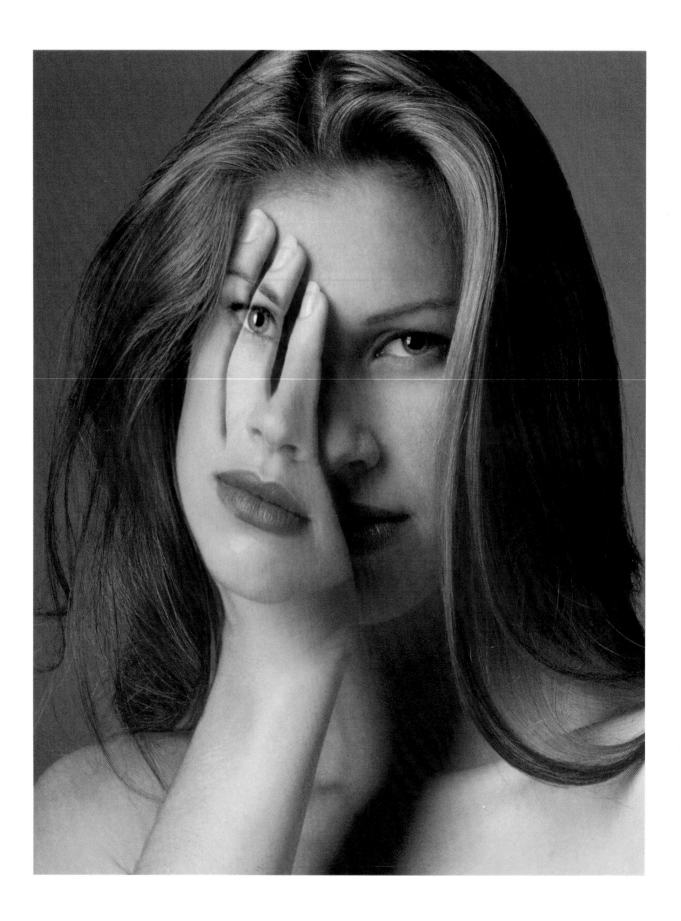

Foreword by Gerald Bybee

I wouldn't characterize Lee Varis as a "skin" photographer. He certainly doesn't land in the crowded genre of fashion, beauty, or "glamour" photographers whose images overflow the women's fashion magazines and men's entertainment glossies that crowd grocery store periodical racks in today's body-oriented society. If you're looking for pointers on shooting nudes or tutorials on photographing sexy models in the desert, this book is not for you. There is already a plethora of those pseudo-technical books exploiting the throngs of photo voyeurs.

Lee isn't about exploitation of our society's fascination with naked skin. Lee's fascination is simply with digital imaging technique focused on the practical application of photographing people, who coincidentally are primarily dermal by nature. His breadth of experience as a commercial advertising photographer, writer, software tester, trainer, and evangelist, and even as a father and family snapshot shooter, qualifies him to write and organize these chapters and tutorials. He bases this work on his own research, experience, and explorations while incorporating references to the most current software, hardware, and digital technologies in use today.

From the time I came to know Lee well over ten years ago, when we both were early adopters of digital imaging technologies, he has stood out as one who could distill large amounts of technical information into very simple and practical applications relevant to the art and business of making photographs. His ability to understand complexity and teach simple understanding is his strength and indeed the strength of this book. His personal and artistic ego stand second to his generosity in sharing a common-sensical approach to applying the latest imaging technologies to making images of human beings, whether for personal pleasure or for commerce.

With this new volume—ranging from simple explanations of often confusing digital capture concepts, practices, and technologies, to Lee's extremely clear, nuts-and-bolts tutorials on lighting and advanced skin retouching techniques used by the pros—he has distilled the essence of state-of-the-art digital photographic imaging relevant not only to photographing skin but to all photographic subject matter. Lee presents information in a way that renders complex jargon and engineerspeak into simple working practice of value to pro as well as to intermediate and advanced amateur photographers. He has selected images, from his own portfolio as well as those of respected colleagues such as Aaron Rapoport and Ken Chernus, that illustrate technique and skill, reality and fantasy, accurate documentation, and manipulated illusion, all without intimidation or mystery. In these pages are imagery and information for all of us, seasoned journeymen and digital newbies alike.

In reality, anyone who points a camera at family, friends, fellow tourists, or strangers encountered on holiday becomes a "skin" photographer. Our images are successful when skin is rendered in a way the viewer perceives as "natural" or when we deliberately alter nature to create a new visual and sensual reality. Kodak and Fuji corporations anchored the success of their films on the ability to record human skin tones. Their emulsions, positive and negative, each had specific color characteristics usually

based on the ability to image bodies and faces in ways we deemed "natural" or to enhance skin color so our eyes perceived the humans in our photos as "real"—or even better than "real." The competing companies each created signature films vaunted for their specific rendition of skin color and then spent millions promoting them. Pros argued and debated the specific color attributes of each film and aligned themselves with Ektachrome 64, 100, 400, Fujichrome, Astia, Velvia, or negative films like Vericolor and Fujicolor and all the iterations and generations thereof.

Many of us no longer even own traditonal film cameras as these same companies rapidly scale back production of film. They are scrambling to design and manufacture imaging chips and new digital technologies. So with today's digital technologies, Lee explains, we don't have to settle for one film or one look per roll or camera load. He shows us how to calibrate point-and-shoots and professional DSLRs in order to capture our own personal "signature" color. He demystifies software and hardware, color control, lighting, and exposure; streamlines workflow to maximize the image capture options; and then explains how to output, print, upload, store, and archive the images.

This book is not just a superficial, skin-deep look at digital imaging. It goes well beyond the dermis. It cuts to the core, exposes and fleshes out just how simple and practical digital imaging technique and workflow can be. Lee is not a "skin" photographer. He's a whole lot more! This book proves it.

GERALD BYBEE
www.bybee.com

Contents

"Though the focus is on skin, the concepts and techniques apply in all types of photography."

Introduction

The book you are holding is the result of 30 years of experience capturing photos with film and digital technology. I have tried to distill all my experiences with people photography into a short volume that concentrates on the technical and creative aspects of digital photography of human subjects.

The biggest problem for me was figuring out what to omit. If I had included every little detail, the volume would have swollen to well over 800 pages. Therefore, I tried to concentrate on information that is not readily available elsewhere and still cover enough basic information to provide some foundation for the more advanced concepts in the book.

The title of this book is *Skin*, but the tutorials contained herein cover much more than just the surface material of the most popular subject for photography. There is skin here, to be sure—just perhaps not the type of "skin" that such a title might suggest. In these pages, you will find valuable information about digital photography and retouching skin—skin that belongs to real people, all kinds of people: young, old, and of all ethnic types. You will find out how to use lighting for portraits, action, outdoors, in-studio, and on location. You'll learn several techniques to make dark skin reproduce better. Although the focus is on skin, the concepts and techniques this book explores have broad application in all types of photography.

I've attempted to address the rather large holes found in most other books on the subject of people photography, where it seems that the photo-universe is populated by exclusively by white middle-class people or skinny, young, beautiful women. I've included examples from other photographers shooting in different styles that range from Gen-X advertising to lifestyle stock, as well as more straightforward portraiture. Much of this work is very contemporary, shot recently, and, as such, it represents current trends in photography rather than legacy work of an author who hasn't shot a real job in years.

Above all, this is a technical book about professional digital photography. Although it is oriented toward commercial, stock, and professional shooters, the technical content is perfectly applicable to fine art photography. You won't find pages and pages of philosophical ramblings about art and psychology, but you will find loads of practical techniques that you can use in any context. Many of these techniques have never been published before now, and all of them are presented in great detail with variations so that you can better adapt these methods to your own specific needs.

Who Should Buy This Book

I've made certain assumptions regarding the reader:

- You are familiar with basic computer functions.
- You know basic photographic principles such as f-stops and shutter speeds.
- You have used a digital camera to capture images, at least as JPEGs.
- You are familiar with basic Photoshop functions.
- You have a rudimentary understanding of layers and masks in Photoshop.

This book is not intended as a basic text on digital photography or Photoshop, but it can be used in conjunction with a basic text to take you to the next level in digital photo mastery. The tutorials herein, with the associated digital files provided on the companion CD, will allow you to learn professional techniques for capturing and enhancing images of human subjects. You will not find the usual simple brightness/contrast or red-eye–reduction techniques that are more than adequately covered in every other book on digital imaging; *Skin* is about *professional* techniques for creative photography.

On the other hand, don't let me intimidate you. There is plenty of material here that can be put to good use by serious beginners. You might need to invest some time and energy, but you'll definitely be rewarded if you follow along with the step-by-step instructions. So roll up your sleeves and let's begin!

What's Inside

Here is a glance at what's in each chapter.

Chapter 1: Digital Imaging Basics begins with a basic explanation of digital capture technology: the hardware and software we photographers have to manage in order to capture and improve our images.

Chapter 2: Color Management, Workflow, and Calibration provides a summary of a best-practices workflow, includes a special section on calibrating your RAW file processing for skin tones, shows important Adobe Camera Raw controls, and demonstrates how to keep your color high-quality and consistent.

Chapter 3: Lighting and Photographing People shows basic lighting techniques, gives examples of more elaborate lighting, and provides diagrams illustrating the placement of lights and reflectors.

Chapter 4: The Color of Skin covers color correction specific to skin tone and shows how to achieve the best possible color rendering for a wide variety of subjects.

Chapter 5: Tone and Contrast: Color and B+W introduces you to the best methods for grayscale conversion and explores the concept and techniques for luminosity blending. It also demonstrates how to tone or colorize B+W.

Chapter 6: Retouching shows how to do basic as well as more advanced retouching for men and women. Special techniques are presented for rebuilding skin texture, minimizing skin defects, smoothing skin, and even slimming figures.

Chapter 7: Special Effects covers advanced Photoshop techniques with creative methods specifically suitable for people photography, including a section dealing with tattoos.

Chapter 8: Preparing for Print provides tutorials for print preparation with sharpening and other print-enhancing techniques.

Chapter 9: Parting Shots brings us back to the full outline of a typical digital photo workflow. It also provides a guide to the contents of the companion CD.

If you prefer to work from a TIFF starting point rather than a JPEG, here's how: For the CD images in Chapters 4 through 8, open the PSD version from the Finish_Files folder, set all layers but the Background to invisible, and then Save As > TIFF.

> **Note:** Many files are collected in ZIP format to save space; use a utility such as StuffIt Expander or WinZip to unpack them and save the uncompressed files to your own drive.

How to Contact the Author

I welcome feedback from you about this book or about books you'd like to see from me in the future. You can reach me by writing to varis@varis.com. For more information about my photography, visit my website at www.varis.com.

Sybex strives to keep you supplied with the latest tools and information you need for your work. Please check their website at www.sybex.com, where we'll post additional content and updates that supplement this book should the need arise. Enter **Skin** in the Search box (or type the book's ISBN—047004733X), and click Go to get to the book's update page.

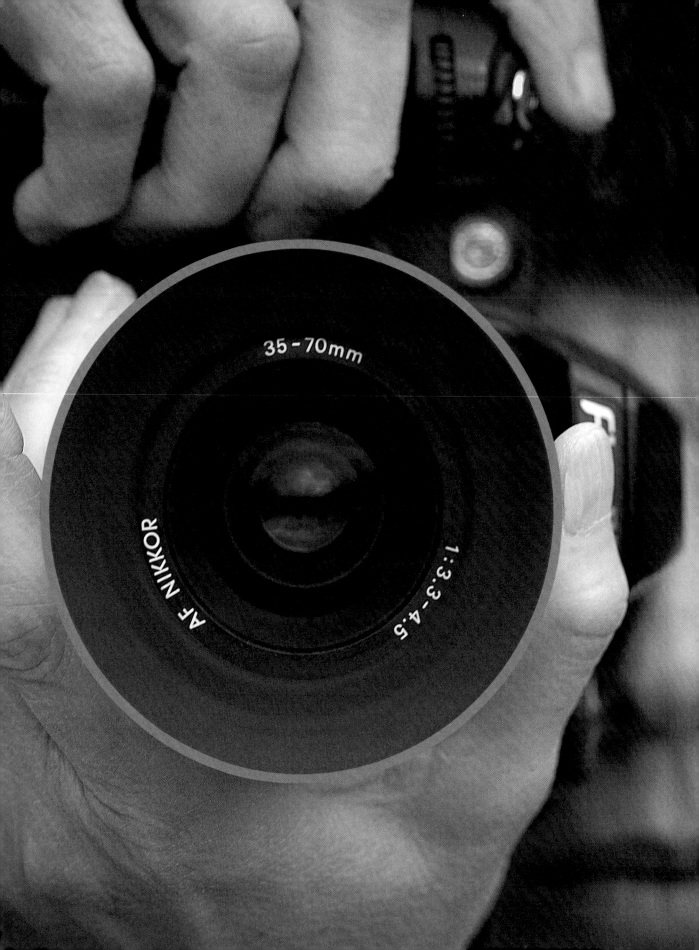

Digital Imaging Basics

Every journey begins with the first step. Unfortunately, for many, the temptation to skip the first few steps is greatly enhanced by the comforting belief that they already know how to take pictures. After all, we've all been snapping photos since we were kids, haven't we? Modern cameras do everything automatically, don't they?

Well, despite the fact that certain aspects of picture taking remain the same, you are striking out into a vast new territory when you forge a path into the digital wilderness. Before you begin, you'll need to learn the basics of how digital photography works; then you'll need to set up your hardware and set your software preferences for the best starting place for your journey. Only then can you take the first tentative steps to digital photo mastery.

Chapter Contents
Chips and Pixels
Setting Up: Hardware
Setting Up: Software

Chips and Pixels

All cameras function like human eyes (Figure 1.1). In both, a lens focuses light through a small hole (iris) onto a receptive surface (retina/film/chip) that translates the varying intensities and colors of the light into some meaningful information. The main distinguishing feature between different cameras and the eye has to do with the receptive surface. The eye's retina is a receptive surface comprising two different structures (rods and cones) with three basic color sensitivities (red, green, and blue). Film is made of one type of structure (silver salt grains suspended in gelatin) with three different layers to receive color. Digital camera chips have one structure of photoreceptor sites on a silicon chip, each of which has one of three different colored filters to record light.

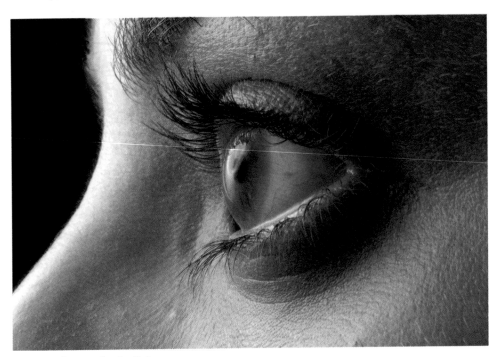

Figure 1.1 All cameras function like human eyes.

Digital cameras are similar to eyes in that the camera's chip translates the light into information (electrical signals) directly. Much as the eye translates the light falling on the retina into nerve impulses (electrical signals) that travel to the brain for processing, the electrical signals from a digital camera require processing in a computer "brain" before they can be used to create photos.

The actual process is rather more complex, but a few things are important to understand. Most digital cameras capture images using chips with receptor sites that have red, green, and blue filters arranged in a regular pattern on the surface of the chip. Light intensity is the only thing captured at a receptor site. During the processing phase, the color of light hitting a receptor is determined by calculating differences in intensities between adjacent sites that have red, green, or blue filters. This process produces an RGB bitmap image. A bitmap is a regular grid of square units of color. These

units are called *pixels*. Color is determined by the relative values of red, green, and blue for each pixel. We, therefore, think of these pixels as being in three "channels" (red, green, and blue) simultaneously so that the complete image is recorded as three different B+W images that form the full-color version. This concept will be important when we get to color correction.

Bayer Pattern Chips

The usual arrangement of red, green, and blue photoreceptors across a digital camera chip surface is called a *Bayer pattern*. This regular pattern alternates green with red and blue so that there are twice as many green pixels as there are red or blue. There are more green pixels because green holds 60 percent of the overall image luminosity (lightness-darkness) in an RGB image. The signals from adjacent pixels are averaged together using complex algorithms to determine the overall color and interpolate this into each pixel in the image. Skin colors sit right between the red and green filter frequencies used in most chip designs, and as it turns out, calculating skin color correctly is difficult. In digital photography, skin color can end up being a little too red. You'll learn how to compensate for this later.

The number and density of receptor sites on the chip determine the resolution of detail. This *pixel count* is given as either dimensions, such as 4992×3228, or as a total, such as 16 megapixels, where "mega" means million (totals are usually simplified to the nearest decimal). Therefore, an 8-megapixel chip has less resolution than a 12-megapixel chip. Professional-quality people photography can be done with cameras delivering 5 megapixels or more of resolution. Pixel count can be manipulated after the fact through mathematical calculations that *interpolate* new pixels from existing ones, but the amount of image detail can never exceed the original *resolution* of the chip. That being said, there is no reason for you to obsess over the number of pixels available as a standard of quality. Movie posters have been made from images with fewer than 6 megapixels, and the quality of those pixels is more important than the quantity used for photographing people.

The dynamic range of a captured scene is an important yardstick for quality (Figure 1.2). This is the brightness range from dark to light that affects how much detail can be rendered in the darkest and lightest portions of the scene. Dynamic range is often represented in f-stops. Digital cameras can often capture a range of 11 f-stops from black to white, where a paper print from a desktop inkjet printer might have, at best, a range of five f-stops. Regular offset lithography, such as magazine printing, has even less dynamic range—typically four f-stops or even less. This disparity between capture and output is at the heart of reproduction problems because we often have to determine how we are going to compress the range of an image to fit the output. You will often hear about "bit depth" in the same breath as dynamic range. *Bit depth* refers to the number of steps between black and white that are encoded in a digital capture. Higher bit depth captures have a finer density of steps and yield a smoother ramp from black to white; however, bit depth does not determine dynamic range. It is certainly better to have higher bit depth with wider dynamic range, but the two are not necessarily interdependent.

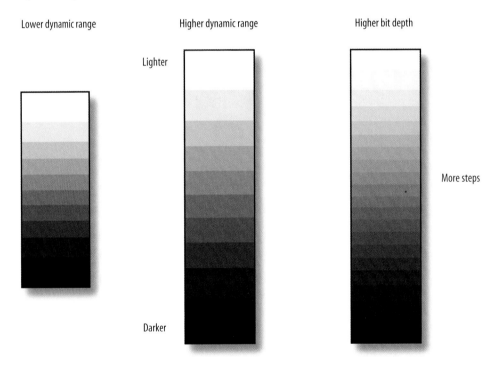

Figure 1.2 Dynamic range and bit depth

The RAW signal from the camera chip can be processed either in the camera firmware or later in software under user control. There is some debate over the merits of both approaches. Generally, if you opt to have the camera do the processing, you will be shooting JPEG files to the memory card or directly to a computer.

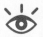 **Note:** JPEG stands for Joint Photographic Experts Group, the organization that developed the file format.

JPEG is a file format that was developed to reduce file size by using mathematical algorithms that simplify the pixel structure in the bitmap image. This process is considered *lossy* because some image detail is "lost" during the process. Digital cameras apply a conservative level of compression or size reduction, and this is generally considered visually *lossless*. This does not mean that there is *no* loss—just that the loss is not apparent at first glance. Even the best JPEG file does not carry the same amount of information or image detail as a noncompressed or unaltered version.

The main advantage to shooting JPEGs is that by compressing the file size, you can fit many more images onto a memory card (so you don't have to change cards as often). Because the files are smaller, they also write faster and enable faster shooting speeds. This can be important for shooting wedding candids, news, sporting events, and any other fast-breaking action. The disadvantage to shooting JPEGs is that you have to accept the camera's interpretation—of color, contrast, etc.—and you limit the potential quality of the image. You give up some flexibility and quality for speed and convenience.

JPEG Compression Artifacts

JPEG compression works by simplifying adjacent tones; similar tones are assigned the same value. This can cause distinctive "blocky" artifacts and "messy" edges, which are most noticeable in extreme magnifications. JPEG artifacts can become a problem when image files are sharpened for print output or scaled up from smaller sizes. For most work destined for offset lithography (magazines and newspapers), JPEG artifacts don't pose a problem because they are obscured by the printing linescreen.

If you are concerned with the best possible quality, then you probably will prefer to record the camera's RAW signal and process this data using your computer software in a *RAW file workflow*. Doing so complicates the process slightly by adding an additional post-processing step to your photography workflow. We'll cover this more thoroughly in Chapter 2, "Color Management Workflow and Calibration." The main advantage to a RAW file workflow is that you can postpone final decisions on color rendering, tone, and contrast until after the shoot, when you have fewer distractions and you can concentrate on basic photo elements such as lighting, composition, and exposure. You also gain a considerable amount of control over color rendering, tone, and contrast. The disadvantage is that you have to take extra time after the shoot to process your RAW files into a useable format.

Setting Up: Hardware

Covering all the available digital photo equipment is impossible. However, as topics require, I will go over more hardware details in the remaining chapters. For now, I'll just give a few general recommendations to consider regarding:

- Camera
- Memory cards
- Batteries
- TV monitor
- Computer
- Monitor and calibrator

Camera

Any digital camera is capable of taking great shots. However, getting great results is easier if you have equipment that delivers quality. Most serious photographers will require, at minimum, a DSLR (digital single lens reflex) camera (Figure 1.3) of at least 5 megapixels resolution. You'll also want to make sure that your camera is capable of shooting (and saving) RAW files. Even if you normally shoot only JPEGs, the ability to shoot RAW will be important on some occasions, and it is often an indicator of a better camera. All of the tutorials and exercises in this book can be completed using cameras costing less than $800. If you are just starting out in digital photography, don't be temped to spend all your money on the camera body. It's better to save some of your budget for lenses and other accessories to build a complete system.

Memory Cards

After you purchase a camera, you'll need to obtain memory cards (Figure 1.4). More memory is better, but focus on procuring multiple cards rather than bigger cards—having two 1GB cards is often better than having one 2GB card. You should have at least three cards, but more will be handy if you don't get the chance to download files during a shoot. Stick to major brands, such as Sandisk and Lexar, and try to get the fastest ones available. Mark your cards (A, B, C or 1, 2, 3, etc.) so you can identify which cards go bad if you discover some file corruption. Also, arrange for some method of

separating shot cards from empty ones (I use two different colored Otter Box water-proof cases). Finally, no matter what method you use to download images from the card, do not erase the image files from the card using a computer; always format the card in the camera you use to take the pictures.

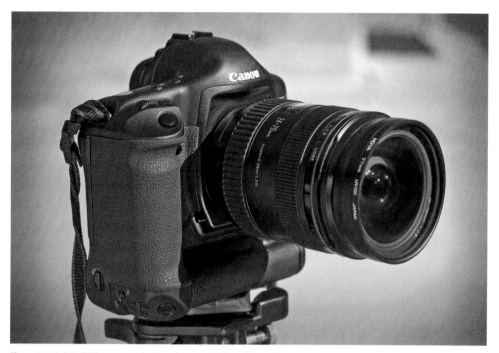

Figure 1.3 A digital SLR camera makes it easier to get high-quality results.

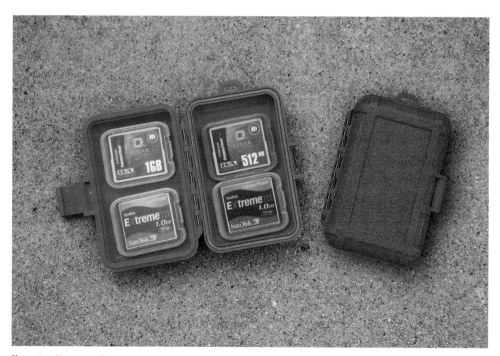

Figure 1.4 Memory cards

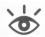

Note: You'll find Otter Box cases at http://www.otterbox.com/products/otterbox/1000/.

Batteries

Digital photography is all about recording electrical signals, and that means batteries are required! Make sure you have a lot of them. Just about all digital cameras require nickel metal hydride (NiMH) rechargeable batteries (Figure 1.5). In many cases, regular alkaline batteries can damage the camera. If your camera takes a special proprietary type, get at least one extra for a backup and keep it charged. Don't forget batteries for flash units, radio slaves, portable card reader/players, or any other accessories you might have. A good battery charger will more than pay for itself. Get something that can reform or revitalize tired batteries that lose their ability to hold a charge.

Figure 1.5 NiMH rechargeable batteries

TV Monitor

High-end digital camera systems have the capability to shoot directly to a computer through a Tethered Operation mode. This gives you a high-resolution display of every shot as you take it, which is quite a luxury. Even relatively inexpensive DSLRs have a video-out plug that can send the LCD preview signal to a TV monitor (Figure 1.6). Although the picture resolution is not as high as a computer display, it is more than

adequate and quite a bit less expensive. It's also quite a bit faster: my Canon EOS-1DS Mark II in Tethered mode takes 7.5 sec to display on my computer monitor, but the video preview is instantaneous. You can adjust the LCD preview delay to keep the image up longer if you prefer, but it's also a simple matter to review images on the spot using the camera controls.

Figure 1.6 Camera with monitor

Note: The image displayed on the TV, like the LCD preview, is essentially the preset JPEG that the camera would render from the RAW data. This may not be exactly the same rendering you would achieve using RAW processing software, so you probably won't be able to rely on the TV image for anything more than a quick review.

Computer

The platform wars are over! As far as basic functionality and speed issues go, Windows and Macintosh computers are equivalent. If you are familiar with one or the other, stick with the computer you have—there will be no advantage to switch just for digital photography. The main software applications you will be using are cross-platform, and the user experience is more or less the same with both computers. If you have not invested heavily in computer hardware yet *and* you are primarily interested in commercial advertising work, then you should consider a Macintosh only because it is the platform of choice for the advertising and design industry. I have used Macintosh

computers since 1985, and I'm very happy with my computer experience. However, I really can't recommend one over the other. I apologize to the majority of readers who will be using Windows machines because all the screenshots in this book are taken on a Macintosh.

Regardless of your computer platform, you will want to load it with as much RAM as possible—there is no such thing as too much RAM for image processing work. This also goes for hard drive space. Again, you can never have too much; plan on having a second hard drive that you can set up as a duplicate for backup purposes. Ideally, you will also have additional drives to use for archiving. Investing in a good monitor and monitor calibrator is absolutely necessary.

A minimal system will have:

- A computer
- A monitor plus monitor calibrator
- Two large hard drives (minimum)
- A CD/DVD burner
- An uninterrupted power supply (UPS), battery backup, surge protection
- A quality inkjet printer
- A card reader: FireWire or USB2 (shown here)

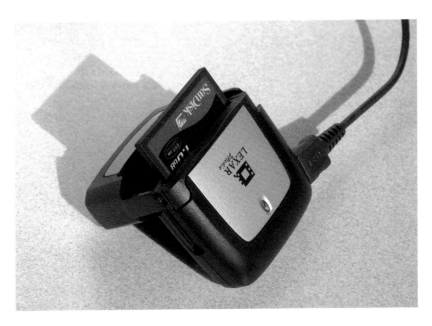

Monitor and Calibrator

A good monitor is an absolute necessity for any serious photographer. However, a good hardware calibrator is even more important (Figure 1.7). LCD monitors have overtaken CRTs in popularity, but the need for good calibration has never been in dispute. You'll

need to purchase a calibrator with the necessary software and use it regularly to keep your display in good working order. Even a mediocre display can be serviceable if it is properly calibrated, but an expensive display is almost useless if it lies to you! Calibrate your display every two weeks to be on the safe side.

Figure 1.7 Monitor calibration

Note: Many hardware calibration devices are on the market. Some popular systems are Eye-One Display (GretagMacbeth), Monaco Optix (X-rite), ColorEyes Display (Integrated Color), and BasICColor Display (Color Solutions).

Before moving on to software preferences, you need to consider your computer setup. I highly recommend that you choose a simple, gray desktop color and select a gray interface option for the overall color scheme for your computer. The idea is to eliminate as many color distractions as possible for the environment in which you will be making color decisions. If the background behind your images is bright blue, you will tend to see everything as warmer than it is because of the *color contrast* with the blue background. You probably will have a tendency to make your colors too cool as a result. A neutral gray background is the safest choice because it will not bias your judgment one way or another.

Setting Up: Software

Your digital camera probably came with software to process the RAW files that it produces. Many photographers are quite happy with their camera software. This book, however, outlines professional procedures and techniques that go beyond the push-button, preset mentality of most camera manufacturers' software. Many software packages are available for professional digital photography. At the time of this writing, Apple and Adobe have just released new applications targeted to the professional photographer. I might include these or other new products in future versions of this book; but for now, the most versatile and professional software for photographers is Adobe Photoshop. I will concentrate on techniques and workflows that are used with Adobe Photoshop CS2, Bridge, and Adobe Camera Raw.

The rest of this chapter will cover some basic preference settings to establish a starting foundation for future explorations. We will cover:

- Photoshop preferences and color settings
- Bridge preferences and configuration

Photoshop: Preferences

The following pages cover various Photoshop CS2 preference settings in some detail. These recommendations are designed for the photographer working to produce print images; however, a thorough understanding of the preference controls will be handy in any intended workflow. Many of Photoshop's workspace customizing features will not be covered extensively. You will have to investigate palette layout, tool presets, and custom brushes on your own. Individual needs in these areas will change and develop over time, so it makes sense to skip over the details for now.

The screen shots presented here were taken in Mac OS X. For the most part, the differences between Windows and Mac OS X are cosmetic. The main difference is that the preferences are entered via the Photoshop menu in OS X (far left, application menu next to the Apple menu) and preferences are entered via the Edit menu in Windows.

The other important difference is the way memory preferences are handled. Mac OS X has a dynamic memory functionality that affects the preferences in Photoshop CS2. Windows versions of Photoshop have an Image Cache preference setting where you determine the number of Cache Levels; Mac OS X also has a Memory Usage setting in the same dialog where you can limit the amount of memory that OS X will assign to Photoshop. This limit is assigned in a fixed way in Windows outside of Photoshop's preferences.

Select from the Photoshop menu (OS X) or the Edit menu (Windows) > Preferences > General (Figure 1.8).

Figure 1.8 The preferences are found on the Main Menu bar, under either the Photoshop or Edit menu.

Most of these settings are self-explanatory. For the most part, you can accept the program defaults. I am going to discuss only items that you might want to change. Your General preferences should look like Figure 1.9: Most settings that are already checked here should be fine. Make sure that Interpolation is set to Bicubic Smoother and that Export Clipboard is not checked. In most cases, you do not want to carry the Clipboard over into other applications. If you forget to purge it, an error can be reported or a serious delay can occur when you move between Photoshop and another application. Bicubic Smoother is the best default interpolation for scaling up files and it gives the smoothest result—smooth is desirable with skin.

Figure 1.9 General preferences

Note: The interpolation method selected here is just a default. It controls which method appears when you first enter the Image Size dialog and it is the method used with Transform commands. In practice, you are free to change the method used in the Image Size dialog by selecting from the Resample Image menu. Although Bicubic Smoother is normally preferred for scaling up, Bicubic Sharper is most often preferred for scaling down.

After you are comfortable with Photoshop, you'll probably want to uncheck Show Tool Tips to get rid of the little yellow notes that describe the function of icons and tools when you hover your cursor over items.

History Log is primarily of interest for forensics or scientific work where you might want a record of everything that was done to the file. Most of us won't find this feature particularly useful.

You can determine file-saving behavior in the File Handling panel (Figure 1.10). Most users will want to check Always Save to save their previews unless they have some consistent need to for smaller file sizes. The cost of storage is at an all time low, so don't economize unless you must. You can uncheck OS platforms that you do not use for Thumbnail. Saving a Full Size image preview is useful with image cataloging programs such as iView Media Pro, Cumulus, or Portfolio; if you don't use a cataloging program, you should.

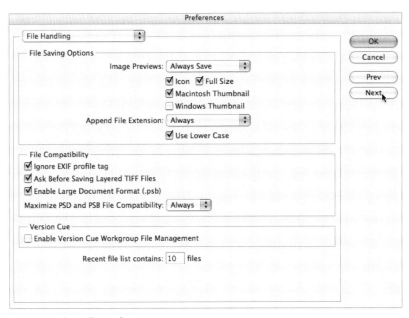

Figure 1.10 File Handling preferences

I *used to* recommend against using Maximize PSD File Compatibility; this creates a *composite layer* (one layer with all other layers rendered into it) for compatibility with Photoshop 3. Now, though, I recommend that you set this to Always; the reason, again, has to do with image cataloging programs. If there's no composite layer, many programs cannot generate a thumbnail to use in the catalog. You should also have Always selected for Append File Extension.

Some cameras will report their color space as sRGB even when they don't have an embedded profile. Ignore EXIF Profile Tag prevents this problem. You should leave Ask Before Saving Layered TIFF Files checked, if only as a double check for when you are saving TIFFs. Currently, Photoshop is the only program that can open layered TIFF files. The only reason to save a file as a TIFF is for maximum compatibility with other image applications, and you would negate this if the file has layers. (Save layered files as Photoshop PSD documents and save yourself some grief later.) Enable Large Document Format (.psb) does just that—but at the expense of some backward compatibility. I don't see this as a problem; however, unless you need to save files that are larger than 2GB, checking it isn't critical.

Display & Cursors is shown in Figure 1.11. *Do not* check Color Channels In Color. Viewing color channels as grayscale luminosity is a lot more useful. By checking Use Pixel Doubling, you can increase the speed at which moving objects are drawn on the screen and layers are repositioned; however, moving objects will be rendered with less fidelity. I find the option distracting, so I leave it unchecked. Cursors should always be set to Brush Size and Precise; I prefer to check Show Crosshair In Brush Tip because the feature is very handy when lining up the Rubber Stamp tool. Full Size Brush Tip draws the circle for the brush size at the outer edge of the feather in a soft brush; it sounds like a good idea, but it drives me crazy so I leave it unchecked.

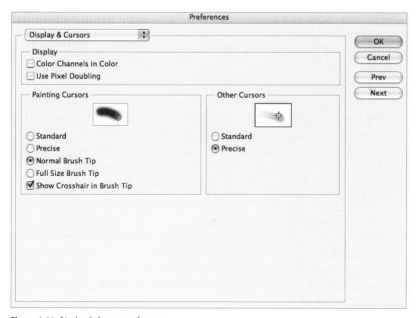

Figure 1.11 Display & Cursors preferences

Transparency & Gamut (Figure 1.12) controls the appearance of transparent parts of image layers. I find the default gray-and-white square distracting when I examine masked edges. I recommend that you change the white squares (click the white Grid Colors patch to bring up a color picker) to a gray value that's just barely different.

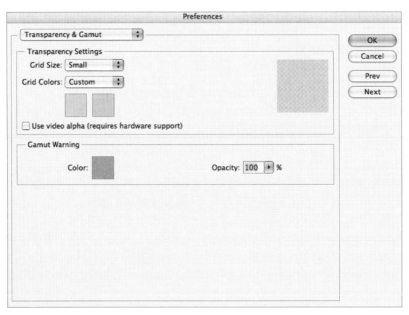

Figure 1.12 Transparency & Gamut preferences

In Guides, Grid & Slices (Figure 1.13), you might have to uncheck Show Slice Numbers; however, that that's the only thing you might have to change here. If you inadvertently select the Slice tool instead of the Brush tool, you can end up with little numbers in the upper-left corner of the image window; most photographers find them distracting. Slices are used to divide an image into sections that will load separately in a web browser; this helps speed up the display of large graphics—obviously, this is important for web designers.

The Plug-Ins & Scratch Disks dialog is shown in Figure 1.14. If you end up with lots of third-party plug-in filters, you can limit the number of filters that load in any given session by designating an Additional Plug-Ins folder. By holding down ⌘-Option (Mac) or Ctrl-Alt (Windows) at the application launch, you can select or deselect the extra plug-ins. Limiting the number of available plug-ins can free more memory for Photoshop and accelerate certain functions. Scratch Disks allows you to select up to four separate disks for Photoshop's temporary "scratch" memory. You can obtain a speed boost by setting aside an empty hard drive (or, at the very least, a separate partition) exclusively for a scratch disk. Extra disks serve as spillover memory for the main scratch in descending order of priority.

Figure 1.13 Guides, Grid & Slices preferences

Figure 1.14 Plug-Ins & Scratch Disks preferences

Memory & Image Cache (Figure 1.15) can usually be left at the defaults. Windows and Mac versions look a little different. I'm showing only the Mac version because its Memory Usage option is a little confusing. Mac OS X has a special dynamic memory allocation feature that allows the foreground application to gobble up memory as needed. Photoshop is particularly greedy with RAM; therefore, in certain

circumstances you'll need to limit the amount of RAM to which it has access. If you have more than 4GB of RAM installed, you can safely assign 100 percent as the Maximum Used by Photoshop because Photoshop can access only up to 4GB anyway. If you don't have that much RAM, giving in to Photoshop's memory demands can be dangerous because you can starve the operating system (OS) and force it to swap memory in and out of the hard disk. More is not always better when you make Photoshop RAM assignments. If the OS has to work harder at managing memory, Photoshop operation can actually slow down. If Photoshop seems slower after you've assigned more RAM, lower the RAM assignment to leave more for the OS.

Windows memory management is a little more straightforward. You assign the specific amount of memory to which Photoshop has access. The only trick is to make sure you have enough memory left over for the OS.

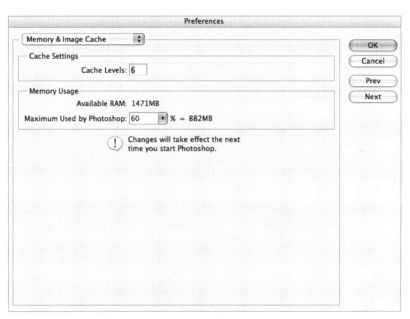

Figure 1.15 Memory & Image Cache preferences

The next area you have to set up is Photoshop Color Settings. From the Main Menu bar, choose Edit > Color Settings. The Color Settings dialog (Figure 1.16) is where you determine the default color management behavior of Photoshop. For our purposes, change the Settings drop-down from North America General Purpose 2 to North America Prepress 2. This will set the rest of the dialog to the most appropriate defaults. We'll go over color management in more detail later because the topic comes up repeatedly in our workflow. For now, just realize that we'll use Adobe RGB as the default color space for all our digital photo files and we'll be using ICC profiles to define the colors with which we'll work.

Color Settings

For more information on color settings, search for "setting up color management" in Help. This term is searchable from any Creative Suite application.

Settings: North America Prepress 2

Working Spaces
RGB: Adobe RGB (1998)
CMYK: U.S. Web Coated (SWOP) v2
Gray: Dot Gain 20%
Spot: Dot Gain 20%

Color Management Policies
RGB: Preserve Embedded Profiles
CMYK: Preserve Embedded Profiles
Gray: Preserve Embedded Profiles
Profile Mismatches: ☑ Ask When Opening ☑ Ask When Pasting
Missing Profiles: ☑ Ask When Opening

Description
North America Prepress 2: Preparation of content for common printing conditions in North America. CMYK values are preserved. Profile warnings are enabled.

OK
Cancel
Load...
Save...
More Options
☑ Preview

Figure 1.16 Color Settings dialog

Bridge: Preferences and Configurations

We will be examining the Bridge workflow; Bridge (Figure 1.17) is the file browser application that is part of Adobe's Creative Suite.

Figure 1.17 Adobe Bridge

At this point, we need to go over only a few of the preference settings. When you first open the Preferences dialog, you will see the General preferences (Figure 1.18). This area controls the appearance of thumbnails and determines which items appear in the Favorites tab. Click the Reveal button to display the locations for the JavaScripts that Bridge accesses for some of its automation features.

Figure 1.18 Bridge General preferences

Metadata preferences (Figure 1.19) determine what metadata fields will be visible in the Metadata tab. Metadata is simply data about data; the data we're interested in is, of course, the image file. You can turn off the display of anything you're not interested in by unchecking that item in the list. Don't get too carried away and turn off too many fields—you don't have to look at them all the time. Make sure you check Hide Empty Fields to prevent the display of fields for which there is no data.

The only other preference worth noting at this point is the Advanced preferences (Figure 1.20). In this dialog, you specify the maximum size for files that Bridge can process (200 megabytes is the default). You can use Do Not Process Files Larger Than to prevent Bridge from wasting time building thumbnails for huge layered files. By checking Double-Click Edits Camera Raw Settings In Bridge, you can open RAW files into Camera Raw without launching Photoshop; this setting is sometimes more convenient than always launching Photoshop. You should check Use Distributed Cache When Possible because it places the Camera Raw XMP and Bridge cache files in the same folder as the RAW files. This can be an advantage when you are moving or backing up data because Bridge won't have to rebuild thumbnails for folders you've already seen.

Figure 1.19 Bridge Metadata preferences

Figure 1.20 Bridge Advanced preferences

To start using Bridge, simply select a folder of images in the Folders tab. Bridge will render size-adjustable thumbnails for image files in that folder in the main window pane in the interface (Figure 1.21). There are many ways to configure the Bridge interface, and we won't cover all of them. However, I would like to point out one configuration that I find useful and that is not particularly obvious.

Figure 1.21 Bridge default layout

The default layout for Bridge has image thumbnails in the main window with various navigation and information tabs in three window panes at the left. You can choose different layouts from the Window menu (Window > Workspace > Lightbox, File Navigator, Metadata Focus, or Filmstrip Focus), *or* you can make your own custom layout. I like to nest all of the tabs into one window pane. Click and drag each tab into the top window pane—everything will collapse into one pane with a long list view (Figure 1.22).

Figure 1.22 Bridge's long list view

You can save any custom layout you want from the same Window menu (Window > Workspace > Save Workspace); your layout will then appear at the bottom of that submenu. I find this long list view very handy for navigating through folders.

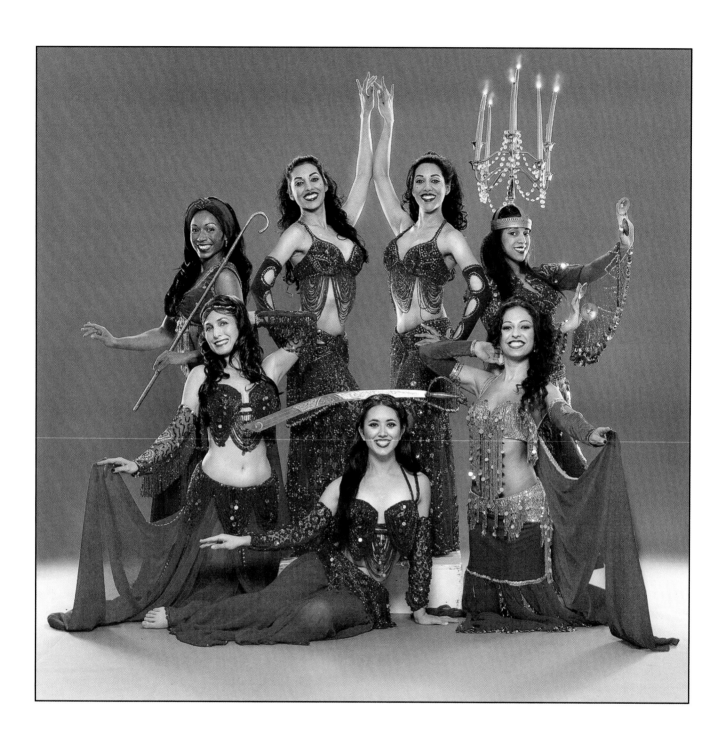

Color Management, Workflow, and Calibration

Color control is a critical challenge for any photographer, and it can be particularly vexing for people photography because there are as many different colors of skin as there are different people.

Because digital cameras do not have the point of reference that film provides, sophisticated software controls are needed to track or manage color from capture through output to ensure quality.

This chapter outlines a simplified approach to calibrate your capture system for the best rendition of skin tones, which is usually the biggest problem for any digital capture system.

2

Basic Digital Capture Workflow

Once your equipment and preferences are in place, you'll need to plan for your basic picture-taking workflow. Each picture-taking situation will demand a slightly different series of steps depending on your specific hardware, software, and working preferences. At the most basic level, you will be

- Capturing images

- Downloading image files to a computer

- Adjusting the files (cropping, color correcting, retouching)

- Delivering images (printing, uploading, saving)

- Backing up files (saving and storing)

The basic steps can change slightly depending on whether you are shooting RAW or JPEG, tethered to a computer or to memory cards, archiving original RAW, or converting to DNG. Many of the repetitive tasks can be automated in certain software or using scripts. Look for more details on workflow automation on the accompanying CD (RawProductionWorkflow.pdf).

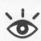

Note: DNG (Digital Negative) is a new, open-published RAW file format developed by Adobe to address the need for a standard format for digital camera data. Currently, most camera manufacturers use proprietary file formats unique to their particular cameras. This is equivalent to Nikon cameras using only Nikon film, which would be an unacceptable situation with the photographer at the mercy of the manufacturer to support his images. A big push is underway in the industry to move toward an openly supported file format that will work with all cameras, and most photographers see DNG as becoming that standard.

Most of the *digital workflow* occurs after the photo shoot because that is where digital photography takes a major departure from traditional photography. A professional workflow maintains a backup protocol from the beginning, always maintaining duplicate copies of files at every step. A typical progression of steps might look like this:

1. After filling your memory card, place it in a card reader and mount on your desktop (Figure 2.1).

2. Copy the image files to a folder on your computer, rename them, and duplicate the files onto a separate hard drive as a backup (Figure 2.2).

3. Verify the integrity of the backup (this automatically verifies the first copy).

4. Once you are satisfied that the files are OK, you can reformat the card in the camera before shooting more images.

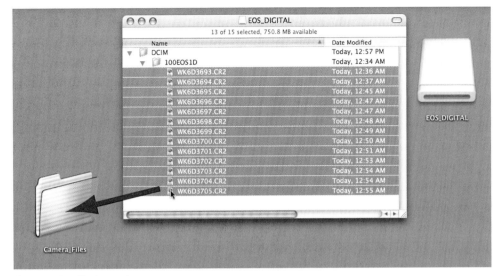

Figure 2.1 Copy files from card.

Figure 2.2 Make a backup copy.

Of course, you might not have enough time to copy, duplicate, and verify while you are shooting, so you might need to have multiple cards on hand. Always strive to have two copies of every image file at any one time. Cards can be downloaded to the computer unattended, so you can always have one copy on the computer and one copy on the card at the very least. Some cameras have the capability to shoot to two separate cards in camera (usually a CF card and an SD card), so you'll have backups automatically as you shoot. Having a computer on hand can be inconvenient for many photographers. In that case, consider using one of the portable, self-contained card reader/hard drives (Figure 2.3) as a temporary backup solution.

Figure 2.3 A FlashTrax card reader

Once you have a plan for your workflow, you can begin the real work that starts with calibrating your equipment.

Calibrating for Digital Capture

Back in the old days, serious photographers tested their equipment and film to establish the best working methods for their particular gear. Ansel Adams developed the Zone System for his work with black-and-white film. Commercial photographers shot tests through different color gels to determine the color bias of a particular emulsion as processed through their particular labs. Testing was an ongoing process that photographers used to stay on top of their game. Modern digital capture has opened up new possibilities for accuracy and color quality, but the need for testing still exists. We'll explore one approach to digital testing and calibration, with a special emphasis on skin tones, that I have used with my equipment and readily available software and hardware. There are as many testing methods as there are different cameras and software, and the following is presented more to illustrate concepts than anything else.

I've already mentioned monitor calibration; this is a relatively straightforward process with a hardware colorimeter. You must calibrate your monitor before doing anything else. The next step is to calibrate your camera with your RAW processing software. We will be using Photoshop, Bridge, and Adobe Camera Raw (ACR) with your camera of choice as a system that works with the widest range of digital cameras. There are other approaches, but none of them currently offer as much control in a convenient and relatively inexpensive manner.

To calibrate your camera, you must shoot a test. The test shot will need to include some kind of standard target (Figure 2.4).

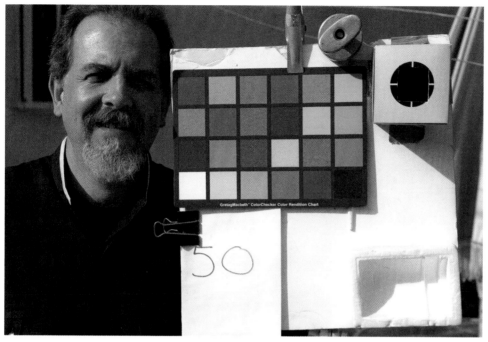

Figure 2.4 Sample test setup

The most widely used target is the GretagMacbeth 24 patch ColorChecker. Originally known as a *Munsell chart,* this target has been in widespread use for at least 50 years in the motion picture and television industries. You should be able to purchase one at any camera store. An ideal test will include this target, a human subject (for *real* skin tone), a *black trap,* and some written reference for the exposure. The black trap, shown in the example in the upper right, is a small cardboard box with a hole cut on the top: the inside is lined with black velvet. This is necessary for a real black reference as the black "patch" of the ColorChecker target is not very black. My test target also includes a highlight reference (some Styrofoam lens packing is in the lower-right corner). This isn't as critical for calibration purposes, but it helps to visualize the dynamic range of the capture in highlights. The curved form creates a soft ramp from near white into a "clipped-to-white" tone and allows you to see just how much detail is preserved in extreme highlights.

Note: The skin color patch on the ColorChecker target is intended to represent average Caucasian skin. Real skin comes in all different colors, and it is practically impossible to represent every kind of skin. Try to have some real skin that you feel is representative of your cultural average in your shots, but don't obsess over it. A real person in the test shot provides a visual reference to balance the technical nature of the target.

The testing procedure involves a series of steps, which are summarized here:

1. Establish lighting that mimics the conditions for your most common shooting situation.

2. Shoot a range of exposures to determine your camera E.I. (exposure index, ISO or ASA rating).

3. View the series of exposures in Bridge and apply "zero-slider" settings in ACR.

4. Identify the best exposure by comparing the exposures in Bridge and ACR.

5. White balance the test file, process it to TIFF, and open it in Photoshop.

6. Compare the ColorChecker as shot to a standard LAB reference file.

7. Adjust the sliders in the Calibrate tab of ACR to match the file.

8. Save your settings and create a new "camera default" setting for your camera.

Establish Lighting

You should shoot your test exposures under conditions as close as possible to your most common shooting conditions. If you shoot mostly outside, then you'll want to set up your test outdoors using daylight, as I did in the sample provided. To cover all your bases, you will want to calibrate for daylight color temperatures (such as flash or sunlight) and tungsten color temperatures (such as regular incandescent or halogen lights). Here are some considerations for various lighting conditions.

Outdoors: Daylight Try to set up in broad daylight under clear sky conditions. Make sure that no shadows hit your target—especially the ColorChecker. Stay away from buildings as much as possible to minimize the effect of reflected light on your test—if you set up near an orange colored wall, it *will* affect the color.

Indoors: Incandescent Lighting Use a single photoflood lamp positioned at a 45-degree angle to the target and about 10 feet away. Make sure you're in a room with white or neutral colored walls. Aim for as even illumination as possible—again, make sure no shadows hit the target.

Studio: Flash Lighting This is very similar in character to daylight, but here you want to simulate your most common lighting. Use the lighting you normally use for your subjects: use the same umbrellas or other light modifiers. Don't do anything special just for the test. If you use two lights, make sure they are the same type or make. You can skip any hair lights and just concentrate on your front lighting.

Fluorescent Lighting Shooting a test under fluorescent lighting is almost not worth the effort, because each uncontrolled situation you encounter will be different. Also, fluorescent lighting is a really unbalanced spectrum with big gaps and spikes in the frequencies represented. These situations almost always require some selective color correction in Photoshop after processing, so the kind of calibration you achieve here will be of limited use. If you frequently must shoot under a specific fluorescent lighting condition, then you can test for that—similar precautions against shadows and uneven illumination will apply.

Shoot to Bracket the Exposure Range

The idea is to shoot a bracket around the expected best exposure to determine the actual best exposure. Set your camera on manual and change only its f-stops to shoot the bracket. Use the lowest default ISO setting for your camera. Using a hand-held light meter works best. A spot meter would be ideal. I use a combo meter that is capable of incident and spot reading in continuous as well as flash lighting (Figure 2.5). The spot meter has the advantage of being able to measure the value of the mid-gray patch (third from the right in the bottom row of patches) from the camera position (Figure 2.6).

Figure 2.5 Sekonic L-558 multimeter

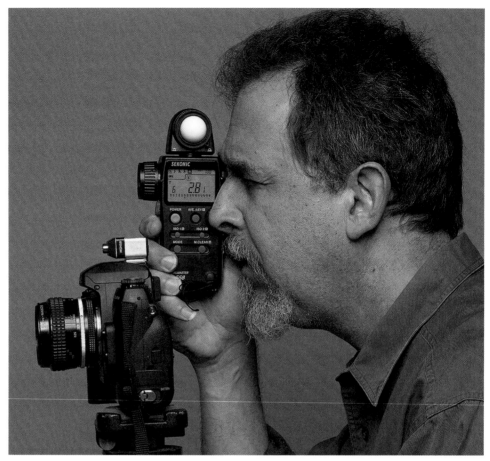

Figure 2.6 Spot meter readings are taken from the camera position.

A spot meter can read directly from the mid-gray patch (third from the right on the bottom of the ColorChecker), and the reading will give you the f-stop for the ISO. If you don't have a spot meter, use an incident meter and take a reading from the sub-ject position pointing the white dome at the main light source. If you don't have a hand-held meter, beg, borrow, or rent one. If you can't rent one, it will be more diffi-cult to get a meaningful reading. To use the camera meter, you must somehow zoom in on the gray patch and try to fill the screen with it. This will be easier if you can get a larger gray card.

Once you've determined your starting exposure, you will shoot additional expo-sures, incrementing the f-stop value by one-third f-stop using manual controls on your camera. Shoot two stops on either side of the starting exposure and keep track of the exposures as you go along. I find it convenient to indicate the exposure change on the target itself by writing on a paper attached to the target. I write down the difference in exposure as a change in ISO. In other words, if I stop down one-third from the ISO 100 reading, I write 125: 2/3 = 160, 1 stop = 200, etc. The beginning of the sequence would go: 100, 80. 64, 50.

Gray Cards

I use a Robin Myer Digital Gray Card from www.rmimaging.com. This is a spectrally neutral plastic material that is virtually indestructible and available in a larger size that makes it easier to fill the frame.

Do not use a Kodak 18-percent gray card because it *is not* spectrally neutral. The Kodak Gray Card is appropriate only as a value reference, not as a color reference.

View Shots in Bridge and Zero Out Sliders

Now you have to evaluate the shots to determine the best exposure. In order to do that, you need to change the default behavior of Bridge and ACR. Using Bridge, select the folder of test exposures in the folders tab. If you haven't changed the ACR camera default, you might notice that all the thumbnail previews look, more or less, the same (Figure 2.7). This is because ACR uses auto adjustments to equalize the exposures. You need to turn off Auto Adjustments and set all the sliders to zero before you can get a good idea about the best exposure. Select all the thumbnails and, from the File menu, choose Open in Camera Raw.

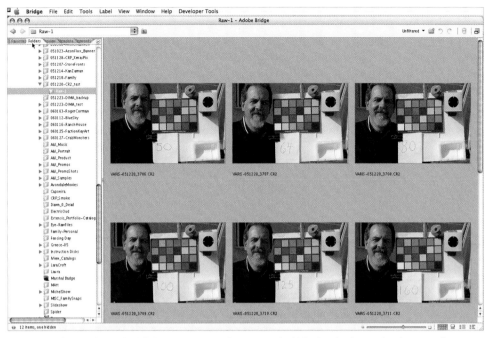

Figure 2.7 Before you change the defaults, ACR uses Auto Adjustments to build the thumbnails in Bridge. This causes the exposure bracket to look the same.

Uncheck Use Auto Adjustments from the Settings flyaway menu. The preview will update to reflect the current Camera Raw default settings for this camera. The Exposure, Shadows, Brightness and Contrast sliders will have positive values (Figure 2.8). You'll need to zero out all the sliders to see what the native performance of the chip is like without any processing enhancements.

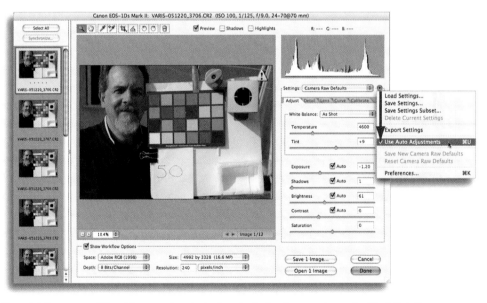

Figure 2.8 You can turn off Auto Adjustments by selecting from the Settings flyaway or by pressing ⌘+U/Ctrl+U.

Determine the Best Exposure

Once the sliders are at zero, click the Select All button at the upper left and then click Synchronize. The thumbnail previews will change, and you will most likely find that the expected E.I. now looks too dark. Usually, it is fairly easy to see which exposure looks the best with a calibrated monitor. You can also evaluate the best exposure based on RGB numbers—the mid-gray patch (third from the right) should have values close to 120 (R=G=B) when your output space is set to Adobe RGB. My camera looks best exposed one f-stop higher than normal, meaning that I have to rate it at E.I. 50 instead of 100 (Figure 2.9).

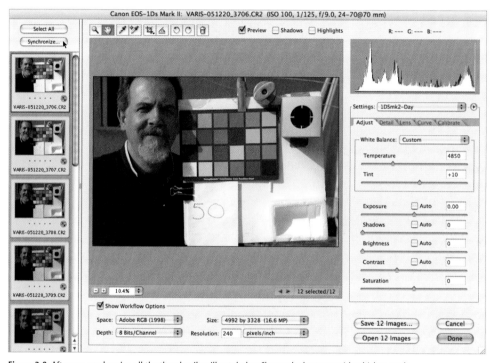

Figure 2.9 After you synchronize, all the thumbnails will get darker. Choose the best one with which to work.

Output: Workflow Options

When you check Show Workflow Options at the bottom of the ACR dialog, you will see drop-down menus for Space, Size, Depth, and Resolution. These settings determine the specifics of the file processed from the RAW data.

Size is fairly straightforward and is given as pixel dimensions. You have a number of choices. Smaller-than-native resolution chip sizes are designated with a minus sign (−) and larger sizes are designated with a plus sign (+).

Resolution determines only how large the file will print, and you can enter any value you want without affecting the pixel dimensions.

Continues

Output: Workflow Options *(Continued)*

Space determines the workspace into which the RAW data will be processed. This choice can have a serious impact on how you handle the color of the image after you've processed it. For the most part, I recommend that you use Adobe RGB because this is an almost universally accepted default and it happens to be the default workspace for Photoshop's North American Prepress setting. Do not choose ProPhoto RGB. This is a very large color gamut workspace that has no special advantage for photographing people. sRGB is a more conservative choice and it can have certain advantages if you are preparing files for CMYK offset lithography.

Depth can be left at 8 bits.

Debates over the merits of 16-bit files are raging. I prefer to work in 8 bits—for practical as opposed to religious reasons—and I haven't seen any compelling evidence to suggest that editing in 16 bits has any advantage over 8 bits *for the work I do.* Most arguments in favor of 16-bit working files currently focus on potential uses in some future display technology. The idea being that soon, in some unspecified display technology that can take advantage of additional color gamut, the 16-bit files that you process today will have real application. I am very much in favor of archiving the original, high-bit RAW data for future use. However, by the time these new display technologies are available, new RAW processing options and new capture technology will surpass anything you are capable of doing today and you will want to use the new methods. I'm not in favor of pushing around more data than I can use or even see to evaluate, so I generally process into 8 bits and stay away from super large gamut workspaces such as ProPhoto RGB.

Occasionally, there are good reasons to process into ProPhoto RGB, but for most people photography there is no special advantage. Photographers will have to decide for themselves if the nature of their work requires additional bit depth; however, most current shooters won't find any consistent need for high-bit processed files.

You may want to select Save New Camera Raw Defaults (Figure 2.10) at the Zero slider settings. This certainly is necessary for future tests, and it will guarantee that the thumbnails in Bridge will give you a better, exposure-accurate view for all future files from this camera. We will continue to adjust the best file to get the most desirable color using the Calibrate tab, and we will save settings—you might want to save the optimal color settings as your default as well.

Adjusting White Balance

Right now we'll concentrate on the best exposure, so make sure you select it for the next steps. Select the White Balance Eyedropper tool and click the second gray patch from the left (lightest gray next to white; Figure 2.11). The Settings drop-down will change from As Shot to Custom, and the Temperature and Tint sliders will change to reflect the new white balance. Note the RGB numbers for the patches. For convenience, you can select the Color Sampler tool and place samplers on the six gray patches (Figure 2.12). With any luck, all the gray patches will be fairly neutral—the RGB

values will be within one to two units of each other. The white patch is usually the only exception, and typically it will read a little warm—the B value will be slightly lower than R and G. Once you have verified the white balance, you can begin fine-tuning the color.

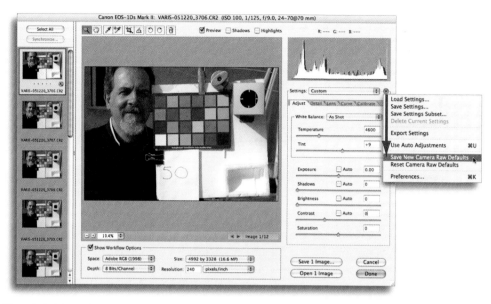

Figure 2.10 Selecting Save New Camera Raw Defaults will save all your settings, so you'll want to save again after you've completed the calibration.

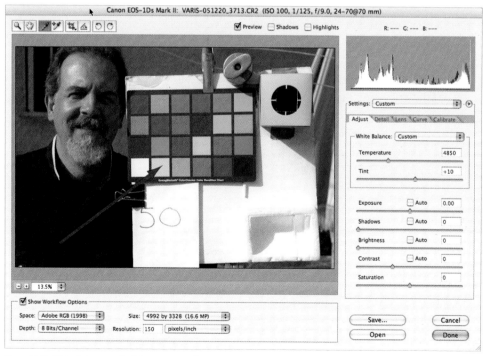

Figure 2.11 White balance to the lightest gray patch.

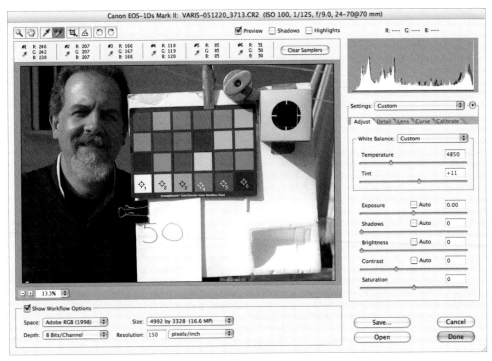

Figure 2.12 If you find that any gray patches are off the mark, try white balancing to the next darkest patch.

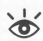

Note: The White Balance tool is supposed to automatically neutralize the color in the area on which it's clicked. The only way to be sure that this has actually happened is to check that the RGB numbers for the gray patches are in fact neutral (R=G=B). You should always check this. Sometimes the results of the White Balance "click" are off, perhaps due to noise in the file or dirt on the ColorChecker. This is why I suggest placing the color samplers on the gray patches.

Adjusting Shadow Tint

Switch over to the Calibrate tab and place one more sampler in the light-trap black hole. You may need to move the sampler around a bit to find the darkest point if you notice some variation in the RGB numbers based on placement (Figure 2.13). All lenses have a certain level of flare that can cause a subtle bias in the lowest values. Typically, zoom lenses exhibit this more than primes. The sensor also can have more noise in one channel or another, and the blackest areas are where this appears. If you are lucky, the black point will be fairly balanced (R=G=B); if not, you can use the Shadow Tint slider to balance the numbers. Moving to the right will shift the tint toward magenta; moving to the left will shift it toward green. Getting all three numbers to match can be difficult. In that case, try to get the highest two to match—it's usually better to get R and G to match and let blue go lower. Don't beat yourself up if the numbers are within two points of each other—look out if one channel ends up being 5 to 10 units higher!

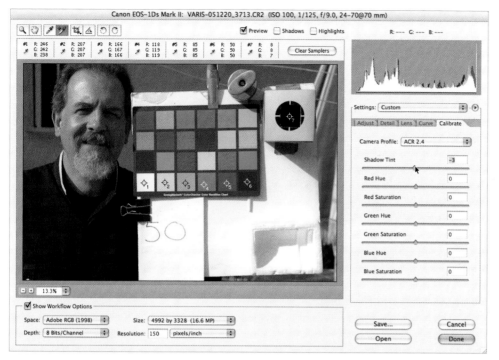

Figure 2.13 Moving the Tint slider to the right makes the R and B numbers go higher. Moving it to the left makes the G number higher and the R and B numbers lower.

Compare the ColorChecker

Now the fun begins. We are going to adjust the Red, Green, and Blue sliders to get the patches on our GretagMacbeth ColorChecker to match the hue and saturation of ideal averaged values. We'd like the H and S numbers in the Red, Green, and Blue patches in both the LAB file and our RGB file to measure within three units of each other

> **Note:** You can get the ideal averaged values from a ColorChecker LAB file developed by Bruce Lindbloom. This is (one file) available from his website at http://brucelindbloom.com/downloads/ColorCheckerCalculator.tif.zip. This file was developed by reading a lot of different ColorCheckers with a spectrophotometer and averaging them. The results provide a reasonable, although not absolutely accurate, reference for the colors in the average ColorChecker. GretagMacbeth does not publish useable values for the patches, and the only other alternative would be to measure your own specific target with a spectrophotometer to get exact color values.

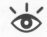

Unfortunately, ACR doesn't give us HSB numbers, only RGB, so the easiest way to figure out how to set the sliders is to process the file and read HSB (Hue, Saturation, and Brightness) numbers in Photoshop. Bear with me now because this gets a little tricky. First, set up a crop with the Crop tool—try to aim for a Crop Size close to 800×600 (select from the Crop Size drop-down in the Workflow options portion of the dialog box). Click Open to bring the image into Photoshop (Figure 2.14).

Figure 2.14 The cropped ColorChecker

The idea is to compare our real-world ColorChecker against an artificially generated idealized chart that has LAB values for each of the color patches. Open the LAB ColorChecker file and set up Color Samplers for the Red, Green, and Blue patches, and then change the read-outs to HSB numbers (Figure 2.15). You can do this by clicking the little Eyedropper icon next to the numbered sampler read-outs in the Info palette and selecting from the flyaway menu. Place samplers in both the real-world file and the LAB reference file.

Figure 2.15

The numbers in the Info palette can be changed by clicking the little Eyedropper icon.

Write down the numbers and compare. We are interested only in the hue (H) and saturation (S) numbers. Now you need to figure out how much to add or subtract from the real-world numbers to get to the LAB file numbers. Make sure you're reading both files in HSB numbers or you will get confused. In the example in Figure 2.16, you need to add 4 to the H and S values for blue, subtract 5 from H, add 9 to S for green, *and* subtract 9 from H and add 16 from S for red.

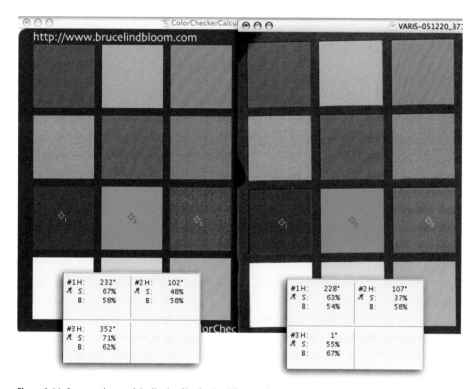

Figure 2.16 Compare the two ColorChecker files for the differences between hue and saturation in Red, Green, and Blue patches.

Adjust Calibration Sliders

Now, reopen your RAW file in ACR (the slider values should be where you left them). Enter the calculated values into the Hue and Saturation sliders for Red, Green, and Blue in the Calibrate tab. Reprocess and open the file in Photoshop. Compare the values again. They probably won't match up yet—you usually have to do this at least three times. Compare the values and figure out the difference. Add the difference to the slider position values and reprocess. Compare again and repeat until you get within one to three units of the ideal.

You may want to experiment with the Contrast slider in the Adjust tab—this can impact the overall saturation. If you notice that the saturation for R, G, and B is extra low, try raising the Contrast or the Saturation slider just a bit. I like to keep these sliders at zero and reserve their use for creative purposes. I prefer to get the color as close as possible using the Calibrate sliders with all the Adjustment sliders at zero.

Figure 2.17 shows the first and last iterations of the Calibrate slider settings and the LAB sampler numbers with the final adjusted RGB sampler numbers.

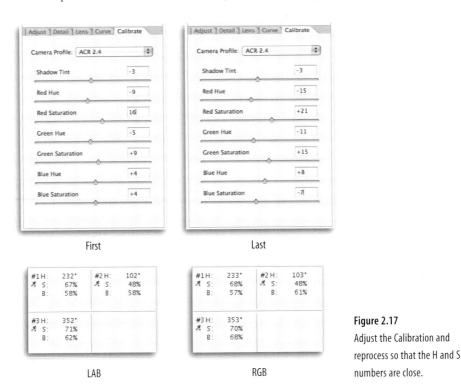

First

Last

LAB

RGB

Figure 2.17
Adjust the Calibration and reprocess so that the H and S numbers are close.

Once the numbers match as closely as possible, you need to visually compare all the color patches in Photoshop (Figure 2.18).

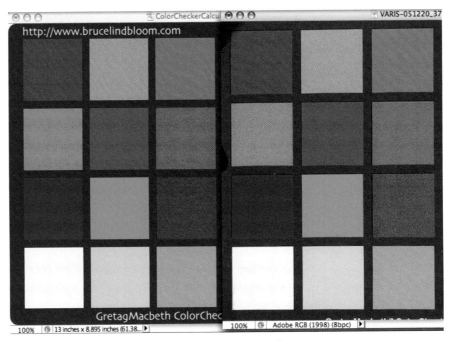

Figure 2.18 Compare the resulting charts to make sure they match visually.

Skin Color Adjustment

At this point, you want to critically examine both files in Photoshop. The colors should match very closely, but a brightness difference between the charts is very common. Pay special attention to the Light Skin color patch (second from the upper left). This one patch probably will appear a little redder in your real-world ColorChecker. This deficiency is inherent with Bayer pattern chips and has to do with the overlap in frequencies between red and green filters on the chip. Skin tones reside in this overlapping region, and it's almost impossible for demosaic algorithms to resolve the problem. This why over-red skin tones frequently appear in digital captures. This "skin tone" patch is the most important color in the whole chart for our purposes here. If it's not spot-on, you'll have to move the Red Hue slider to the right a bit in the Calibrate tab. This will bias red toward yellow and take the "red curse" off your skin tones.

Readjust the Red Hue and Saturation sliders, reprocess the image, open it in Photoshop, and sample the "skin" patch to evaluate. You can leave the G and B sliders alone and just work the R slider to bring the values into alignment. Obviously, this will come at the expense of deep saturated reds in other subjects. For our purposes, skin is a much more important color. It is also more difficult to correct later, so it pays to get skin color right at the capture stage. Once you readjust the red bias, compare the charts again and look for more agreement in the skin patch (Figure 2.19).

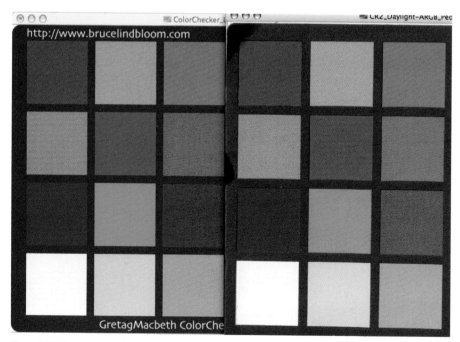

Figure 2.19 Here are two versions again. This time, the real chart on the right has been calibrated to the skin patch, and we can see a better match. However, the red patch is now decidedly more yellow. This is the main trade-off: bright reds will render more orange using the skin calibration.

Note: If you're serious about skin tone you will want to do your calibration using the skin patch instead of the red patch! Repeat the process with color samplers on the skin color patch. Compare HSB values on the LAB ColorChecker and your real-world ColorChecker. The Red Hue and Saturation sliders will mostly affect the skin color values, but you may need to adjust the Green saturation a little to match things up perfectly. When the skin patch values are close, process the whole image and look at the real skin in the test shot. You have to balance the technical readings with the effects on your subject. Don't be afraid to readjust if you feel the real person looks wrong even if the skin patch measures right.

In essence, we've built a custom camera calibration setting in Adobe Camera Raw without using additional third-party software. This calibration goes beyond a general camera profile to specifically calibrate for the best skin color. The next step is to make this setting available for general use in your photography.

Save a New Camera Default

Reopen your RAW file—the Calibration settings will be where you left them. Before doing anything else, select Save Settings Subset from the Settings flyaway menu. A dialog box where you can save a subset will appear; choose Calibration from the drop-down menu (Figure 2.20). Name the settings for the particular situation for which you are calibrating—in the example, I chose CR2-Daylight. This setting can be recalled and applied to any future shots taken with this camera in daylight. You want to save only the Calibration settings because white balance can vary somewhat from scene to scene, and you want to maintain some flexibility. If your primary subject matter is people, you might consider incorporating this calibration in your camera default. Otherwise, you will have to apply it separately when processing your files.

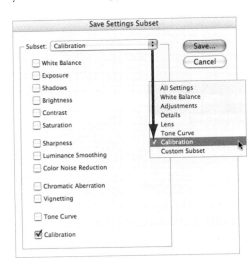

Figure 2.20

Settings Subset

Follow along carefully now. If you want to incorporate this calibration in your camera default settings, you will need to carefully set the rest of the settings in the various tabs. Step back through the tabs and make sure they are set at your desired defaults. The Curve tab should probably stay at Medium Contrast. The Lens Tab sliders should remain zeroed out. The Detail Tab sliders should all be set to zero. Finally and very important, you should reset the Adjust tab White Balance back to As Shot (Figure 2.21). The Camera Raw Default will save all the slider positions in all the tabs. The only way to leave the white balance out of the settings is to save that slider at As Shot. If you leave your camera set to Auto White Balance, ACR will pick up the white balance setting from the camera and adjust the slider to match. This will help ensure that the initial previews generated in Bridge will be reasonable.

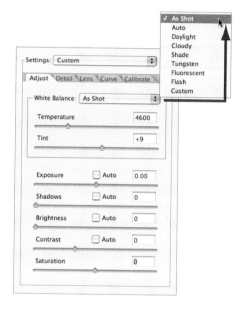

Figure 2.21
White Balance As Shot

Once everything is set, you can select Save New Camera Raw Defaults from the Settings flyaway (Figure 2.22). The first time you open a new RAW file from this camera the dialog will be set up as you see here, and you can adjust it for creative purposes without worrying about color integrity.

When you calibrate this way, you maintain the best possible quality and retain the most flexibility for processing your RAW files. Establishing a calibration with Zero slider positions ensures that the RAW data is recorded at the highest signal level without encountering serious white point *clipping*. This is pretty much like "exposing to the right of the histogram" but with greater precision. The only drawback is that the previews on the camera LCD might seem a little bright. Adobe Camera Raw is the only RAW processing software I'm aware of that allows for true zero or linear defaults in all its settings, so this calibration strategy won't work with your camera software or something like Phase One's Capture One software.

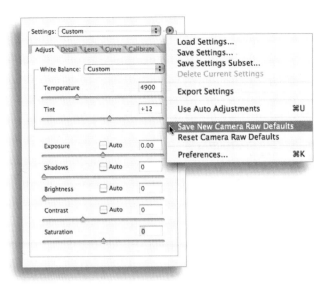

Figure 2.22 Save New Camera Raw Defaults

Exposing to the Right

You might have heard that it's a good idea to "expose to the right of the histogram." Experts often recommend doing so when you evaluate the exposure based on the histogram display on the LCD on the back of the camera (see the accompanying graphic). The idea is to open the exposure enough that the main peak in the histogram is right of center but not slammed against the right edge, thereby placing the captured data where most of the useable bits are.

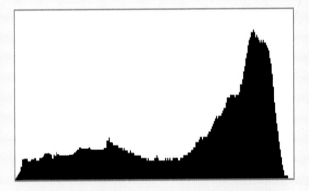

The idea is good theory but bad practice because the histogram cannot tell you where you are placing your tones with any precision, and it can't tell whether the histogram is appropriate for the subject. (What picture goes with this histogram?) The camera's histogram is only a general indication of the distribution of values in the camera-generated JPEG. It is usually a composite of all three channels. The RAW data has a much wider distribution of tones that will vary in each channel, so you may not know if you are clipping important data in the Red channel simply by looking at the histogram display on the camera.

Working with Your Calibration

Although a full exploration of Adobe Camera Raw is beyond the scope of this book, I can offer the following general breakdown for using ACR.

Ideally, you should shoot a gray card in the same lighting as the bulk of your subject matter. Most often, this can be a simple test shot done at the beginning of a shoot (Figure 2.23). Have the subject hold the ColorChecker or a gray card.

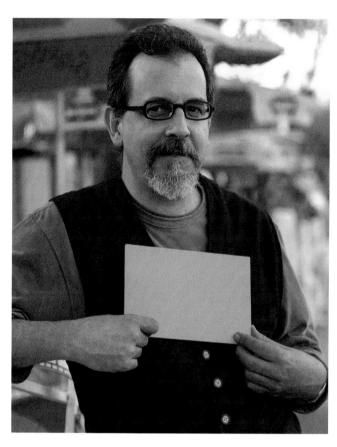

Figure 2.23

For this test, I stood in for the subject and had an assistant shoot for the gray card. The remaining shots were taken of the real subject, and this shot was used to white balance only.

When you are ready to process the shots, simply use the White Balance tool on the gray card in the first shot and apply the settings to the rest of the images. You can either synchronize in ACR (as we did earlier when we determined the best exposure) or select Edit > Apply Camera Raw Settings > Previous Conversion from the Bridge menu after white balancing the first file.

If you do not have the opportunity to shoot a gray card, you can select a default from the White Balance drop-down in the Adjust tab (applying this to the remaining shots) or accept the As Shot settings.

Overexposed files can be easily rescued by using the Exposure slider in minus positions (Figure 2.24). Underexposure is usually best dealt with using the Brightness slider as this will ensure that you don't clip the highlights; a +50 percent position equates to plus one f-stop. Contrast and Saturation start off at zero but can be adjusted for specific subject and lighting easily and logically.

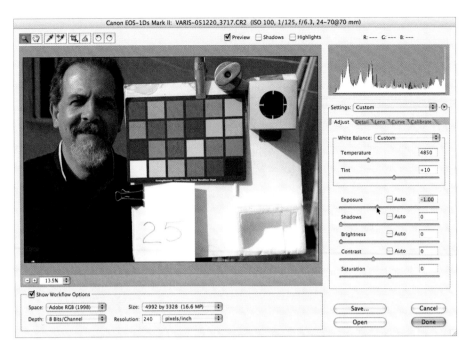

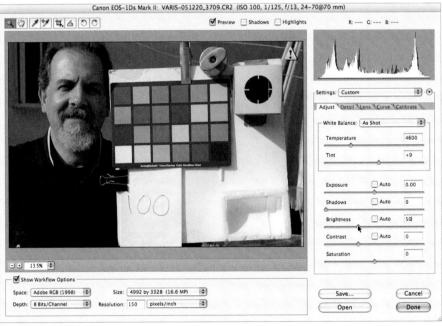

Figure 2.24 Underexposure (top) and overexposure (bottom)

I have had great success using this calibration strategy. I test every new camera this way and establish calibration settings for daylight and tungsten light. The beauty of using the HSB numbers for establishing color fidelity is that you can use any RGB workspace you like. There is no need to use ProPhoto RGB at 16 bit for testing purposes, and for the most part, I recommend sticking with Adobe RGB or sRGB for the bulk of your work anyway.

Alternative Approaches to Camera Calibration

Readers who are familiar with Bruce Fraser's book *Real World Camera Raw* may notice that my calibration procedure is similar to his, although it does have important differences. Bruce recommends calibrating to RGB values in a ProPhoto RGB image of the ColorChecker. Unfortunately, there are no RGB sliders in the ACR Calibrate tab. Bruce suggests that you do not try for an exact numeric match for the patches. Instead, he suggests you try for a general hue and saturation relationship. I find it much easier to simply use Hue and Saturation numbers in the Info palette for this.

His recommendation of ProPhoto RGB is in line with ACR's internal processing in a linear-gamma color space with ProPhoto primaries. However, if you are processing your files into Adobe RGB or some other more-constrained color space and your final destination is some kind of print output color space, then it is better to reference to the LAB connection space represented by Bruce Lindbloom's LAB ColorChecker. Either way, it is far less mentally taxing to use the HSB numbers in Photoshop to adjust the Hue and Saturation sliders in ACR. Also, by using Hue and Saturation numbers, you avoid having to tweak the Exposure, Brightness, and Contrast sliders to match gray patches to RGB numbers. In practice, I find it more practical to calibrate to a zero-slider state (for exposure, brightness, contrast, and saturation) in ACR. This provides a logical base to *adjust from* for creative effects.

Thomas Fors has developed a calibration JavaScript for ACR, which you can download with instructions from http://fors.net/chromoholics/. The script automates the calibration process by multiple iterations of processing and measuring the outer patches in a ColorChecker target. This takes a very long time to run, but at least you don't have to be actively involved in the measuring process (go out for lunch while the script runs). The results are reasonable, but I do not think the script does as good a job as you can do on your own using my method and it makes no allowance for skin color adjustment.

Another alternative that some readers might find compelling is to use third-party profiling software to build a custom ICC profile for the camera. Here you would white balance in ACR only, process into Adobe RGB, and run the profiling software to build a profile for the resulting file. In practice, you would then process in ACR the same way (white balance only) and then *assign* the custom camera profile to the processed RAW file (even though you are processing into Adobe RGB from ACR). You would then *convert* from this custom profile back into Adobe RGB for further editing. The profiling process itself is very easy, but you do have to buy additional software and hardware. Of course, this requires extra steps in your workflow and, again, in practice the results are not substantially better than what you can achieve using ACR calibration by itself. This method also doesn't accommodate skin color adjustment. You can achieve somewhat better accuracy by building your own LAB reference file from your own ColorChecker and using profiling software. The law of diminishing returns kicks in here though, because you will need a spectrophotometer with the appropriate software (at around $1500) to create the reference file, as well as the profile, and the improvement in overall accuracy still does not specifically address skin color.

I use the calibration method illustrated here because I find it much more flexible with regard to calibrating for desirable skin tones. Absolute color accuracy with any system is impossible. Even if some modest level of accuracy were achievable, it would only be appropriate for scientific purposes. One person's idea of what accuracy means is most often different in significant details from the next person's. This difference is the result of a complex collection of cultural and personal influences, and it gets back to the desire for idealized, pleasing color. ACR calibration allows for a personalized color rendering directly from the RAW data. The user can adjust for the desired rendering of a specific range of colors as well as a general visual match to the overall colors of the ColorChecker. The saved settings can be applied easily, and the system is useable with a wide variety of cameras.

I encourage you to tweak your calibrations to suit your personal preferences. You shouldn't necessarily accept the numerically accurate HSB renderings of the color patches—most of us don't sell pictures of ColorChecker targets. Think about how you prefer your color. More contrast? More saturation? Put these into your calibration so you don't have to tweak every file every time.

Remember, you are calibrating a complete capture system that includes the lens. You can usually count on lenses from the same manufacturer to have the same color bias, but as soon as you switch to a different manufacturer (a third-party lens), you will likely affect the subtle color bias and you'll need a different calibration. For that reason, I recommend staying with your camera manufacturer's lenses if possible.

Finally, calibration is no substitute for creativity. You should feel free to break away from rigidly accurate color renderings to suit your creative needs or the needs of your clients. Your calibration settings are only a starting point from which you are obligated to depart on a journey to your personal vision. You should also save creative renderings as presets that you can call on for different purposes. The calibration method outlined here should be considered a tool to allow you control over your photography and not an end in itself.

Putting Color Management in Context

Color management is a relatively new discipline that is still evolving. The goal of color management is to control color appearance in various input and output devices so we can achieve better agreement between the different renderings of the same image viewed in different media. Notice that we are specifically *not* talking about color matching. Real color matching is currently impossible, and some level of difference has to be tolerated. There is considerable disagreement about what differences are tolerable under what conditions, so talking about color management in absolutes is difficult. Control over color *is* highly desirable, however, whether or not we agree on how that control is applied.

Color management starts by attempting to define color in an unambiguous way. Not too long ago a group of manufacturers in the graphics industry got together and developed the ICC profile as the foundation for a digital color definition. An ICC profile references the color appearance of a particular device (camera, monitor, printer) to a numerical representation that is independent of any specific device. This numerical representation is currently CIELAB (essentially the same as LAB in Photoshop). Profiles are generated by capturing the color rendering of specific devices and mapping the results to the numbers required to generate colors on that device. As an example, your monitor uses a certain set of RGB numbers to generate a color that can be defined as a specific shade of red in LAB. When you want to display that shade of red (as defined in LAB) on another monitor, you will likely need a different set of RGB numbers. If the other monitor has been profiled, you can derive the new set of RGB numbers by running the LAB numbers through the profile for that monitor. As such, profiles allow for some method of translating colors for different devices by referencing into and out of LAB.

Profiles are also used for generic color editing environments called *workspaces.* Adobe RGB, Colormatch, and sRGB are examples of standard RGB workspaces. An RGB workspace is defined in a way that allows for easier color editing, and one unique property of this is that neutral gray is always defined with equal values in Red, Green, and Blue. One of the common activities in color management is transforming color numbers from a capture device into workspace numbers for editing and then transforming those numbers into numbers appropriate for a printer or display device for viewing.

Most of the problems associated with color management concern the mismatch between color spaces with different gamuts. *Color gamut* is the volume of colors defined in a given color space. The real world represents a huge volume of possible colors. Digital cameras are capable of encoding a somewhat smaller volume of colors. The Adobe RGB workspace is smaller still, and almost every output device can represent a smaller volume than Adobe RGB. Overall volume is not the only factor. There are other mismatches where some possible colors in one workspace don't exist in another even if the overall volume in the second space is greater. Imagine trying to fit a square peg in a round whole—color spaces can be thought of as having 3D shapes based on different regions of colors. The graphics industry has adopted various methods of translation or gamut mapping between these different color space shapes using ICC profiles in an attempt to mitigate these problems.

Most of the time photographers make a bigger problem out of this than is necessary. People photography is mostly concerned with the color of skin. As it turns out, skin color is easily defined in just about every color space with which we can work. Conservative color spaces such as sRGB are perfectly adequate for people photography, and translating between sRGB or Adobe RGB and any type of output we need is not a problem. Problems typically arise with attempts to match garment colors or other products that may be of primary interest to an advertising client. Some products might contain colors that are outside the range of Adobe RGB but just inside CMYK for a magazine ad. Sometimes the dyes and colorants used to manufacture these items do not reproduce accurately no matter how well the system is color managed. Most of the time, the solution involves color correction in the final output space and not color management. The odd color mismatch in a manufactured product can usually be tolerated; however, if you can't get good skin color, you are in trouble.

For our purposes, color management simply involves calibrating the monitor, choosing an appropriate workspace, and utilizing printer profiles at output. You do not *absolutely* need anything more exotic than Adobe RGB as your workspace. If you shoot RAW, as you should, then there really is no *absolute* need for a custom camera profile because the RAW data can be processed into a standard workspace in ACR. The calibration steps we've just gone through determine how your color is rendered into the workspace. You can think of the workspace as the color definition that determines what the various RGB number values look like. Once a file is *tagged* with a workspace definition or profile, you can track the colors in the image through editing and finally into a print.

We will examine various color management issues as they come up throughout the rest of the book.

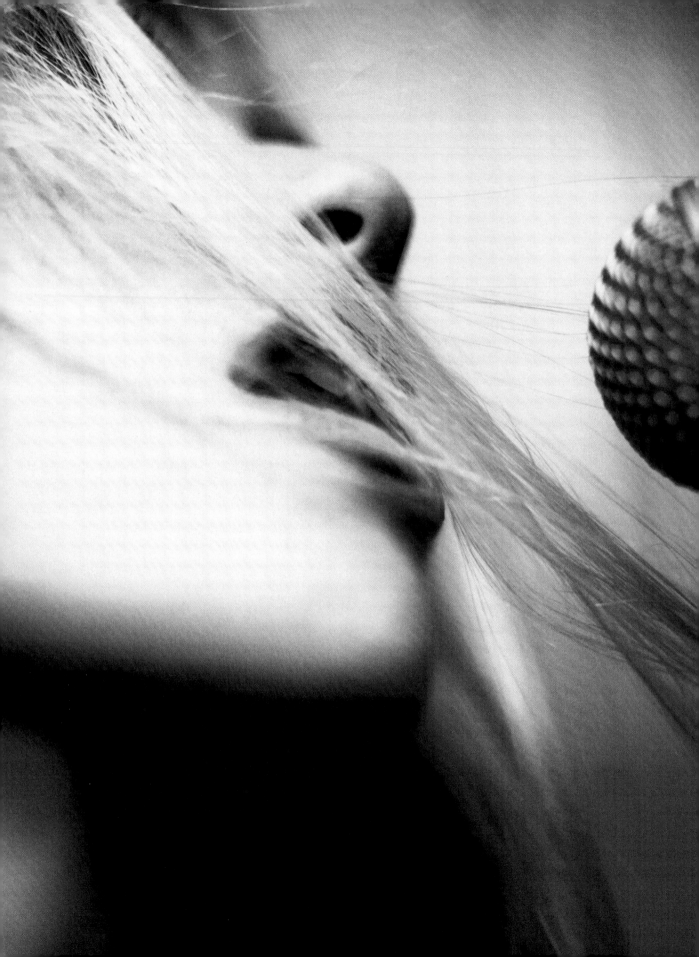

Lighting and Photographing People

3

Digital photography is the process of recording focused light that falls on the image sensor in a camera. This recorded light is the essence of photography, and control over lighting is one of the core disciplines in the art. We are going to explore various approaches to lighting as it pertains to digital capture and human subjects. We will also go over different shooting scenarios and how to deal with people in your photographs.

Chapter Contents
Lighting Technology
Basic Portrait Lighting
Advanced Lighting Techniques
Experimenting with Light

Lighting Technology

Many different types of light, both artificial and natural, can be used with human subjects. Natural light originates with the sun, but it can have many different characteristics depending on the time of day or weather. Artificial light can be generated in a number of different ways, and it is mostly categorized by color temperature. (Table 3.1 lists the temperatures of the most common artificial sources.) Light control remains the most important element for the photographer regardless of the light source. Light must be directed and the intensity controlled. Shadows must be balanced against highlights, and their edges must be softened or sharpened.

Table 3.1 Common Artificial Light Sources

Light Type	Typical Color Temperature (degrees)
Incandescent/household bulb	2800 K
Photoflood	3200 K
Tungsten (halogen)	3400 K
Fluorescent	3800 K (approximately)
Electronic flash (strobe)	5500 K

Note: Flash is usually the most desirable light source to use for photographing people because it provides the most light with the least heat. Regular fluorescent lights are the worst light source because their spectrum is very "spikey" or uneven, and this makes it difficult to fully color correct for good skin color.

The most basic light controller is a simple board that can block or reflect light. This simple tool has evolved into a wide variety of specialized reflectors and flags—white, black, silver, and gold. The most recent innovation is the spring-frame reflector that can be folded into a relatively small disk and unfurled into a larger disk or panel (Figure 3.1). Most often these panels are double-sided or have reversible fabric covers that allow an assortment of surfaces to be employed as the situation demands. These panels are particularly convenient to use outdoors for available light control. Panels can be used as translucent diffusers to soften harsh direct light.

Large 4′×8′ sheets of foamcore can be used to create V-flats (Figure 3.2). These are great bounce-light reflectors that provide a large diffused-light source that is particularly well suited to rim lighting a subject (more on this later).

Another classic variation on the simple black card is the fabric *flag*, which is a wire frame with black fabric stretched around it (Figure 3.3). These flags come in all sizes and are utilized extensively in movie production. Flags are made to be used with C-stands and fit into the jointed knuckles of the stand, which allows them to be easily and precisely positioned.

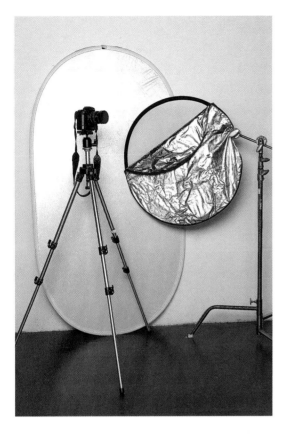

Figure 3.1
The large panel folds into a disk half the size of the disk at the right. The smaller light disk is a translucent panel with a removable cover that can be reversed to show a white, gold, or silver side. It is essentially four panels in one.

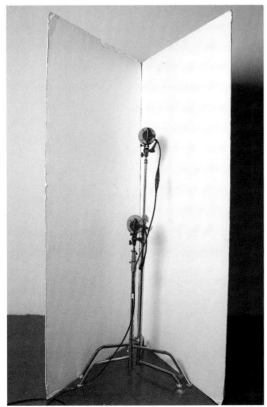

Figure 3.2
Two bare flash heads aimed into the V-flat provide a broad diffused-light source.

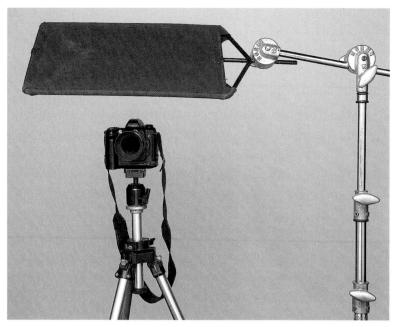

Figure 3.3 This flag is being used to shade the camera from light that would otherwise fall on the lens and possibly create flare.

Reflectors and flags can be universally applied in all lighting scenarios—outdoors, in-studio, and with all kinds of available light. The remaining lighting equipment that we'll cover is utilized with electronic flash lighting. Flash is usually the lighting of choice for people photography because it produces a lot of light with very little heat. This cool lighting is much more comfortable for the subject, and its use minimizes perspiration and makeup problems. A number of specialized reflectors and diffusion systems, as well as different flash heads for on-camera and off-camera applications, are available.

Besides the usual polished reflectors, the most common flash lighting accessory is the umbrella (Figure 3.4). The umbrella is just that, an umbrella with an inner surface that is lined with reflective material. A flash head is commonly made to accept the rod-end of the umbrella so that it aims into the parabolic reflector dish made by the open umbrella. Umbrellas usually have a removable black backing that controls any light spilling through the back. By removing the black backing, you can *shoot through* the translucent umbrella and use it as a light diffuser rather than a reflector.

The *softbox* is another common flash lighting controller (Figure 3.5). This is a tent-like enclosure that the flash head shines into at one end; the inner surfaces are reflective, and the other end opens to a diffuser panel. The softbox acts as a portable window light and creates a nice, soft light source that is especially useful with portrait photography.

There are many specialized lighting units that incorporate unique reflectors, but perhaps the most exotic light used to photograph people is the *ring light* (Figure 3.6). This light is most commonly an electronic flash in the shape of a ring that can be fitted around the lens. It is used to create a unique light that manages to preserve some sense of sculptural modeling while eliminating shadows. We will see some examples of its use in the following pages.

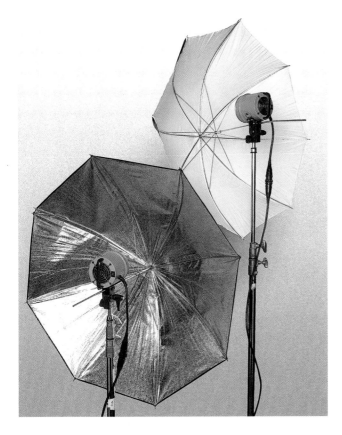

Figure 3.4
The umbrella reflector can have silver or white reflective material. It can also have a gold reflective surface, but that is less common.

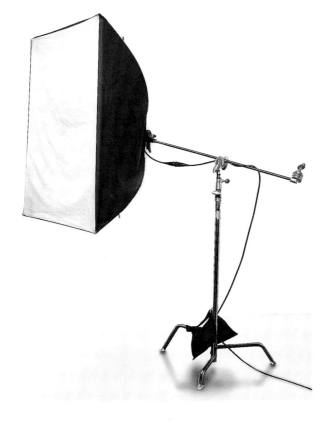

Figure 3.5
Softboxes can be found in all sizes. The one pictured here is a medium-sized box that is appropriate for portrait photography.

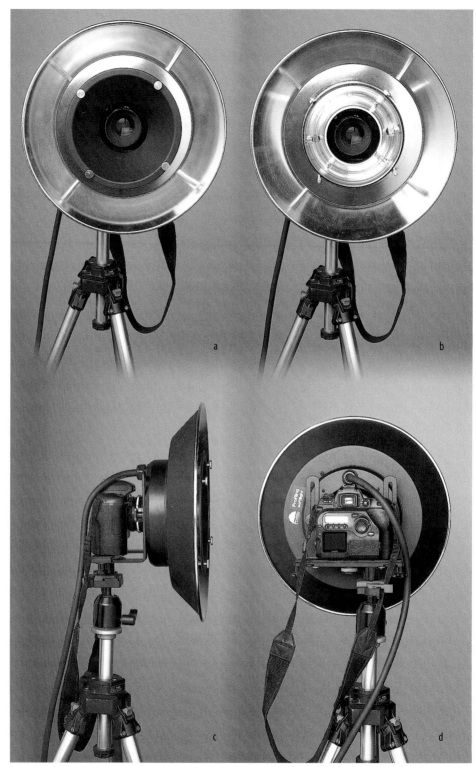

Figure 3.6 (a) The ring light with an inner reflector mask hiding the direct ring flash tube (lens is in the center); (b) the mask removed to show the flash tube; (c) a side view showing the camera; (d) a rearview

A *radio slave* is an absolute must-have accessory for the digital photographer working with studio flash lighting (Figure 3.7). It is a radio-remote that consists of a transmitter and a receiver that can trigger a flash unit without directly connecting the camera to flash through a sync cable. Although modern flash units pose less of a problem than older units, the high voltage of most studio flash equipment will degrade the sensitive electronics inside a digital camera with repeated flashes through the sync contacts on the camera. The radio slave separates the camera from the flash source, and the signal generated by the radio transmitter is very low power; therefore, repeated flashes are no longer destructive.

Figure 3.7 The transmitter of the radio slave fits in the hot shoe of the camera and synchronizes the flash unit through radio signals.

Basic Portrait Lighting

Two basic light qualities are applied to most portrait photography. Light, as used in photography, is normally thought of in terms of *softness* or *hardness,* qualities that relate to the character of the shadows created by the light. A large diffused-light source will have a soft shadow. A small, directional light source will have a hard shadow. The art of lighting is involved with the creative manipulation of these two extremes.

In addition to the hard or soft nature of light, the direction of the light hitting the subject is important. We will examine the basic elements of portrait lighting with the assistance of Erin Manning, a talented photographer who is normally found on the other side of the camera. Each of the following examples will show a lighting diagram as an overhead schematic, along with the resulting image. Each lighting style is presented in its most basic form and also in more enhanced versions with additional lights and reflectors.

Beauty Light

Beauty or glamour lighting usually places the light source centered on the planes of the face directly above the camera and evenly lighting the face (Figure 3.8). Sometimes called *butterfly lighting,* after the shapes of the highlights on the face, this even light is considered the most flattering for women. The essential element of this style of lighting is that the light source is oriented in line with the center of the face regardless of the direction the subject is looking (Figure 3.9). Most of the time beauty light utilizes a large diffused-light source such as a softbox or umbrella.

Figure 3.8
Beauty light creates even shadows below the nose and chin.

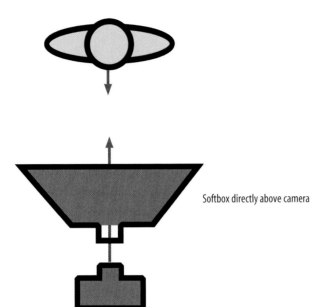

Softbox directly above camera

Figure 3.9
The softbox is place above the camera in line with the center of the face.

It is common to use a reflector, placed in front of the subject just out of frame, to fill the shadows under the chin and nose. This reflector, which is sometimes referred to as a *nose light*, also helps smooth skin texture and wrinkles. Figure 3.10 shows what the subject sees; the white card reflector here is clamped in a low C-stand directly below the softbox and angled to bounce light back up at the subject. The result gives a softer, more open look (Figure 3.11).

Figure 3.10
The subject's view of the lighting setup shows the softbox with a white card reflector directly below the light source.

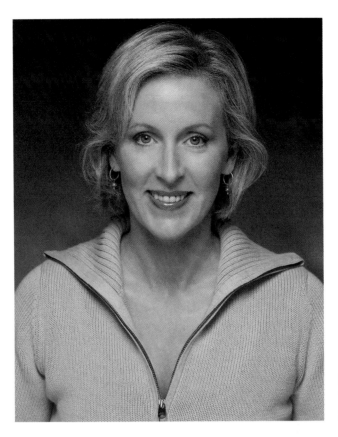

Figure 3.11
The *reflector fill* creates a
softer look.

Next, you might want to add a *hair light* above and directly behind the subject (Figure 3.12). Many lighting manuals simply suggest using a flash head with reflector; however, using another soft light source will spread the highlight into the hair and prevent hot *sparkles*. This is especially important to keep blond hair from looking dirty. It is best if you can place this hair light close to the subject, so I recommend using a softbox rather than an umbrella. (I find an umbrella more suitable for the front light.) The result places attractive highlights along the shoulders as well as hair; this helps to separate the subject from the background and creates a nice dimensional effect (Figure 3.13).

Beauty Light Variations for Dark-Skinned Subjects

Normally, with fair-skinned subjects, I try to avoid having shiny highlights on the skin. Shadows formed by the natural fall-off of the light delineate the shape of the face and details of the features. Makeup is "powdered" to eliminate moisture that creates hot reflections because the skin is already light and more shadow is needed.

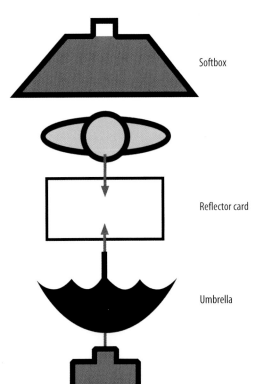

Softbox

Reflector card

Umbrella

Figure 3.12
All the lighting elements are placed in line with the subject and camera.

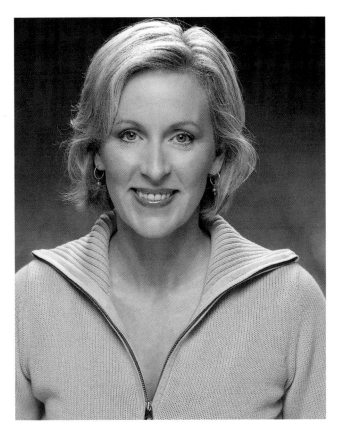

Figure 3.13
The classic beauty light includes a hair light to create the soft highlights in the hair and along the shoulders.

64

Shoot a Card

For color calibration purposes, it's always a good idea to take a shot with a neutral gray card so you have something to use to white balance. It is equally important to make sure that your light sources are balanced. This means that you use the same color-temperature flash heads for your lights and test for consistent color when using any light modifiers such as umbrellas or softboxes. You don't have to get too carried away with this. Just be aware that if you are using two umbrellas and one of them is much yellower than the other, the color of the light will not match.

Regardless of any color-matching issues, you should always white balance to the main light. You can also use the card to judge exposure. I use the Robin Myers Digital Gray Card, which has a documented brightness of RGB = 150 in Adobe RGB. When I'm shooting men, I aim for RGB = 155. When I'm shooting women, I aim for RGB = 170. I've found that shots of women almost always look better if they are overexposed just a little, in most cases by $1/2$ to $2/3$ stops.

The opposite is desirable with darker complexions. Baby oil is sometimes applied to create extra moisture for hotter highlights. Very dark skin benefits from light sources placed near the axis of the lens to maximize reflections off the moisture in the skin. The beautiful woman in this portrait by Ken Chernus has a well-developed "shine" (Figure 3.14). Ken has placed additional lights at the sides just to the rear of the subject. This creates additional highlights that lighten the skin without changing the overall impression of a beautiful "chocolate-toned" complexion. You can count the number of light sources in the reflections in the apple. Ken placed the main light just above the lens with a large umbrella fill light directly behind the camera. All this on-axis light forms nice reflected highlights on the young woman's face (Figure 3.15).

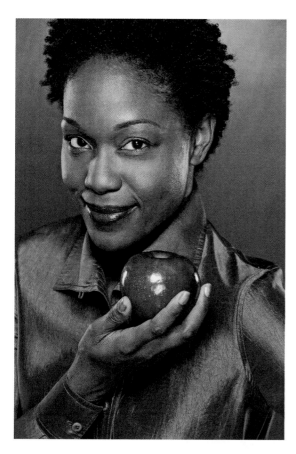

Figure 3.14
The shine on the subject's face helps to
lighten her skin and delineate her features.
(Photo by Ken Chernus)

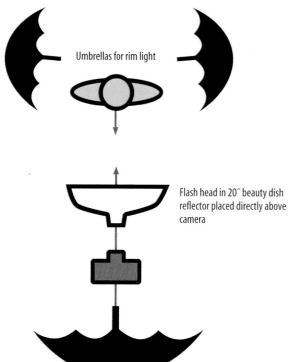

Umbrellas for rim light

Flash head in 20″ beauty dish
reflector placed directly above
camera

Large 6′ umbrella directly behind camera

Figure 3.15
The front light sources are placed near the
lens axis to maximize reflections off the skin.

Rembrandt Lighting

Rembrandt lighting is a classic style of lighting named after the famous Dutch master. The main light is off to the side, creating a distinctive triangle highlight on the shadow-side cheek (Figure 3.16). More commonly used for men, this lighting emphasizes shape and texture. The result is often more dramatic and dimensional (Figure 3.17).

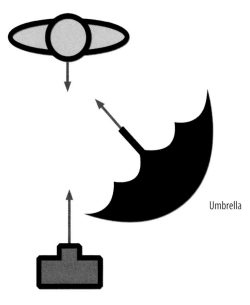

Umbrella

Figure 3.16
Rembrandt light comes from the side, about 45 degrees off-axis.

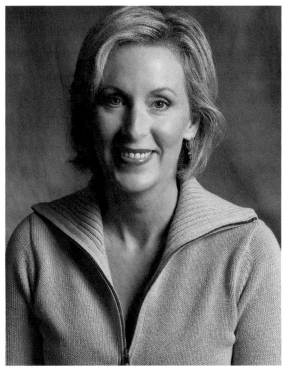

Figure 3.17
Notice the triangular highlight on the left cheek under the eye.

The effect is softened considerably with the addition of a fill card and hair light (Figure 3.18). The direction of light is preserved, but the harsh shadows are filled with light reflecting off the fill card (Figure 3.19). If you move the fill card very close to the subject, the shadow side can be opened up even more to mimic the open quality of beauty light (Figure 3.20).

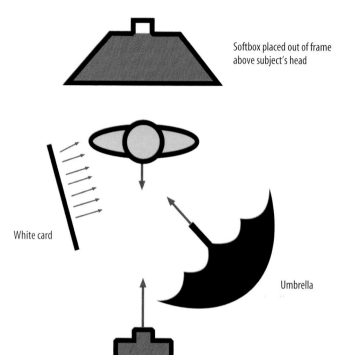

Softbox placed out of frame above subject's head

White card

Umbrella

Figure 3.18
A white card opposite the main light is used to fill the shadows.

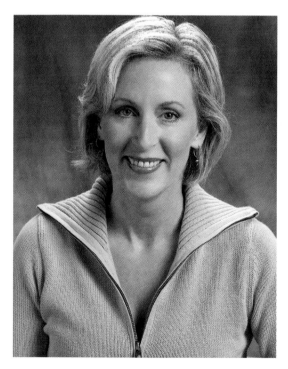

Figure 3.19
The fill creates a softer effect.

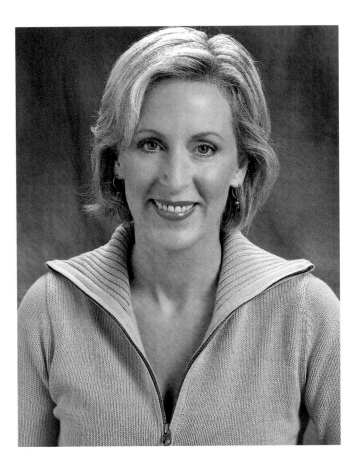

Figure 3.20
Extra fill almost destroys the effect to approximate beauty light.

An interesting variation of this lighting technique is something I call *Reverse-Rembrandt*. Here the shadow and highlight areas are reversed. The main light is a little hotter and occupies the area normally held by the shadow. The fill light is now the main light with the filled shadow falling across most of the face, creating a darker triangle shape in the highlighted half of the face (Figure 3.21). To create this effect, bring your main light around more to the side so that the far side of the face is completely in shade. Use a larger reflector card or another light to fill in the main planes of the face (Figure 3.22). The main light is now an accent. You should increase the intensity, but be careful so that it doesn't *blast* to white. The shadow side is filled with enough light to bring the exposure to ideal for the skin.

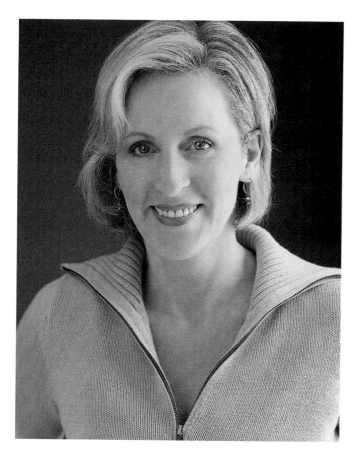

Figure 3.21
The highlight and shadow areas are reversed. The fill now occupies the main planes of the face, and the area that would normally be shaded in traditional Rembrandt lighting is highlighted.

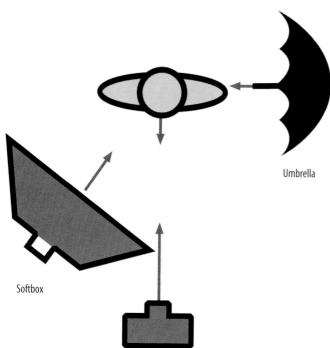

Umbrella

Softbox

Figure 3.22 Here the main light is farther around to the side, and an additional light is used at lower intensity to fill the face.

Rembrandt lighting lends itself to strong dramatic effects. Instead of fighting the harshness of unfilled shadows, Aaron Rapoport emphasizes them by using a small, focused Fresnel spot light in this dramatic portrait of a boxer (Figure 3.23). The light is high and to the side to emulate the look of a bare bulb fixture in the gym. No fill was used, allowing the shadows to go inky black. The harsh direct light brings out the texture and at the same time reflects strongly off the moisture of baby-oiled skin, which helps to lighten the dark complexion and increase the contrast. Very simple, one source lighting is used to great effect in this powerful portrait.

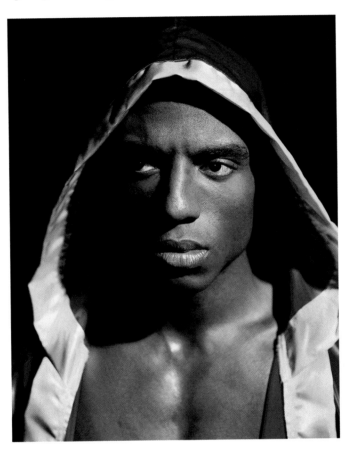

Figure 3.23
Harsh lighting complements the strong features in this powerful portrait. (Photo by Aaron Rapoport)

Natural Light

When photographers work with lights in the studio, they usually aim for a naturalistic feel. The lighting used in this example attempts to emulate natural light. However, the studio can offer many opportunities to use natural light in portrait settings. One of the most obvious applications of natural light is window light. With this technique, the subject is placed next to a window, re-creating a true Rembrandt lighting effect (Figure 3.24). Because the camera can't be positioned inside the wall, we are a little more constrained with the direction of the light; therefore, it is sometimes necessary to have the subject turn into the light a little, as you see here. Move a fill card in toward the subject, and you can lighten the mood (Figure 3.25).

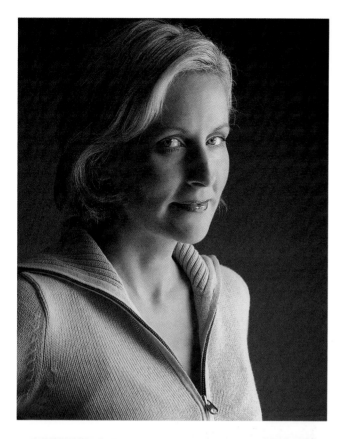

Figure 3.24
Erin is posed next to a window
for a classic Rembrandt look.

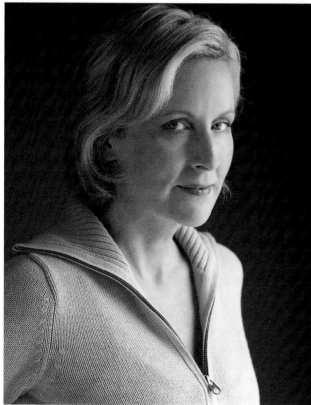

Figure 3.25
To lighten the mood, add a fill card.

Natural beauty light can be created by placing the subject where the face can be evenly illuminated by a broad expanse of sky. Here Erin is standing in an open doorway facing out into the backyard (Figure 3.26). The sun is on the opposite side of the building, and all the illumination comes from open sky. She is actually holding a large fill card at her waist. The result is soft and open.

Figure 3.26
The sky makes a perfect large diffused source for this flattering, natural beauty light.

One of the problems with all this natural light is that frequently it is too intense for comfort. Subjects frequently squint at the bright light, especially if you use a white fill card. To remedy the situation, have the subjects close their eyes and open them only at the moment of exposure. Another subtle problem has to do with *catch lights* in the eyes. The extra-broad expanse of sky creates a great soft light, but the spectral highlights in the eye, the catch lights, are diffused so that the effect is a less-lively glazed look. Notice how simply adding some bright catch lights livens up the eyes (Figure 3.27).

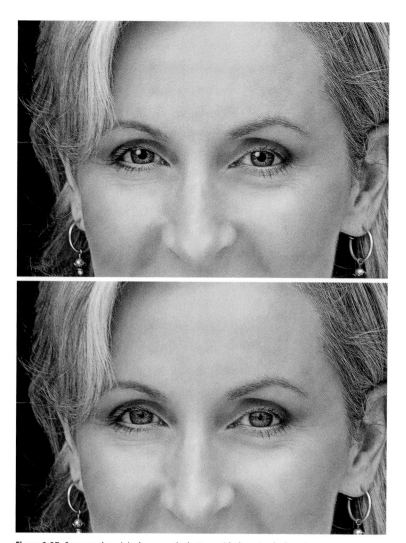

Figure 3.27 Compare the original eyes on the bottom with the retouched version on top.

Years ago, a university psychology study examined people's responses to photos of other people. Test subjects were shown two sets of photos. In one set of photos, the eyes had been retouched to have larger pupils. That was the only difference between the sets. The subjects consistently reported that the people with larger pupils seemed to be warmer and friendlier, even though they were not aware of the difference between the shots. For this reason, I often enlarge the pupils if I am retouching the eyes. You can see the difference in Figure 3.27.

Note: Catch lights in the eyes are the reflection of the light source. However, this reflection is not 100 percent white. When you paint these spots, do it in a new layer and reduce the opacity to 50 to 60 percent. You can enlarge the pupils by painting with black in another layer; this layer can be at full opacity, but place the Pupil layer beneath the Catch Lights layer.

Notice how the retouched version of this shot (Figure 3.28) has so much more life and sparkle in the eyes. When your lighting doesn't create nice catch lights, retouch them. Don't be too heavy handed with the technique, and it will go a long way to enhance your portraits.

Figure 3.28
Compare this retouched version with the original in Figure 3.26.

On-Camera Flash

Although photographers like to avoid it, there are times when we have to use on-camera flash. The small light source attached to the camera right above the lens does not have the most flattering quality (Figure 3.29). It's hard to avoid the "deer in the headlights" look with this kind of police mug-shot lighting.

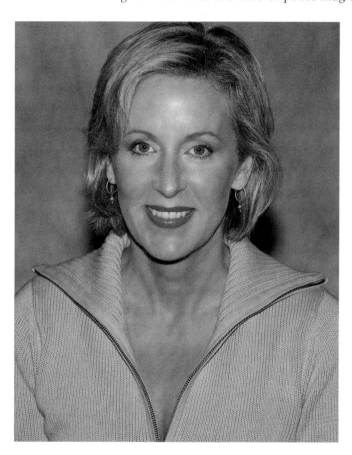

Figure 3.29
On-camera flash tends to emphasize shiny highlights and creates a strong edge shadow under the chin. Close backgrounds show a strong black shadow behind the head.

Anything you can do to broaden and soften the light source will make an improvement. A number of bounce reflector gadgets are available for the small, hot shoe camera flashes. These lights are often set up with swiveling heads to facilitate bouncing the light. You can make your own bounce reflector from a piece of white cardboard as shown here (Figure 3.30). In a pinch, you can even tape a small business card to the flash.

Figure 3.30 This reflector was made from a 8.5″×11″ cardboard shirt stiffener.

The bounce reflector moves the light farther away from the lens and spreads it to soften the light considerably. This becomes, in effect, a small beauty light setup. You can get very nice lighting without giving up the portability that an on-camera flash affords (Figure 3.31).

The catch lights are still likely to be small and positioned in the middle of the pupils, so you might consider retouching to put some sparkle in the eyes (Figure 3.32).

Even the lighting from a tiny point-and-shoot camera with a built-in flash can be improved with a little tape and some tissue paper (Figure 3.33). This setup can help you get decent lighting for those happy snaps at parties (Figure 3.34). Although this type of lighting won't win any awards, you will still generate a more natural effect and spread the light around so it bounces off walls to give a little more natural fill. The tissue over the tiny flash will soak up some of the intensity, so you may have to use a little higher ISO setting to shoot at any distance from your subject.

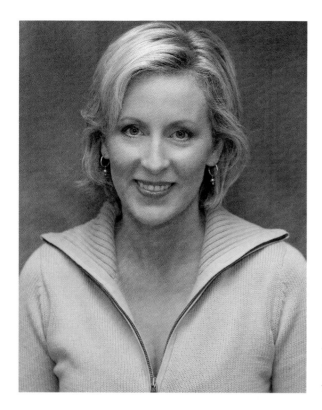

Figure 3.31
The effect produced by bouncing the light off a small reflector approaches the quality of beauty light.

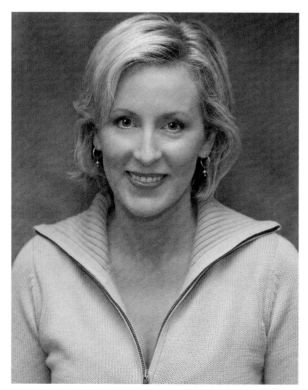

Figure 3.32
Adding catch lights helps the overall effect.

Breaking the Rules

So far we've been looking at the standard formulas for portrait lighting, but sometimes the best pictures break the rules. An unusual face deserves unusual lighting, as we can see in this portrait of Michel Karman (Figure 3.35), the master B+W printer responsible for most of Helmut Newton's prints as well as many other famous photographers. This image was captured in available light. The main light source is sunlight coming through an open doorway and bouncing off the floor just to the left of the subject (Figure 3.36). This low light angle is sometimes referred to as *Boris Karloff lighting*, after the famous character actor who played Frankenstein's monster in the movies of the 1930s and 1940s. To fill the shadow side of his face, Michel held a white card just out of frame to the right. You can see the bright patch of light on the floor and the fill card in his glasses.

Figure 3.35
Michel Karman's strong features
are well served by the unusual
lighting angle.

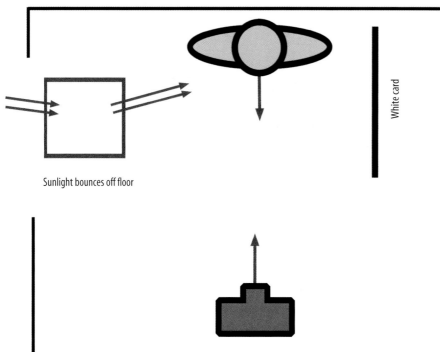

Sunlight bounces off floor

White card

Figure 3.36 All the light for this image comes from sunlight bouncing off a polished wood floor.

Look for unusual lighting opportunities. A pocket mirror can do wonders. An unusual camera position can create an unusual lighting direction. Don't get stuck with the ordinary approaches. Remember that rules are meant to be broken.

Advanced Lighting Techniques

Once you've mastered the basics, it's time to start exploring alternatives. Photographers have a lot of fun creating complex artificial lighting effects, often using specialized equipment. Sometimes this requires lots of lights in different combinations of hardness and softness with different lighting directions. Sometimes, as we'll see, one simple light is all that is needed. Lighting for people photography is typically not as difficult as product or still life photography, but it can become surprisingly complex when trying to re-create an enhanced natural light effect.

Ring Light

One easy way to get a different look is to use a *ring light*. A true ring light, such as the one in Figure 3.6, has a unique look. Figures 3.37 and 3.38, by Ken Chernus, demonstrate the classic ring light effect. There is a distinctive halo shadow all around the figure when the background is not too distant. The light fills everything evenly, but the edges darken slightly as the light wraps to the rear, creating a subtle modeling or three-dimensional effect. As a result, there is no shadow under the chin, but the chin edge is still strongly defined.

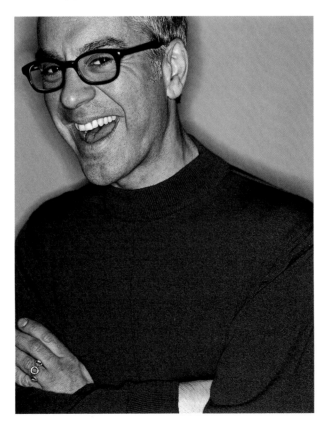

Figure 3.37
Strong contrast without shadows is typical of ring light. This man is wearing glasses without lenses to avoid the direct reflection that would normally occur with this type of light. (Photo by Ken Chernus)

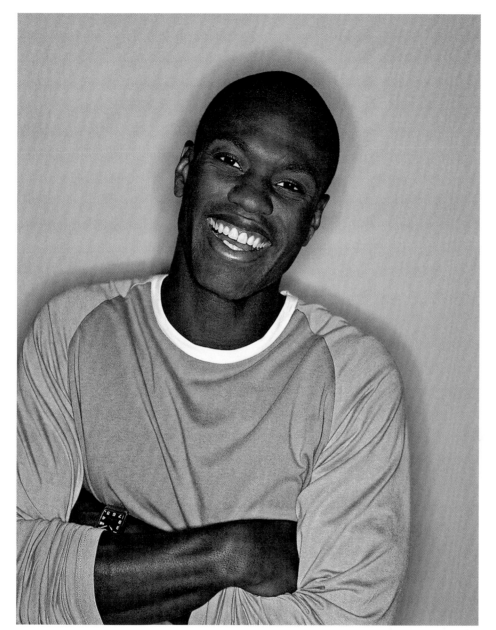

Figure 3.38 Ring light is very good for lighting dark skin. It will create a good reflection off moisture in the skin. This produces highlights on dark skin. They are the most noticeable on the man's forearm, but they also appear as a slight *sheen* on his face. (Photo by Ken Chernus)

Ring light lends itself to a high-contrast altered look, as we can see in the next shot by Aaron Rapoport (Figure 3.39). In this shot, Aaron deliberately overexposed and pushed the contrast to render the young woman's skin pure white. The edge-darkening effect of the ring light lends a kind of illustrated effect and enhances the *goth* look. A side effect is that the light carries nicely into the room behind her. The ring light is truly a one-light wonder.

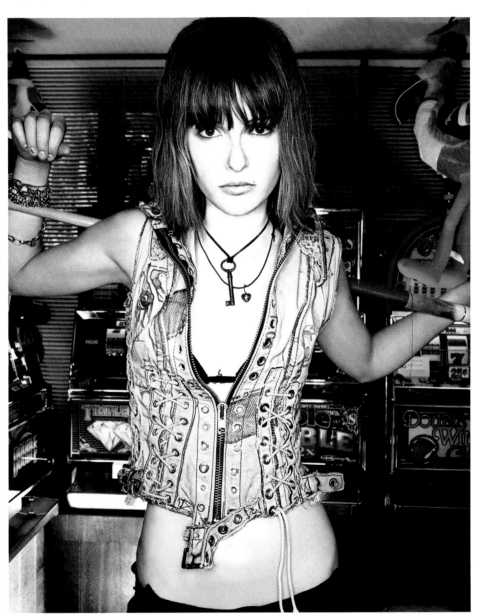

Figure 3.39 Pure white vampire skin enhances this goth-girl portrait. (Photo by Aaron Rapoport)

In yet another application of the ring light, Aaron Rapoport photographed this somber group outdoors in broad daylight. By using a powerful source and a shorter shutter speed, he overpowered the daylight (Figure 3.40). The natural falloff of the light, as it reaches the figures in the back, created the "group emerging from the darkness" effect seen here.

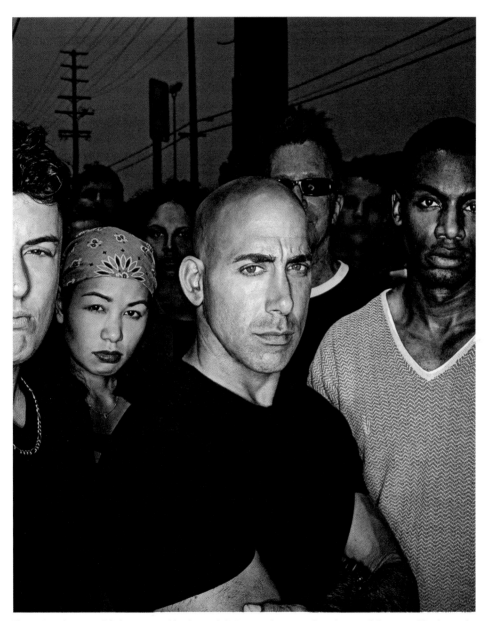

Figure 3.40 Strong catch lights are typical for the ring light. You can also see a reflected image of the ring itself in the sunglasses of the man standing behind the main figure. (Photo by Aaron Rapoport)

In this application of ring light, the light doesn't really look like ring light because other lights are in the mix. Aaron Rapoport re-created a rave-party feel in this staged photograph (Figure 3.41). Ring light is the main light source, as evidenced by the reflection in the man's sunglasses. However, this time some extra lights were placed at the rear of the group—one shining directly into the lens (Figure 3.42). Multiple light directions, hard shadows, and lens flare suggest the nighttime party ambiance.

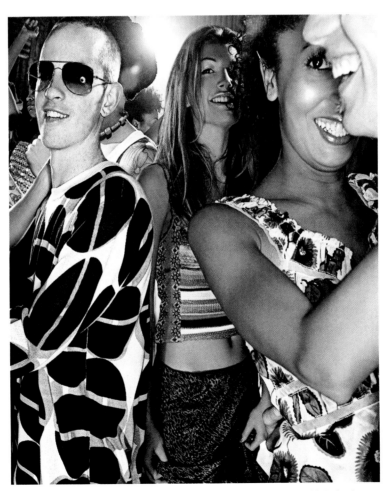

Figure 3.41 Multiple lights, hard shadows, and lens flare add to the party feel and hide the character of the ring light. (Photo by Aaron Rapoport)

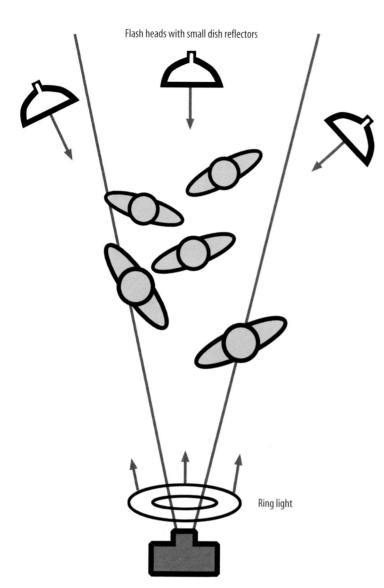

Flash heads with small dish reflectors

Ring light

Figure 3.42
Three lights are placed at the rear. The center light is clearly in frame with the other two high and just out of frame. The ring light illuminates from the front, filling all shadows and lending an appropriate flash-on-camera look to the party photo.

Many photographers feel like they are cheating when they use ring light because it's so easy to create something cool by using it. The examples shown here prove that ring light can be used in lots of different ways without looking too obvious.

Combination Lighting: Daylight Plus Flash

It has become very fashionable to combine daylight and flash light to create interesting altered effects rather than simply fill the shadows inherent with daylight lighting. This usually means that flash lighting will be the dominant source with daylight acting as fill or accent. Figure 3.39 gave you a glimpse of this technique. Here is another more complex example by Aaron Rapoport (Figure 3.43). The wide-angle lens and stark arrangement of faces combine with multiple light sources and strong shadows to emphasize the tension in this scene. There is no attempt at realism here. Although the scene clearly

takes place in daylight, the artificial flash lighting reflects the emotional state of the recruit in the center of the frame. Aaron utilized direct flash heads in small reflectors to create the high-contrast lighting (Figure 3.44).

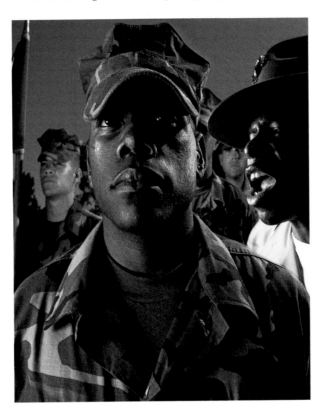

Figure 3.43
The strong contrast lighting transports us into the mind of this young recruit. (Photo by Aaron Rapoport)

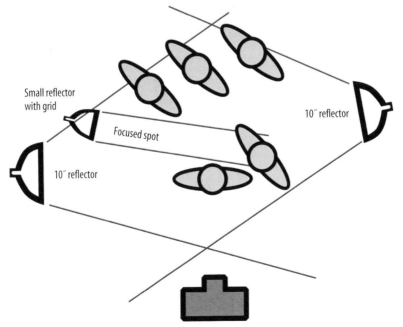

Small reflector with grid

Focused spot

10″ reflector

10″ reflector

Figure 3.44
Hard direct flash overpowers the daylight in this scene.

The classic approach to combining flash with daylight is commonly called *flash fill lighting*. In this style of lighting, daylight is the dominant light source and flash is used to fill the shadows. Another image by Aaron Rapoport, this shot of a young soccer player uses flash fill lighting, but the key light is really the flash right above the lens (Figure 3.45). The very strong daylight is directly behind the subject. This would ordinarily place him completely in the shade and open sky light would be very soft with low contrast. By lighting the subject with a direct flash, Aaron has created much higher edge contrast and added catch light sparkle to the boy's eyes (Figure 3.46).

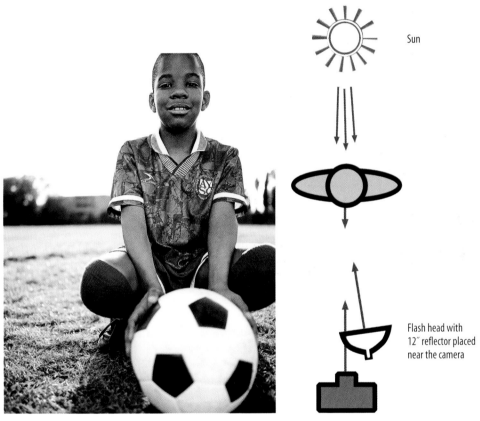

Sun

Flash head with 12″ reflector placed near the camera

Figure 3.45 Direct flash fill creates great edge contrast in this shot by Aaron Rapoport.

Figure 3.46 The two light sources are directly opposite each other.

This image combines fire and flash for an interesting public relations shot of Polynesian fire dancers (Figure 3.47). In this image, the fire is more of an accent because it doesn't really provide much illumination. Most of the lighting comes from flash heads bounced out of V-flats placed to the rear of the figures. A medium softbox directly over

the lens fills from the front. The shutter speed was slowed enough to allow the swinging fire lantern to burn in the circle around the dancers (Figure 3.48). All other ambient light, including the flash modeling lights, were turned off so that they didn't affect the exposure during the long shutter.

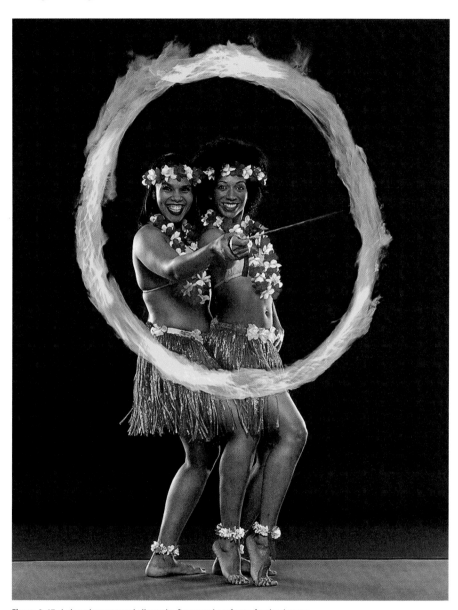

Figure 3.47 A slow shutter speed allows the fire to make a frame for the dancers.

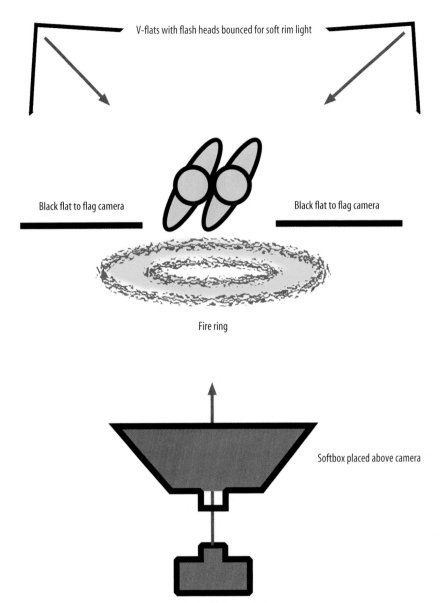

V-flats with flash heads bounced for soft rim light

Black flat to flag camera

Black flat to flag camera

Fire ring

Softbox placed above camera

Figure 3.48 V-flats bounce light to create edge highlights on the figures.

A slow shutter was also used in the surreal nighttime shot by Aaron Rapoport (Figure 3.49). Aaron used multiple light sources, combining flash with tungsten light, and deliberately white balanced for a yellow color. He matched the flash to the tungsten light and set the color temperature to 6500 K. He used a slow shutter speed to *burn in* the relatively dim Christmas tree lights and the Translite backdrop. This backdrop is actually a giant transparency that is backlit with halogen movie lights. The

figure was lit from camera right with a bare flash head. The flash stops the motion of the figure, but the slower shutter necessary for the backlit background causes a subtle blur halo to appear around the moving figure (Figure 3.50).

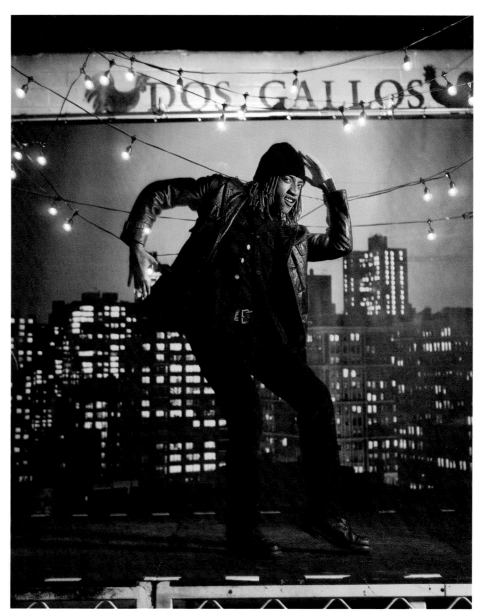

Figure 3.49 This wild surrealistic shot uses multiple light sources of different types. (Photo by Aaron Rapoport)

Dos Gallos wall

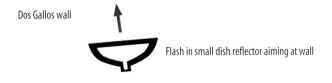

Flash in small dish reflector aiming at wall

Halogen movie lights aimed through backdrop

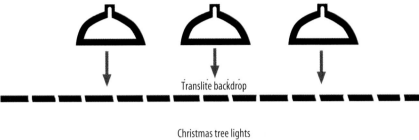

Translite backdrop

Christmas tree lights

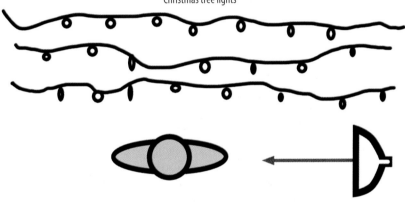

Flash head in 10″ reflector

Figure 3.50 A fairly complex lighting scheme was used to achieve the odd color and subtle movement effect.

Controlling Natural Light

Natural light can be the most beautiful light available, but it often poses many problems when you want a subject-flattering effect—especially if you are trying to preserve a natural look. There is always one light source with natural light: the sun. When you aren't trying to create a stylized, altered look, photos taken under natural light conditions should look as if there is only one light source. Any lighting should be invisible. Sometimes this is easily achieved, but sometimes it is not so easy.

One of Anthony Nex's specialties is photographing kids for advertising and stock. He typically utilizes broad, even illumination because kids don't stand still for very long, and he likes to make sure they have a large area to move around in and still be in the ideal light. In this adorable portrait of three little girls, the lighting is extremely simple (Figure 3.51). They are outdoors in a broad area of open shade looking up at the photographer. The open sky is directly behind the camera, and the only additional lighting is a large, white reflector board positioned just out of frame, camera left (Figure 3.52). This reflector is the brightest thing in the vicinity of the girls, so it actually acts more like a soft-light source, providing a gentle direction for the light as well as the bright catch lights in the girls' eyes.

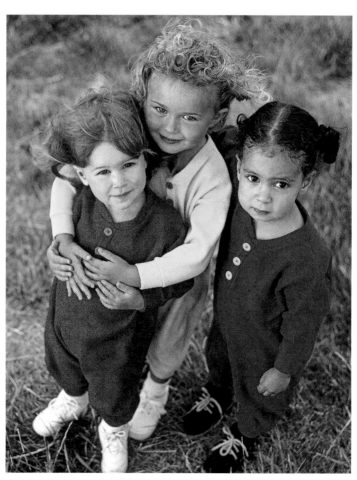

Figure 3.51 By looking up, the girls are actually looking into the source of light behind the camera. (Photo by Anthony Nex.)

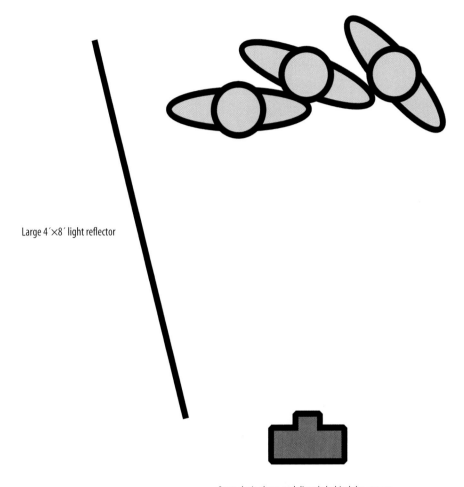

Large 4´×8´ light reflector

Open sky is above and directly behind the camera.

Figure 3.52 The reflector is the only addition to the natural skylight that illuminates this scene.

An assistant holds the reflector board. If the kids move, it is easy to follow them around because the overall sky lighting is so even from spot to spot. In these situations, Anthony shoots hand-held so he can move with the kids.

Ken Chernus is another master of natural light control. He shoots lifestyle stock imagery in various locations. Sometimes he can be very lucky. In this shot of the man at the beach (Figure 3.53), there is no additional lighting. This kind of luck has to be planned. In this case, timing was everything. Right after the sun dips below the horizon after sunset, light takes on a special quality photographers like to call *magic light*. This period of time after sunset is sometimes referred to as the *magic hour*. It can offer many opportunities, depending on the weather. This particular shot benefited from a soft haze that covered the area and provided a natural diffusion for the bright sky. The light sand was a natural source for bounce fill light. All Ken had to do was position the subject, point his camera, and shoot. All the elements of the scene were within the dynamic range capabilities of his Canon digital camera.

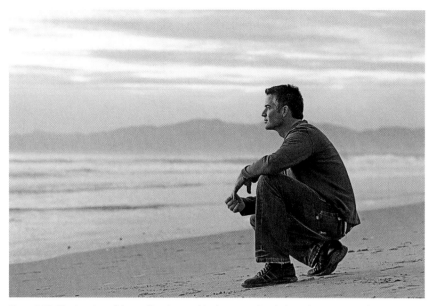

Figure 3.53 Weather, time of day, and location combined to create the ideal set of circumstances for this shot.
(Photo by Ken Chernus)

For the next shot, Ken had to make his own luck (Figure 3.54). Shooting in the back yard in the middle of the day is a far cry from magic light. He created a soft backlight effect using a translucent silk *scrim* to diffuse the harsh sun.

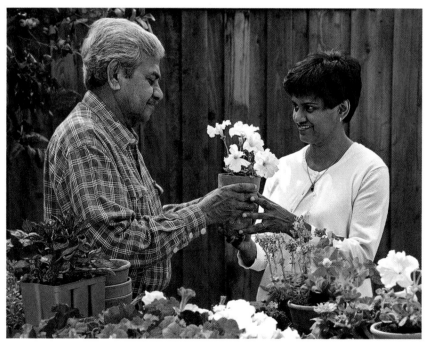

Figure 3.54 This father/daughter portrait was captured by diffusing the direct sunlight with a silk scrim.
(Photo by Ken Chernus)

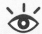

Note: A *scrim* is a translucent panel often used in movie lighting to soften a direct light source. It is sometimes referred to as a *silk,* after the fabric commonly stretched over an aluminum frame to create the scrim. Spring frame panels, as mentioned earlier in this chapter, can also come in a translucent version used for the same purpose.

The scrim doesn't completely cover the subjects; however, Ken pulled the silk away from the frame at the back edge to allow a small shaft of direct sun to hit the girl's right shoulder. This put a splash of hot white light right behind the flowers to provide a little contrast and create the effect of sunlight filtering through the leaves. A white card, just out of frame to the right, provided fill from the front. The overall effect is quite natural, but it took a bit of rigging to get the light to work (Figure 3.55).

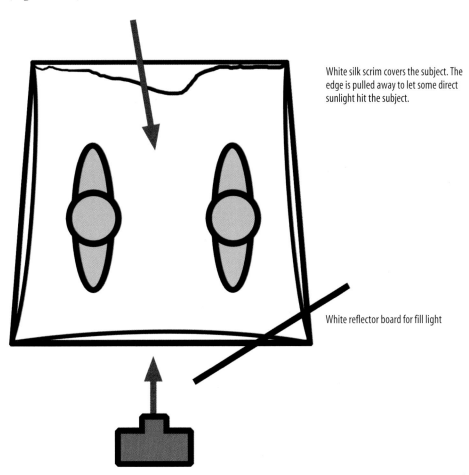

White silk scrim covers the subject. The edge is pulled away to let some direct sunlight hit the subject.

White reflector board for fill light

Figure 3.55 The silk panel was pulled away from the edge of the scrim frame to allow a little bit of direct light to hit the subject.

Shooting in direct sun is usually a recipe for harsh shadows. In this case, Ken Chernus carefully filled the shadows by using white reflector boards (Figure 3.56). The subject is facing the late afternoon sun. Ken placed a large white board on the ground in front of the guitar player and another white board behind him, just out of frame to the left (Figure 3.57). Situations such as this call for close attention to lighting ratios. The huge dynamic range of natural light can be completely tamed only through lighting control. Take a reading of the highlight and shadow in the subject and reduce the difference by filling the shadows so the two values are within four f-stops of each other. This image shows a highlight (LAB) L value of 85 on the man's forehead. The shadow side of his face shows an L value of 53, which is a difference of 32 or 3.2 f-stops. In the field, of course, you'll have to rely on a good light meter to get f-stop readings directly. Move reflector cards closer or farther away to get the desired ratios.

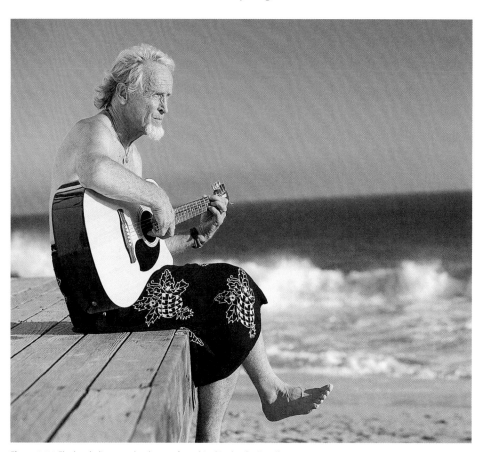

Figure 3.56 The harsh direct sun has been softened in this shot by Ken Chernus.

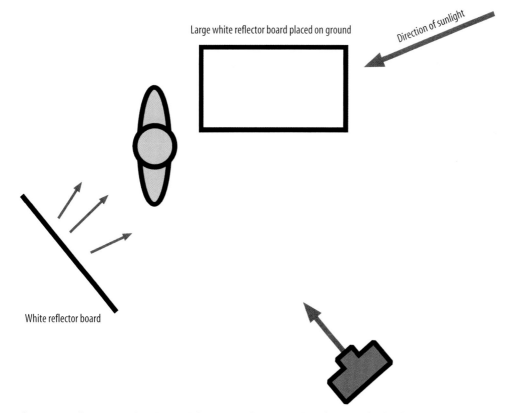

Large white reflector board placed on ground

Direction of sunlight

White reflector board

Figure 3.57 Reflectors are used to adjust the lighting ratios. Fill shadows to bring the ratio within four f-stops.

Well-placed reflectors are mandatory with direct sun, but they are sometimes also necessary with soft overcast lighting. This final shot from Ken Chernus was taken during the same magic hour light as Figure 3.53, but a small fill card was still needed to fill the subjects face (Figure 3.58). The majority of the soft skylight is coming from the woman's left rear. The position of her head causes her hair to block the light from her face. The fill card redirects the light back into her face to provide the even beauty-light look (Figure 3.59).

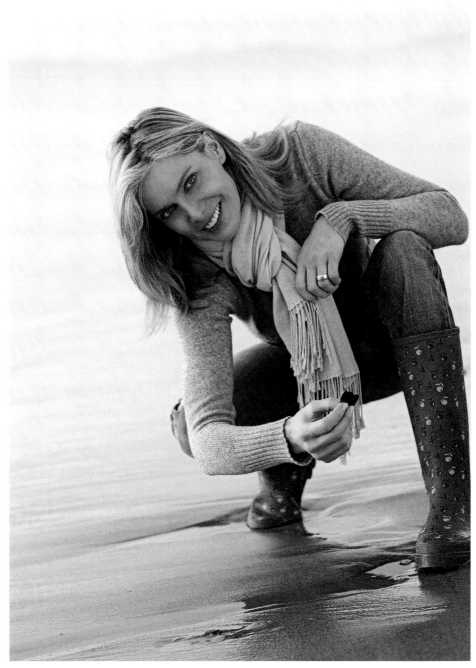

Figure 3.58 Reflector fill is sometimes necessary even with soft overcast lighting. (Photo by Ken Chernus)

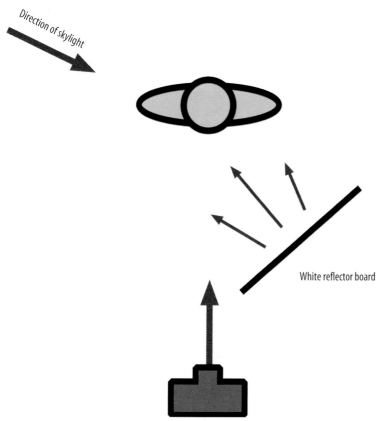

Direction of skylight

White reflector board

Figure 3.59 The fill card lights up the woman's face shadowed by her hair.

Action Stopping Lighting

In Figure 3.49 you saw one example of action stopped using a flash. A very short flash duration is needed to obtain maximum action-stopping effects. Modern flash units can vary the intensity of the light by shortening the duration of the flash. Turn the flash intensity down all the way to get the shortest flash duration. The best strategy for action stopping is to use the intensity controls to shorten the flash duration and add multiple lights to build up the intensity to desired levels. Figure 3.60 shows this action-stopping effect. The woman jumping on a trampoline is stopped in midair by the short flash duration of multiple synchronized flash units.

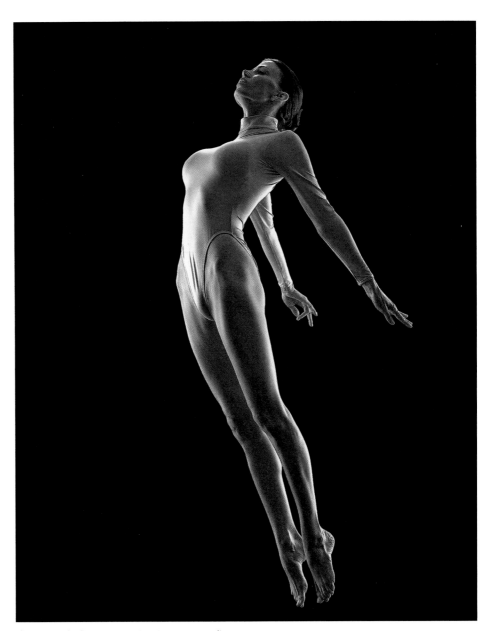

Figure 3.60 The flying woman is jumping on a trampoline.

The figure is wrapped in a soft rim light that comes from V-flats and softboxes positioned to the rear. A 40″ umbrella provides the front fill lighting. Large 4′×8′ white foamcore boards act as front fill and shade the camera from the rear lights. In all cases, multiple lights are used at low power for all the sources—three lights in each V-flat, three lights in the rear softbox, and one light from the front (Figure 3.61).

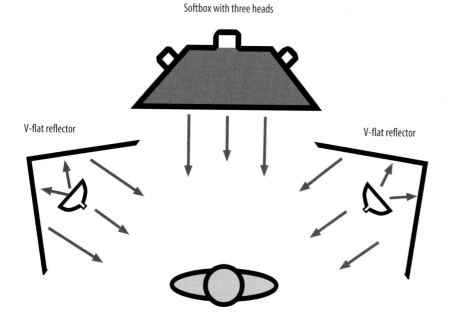

Softbox with three heads

V-flat reflector

V-flat reflector

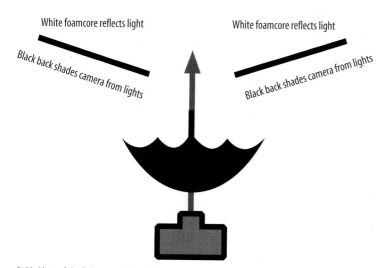

White foamcore reflects light

White foamcore reflects light

Black back shades camera from lights

Black back shades camera from lights

Figure 3.61 Most of the light comes from the rear to create the soft wrap-around rim light. Action stopping comes from multiple lights at low intensity for shorter duration.

The same lighting scheme was used for the next shot. This time the flash lighting froze the water splashing off the figure as she emerged from the pool (Figure 3.62). The rigging for this setup was much more complicated because everything was done in the backyard of the photo shoot's art director.

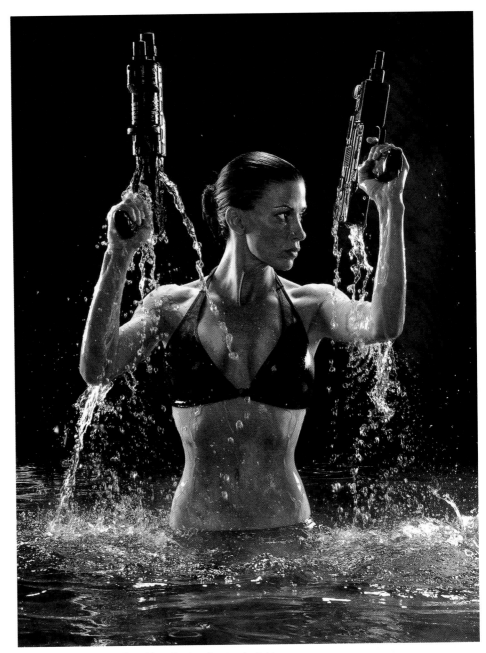

Figure 3.62 An action hero shot with maximum action stopping light

The following production stills show the elaborate rigging of softboxes, flags, and reflectors that went into the production of this shot:

- Three softboxes were positioned at the rear of one end of the pool, and black plastic was laid into the pool and held down with sand bags to create a black bottom (Figure 3.63).

- A black foamcore card was placed to shade the camera from the top softbox.
- To block the side softboxes from the camera, black cloth flags were cantilevered over the water on the ends of C-stand arms (Figures 3.64 and 3.65).

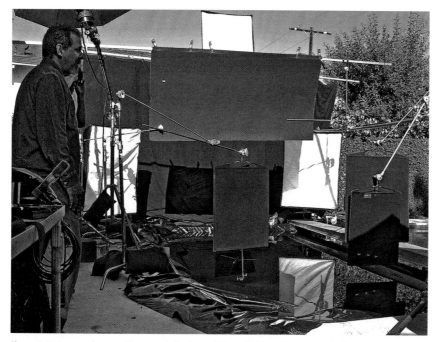

Figure 3.63 I survey the setup. You can see the three softboxes, black cards, and the black plastic laid into the pool.

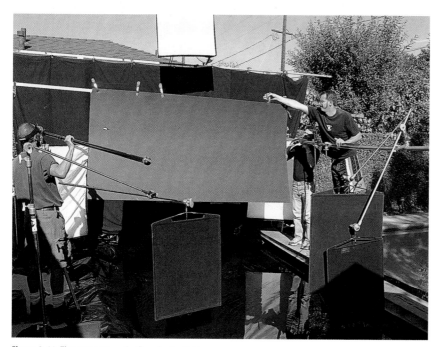

Figure 3.64 The crew sets up the flags for the lights.

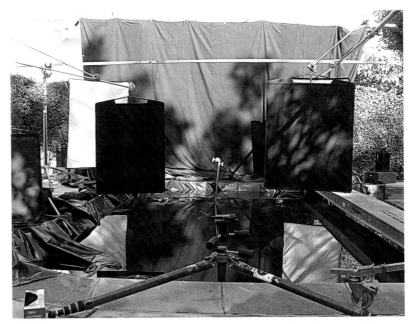

Figure 3.65 Here you can see how the flags are used to hide the rear lights from the camera position to prevent flare.

- My assistant, Kent Jones, took meter readings from the subject position to balance the light intensity (Figure 3.66).

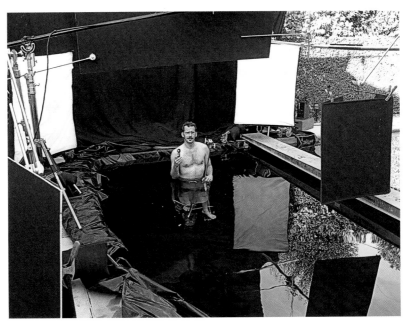

Figure 3.66 Kent Jones takes a meter reading.

The rigging took all day, but by nightfall we were ready to shoot. In Figure 3.67, you can see the 8′ Octodome softbox directly behind the camera used for the front fill lighting. This large source helped to light up the water droplets even though most of the light came from the softboxes at the rear. The rear lights provided the soft rim effect on the figure that enhances the dramatic nighttime feeling (Figure 3.68).

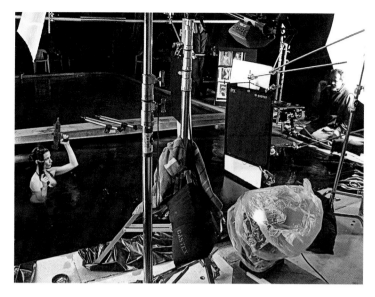

Figure 3.67
I am giving directions to the model; you can see the large Octodome softbox behind me. The camera is on a tripod that's halfway into the water. Plastic bags cover the flash units to protect against splashing water.

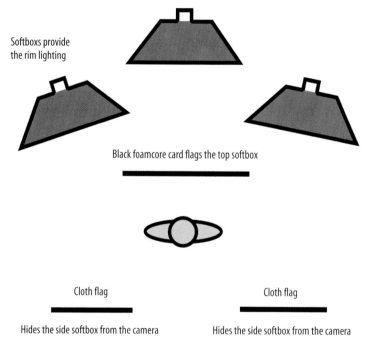

Softboxs provide the rim lighting

Black foamcore card flags the top softbox

Cloth flag

Cloth flag

Hides the side softbox from the camera

Hides the side softbox from the camera

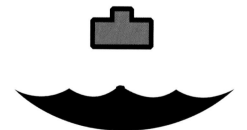

Figure 3.68 The lighting diagram shows the basic layout of lights and flags.

Experimenting with Light

Good lighting is often what separates the great photographers from the ordinary ones. Quality light is not something you can re-create inside Photoshop; it must exist in the shot as captured. You can enhance things that are already there, brighten shadows, correct color, etc., but the hardness or softness of the actual light and the direction of the actual light in a shot cannot be altered in any substantial way. It pays to get the light right when you capture. Pay attention to lighting ratios so you won't have to fix them later; you will always get better quality this way.

Playing with light is ultimately much more rewarding than playing with Photoshop filters. The immediate gratification with the instant review capabilities of digital capture make it easier than ever to experiment with light on the shoot. Try things and see what you can discover. Sometimes the best lighting is the kind that breaks all the rules. For example, Figure 3.69 has hard shadows and a splash of white-clipped highlights. As you can see, you don't always have to try for a "detail everywhere" technically correct rendering.

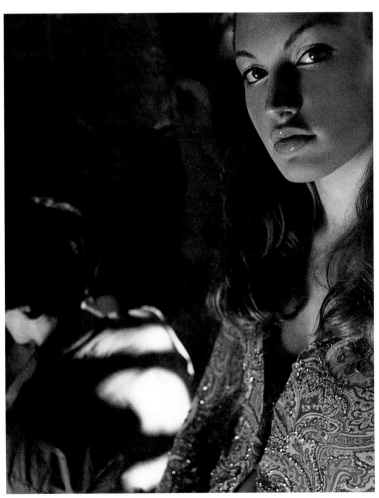

Figure 3.69 The odd direction and warm color create a moody club interior in this shot by Aaron Rapoport. The surprise splash of light in the lower center creates some visual tension with the strong face at the right of frame.

You don't necessarily have to color balance to the light source. Shoot with a daylight default color temperature in tungsten light or choose tungsten color temperature for flash or daylight, as was done for the chapter opener image. When you are on an assignment, you'll need to get the expected shot to satisfy a client; however, if you have time, move the lights or turn off the extra lights and shoot the subject with one light. Make some time to play with light, so you can discover really cool effects (Figure 3.70) that go beyond the push button, CGI-filter stuff that is so popular today because it is so easy.

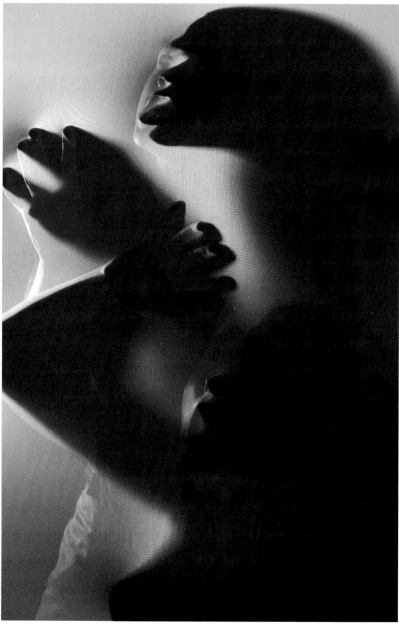

Figure 3.70 This complex horror light was created with only one flash head in a 10″ reflector. A silk diffusion panel was placed in front of the subjects to catch the shadows and light coming from the left rear.

The Color of Skin

Most people will say they want "accurate" color, but what they prefer (and what clients buy) is "pretty" color—not wild surrealism, but usually some departure from reality. This is where color control becomes important. This chapter examines color in detail starting with a basic technical foundation, moving through basic color controls, and ending up with detailed step-by-step instructions for adjusting color.

Chapter Contents
White Points, Black Points, and Places In-Between
Zone System: Contrast and Tone
Neutral Color: Using Balanced Numbers
White/Black Point Correction
The Family of Man: Cultural and Psychological Issues

White Points, Black Points, and Places In-Between

By far, the biggest problem that digital photographers face is getting the color right. If you've been photographing traditionally for any number of years, you've most likely learned how to expose images properly and you've assembled a collection of lighting tricks that have served you well. Before digital capture became practical though, you never really had to take much responsibility for your color rendering beyond choosing the right film emulsion for the color temperature of the light. If you shot negative film, you could leave everything up to the lab. Even if you shot transparencies, the lab was mostly responsible for delivering credible color based on what the film manufacturer created with a batch of film.

Nowadays, that's not quite the case. Even if you have all your printing done at a lab, you still must assume at least part of the responsibility for the exact rendering of the color in the digital file. Most photographers approach this as a problem in color calibration or color management. This is consistent with a traditional film testing approach—you get a new batch of emulsion and you test it by taking photos through different colored CC filters: 025Y, 5M, 81A, etc. The idea is to find the particular bias of a certain emulsion and compensate for it. The concept behind digital color management is similar, although it's a bit more complex. The problem is that, with film, the basic tonal/color rendering is fixed at manufacture. The photographer/lab has only minor influence on the color rendering. Digital, on the other hand, is much more malleable. Hue, saturation, and value rendering can be manipulated to extremes. This kind of control is scary for the traditional photographer because the safety valve of fixed rendering is no longer present. The color can be anything you want it to be... so what *do* you want it to be?

Many digital photographers attempt to replace that safety valve with a rigorous ColorSync color management system. By shooting targets of color patches and using software to build detailed color description *tags* for digital files, the idea is to create color that is accurate to the original scene. Debates about exactly how to do this are ongoing—we examined one method using ACR in Chapter 2, "Color Management, Workflow, and Calibration." There are many other methods for creating accurate color. For some commercial photographers, this "accurate color" may be all they need because all creative color decisions will be made later on in the post-production phase of a project.

Unfortunately, accurate color is often boring color. For many people, as professional photographer Jeff Schewe likes to say, "Reality sucks." We are conditioned to expect an idealized Hollywood version of color in photos. This is not necessarily supersaturated Kodachrome-Velvia color, but usually it is a departure from strict accuracy.

Zone System: Contrast and Tone

Often when you mention the *Zone System,* certain people break out in a sweat. We associate the Zone System with tedious technical exercises and tests, and it's all so dry. Didn't we leave all that behind in high school science labs? Bear with me here. The following discussion is fairly technical, but I promise to relate this to color correction for people photography in a minute.

Photoshop has a wealth of tools for manipulating color; however, before you can begin to fix color problems, you should understand what we are trying to achieve in producing a two-dimensional representation of reality on a printed piece of paper. The real challenge in reproduction is how you compress the vast dynamic range of visual reality into the limited range of ink on white paper. If you simply map all the tones inward in a linear fashion, you will end up with an image that looks very gray. Typically, photographers try to compress tones at the highlights and shadows and separate tones in the midrange to create something that approximates how the human visual system treats local contrast in areas of interest.

The typical human observer can see approximately 100 to 150 tones, or *steps* of value change, simultaneously. This is one of the reasons that 256 steps of tone in an 8-bit grayscale image are more than enough to create the impression of continuous tone. Ansel Adams created the Zone System of 10 steps as a way to simplify the classification of observable tones for reproduction purposes, and we can use this system today with even more precision.

Table 4.1 gives the 8-bit values for zones of 10 percent value change in Adobe RGB color space. In this table, L is lightness (the *L* in LAB), 0 is black, and 100 is white. Figure 4.1 demonstrates these same values visually.

Table 4.1 Zone System Values in Adobe RGB

Zone	RGB value	LAB value
Zone 0	0	L=0
Zone I	33	L=10
Zone II	51	L=20
Zone III	72	L=30
Zone IV	94	L=40
Zone V	118	L=50
Zone VI	143	L=60
Zone VII	169	L=70
Zone VIII	197	L=80
Zone IX	225	L=90
Zone X	255	L=100

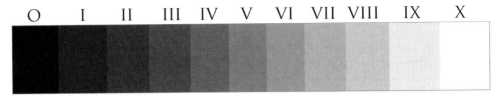

Figure 4.1 A LAB Zone System

You can see that there are actually 11 zones in this digital Zone System. This is necessary in order to place Zone V at the midpoint (L=50 in LAB) mathematically. The traditional Zone System uses Zone I as black but the basic idea is the same.

With little effort, most people can clearly see a difference in one-half zone of value change in shadow values, Zone 0 thru Zone II (roughly 15 RGB levels between values) if tones are right next to each other. It becomes harder to see finer differences in shadow values darker than Zone I. This impacts how we might approach contrast and brightness correction in an image. When we start thinking about color, however, differences of 5 RGB levels can easily be visible when we are looking at near neutral tones and almost totally invisible when we are looking at saturated colors. This has to do with the way the human visual system focuses on changes in value at the midrange over either extreme. Visually, the change from Zone V to Zone VI seems more noticeable than the change from Zone I to Zone II.

Differentiating Values in Print

It is extremely difficult to predict exactly how well values will differentiate in print. The accompanying graphic shows a series of *step wedges* that divide a gray ramp from black to white into progressively smaller "steps." The red arrow identifies the midpoint. The wider-spaced tick marks show divisions for the 11 steps of our digital Zone System. The 20 steps of gray above that are one-half zone steps. The narrow-spaced tic marks show the division points of the 40 gray steps directly below the marks. Beneath the 40 steps, there is a smooth ramp from black to white, and beneath that there is a 60-step ramp.

Can you see the "steps" in the 60-step ramp? These steps are represented by a change of five levels in RGB. Chances are that you will be able to see finer steps in values lighter than middle gray, and you will have a hard time seeing steps below Zone II in even the 40-step ramp. This same file printed on an Epson R2400 with Enhanced Matte paper shows clear value changes in the 60-step ramp down through Zone I.

Neutral Color: Using Balanced Numbers

Being able to see differences in five RGB levels between steps of tone near neutral does not mean that humans are particularly good judges of neutrality. This poses certain problems when we try to adjust colors visually. The human visual system adjusts dynamically to the color temperature of a given light source. This gives us the ability to evaluate colors independently from the color of the light illuminating those colors. This is called *color constancy*. Basically, it means that white looks white even if it's illuminated by yellow tungsten lighting.

The downside of this phenomena is that the longer we look at something that is close to neutral, the more neutral it starts to look—we tend to compensate for color casts. Sometimes we can see that there is some kind of color cast, but we may not know precisely what to do to correct for it if we must rely only on our visual system.

This is where numbers come to the rescue. The Info palette and the Eyedropper tool can help tremendously when you are evaluating and correcting colors. If you can neutralize highlights, shadows, and midtones that should be neutral, all other colors will fall into place.

Look at Figure 4.2. Medium gray, white, and black squares are stacked into each other. This image has maximum local contrast and maximum neutrality... or does it?

Figure 4.2 This image appears to have neutral tonality through black and white.

Now turn the page and check out this image again, in Figure 4.3.

Figure 4.3 These values are actually neutral. Compare them to the version in Figure 4.2.

You may, or may not, have noticed that the squares have shifted somewhat and that now they are, in fact, more neutral (or at least a slightly different hue). Did you notice that the white square is brighter? How about the black square? Without something to compare them to, the previous squares looked neutral. Yet, if you measure the numbers for the gray, white, and black squares, you could clearly evaluate the color cast in the previous image, as these numbers for Figure 4.2 show.

Gray =	R: 120	White =	R: 245	Black =	R: 0
	G: 125		G: 245		G: 10
	B: 132		B: 250		B: 15

The lesson here is to avoid placing too much trust in your eyes when you're making critical color judgments. You should keep the Info palette visible and get in the habit of checking the numbers.

The discolored band running through the middle of the squares in Figure 4.4 shows the tones of the original squares next to the neutral values of the current image. When the tones are next to each other, you can easily see how far from white and neutral gray they are. In order to have maximum range in your prints, you must be careful to set white and black points appropriately. In a more complicated image, the white and black points might not be so obvious. Always check the numbers.

When choosing values for white and black points in an image, be aware of the textural limits you may want to enforce. The traditional Zone System sets Zone III as the darkest value that will show texture and Zone VIII as the lightest textured value.

Our digital Zone System places those limits in Adobe RGB at a level of 51 for dark and 197 for white. Absolute black should still be placed at 0, and spectral highlights should still come to 255. These rules are not iron clad, and stretching the range from a dark value of 15 to a light value of 245 could be more appropriate in many cases. Many of Ansel Adams' early prints look rather dark and somber because of a rather rigid insistence on textured high values of Zone VIII. Later in his career, he let tones go all the way to Zone X or paper white, and these prints have a lot more life in them.

Figure 4.4 A discolored band contrasts with the neutral gray and white.

Color images have other challenges besides setting white and black points; however, it is interesting to note that as a tone approaches black or white, it gets more neutral numerically. A very dark shadow in a region of green will always measure more neutral as it gets darker. By neutralizing shadows and highlights, you frequently can eliminate color casts automatically. We'll look at a practical application of setting white and black points in color correction in the following pages.

Curves: The Basic Color and Tone Tool

The primary tool for color and tone manipulation in Photoshop is the Curves dialog. You open the Curves dialog either by choosing Image > Adjustments > Curves or by making a new Curves adjustment layer. Using an adjustment layer is the better method: Click the Adjustment Layer icon at the bottom of the Layers palette and select Curves from the resulting menu (Figure 4.5).

Figure 4.5

Creating a Curves adjustment

The first time you enter the Curves dialog (Figure 4.6), you'll see the standard, straight diagonal line graph.

Figure 4.6

To reverse the direction to progress from dark to light, click in the gradient along the bottom of the graph.

This is an *xy* plot of input to output values—input values plot along the bottom and output values plot along the left edge. The diagonal line represents the relationship between input and output. This perfect diagonal means that there is no change (that is, *x* equals *y*), and output values are the same as input values. The gradient along the bottom and the left edge indicates the progression of values from light to dark as they are mapped to the line.

Sometimes the gradient is set up to represent ink densities so that as it progresses from left to right, it gets darker—adding density. Photographers working with additive color, as with RGB, usually prefer to think in terms of adding light so you can reverse the gradient by clicking anywhere inside the gradient. We will use this arrangement, progressing from dark to light, in this book.

You can use a finer grid by Option/Alt+clicking the grid to toggle between fine and coarse views. The input and output values for any point that the cursor is over will be shown below the curve.

The Channel drop-down at the top of the dialog allows you to affect all channels or individual channels depending on what is selected. We will confine ourselves

here to examining the contrast and tonal effects of the curve so we will only look at the composite (RGB) channel.

Contrast Control: The Basic Curve Shapes

In the next few figures, several different curves are applied to a black-and-white image, and a 10-step Zone scale is placed at the bottom of the curve dialog in each to help you visualize the different effects of various curve shapes. The straight diagonal line in Figure 4.7 provides an undistorted linear grayscale—there is no change in tone or contrast.

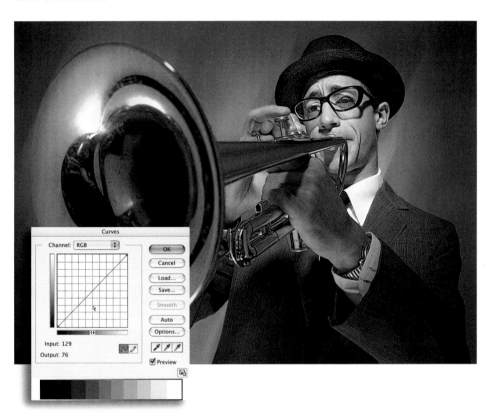

Figure 4.7 A straight line curve shows no change in contrast or brightness from the original.

Click and drag the endpoints inward along the edge of the grid and you will *clip* the light and dark ends of the scale. This results in more contrast—the change from black to white happens more rapidly (Figure 4.8). You can see the Zone IX value has merged with the Zone X value. The same thing has happened at the other end of the scale. The midtone values have more *separation*, a more obvious change from one value to the next. The more vertical the line, the more contrast you will have. When your image has no tones below Zone III or above Zone VIII, you can greatly expand the range by forcing the Zone III value to Zone I and the Zone VIII value to Zone X, mapping the darkest point in the image to black and the lightest point to white.

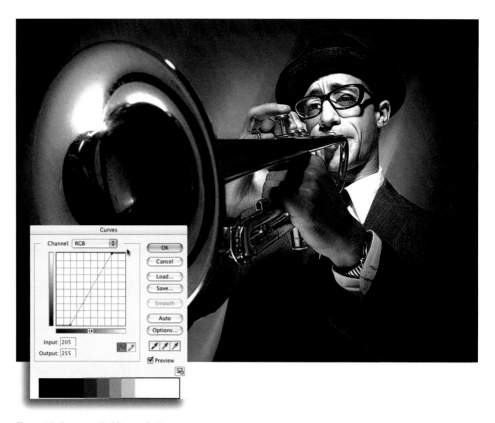

Figure 4.8 A more vertical line results in more contrast.

To achieve the opposite effect, click and drag the endpoints in the other direction, down and up along the right and left edges of the grid. White and black are suppressed to light gray and dark gray. The whole scale becomes grayer with less noticeable change from one tone to the next. Here you can see that the more horizontal the line is, the less contrast there will be (Figure 4.9). This is one reason images with less contrast are called *flat*. This compression or expansion of tone is how we manipulate the color and contrast of our images.

So far, we've only looked at straight line "shapes" for the curve. Things get more interesting when you place extra points on the curve.

Figure 4.10 shows the classic S-curve that is considered a contrast enhancing shape. By leaving the endpoints alone and placing two additional points on the curve, you can twist the center portion of the line into a steeper incline and increase the contrast in the midtones. You can see this effect quite prominently in the Zone scale at the bottom.

We've avoided clipping the highlights and shadows, but by adding contrast to the middle, we've reduced contrast at the ends. It is important to note that this shape can have a deleterious effect on detail in the shadows and highlights. In other words, there is no free lunch! If you increase contrast somewhere, you will decrease it somewhere else.

Most of the time we are more concerned with detail in the midtones, but not always.

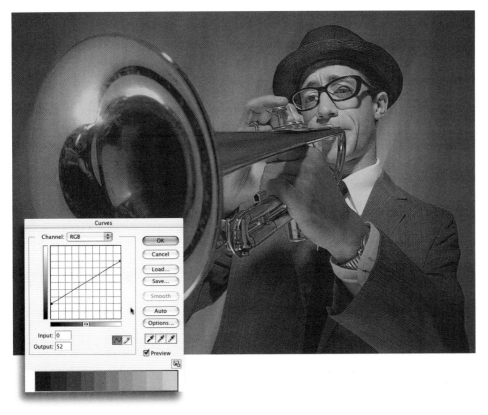

Figure 4.9 A more horizontal line results in less contrast.

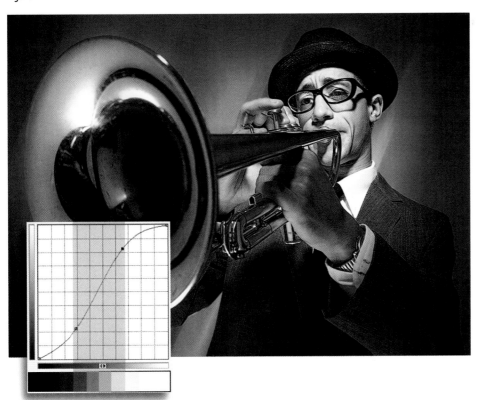

Figure 4.10 The classic S-curve has more contrast in the midtones but less at either extreme.

The curve shape in Figure 4.11 shows a lower contrast in the midtones but more contrast and separation of tones in the highlights and shadows. Very often, we have to adjust curves to steepen the line at areas where we want more tonal variation and allow other areas with little inherent detail to compress.

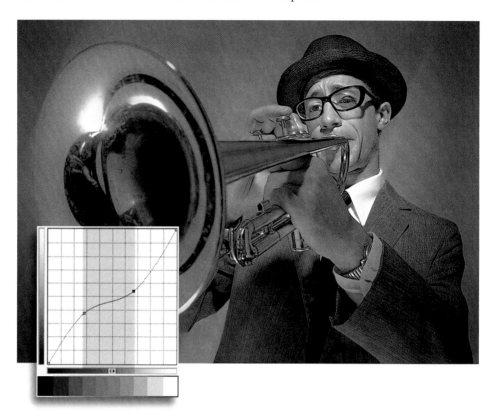

Figure 4.11 A reverse S-curve flattens the midtones.

The curve shape in Figure 4.12 is characteristic of a brightness-enhancing move. All of the points, save the endpoints, have moved up. The upper half of the tonal scale has compressed, and the lower have has been expanded. The line is steeper in the low end and flatter at the high end. Typically, images that are too dark need to have more details brought out in the shadows. The high end of a dark image may be relatively unpopulated with tones, so the compression of high values won't be noticed.

The exact opposite would be true of a light image. If you could get more detail and contrast in the high values, you wouldn't care if the few dark tones compressed together. If Figure 4.12 were reversed and all the points were lowered, you would have a very flat section at the lower part of the line and a steeper section at the top.

The real power of curves is that you can place points of interest and position them precisely to hit desired values and the rest of the values in the image move smoothly to accommodate the new values. Keep these curve shapes in mind as you work the values in your images. Try to work more steepness into areas where you need contrast.

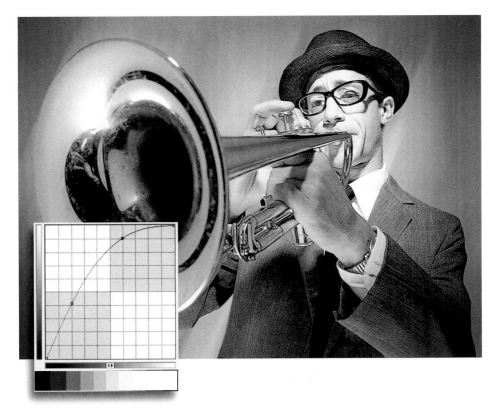

Figure 4.12 A tall bulge pushes values up, resulting in a lighter image

Keep Saturation in Mind

So far we've been looking at monochrome images because we've been concentrating on tone and contrast. When we start including color, we have to be careful with contrast-enhancing curves because they almost always increase saturation as well. If you need to increase contrast without increasing saturation, you can use RGB curves in an adjustment layer and change the Layer Apply mode to Luminosity.

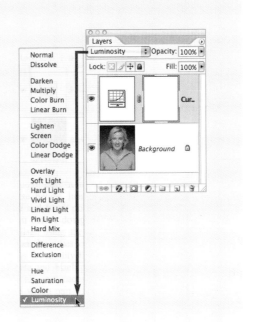

Info Palette: Reading Basic Numbers

Now you need to set up so that you can read numbers properly. Select the Eyedropper and set the options in the Tool Options bar to a Sample Size of 5 by 5 Average. This means the reading given in the Info palette will be the average of a 5 by 5 pixel area under the cursor, minimizing the effect of random noise on the reading. You can use the RGB and CMYK numbers as a guide to help you evaluate color more consistently. You will learn more about *specific* color numbers later—for now we're just concerned with white, black, and neutral values.

Before going any further, you need to look at the Info palette. Make sure the Info palette is open (by choosing Window > Info), and then select Palette Options from the drop-down menu (accessed from the triangle in the upper right of the palette, as in Figure 4.13). Set up the options as shown, with First Color Readout set to Actual Color and Second Color Readout set to CMYK. When you move the cursor into the image, the Info palette will display the numerical values for the color under the cursor.

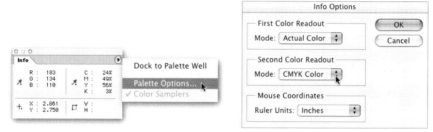

Figure 4.13 The Info palette and palette options

White/Black Point Correction

Now that you have a basic understanding of RGB numbers, tonal values, and curve shapes, you can start to develop strategies for dealing with color correction. The first approach you need to master is identifying color values that need to be neutral (R=G=B). You can use points on a curve correction to force these values to be neutral. Once you've established the neutral values, any color cast in the image will usually be eliminated. Then you can concentrate on the actual color values for skin. The remainder of this chapter will deal with color correction of skin tones starting with a simple step-by-step tutorial in which black point and white point neutrals are identified and then ideal skin tone values are forced by using a Curves correction.

We're going to work with a photo of a water polo athlete (Figure 4.14) by Ken Chernus. We suspect that there is a color cast. It just seems a little yellow. We can't be

certain that the concrete behind him is really neutral, so we're going to have to check white and black points to find out. Make sure that you have the Info palette open before doing anything else. You can place multiple sample points in the image using the Color Sampler tool (find it under the Eyedropper tool). When you do, it will be easy to watch the numbers change in more than one point as you modify the color using adjustment layers. Although it is easy to find white and black points in this image, in many images it is not so easy—nor is it necessarily obvious which part of the cap is the lightest point and which part of the bathing suit is the darkest. We will use a little trick to help you locate the lightest and darkest points in this image.

Figure 4.14 Water polo athlete (©2003 Ken Chernus)

You can use a temporary Threshold adjustment to locate the lightest and darkest points in the image. With the Color Sampler tool still selected, make a new Threshold adjustment layer by clicking the Adjustment Layer icon at the bottom of the Layers palette and selecting Threshold from the resulting flyaway menu (Figure 4.15). Move

the slider to the right to set the break point between black and white at a high value—that will locate the lightest point in the image by turning everything else black, as shown in Figure 4.16.

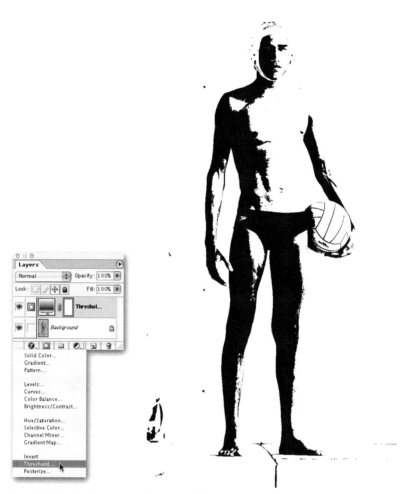

Figure 4.15 Threshold layer **Figure 4.16** High contrast

To duplicate Figure 4.17, move the slider to the right until only the lightest part of the cap is visible as a white patch. Click OK in the Threshold dialog, and you'll be able to access the Color Sampler tool. Click it to place a sampler for the white point in the white area.

Do the same for the black point. Double-click the Threshold Adjustment Layer thumbnail; the Threshold dialog will appear. Move the slider to the left until only the small black area at the left side of his bathing suit is visible (Figure 4.18). Click OK to close the dialog. Now click with the Color Sampler tool to place a second sampler for the black point.

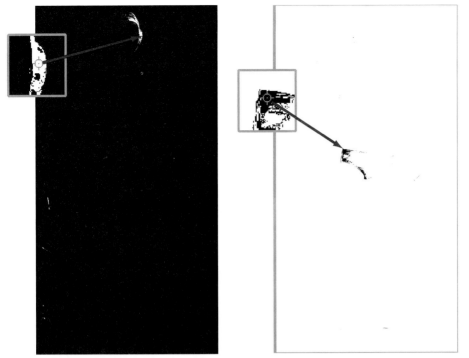

Figure 4.17 White point **Figure 4.18** Black Point

Adjusting Numbers for the Color of Skin

Now that you've identified and placed samplers for the white and black points in the image, you can discard the Threshold adjustment layer and begin color correcting. Drag the Threshold adjustment thumbnail to the Trash icon at the bottom of the Layers palette to discard it. The Color Samplers remain ready for use—their values appear at the bottom of the Info palette and are labeled #1 and #2. You're going to want to watch sample point value for skin on his chest. Identify this point by simply placing the cursor on his chest while you make the curves adjustments. You'll need this secondary color readout to properly evaluate the color of the skin tone—you get only one readout for the numbered Color Sampler points. Make sure your Info palette has CMYK specified for the secondary color readout. A good skin tone value for a Caucasian will have the highest values almost equal in magenta and yellow, with yellow a little bit higher (more on this later). Cyan will be one-fourth to one-third of the high value for yellow—for this suntanned athlete, you'll want at least one-third for darker skin (Figure 4.19).

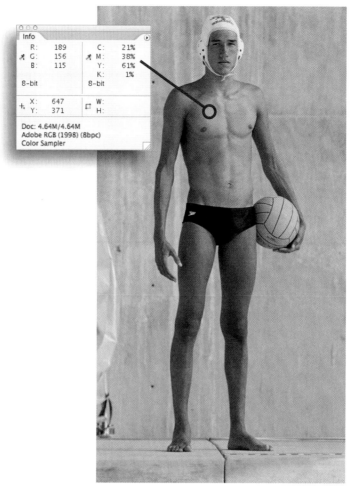

Figure 4.19 The skin value is too yellow because the yellow number is more than 20 units higher than magenta in the Info palette.

Create a Curves adjustment layer by clicking the Adjustment Layer icon at the bottom of the Layers palette and selecting from the resulting menu. Our strategy for correcting this image will be to set black and white points in each channel and make sure that they are neutral. We will then sample various points for the skin tone and wiggle the curves for each channel so that we hit a good recipe of RGB/CMYK numbers for skin tone.

Neutral gray color will always be represented by equal numbers in RGB. When R=G=B, there will be no color cast one way or another. The first numbers shown in Figure 4.20 represent 50 percent gray. You can use this principle to evaluate neutral tones anywhere in the image. Black and white point numbers will be near neutral in images that do not have a color cast even if they are part of a colored subject.

Info				
R:	128			
G:	128			
B:	128			
8-bit				
X:	2.905			
Y:	4.480			

Info			
R:	214	C:	11%
G:	184	M:	28%
B:	161	Y:	35%
		K:	0%
8-bit		8-bit	
X:	1.556	W:	
Y:	1.474	H:	

Figure 4.20 Neutral RGB (left); skin numbers (right)

The CMYK numbers in the figure are good values for medium skin tone in a Caucasian. It is much harder to evaluate skin color with RGB numbers. In CMYK the relationship of CMY will be fairly consistent: Magenta and Yellow should be roughly equal, with Yellow usually a few points higher but typically, not more than 10 units higher. Cyan should be about one-fourth to one-third of the value for Magenta or Yellow; if it is too much higher, the skin will look too gray. Of course, there are all types of skin tone and even a considerable variety of correct numbers within the same subject. Highlight values will be smaller, and shadows will have more cyan relative to medium skin values. Different ethnicities also vary somewhat from these standards (more on this later). Use the CMY numbers as a guide to indicate how you need to move the curve to correct the color.

Start correcting by moving the endpoints in the curve for each channel—aim for a black of 15,15,15 and white of 245,245,245 (Figure 4.21). Set black first and then move to white. You may have to tweak the black endpoints after you work with the white—keep an eye on the Info palette! Do not be tempted to move the black point all the way to zero because there is no texture in the bathing suit. Anything darker than 15 will collapse into black when the image prints. Keep the dark point high enough that dark values that should be lighter than black will actually print that way. This will help to preserve shape in the bathing suit. The white cap could go all the way to 255 on the highlight side (we could consider it a *specular* highlight), but some subtle shape would get lost as the tone progressed across the top—the lettering would also start to get a little weak if we pushed it too far.

Note: These black and white point numbers are only a general guide for RGB images that will be printed on desktop inkjet printers. Values for CMYK offset lithography might need to be even more conservative, depending on the image and the artistic intent. You can push values lower and higher if there is no texture or detail that you want to preserve in the shadows or highlights.

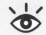

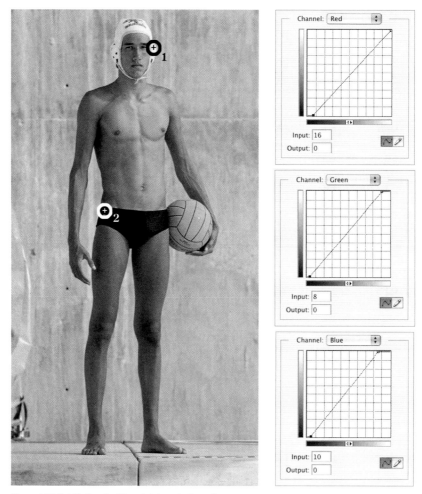

Figure 4.21 Set black and white points in each channel.

By setting white and black points, you expanded the range and put some contrast into the midtones; however, you still need to address the color of the skin. Right now the skin has developed a cyan/green cast. ⌘/Ctrl+click a midtone in the chest to place a point on the curve in the *blue* channel (Figure 4.22). Adjust the channel using the arrow keys and keep your cursor on the chest. Start by moving the point *up* in the blue channel. You can keep an eye on the RGB and CMYK values while you move the point with the arrow keys.

When you start making your corrections, there will be two columns of numbers for each Color Sampler (Figure 4.23). The column on the left represents the starting values. The column on the right represents the new. These new values are the output values at the bottom of the Curves dialog.

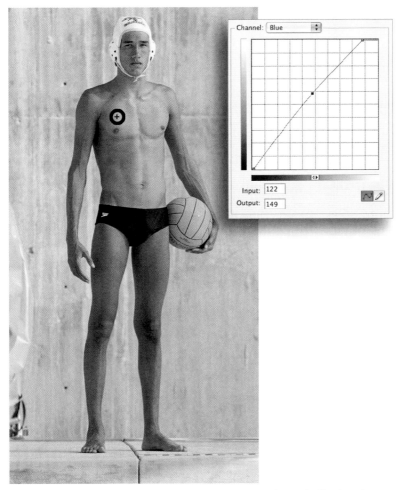

Figure 4.22 To correct the yellow/green cast, start with a point on the chest in the Blue channel.

Info

R: 198/ 207	C: 17/ 14%
G: 165/ 176	M: 35/ 31%
B: 125/ 154	Y: 55/ 37%
	K: 0/ 0%
8-bit	8-bit

| X: 1.481 | W: |
| Y: 1.424 | H: |

#1 R: 245/ 245	#2 R: 25/ 10
G: 226/ 245	G: 18/ 10
B: 216/ 245	B: 20/ 10

Doc: 3.44M/3.44M
Adobe RGB (1998) (8bpc)
Eyedropper

Figure 4.23

Color Sampler numbers—at the top of the palette, RGB and CMYK numbers are at the location of the cursor. The #1 and #2 numbers represent the white and black point samplers.

Use the same strategy for the other channels: raise the values for red and blue and lower the values for green until you arrive at the desired values in the Info palette. Try to keep your neutrals (white and black) within a three-point spread. The CMYK values for the skin tone should put yellow within 10 points of Magenta with Cyan approximately one-fourth to one-third of the value for Yellow (Figure 4.24). Remember that to reduce cyan, you add red. To reduce yellow, add blue. To add magenta, reduce green. Try to keep your cursor in the image and use the arrow keys to move your points on the curve.

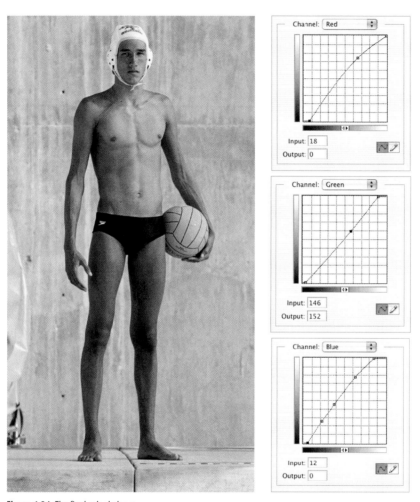

Figure 4.24 The final color balance

Once you get the values for skin to where you want them, you will probably have to reedit the values for the black and white points. Feel free to place additional points near the endpoints to tweak the low and high values into shape without pushing the skin values around too far. If you go by the numbers, you will have a much easier time of zeroing in on the color you want.

Opponent Colors

When working skin color in digital photography, you'll end up editing RGB numbers but looking at CMYK numbers. For many photographers, this is a bigger hurdle than it needs to be. RGB numbers work in "opposition" to CMYK values. To reduce cyan, you add red. To reduce yellow, you add blue. To add magenta, you reduce green. The Info palette contains a hint to help you determine opponent colors. If you read across the top, you will see that R is opposite C, G is opposite M, and B is opposite Y. You can see to the right that increasing red has reduced cyan and increasing blue has reduced yellow. The slight increase in green has served to keep magenta where it was even though the image got brighter overall.

The image of the water polo athlete represents a fairly easy correction. The image was originally a well-exposed camera JPEG. The color bias most likely was due to a standard color temperature setting in the camera, probably Daylight–5000 K, used with late afternoon "warm" light. A yellow wall, out of frame but near the subject, might also have contributed to the yellow bias in the skin color. Many possible lighting scenarios can result in "off color" shots. Many times even the best, calibrated color management systems can fail to deliver anything close to the ideal color for a particular image. The ideal color may not be the actual color of the original subject either. I settled for a slighter redder color for this athlete's suntanned skin because I felt that it looked better this way and gave a nicer contrast with the wall behind him.

Photoshop offers knowledgeable photographers a wealth of tools to shape the tones and colors of their photography in any way imaginable. Using the Info palette numbers as a guideline, you can fine-tune color and tone very quickly to get the best reproductions possible. Color correction can become a labor-intensive chore of trial and error when you don't understand basic color "numbers." Most of the time, you won't know if the color is the best it can be without at least referencing the color numbers as a point of departure.

However, color numbers are only a guide. Even when you use them, you still have to use your own eyes and judgment to arrive at the right color appearance for your needs. These guide numbers are the result of years of printing images and developing a cultural consensus for what constitutes good skin tone. Before departing from that consensus, you should know how to truly control the color to get what you want. If you know how to hit the numbers, you will know how to hit any color interpretation you want.

The Family of Man: Cultural and Psychological Issues

The subject of skin color is fairly complicated one that you can only begin to comprehend here. The following images are presented with their corresponding Info palette numbers to illustrate some of the varieties of photographically acceptable skin tones in various cultures.

The mother and daughter portrait in Figure 4.25 illustrates typical Anglo-Caucasian skin color values—magenta and yellow close with yellow slightly higher, and cyan at one-fourth to one-third the value of magenta/yellow. Children's skin tones are typically lighter and pinker than adults'. Still, you'll want to avoid having magenta be equal or higher than yellow except in cheeks and lips. Take several readings from the forehead, chin, shoulders, etc., to get a general idea of the color ratios rather than relying on a single point.

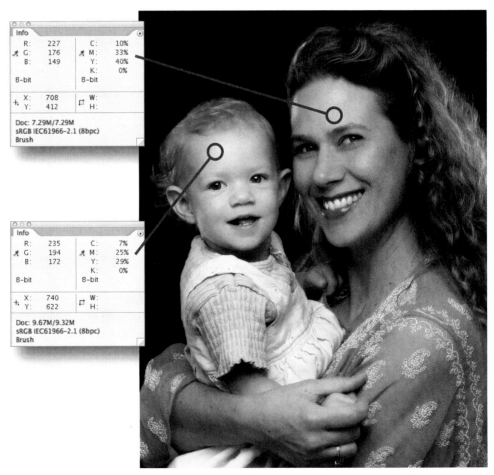

Figure 4.25 A mother and child with Caucasian skin: slightly higher Y and lower C

African American skin values usually look better with a little more magenta than you might use for Caucasian skin—especially if the skin tone is very dark. In Figure 4.26, the magenta is equal to yellow. This is about as much magenta as I would tolerate. In reality, skin values are all over the place, and it's common to find black skin that has a very yellow bias. While this is real, it usually is not desirable in print because it makes the skin look green. Darker skin will have a higher percentage of cyan—this is what adds weight and shape to the skin tone. As the skin gets darker, I tend to raise the level of magenta in the ratios to balance out the yellow-cyan "greenness." To raise the magenta values (you guessed it), subtract green. Really dark charcoal-colored skin can have an almost blue cast, but, again, this is undesirable in print most of the time.

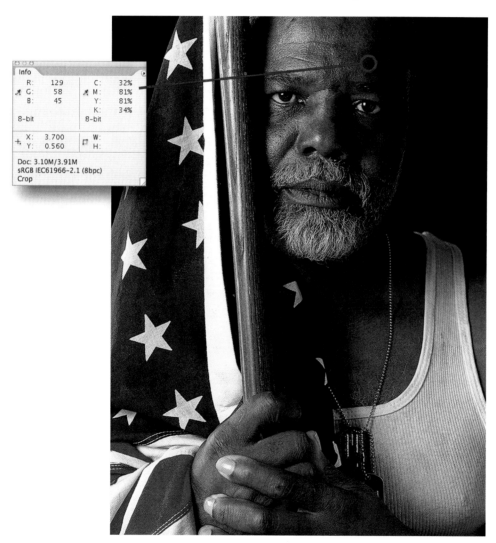

Figure 4.26 This African American man's skin has a higher magenta value. (Photo by Ken Chernus)

Asian skin is more yellow; the trick is to not let it get too yellow. In Figure 4.27, most areas of the girl's face are about 11 units higher in yellow than magenta. The biggest problem with this particular image is that she is standing on a big, green golf course. This green is reflecting into the underside of her cheeks, arms, and even eyebrows where it looks like green eye shadow in the original version. I used a Hue-Saturation adjustment trick to equalize the skin color and limit the appearance of green in these problem areas. I will reveal this trick in Chapter 6, "Retouching." The corrective technique is a very powerful one that is particularly useful in eliminating red blemishes.

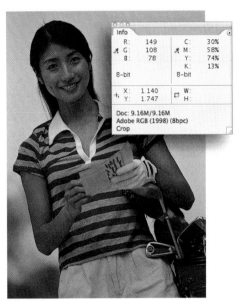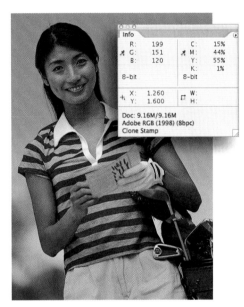

Figure 4.27 An Asian girl. The original (left) has a green cast under her eyes and cheeks, the white point is suppressed and pink, and the skin is overall too dark and yellow (except for cheek highlights). (Photo by Ken Chernus)

Whenever a subject is very close to grass, you'll need to be careful of an overly yellow bias in the skin color. You can see that quite prominently in Figure 4.28. Both the highlight and shadow values of the face show over 30 units more yellow than magenta. The bias is also polluting the red hair color. The corrected version (Figure 4.29) shows that by paying attention to appropriate numbers for the peaches-and-cream complexion of this cute little girl, you can clean up the color considerably.

Overly red skin tone is a common problem with digital capture, especially where the skin tone is a little on the red side anyway. As a result, the baby in Figure 4.30 appears to be beet red. Everywhere in the skin, the values with Magenta are noticeably higher than yellow. If we want a baby that doesn't look sunburned, we will have to reverse that.

Balancing the white numbers to neutral in the hat helps reduce the red everywhere else. A few more points on the curve to add more green in the shadow values of the skin produces the image in Figure 4.31.

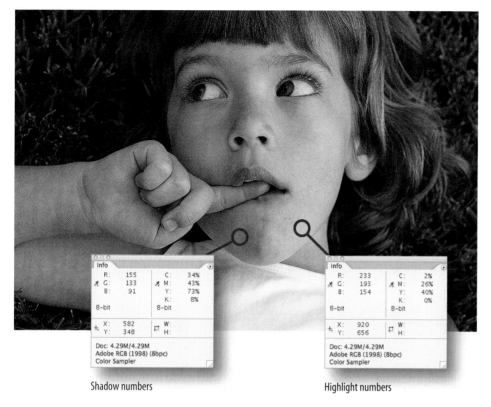

Shadow numbers

Highlight numbers

Figure 4.28 The original image, by Erin Manning, has a decided yellow bias.

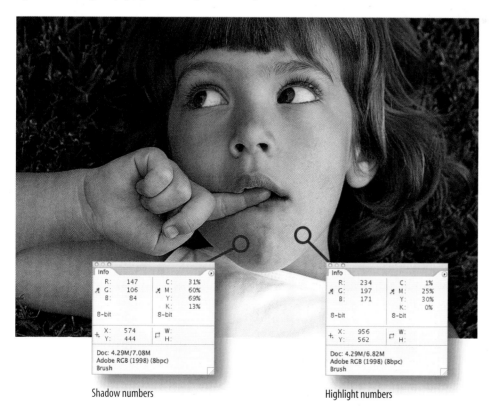

Shadow numbers

Highlight numbers

Figure 4.29 The corrected version has truer colors in the skin and hair.

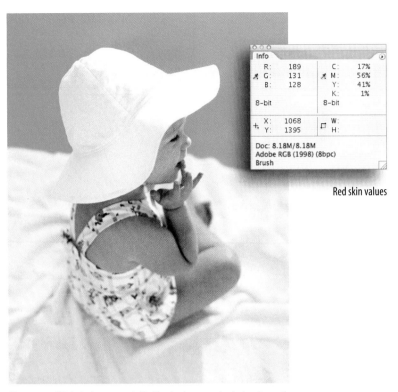

Red skin values

Figure 4.30 This baby has very red skin. The shadow areas in the hand near the face are practically glowing. Note that the Info palette shows too much Magenta. (Photo by Anthony Nex)

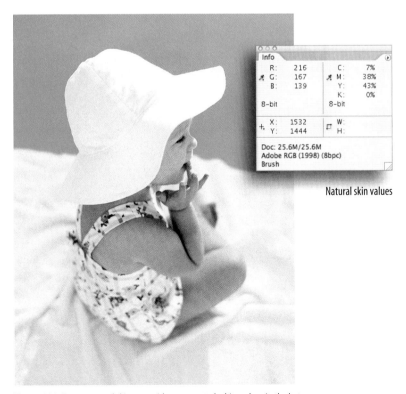

Natural skin values

Figure 4.31 A more natural skin tone with more neutral white values in the hat

Cultural and Personal Color Bias

In reality, there is no ideal skin tone—skin color is all over the place. There is considerable variation in different ethnicities, ages, and skin conditions—not to mention makeup! While all this variation exists in the real world, we tend to tolerate much less variety in print for various reasons. One reason is cultural norms, and this can get you into trouble if you're not aware of it. I can illustrate this with a couple of stories that actually happened to me.

It happened when I was working on a catalog that was going to be printed in Hong Kong. There were numerous shots of models interacting with the product, and we were shooting digital. This was in the early days of digital production photography. Printers were just trying to get up to speed with the whole process, and clients were not completely comfortable with things yet. Our particular client decided to use a printer in Hong Kong to save money. The client had done a few packaging projects with them but never a full catalog and never with human subjects.

Well... we tested, calibrated, and color managed the heck out of that shoot. We supplied inkjet cross-rendered press simulations for the SWOP standard separations (even though the printer was in Hong Kong, they assured us that they printed to SWOP, a standard for U.S. web presses). The client loved it and signed off on everything. We sent everything off to China.

The Chinese printing representative called back and said there were a lot of problems with the color—they had to color correct all the people. The client agreed to pay for additional color correction and was mad at me (it somehow always ends up being the photographer's fault). Finally, the matchprints/press proofs started coming back and they were horrible—all the people shots were pale, washed out, and kind of yellow. Hmmm...

The client convinced the printing rep to come to the United States for a meeting. We showed her our nice, healthy, saturated skin-toned proof prints, whereupon she said, "See... skin look dead!"

Apparently, in China, when skin is rendered in a way most Americans would consider healthy, it means the opposite. The Chinese preference is for pale, ivory-colored skin tones. Any red in the skin color is considered bad. If you look in Chinese magazines, you can see this preference in operation. There are regional preferences and different cultural preferences (Peking Opera posters can have very light pink makeup for certain characters). In the end, it was almost impossible to explain that American clients usually preferred a "California tan" look in the skin tone!

My second story concerns a job I did in this country for the Belly Dance Twins, Neena and Veena. I did some promotional photography for these two gorgeous Indian dancers—several of the shots were taken with traditional Indian costumes that were quite colorful. My first prints looked like Figure 4.32.

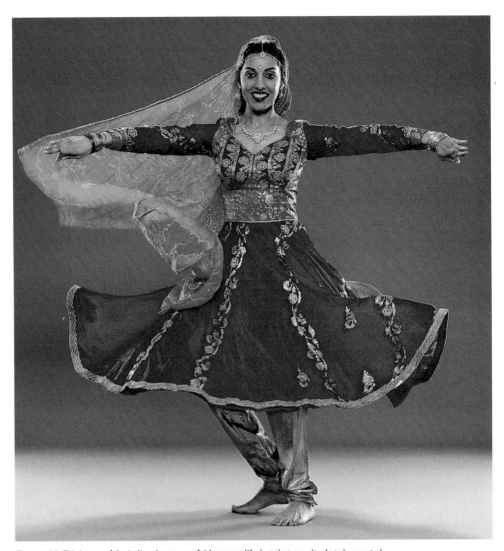

Figure 4.32 This image of the Indian dancer was fairly true to life, but that wasn't what she wanted.

The Twins were not happy—they thought the skin tone was too dark. To me it looked authentically Indian, which I thought was the whole point. I was not aware of the cultural issue here: dark skin is associated with the lower caste—pale skin color is more desirable. (In Hindu religious iconography, the color of the various female Devas is almost always very pale, in some cases blue-white.) Everything I did for them had to be revised with a lighter color (Figure 4.33).

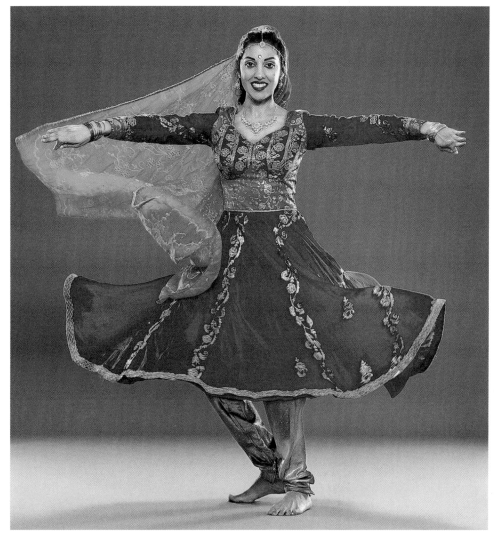

Figure 4.33 The lightened image

In conclusion, getting the right skin color is far from trivial. Simply calibrating your capture system is not going to guarantee that you will get an ideal skin tone. You have to be prepared to edit the color to satisfy the cultural, personal, or psychological needs of your clients or yourself. There are many creative departures possible as well. You need to develop the color "chops" necessary to get the color you want consistently, and a thorough grounding in Photoshop color editing is an absolute must.

Remember that the color of skin that is acceptable in reproduction is most often a departure from reality. The numbers supplied here are good guidelines, but they are only *guidelines*. Don't forget that you might need to deviate from these values.

Tone and Contrast: Color and B+W

The B+W aesthetic is familiar and often desirable for photographing people. Unfortunately, with digital photographs, the process of converting from color to B+W is often treated as a trivial mode change followed with contrast-enhancing curves. Photoshop provides many different methods for creating monochrome images. After you learn the types of controls available, a whole new creative frontier opens for you to explore. Photoshop can truly become the ultimate B+W darkroom, allowing the digital photographer to go well beyond the Ansel Adams Zone System.

We are going to examine a wide range of B+W options and also see how to apply B+W tonality to color images.

Chapter Contents

Converting to B+W

Using the image shown in Figure 5.1, let's explore the process of converting to black and white. Let's start by examining some different approaches to creating a black-and-white (B+W) rendition of this RGB color image.

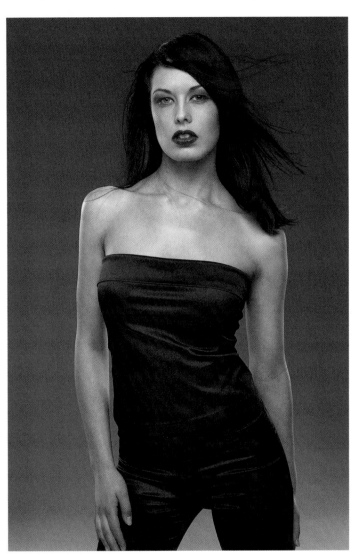

Figure 5.1 The lovely Jamie Bjorge in full color

The first and obvious approach is to choose Image > Mode > Grayscale and use the default conversion to arrive at a grayscale version. Although this is certainly not a horrible approach, it doesn't really offer much control over the way colors are rendered into gray values. To start to understand what's happening, you need to realize that RGB image files are made up of three different grayscale images. When these three grayscale versions are combined in RGB, the final image contains the full range of color as defined by the additive color space of the particular variety of RGB, be it sRGB, Adobe RGB, ColorMatch, or whatever.

Examining the channels individually and noting their differences in this image can be especially instructive. To do so, go to the Channels palette and click the Eye icon for each of the channels (Figure 5.2).

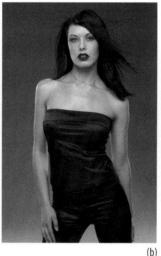
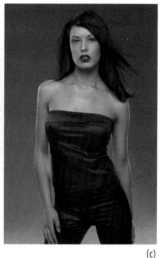

(a) (b) (c)

Figure 5.2 (a) Red channel; (b) Green channel; (c) Blue channel

The Channel Mixer

The default grayscale conversion utilizes a formula for blending the different grayscale channels into a single composite version. A convenient method for controlling this process is to use the Channel Mixer to create the grayscale blend. Choose Image > Adjustments > Channel Mixer to view the Channel Mixer dialog. Make sure you check the Monochrome check box in the lower-left corner of the dialog. The output menu at the top of the dialog will change to gray, and you'll see a B+W version that represents the Red channel of the image—the Red slider will be at 100 percent.

Move the sliders so you can see that the default conversion (Image > Mode > Grayscale) is basically identical to a channel mix of 30 Red, 60 Green, and 10 Blue (Figure 5.3), resulting in a "standard" gray rendering.

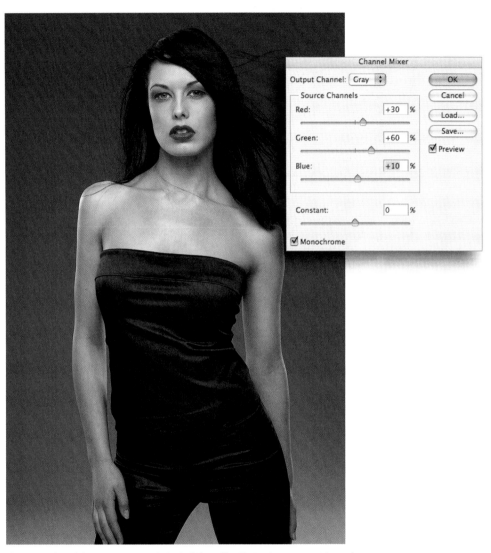

Figure 5.3 These slider positions mimic the look of Plus-X film. The resulting image is identical to the one generated by Image > Mode > Grayscale.

The different percentages in the sliders add up to 100; this preserves the overall luminosity of the image. You can try other percentage mixes, and as long as you maintain the 100 percent total, you should arrive at a fairly reasonable rendition.

Note: You can think of the different combinations of channel percentages as somewhat equivalent to traditional B+W film shot with colored filters. A 50 percent Red/50 percent Green mix would be similar to using a yellow filter, and a 100 percent Red mix would be similar to using a red filter.

You might prefer the version in Figure 5.4, a 70/30 blend between red and green, because it has a slightly lighter skin tone that some find more attractive for a woman. As shown here, the Channel Mixer is being used as an adjustment layer, the preferred method for all types of adjustments.

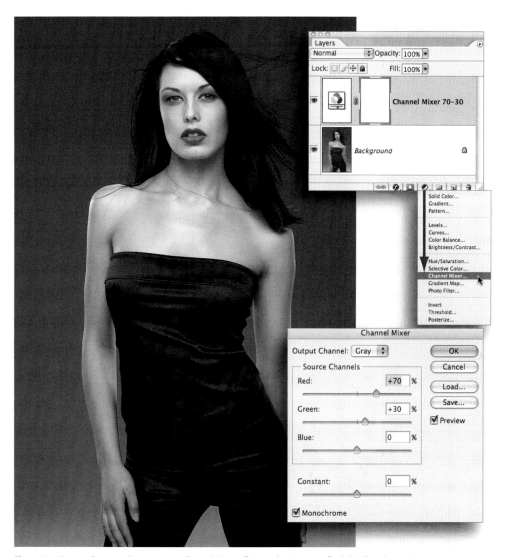

Figure 5.4 Use an adjustment layer to create Channel Mixer effects and retain some flexibility for other options.

If, on the other hand, you are not looking for reasonable but instead want dramatic, you might want to break the 100 percent rule and do something similar to Figure 5.5.

Yes, you can subtract channels in the Channel Mixer. Obviously, this approach will yield much different results than using color filters with B+W film.

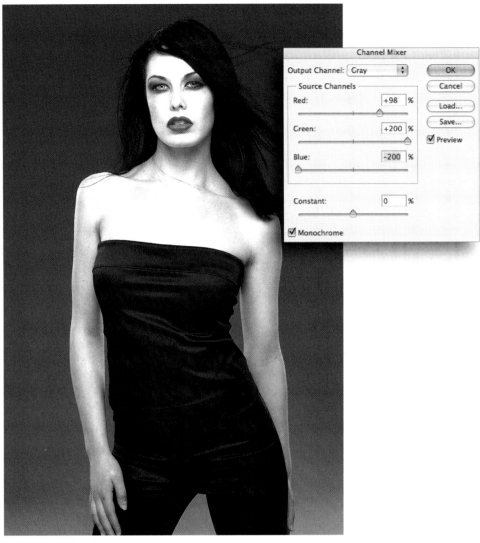

Figure 5.5 The settings cause the model to have very pale "vampire" skin and dramatic eyes.

Why stop there? Now that you realize all rules are to made to be broken, let's really try to "break" this image (Figure 5.6). You can easily see that the Channel Mixer gives you the same control (and then some) that traditional B+W photographers have when using color filters and specialty films.

Note: The Channel Mixer method works on RGB images by duplicating the "mix" into all the channels; when you flatten the image, you will end up with a monochrome RGB file. If you need an actual single-channel grayscale document, you must convert to grayscale from the Image menu (Image > Mode > Grayscale).

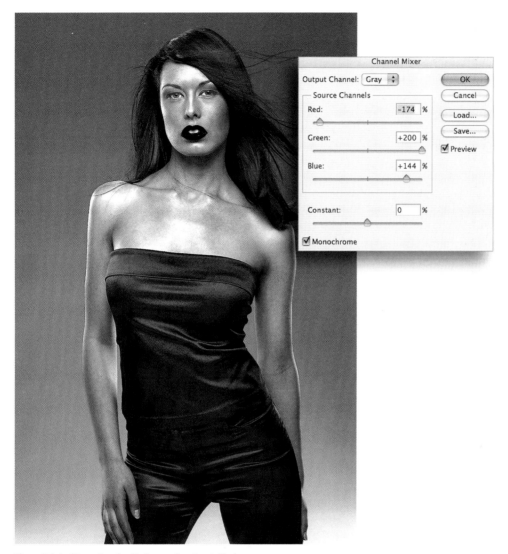

Figure 5.6 In this version, the skin has an almost metallic sheen.

Split Channels: Layer Blending

There is another method of blending channels that offers additional controls. Starting with the RGB original, go to the Channels palette, click the Options triangle in the upper-right corner to get the drop-down menu, and select Split Channels (Figure 5.7). This will "split" the RGB file into three separate grayscale files and name them according to the channels from which they originated. You can drag one file on top of the other to create a layer stack that you can use to blend the channels (Figure 5.8).

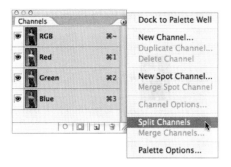

Figure 5.7
Select Split Channels from the flyaway menu at
the upper-right corner of the Channels palette.

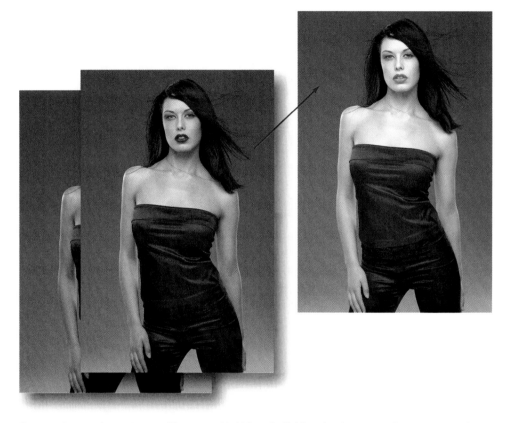

Figure 5.8 To ensure that two images will be registered, hold down the Shift key when dragging one document onto another.

You can re-create the 70/30 Channel Mixer version by dragging the green document on top of the red document (hold down the Shift key while you do this to maintain layer registration). Change the Layer Opacity to 30 percent. You can duplicate any Channel Mixer blending effect that uses positive slider values (that add up to 100) by stacking the channels in layers and adjusting the relative opacities. Place all three channel documents into a layer stack and work your way up from the bottom. Adjust the opacity of the first layer first by temporarily turning off the visibility of the top layer (click the Eye icon to the left of the thumbnail). When the first layer is adjusted, turn on the visibility of the top layer and adjust the opacity against the other two. You'll need to experiment with the layer order to arrive at the best combination. This makes it less convenient than the Channel Mixer method for simple blends.

To really appreciate the power of stacked layers, you need to take advantage of the additional controls available in the form of layer masks and blending options. You can start by making a layer mask for the Green layer. Hold down the Option/Alt key and click the Layer Mask icon at the bottom of the Layers palette; this will create a Black Layer mask and hide the Green layer (make sure visibility for the top Blue layer is turned off). Now you should see only the bottom Red *Background* layer (Figure 5.9). Immediately after the layer mask is created, the mask is selected. A double outline should appear around the black mask thumbnail. Check to make sure it's there. Now when you paint the mask with white, you will reveal the contents of the Green layer. By doing this, you can selectively paint parts of the Green channel on top of the Red channel.

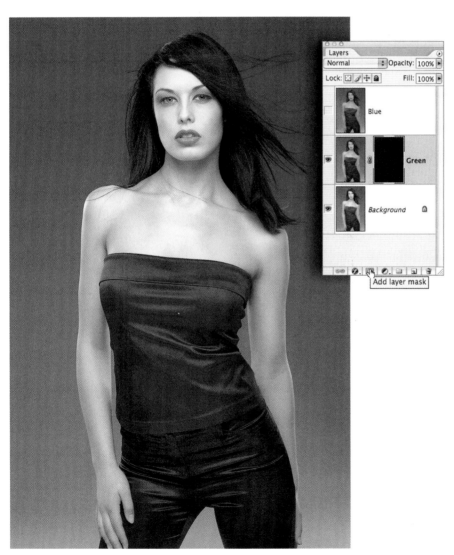

Figure 5.9 Visibility for the Blue layer is turned off, and the Green layer is hidden with a Black Layer mask. Only the Red Background layer is visible.

The final stacked version (Figure 5.10) uses the Red channel as the base primarily for the lighter skin. The eyes were painted in the Green layer, creating the darker eye shadow and lightening the pupils (the model had green eyes). The Blue layer was used to create subtle shading on her arms, shoulders, and cheeks. The darker skin color was painted over the edges of the figure. (To do this, use a lower opacity for the brush and build up your strokes slowly.) The darker lips of the Blue layer were also painted. The result is dramatic but very natural. The image can be further refined with Curves if necessary; however, simply combining the best parts of each channel frequently will do the job. Save the layered version so you can revise it later if needed. When you are done, you can flatten the file by going to the Layers menu and selecting Flatten Image or by selecting Flatten Image from the Layers flyaway menu. You will then have a single channel grayscale document.

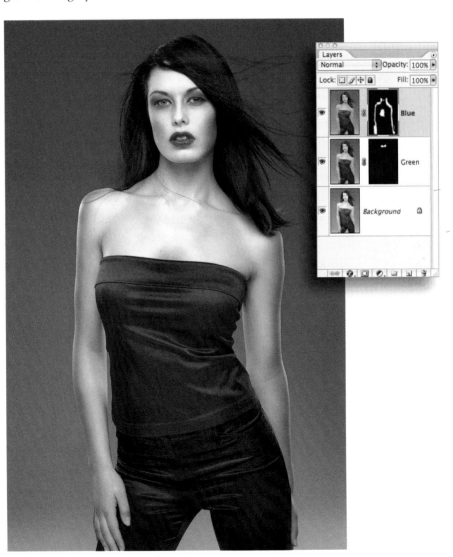

Figure 5.10 The final B+W with enhanced tones

Figure 5.11 is another good example of classic B+W. Using a Canon EOS-1DS Mark II, Ken Chernus captured this image in color. He converted it to B+W using the methods just described. To create the feel of an old Hollywood studio portrait, he enhanced the lighting quality with channel contrast in layers.

Figure 5.11 The quality of the lighting plus channel layering re-creates the look of a classic studio portrait from a bygone era. (Photo by Ken Chernus)

Luminosity Blending

Something very interesting will happen when you drag the new B+W version (the one shown in Figure 5.10) on top of the original color version (Figure 5.1) and change the Layer Blending mode to Luminosity. (Remember to hold down the Shift key when you do this.) You should get the results shown in Figure 5.12. The Luminosity mode will take the value structure from the B+W version and the color from the underlying layer to render a new version of the color image. The result has more contrast and contouring in areas of skin, lighter garments, and more tonal separation in the hair and pants. It would be much harder to achieve a similar effect using Curves alone.

One of the most compelling things about good B+W imagery is the way the tonal structure of the image is simplified by eliminating the influence of color. Light and shadow often provide most of the visual impact in a photograph, even an extremely colorful one. Viewers can tolerate color deviations quite well; however, if an image lacks tonal interest, they will complain bitterly. Differences in value are easier to visualize and, therefore, control in B+W. This is perhaps one of the reasons Ansel Adams was never that fond of color photography: those darn colors kept getting in the way.

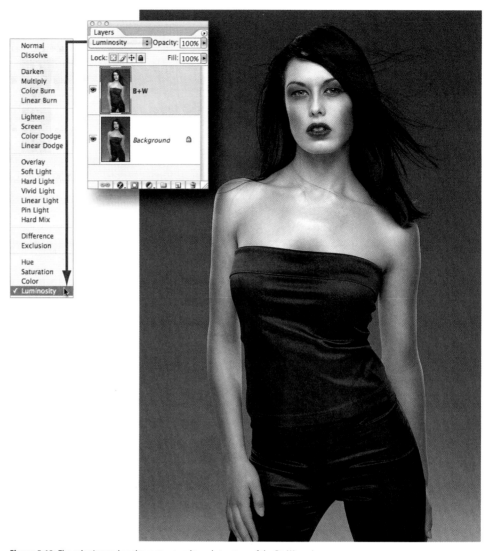

Figure 5.12 The color image has the contrast and tonal structure of the B+W version.

The key problem in color correcting photographic imagery is maintaining control over tonal shape—the value structure underlying the colors in the image. Color and contrast seem to be inextricably mixed in an image, and normal contrast-enhancing moves tend to seriously impact hue and saturation. Color correction will be easier if you can separate the color from the tonal values and deal with them separately. The luminosity blending approach offers a powerful method of doing this.

Instant Tan

Before we return to monochrome imagery, let's examine how luminosity blending can be used to solve some vexing problems.

Figure 5.13 is a portrait of Nathan, a martial arts instructor in Southern California. Unfortunately, the soft lighting has given the skin a pale, pasty look that is less than ideal. The problem is one of tone or value, not color. Darkening the skin without also darkening the already dark clothing will be difficult.

Before you make any adjustments, examine the three channels individually so that you can get a feel for the B+W value structure of the image (Figure 5.14).

Figure 5.13 Nathan was photographed in soft, directionless light.

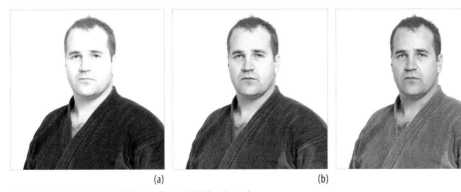

(a) (b) (c)

Figure 5.14 (a) Red channel; (b) Green channel; (c) Blue channel

You can see that the skin in the Red channel is almost completely white, and this is contributing to the pasty look. Usually, the Green channel is the best overall; however, in this case, the darker tones in the Blue channel should work to your advantage in a luminosity blend. Start by creating a Channel Mixer adjustment layer: select Channel Mixer from the Adjustment Layer menu at the bottom of the Layers palette. Change the Output Channel to Blue, and then check the Monochrome check box. You should have a grayscale version that is 100 percent of the Blue channel (Figure 5.15).

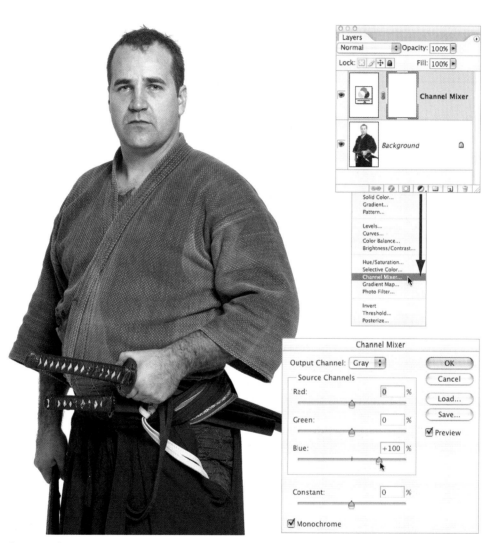

Figure 5.15 This B+W version is the same as the Blue channel of the color version.

Now the magic starts. Change the Blending mode to Luminosity (Figure 5.16). (Now, that's a tan.) His face has some tone; however, his beard shadow hasn't darkened, so it is minimized somewhat. The blue clothing and his blue eyes have gotten lighter.

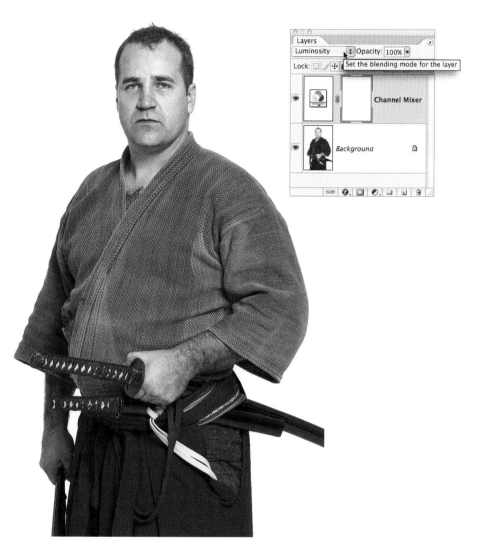

Figure 5.16 The skin has become dramatically darker, and the blue gi jacket has gotten lighter.

You might not like the light blue rendition of the gi jacket even if you prefer the lighter and more detailed gi pants. If not, you can hide the effect of the Luminosity layer by painting the adjustment layer's mask with black (Figure 5.17). This Blue channel luminosity blend is great for generating that swarthy look for men. Although you might still prefer more dramatic lighting, the subject does have more tone and a sense of texture, which were created without using Curves.

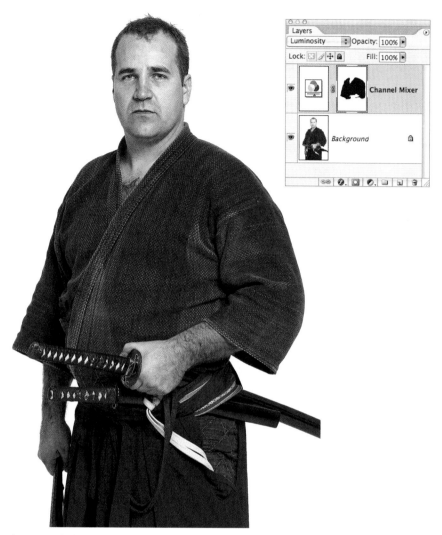

Figure 5.17 The final version has darker skin, lighter gi pants, and better detail everywhere. All the enhancements were made without using any Curves adjustments.

When Color Overwhelms: Look for the Good Channel

The next example has a unique problem (Figure 5.18). The dancer has been captured behind the sheer veil, but I'd like to be able to see more of her face. The red veil is very saturated, but the face behind it has very little contrast. It would be impossible to apply a Curve adjustment steep enough to bring out the desired detail. This problem is something photographers see all the time when they are dealing with highly saturated colors. Everyone says they want bright, saturated colors, but they often come with a price.

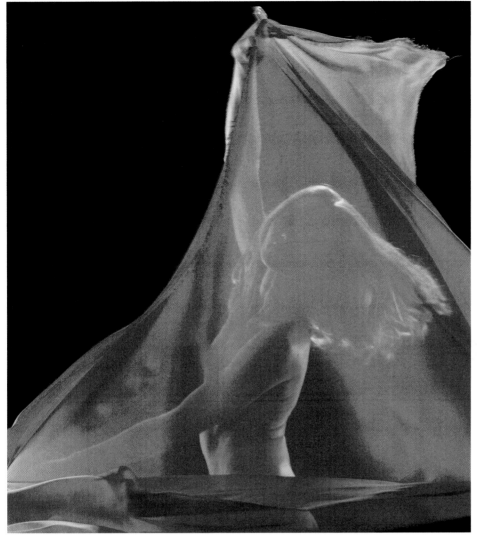

Figure 5.18 The dancer's face is obscured by the red veil.

The solution is to forget about the color, for a moment, and concentrate on B+W. To begin, look at the grayscale channels that make up the full-color image. You are looking for an ideal candidate for a B+W conversion of this image. When you look at the individual channels, you can see that Red is obviously where the biggest problem appears (Figure 5.19). There is no face in that channel at all; Red is so highly saturated in this image that most detail has clipped to white in the Red channel. Blue is better (Figure 5.20). However, most of the detail resides in the Green channel (Figure 5.21).

The detail and contrast is clearly in the Green channel, even though the image is a little dark. You can use this information to create a monochrome Channel Mixer adjustment layer and push the Green slider past 100 percent (Figure 5.22).

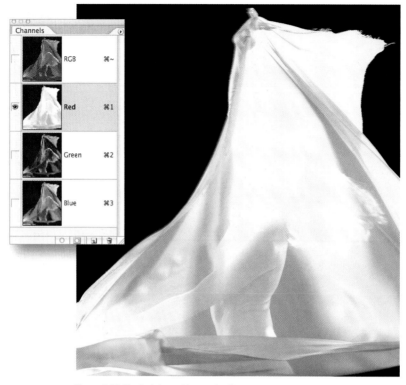

Figure 5.19 The Red channel has no detail.

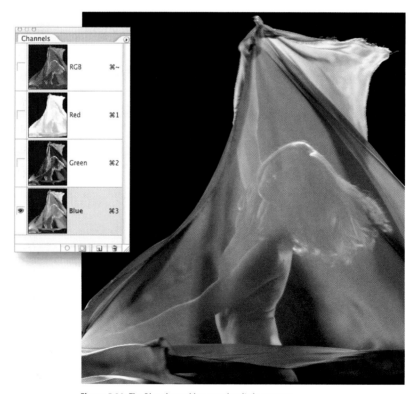

Figure 5.20 The Blue channel has tone but little contrast.

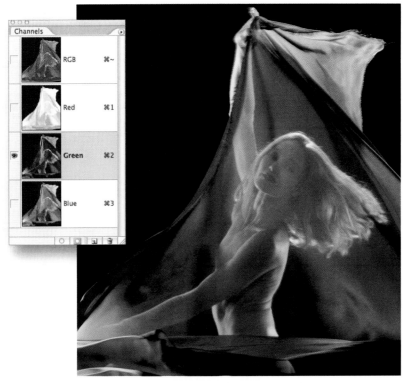

Figure 5.21 The Green channel has the best contrast in the face.

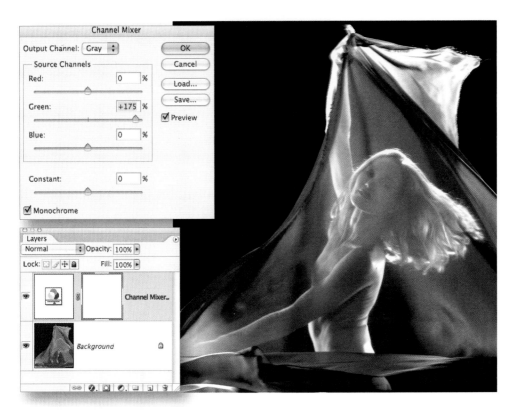

Figure 5.22 Pushing the Green slider past 100 percent lightens the values and increases the contrast.

Next, change the Blending mode to Luminosity (Figure 5.23). You can see the face more clearly, but the veil now has harsh black shadows and a slightly posterized look.

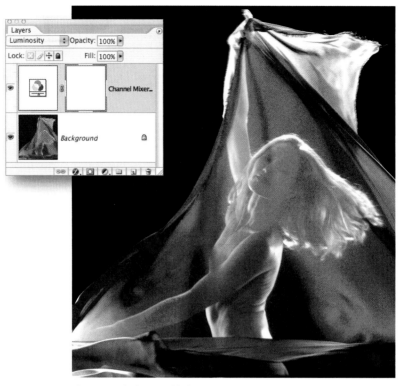

Figure 5.23 The face is visible, but now there are harsh, unattractive shadows in the veil.

To solve this problem, you can use a little-known Photoshop trick: advanced Blending Options. Select Blending Options from the Layer options flyaway menu at the upper right of the Layers palette (Figure 5.24).

Figure 5.24
The Blending Options menu

The Layer Style dialog box will appear. You can use the Blend If sliders to control where the Green channel luminance blends back into the original image in the underlying layer. The idea here is to bring back the tone and color of the original image in the areas that turned black after the luminosity was applied. Because you are using the Green channel luminosity in this layer, you will use that channel in the Blend If area of the dialog. To select the Green channel, change the Blend If drop-down to Green. Drag the black triangle on the This Layer slider to the right until the black parts of the image regain their original tone. You can feather the transition by holding down the Option/Alt key and splitting the triangle into two halves; drag the right half to the right until the tones are smooth (Figure 5.25).

Figure 5.25 Split the Blend slider to feather the transition between the upper layer and the Background.

Note: The Blend If sliders are extremely powerful tools for seamlessly blending layers based on the channel luminosity in each layer. By combining different channel slider positions in the top and bottom sliders, you can achieve very complex blends.

In Figure 5.26, the image has been further adjusted by masking off sections of the figure that had better contrast in the original Background layer.

This example clearly shows the advantage of utilizing grayscale information to affect the tone and contrast of color images. Very often, even good color images can be enhanced in unexpected ways by applying B+W tonality to the color values.

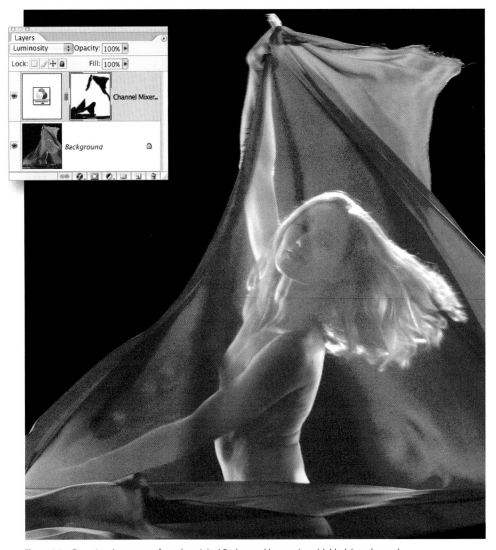

Figure 5.26 To retrieve better areas from the original Background layer, paint with black into the mask.

Another very common use for Luminosity blending is with darker-skinned subjects. The portrait by Ken Chernus in Figure 5.27 utilizes a direct reflection on the skin (shine) to help lighten the dark skin. This is a great dramatic shot, but it is still too dark for certain types of reproduction.

Make a monochrome Channel Mixer adjustment layer using 100 percent of the Red channel, change the Blending mode to Luminosity, reduce the opacity of the layer a bit, and you'll get Figure 5.28.

The Red channel is lighter in all shots of people. By applying the Red channel Luminosity to the color image, you can lighten dark skin color. In this example, the skin highlights are lightened too. You can reduce the highlight intensity and minimize the skin texture by blending back into the original highlights using Blending Options. Flatten and place the lighter version in a layer above the original. Figure 5.29 is the result of blending into the highlights of the original image in an underlying layer using the slider positions shown.

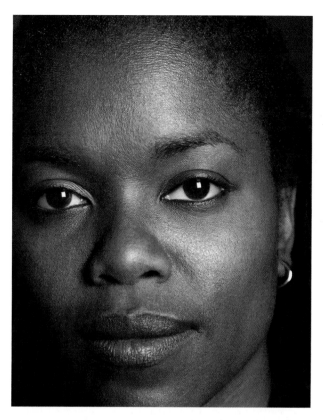

Figure 5.27
This dramatic portrait could still be too
dark for some print conditions.

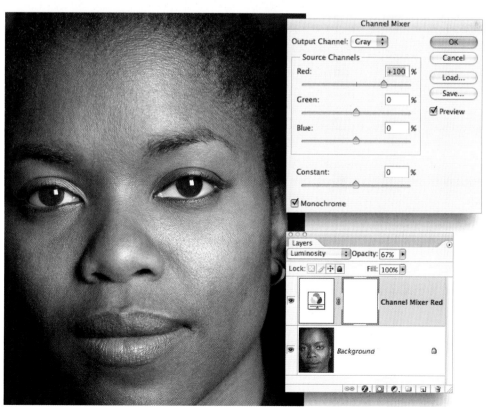

Figure 5.28 Red channel Luminosity brightens the image considerably.

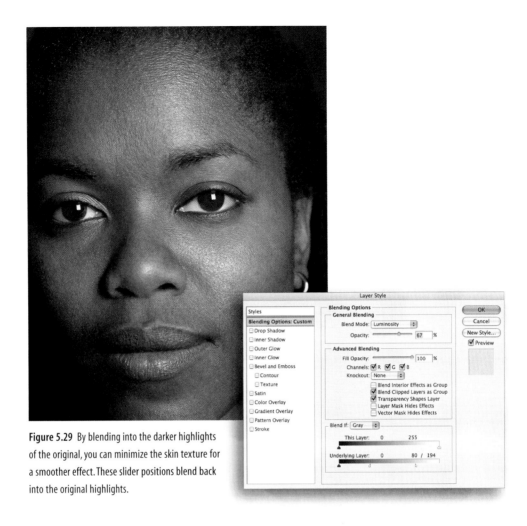

Figure 5.29 By blending into the darker highlights of the original, you can minimize the skin texture for a smoother effect. These slider positions blend back into the original highlights.

I could write a whole book about applying B+W luminosity in color images. I hope these few examples have opened some frontiers for you to explore.

Hue/Saturation Toning Effects

Let's return to monochrome images to explore working in the opposite direction—applying color to B+W. Monochromatic images don't have to be neutral gray. The creative use of color in B+W imagery has a long tradition. Silver bromide prints were often *toned* using various chemicals to impart color to otherwise colorless images. Sepia, selenium, gold, and blue toners were used sometimes with a "split-tone" effect. All of these effects and more are possible with digital techniques that offer far more control (and much less odor). Let's start with the B+W image of Jamie that we used earlier in this chapter (Figure 5.30).

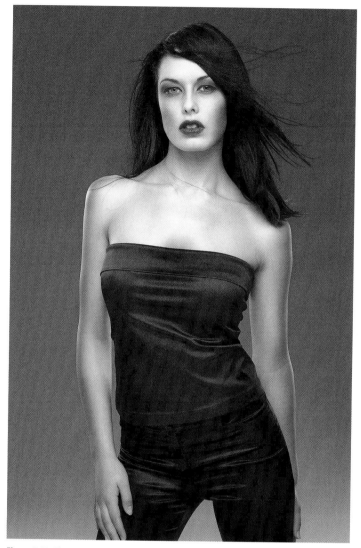

Figure 5.30 The original neutral gray version

Before you can colorize your grayscale image, you must convert it to RGB. Select: Image > Mode > RGB to set your grayscale image to your default RGB workspace. After you do that, you can *colorize* your image using Hue/Saturation.

Create a Hue/Saturation adjustment layer and check the Colorize check box when the dialog appears (Figure 5.31).

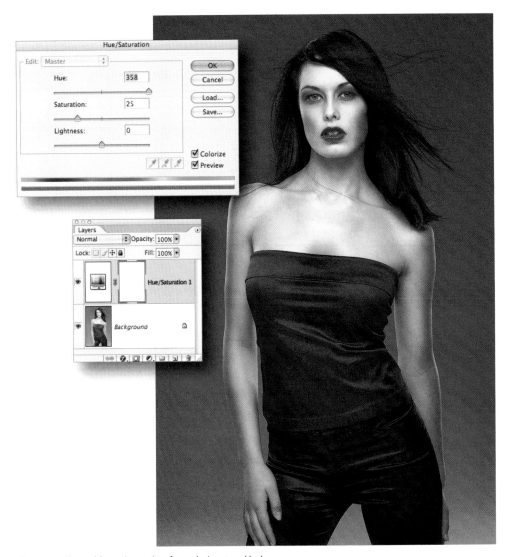

Figure 5.31 Hue and Saturation settings for a selenium-toned look

The default color effect here is a fairly rich reddish brown. If you move the Saturation slider down to about 10, you'll end up with a fairly convincing imitation of selenium toning. Shift the hue toward yellow (set the Hue slider to about 30), and you'll be in sepia territory. An infinite variety of color-toning effects are possible with this approach. The Hue/Saturation adjustment layer is very interactive, making it easy to see the color change as you move the sliders.

Ken Chernus used an almost olive brown tone to simulate the look of old-fashioned, warm-toned Chlorobromide photographic paper in Figures 5.32 and 5.33, which were taken for a series on Baptist churches.

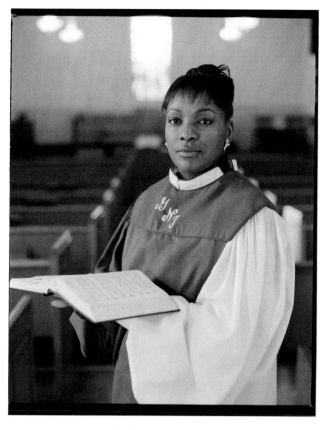

Figure 5.32
The olive color simulates the look of
old, warm-toned Chlorobromide paper.
(Photo by Ken Chernus)

Figure 5.33
The warm tone enhances the
nostalgic feeling of the photograph.
(Photo by Ken Chernus)

Split-Toning

Split-toning is a classic toning effect. This effect is traditionally achieved using selenium toner warmed up to about 80° F. The print is pulled from the toner tray when the shadow values just start taking the color, and then it is rapidly immersed in cold water to stop the process. High values remain untoned; cooler or more neutral and shadow values develop the rich, purple-brown look of selenium toner. This process is very "hit or miss," difficult to control, and very toxic. Fortunately, *digital* split-toning does not suffer from these disadvantages.

To perform split-toning, make another Hue/Saturation adjustment layer above the first one. Check Colorize and shift the hue to a different color, as in Figure 5.34.

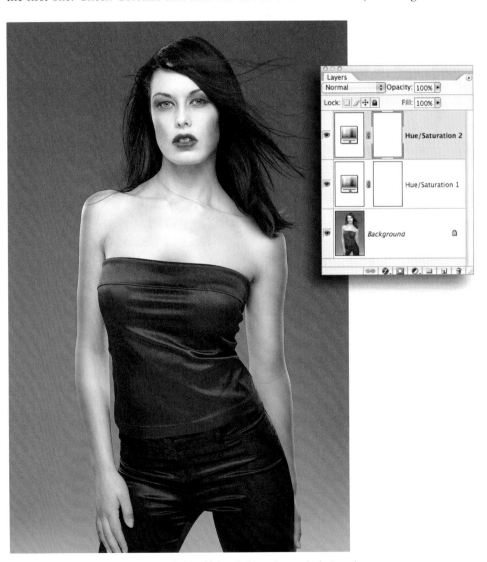

Figure 5.34 For maximum color contrast with the reddish underlying color, a teal color is used. You should experiment with different color combinations.

Now for the magic trick: choose Blending Options from the Layer Options flyaway menu at the upper right of the Layers palette. When the Layer Style dialog appears, go to the Blend If area and move the black triangle slider (either layer will work—here we're using This Layer, which is the top layer) to the right until the brown, dark values from the underlying layer show through (Figure 5.35).

The tones are now "split." To soften the transition between the two toning colors, hold down the Option/Alt key and split the slider into two halves, moving them apart until the desired look is achieved (Figure 5.36).

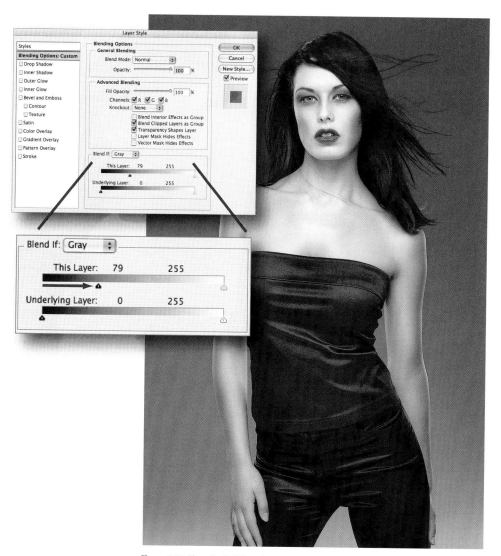

Figure 5.35 The color "split" is a fairly hard transition, which creates an almost posterized look.

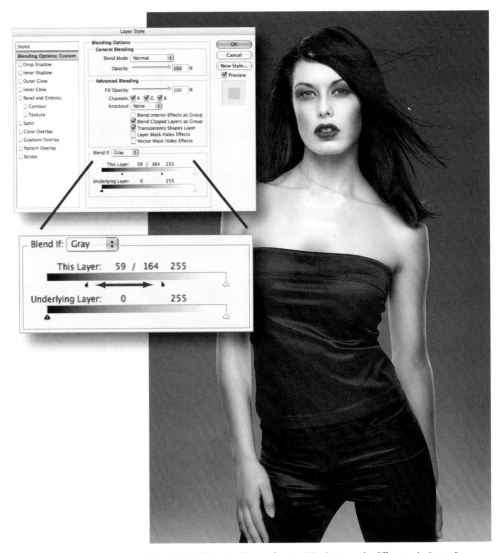

Figure 5.36 This version has a softer transition between the different color "tones."

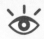

Note: For maximum effectiveness, the color combinations used for split-toning should take advantage of the value differences between hues. Light colors, such as yellow and cyan, can be used for highlights. Darker colors, such as red and blue, can be used for shadows. Of course, all rules are meant to be broken. Use opposing colors to emphasize the split-tone effect.

You can combine the best features of the last two split-tone versions by duplicating the top Hue/Saturation adjustment layer, returning the blending options to their previous unfeathered setting (create a black layer mask for the duplicate layer by Option/Alt-clicking the layer mask icon at the bottom of the Layers palette, then paint into the black mask with white over her top and hair to put the cool highlights back (Figure 5.37).

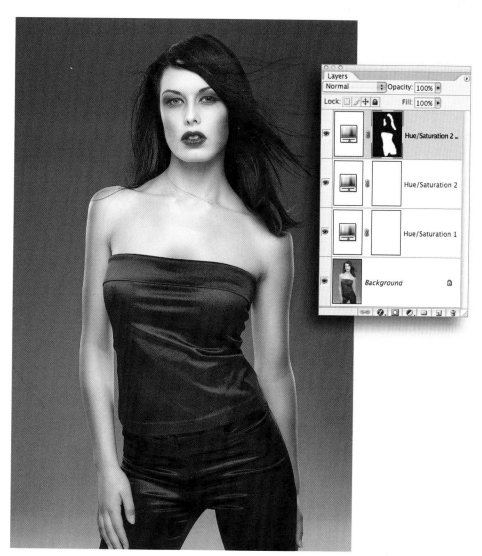

Figure 5.37 Harder transitions appear in the cool highlights on Jamie's top and in her hair.

Fairly strong colors were used for the example so that the "split" is easier to see. You can create a more subtle effect by reducing the opacity of the Hue/Saturation layers. First, group the layers by selecting them in the Layers palette (Shift+click the thumbnails), and then select New Group From Layers from the Layers palette menu. Now you can reduce the opacity of the Group to desaturate the effect (Figure 5.38).

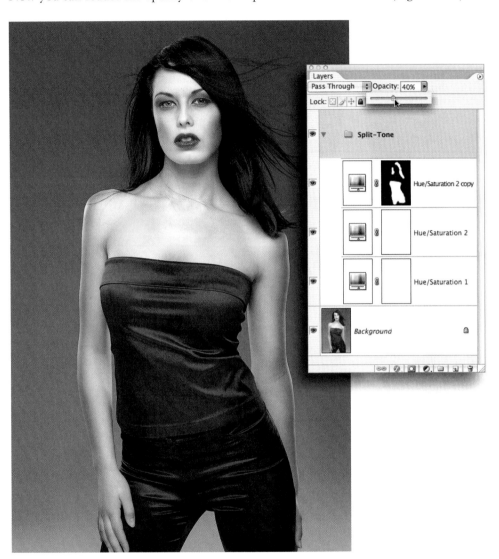

Figure 5.38 This more desaturated split-tone can be used to suggest more dimensions in the monochrome image through subtle hue shifts.

The beauty of having the toning effects in a Hue/Saturation layer is that the colors can be edited after you've established the basic effect. It's very easy to generate variations by double-clicking the adjustment layer to activate the Hue/Saturation dialog again and change the Hue or Saturation sliders (Figure 5.39).

Figure 5.39 This version puts a warm color in the highlights and a cool color in the shadows.

Figure 5.40 is a slightly more subtle example of a simple, cool shadows/warm highlights "split."

You don't have to stop at two colors. When you add another Hue/Saturation adjustment layer, you can split the color tones into highlight, midtone, and shadow values. If you use colors that synchronize with the value structure of the image—deep colors for low values, medium colors for midtones, and light colors for highlights—you can create the illusion of extended dynamic range. This can give your monochromatic images a more three-dimensional look (Figure 5.41).

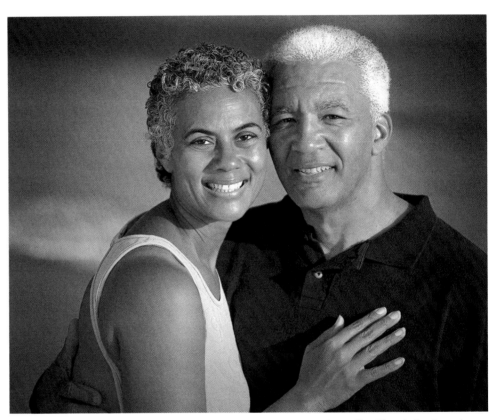

Figure 5.40 Cooler shadows recede and warmer highlights come forward to enhance the 3D effect. (Photo by Ken Chernus)

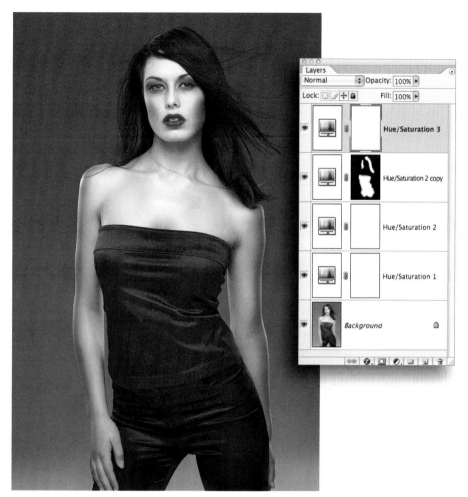

Figure 5.41 By moving from deep purple through reddish brown to pale cyan-blue, you can enhance the grayscale contrast with color contrast that seems to extend the dynamic range.

Gradient Map Colorizing

More complex colorizing effects can best be achieved using the Gradient Map adjustment layer. Starting with the original grayscale image, select Gradient Map from the Adjustment Layer menu, which is accessed by clicking the New Adjustment Layer icon at the bottom of the Layers palette (Figure 5.42).

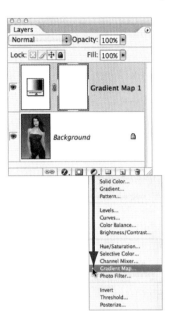

Figure 5.42

Gradient Map is a special adjustment layer accessed from the Layers palette.

1. Click the triangle to the right of the gradient in the Gradient Map dialog.

2. Select the Blue, Red, Yellow gradient in the resulting Gradient Picker. Click inside the gradient to bring up the Gradient Editor (Figure 5.43).

3. Use the Editor to customize the gradient. The pointers along the top control the opacity of the gradient—leave them alone. The bottom pointers determine the colors in the gradient. By clicking anywhere along the bottom edge of the gradient, you can add a new color "stop" to the gradient. You can drag these new color pointers (while you preview the effect in your document) and also adjust the blend between colors by dragging the small diamonds between the stops. Click the Color patch in the Stops area to bring up a Color Picker that allows you to select a new color. When you have finished designing a new gradient, you can enter a name and click the New button to add it to your gradient presets. Click OK to return to the Gradient Map dialog and click OK again to apply the effect. In this example, I created a very wild saturated-color crossover effect that progresses from black through purple, red, orange, and yellow to white (Figure 5.44).

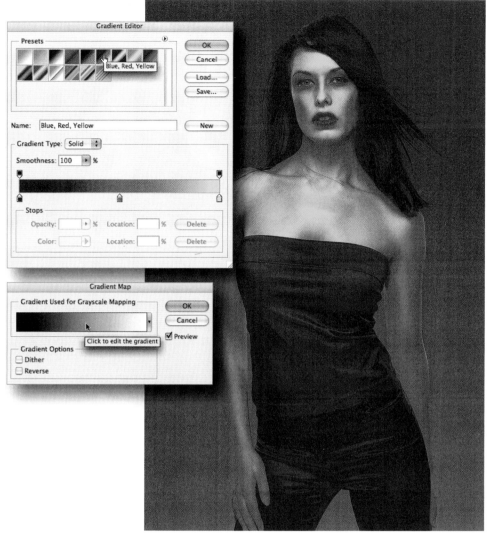

Figure 5.43 The brilliant saturated tones are overwhelming and require some editing of the gradient to tame the image.

You can simply change the opacity of the Gradient Map layer in the Layers palette to create a whole range of more subtle effects (Figure 5.45). The big advantage of using Gradient Maps is that you can build multicolor split-tones with just one layer. The disadvantage is that it is a bit more difficult to control the interaction of color tone and crossover points using the Gradient Editor.

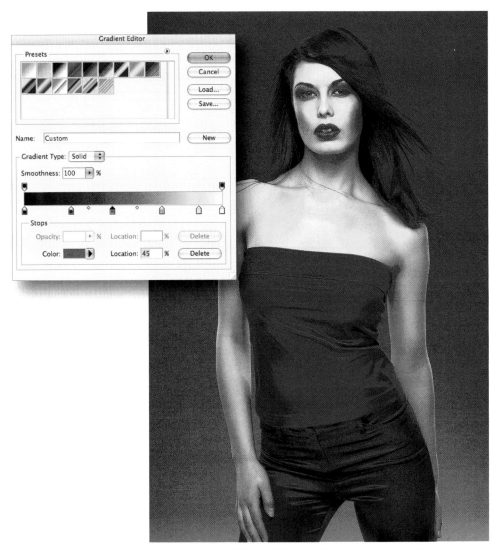

Figure 5.44 It is usually best to design a gradient that progresses from dark colors to light colors.

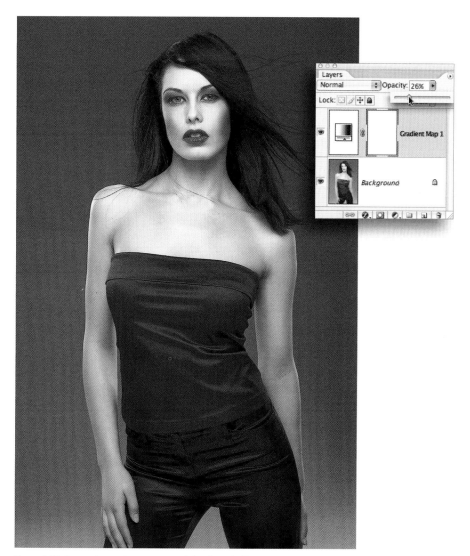

Figure 5.45 Change the opacity to create a subtle colorized effect.

Figure 5.46 shows another example of Gradient Map color toning. This lovely fine art portrait by Erin Manning has an interesting "faded color" effect created through a subtle application of a multicolor Gradient Map.

Besides Peter Max coloring, you can also achieve super "solarized" and other psychedelic effects by using more radical gradients. Experimenting is great fun!

Figure 5.46 The subtle hues turn this B+W image into what looks a bit like a faded color photo.

The Power of B+W

Learning how to create outstanding black-and-white images can have more than just the obvious benefits. Converting color into B+W can be done for its own sake, or it can be utilized to control tonal structure in color photography. Good B+W can also serve as a springboard for creative color explorations through various toning techniques. The examples in this chapter are by no means exhaustive. Think of this introduction as the tip of the iceberg. The same principles used in layer blending and masking can be applied in many different ways to generate special effects or subtle corrections in color and B+W imagery.

A good basic image development strategy is

1. Begin with the lighting and exposure of your photograph—optimize them first.

2. Process the files into your RGB workspace. For most people photography, you will use Adobe RGB.

3. Perform basic color editing and corrective measures (retouching, etc.).

4. Examine the individual channels for grayscale information. Is a great black-and-white image lurking there? Can you utilize grayscale tonal structure in the channels separately or in combination to enhance contrast or detail in the color image?

5. Create a B+W version to test contrast and value.

6. Apply the B+W version to the color image; decide whether you can improve the image this way.

7. Fine-tune the color with curves.

In some cases, the color image will be just fine after you've made some basic edits. In many cases, the color image can be improved by the application of idealized grayscale information. The effects can be dramatic or subtle, and they are almost always worth exploring.

Let's put this strategy to use in this final image by Anthony Nex (Figure 5.47). The original shot is a great example of Anthony's high-energy style of kid photography. A great expression captured in the studio with motion-stopping flash lighting, the shot was processed into Adobe RGB.

Figure 5.47
A great shot, but the boy's skin is a little too dark for some print conditions.
(Photo by Anthony Nex)

The biggest problem is that this handsome African American kid will likely reproduce too dark in the average magazine or book, so we need to look for a way to brighten up the skin. The solution is an application of red channel luminosity using a Channel Mixer adjustment layer: Red slider at +100 and Blue slider at +14 to further brighten the highlights—check the Monochrome check box and change the Mode to Luminosity in the Layers palette (Figure 5.48).

Figure 5.48
The skin is much lighter after an application of Red channel luminosity.

With the biggest problem solved, we now turn our attention to the skin color. The skin is too magenta and lacking in saturation. A Curves adjustment subtracts blue and adds red and green to boost the saturation and bring the yellow back into balance with magenta (Figure 5.49).

The finishing touch is a special "High Pass" sharpening technique to enhance the highlights on the skin even further (Figure 5.50). We will go over this technique in more detail in Chapter 8.

Figure 5.49 Curves adjustments add saturation and yellow to the skin tone.

Figure 5.50 The highlights are enhanced with a High-Pass Overlay layer.

Retouching

The days of airbrushing, dye transfers, spotting, and etching are long gone, but the need to clean up or enhance photographs has never been greater. Every professional photographer is expected to know enough to do basic digital retouching. Of course, what is considered basic today would have been beyond the capabilities of all but the most-advanced retouchers of the celluloid era. These days clients demand even more because the general public has unlimited expectations. The phrase "We can Photoshop it" is clear to just about everyone.

People photography has always required a certain amount of retouching to flatter the subject, and this chapter will attempt to cover some of the basic and not-so-basic techniques.

Chapter Contents

Basic Image Repair

Hue/Saturation Color Repair

Beauty Retouching

Figure-Thinning Techniques

Subtle Retouching

Basic Image Repair

Digital photography frequently requires only some basic cleanup—remove a mole, take out a stray hair, or remove a spot on the background. Photoshop includes a wealth of sophisticated tools for these kinds of remedial image repairs. The photo of me at the beginning of this chapter is an example. It was taken as an in-camera JPEG by Jeff Boxer, and a fair amount of sharpening was applied before I began working on it. Normally, I prefer not to have every pore on my face so well defined, but for now I just want to perform some basic cleanup.

Sometimes I like to start with a markup to indicate the areas I'd like to fix. You may find this technique especially important when working with clients, so you can communicate what will be fixed before work begins. In Photoshop, create a new empty layer and then draw into this layer with a contrasting color to mimic a grease pencil on a print (Figure 6.1). You can leave this layer in the document and turn it off and on to double-check your progress.

Figure 6.1 Circle the defects you intend to remove.

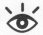

Note: There are many different applications and techniques you can use for retouching, and we cannot cover everything in just one chapter. The methods outlined here should serve as a starting point for further exploration in your own work.

Once you've decided what to do, you can start your repairs. Photoshop has a wealth of specialized tools that make detailed retouching easy. Before you do anything else, make a new empty layer. Whenever possible put all the retouching into a separate layer so you can retrieve the original image at some later time if necessary (Figure 6.2).

Figure 6.2
Make a new empty layer to hold your retouching.

Photoshop CS and Photoshop CS2 have a retouching tool just above the venerable Clone Stamp tool in the Tool palette; click and hold it to see and select the different variations. The Spot Healing Brush (Figure 6.3) is the first choice in CS2. Most of the time, you can leave the tool options set to the defaults with Proximity Matching checked (Figure 6.4). Make sure Sample All Layers is checked.

Figure 6.3
Click and hold for the flyaway tool selector.

Figure 6.4 The default tool options are usually good. You can try the Create Texture option if you think the spot is healed too smoothly.

This tool works like a Magic Spotting Brush: it will fill in small dark or light spots with color and texture from the surrounding area. Size your brush so that it's big enough to cover the spot. The size of your stroke is pressure sensitive—more pressure, bigger stroke. However, the size of surrounding area from which you sample depends on the diameter of the brush. If you use too small a brush, you won't sample from enough clean skin to get a good color over the spot. Too large a brush might sample an area that pulls in color from some nearby defect. Dab the brush over the spots you want to remove (Figure 6.5).

Figure 6.5 Paint over the spots you want to remove with the Spot Healing Brush.

Occasionally, when you work the Spot Healing Brush near an edge with a contrasting color and texture, the tool will pull some of that area into the brush area, as you can see near the hair in Figure 6.6. To avoid copying the wrong area, use a smaller brush and don't place the outer boundary of the brush circle into the other area. Larger brushes use larger sample areas.

Figure 6.6 The hair from an adjacent area is pulled into the brush.

Spots are easy to get rid of; however, larger more-complex areas, such as the bags under my eyes, used to be more difficult to retouch than they are now. The next tool, introduced in Photoshop CS, is the Healing Brush; this magic cloning tool makes short work of problem areas. Select the Healing Brush tool (Figure 6.7). Make sure your tool options are set to Sample All Layers (Figure 6.8), Option/Alt+click to sample an area of good skin (such as the top of my cheeks), and use a fairly large brush to completely cover the bags under the eyes (Figure 6.9).

Figure 6.7
The Healing Brush is under the Spot Healing Brush.

Photoshop File Edit Image Layer Select Filter View Window Help

Brush: 10 ▾ Mode: Normal ⬍ Source: ⦿ Sampled ○ Pattern: ▾ ☑ Aligned ☑ Sample All Layers

Figure 6.8 Check Sample All Layers.

Figure 6.9 Cover the bags with clear skin.

The lighter skin contrasts with the surrounding area, and it looks horrible. However, as soon as you release the brush, the area magically blends in, replacing the original texture but keeping most of the underlying tone of the original (Figure 6.10). The retouching now blends seamlessly; however, as you can see, the newly retouched eyes look a little weird—like the eyes of an alien from outer space. The fix is simple if you did all this retouching in the new empty layer.

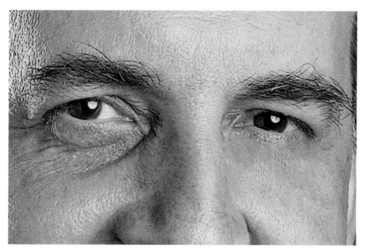

Figure 6.10 These ultra-smooth eyes do not look human.

Change the layer opacity by dragging the slider to the left, revealing a little bit of the original underlying image (Figure 6.11). The bags are now soft folds, which are much more natural looking without being unattractive (Figure 6.12).

Figure 6.11
Lower the opacity to reveal more of the original underlying image.

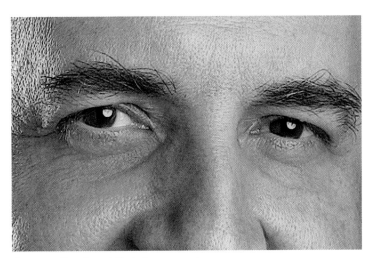

Figure 6.12 The softer wrinkles look more natural.

You might be inclined to stop here, but there are still a few wrinkles that can be minimized a bit. Using another technique, you can do that without destroying the skin texture. First, hold down the Option/Alt key and click the New Layer icon at the bottom of the Layers palette. This will bring up the New Layer dialog (Figure 6.13).

Figure 6.13 The New Layer dialog allows you to change the mode and fill the layer with 50 percent gray in one step.

You need to make a special layer to *dodge and burn* (selectively lighten and darken). The trick is to change the mode to Soft Light and then check Fill With Soft-Light-Neutral Color. This will fill the new layer with 50 percent gray. In a Soft Light or Overlay layer, 50 percent gray has no effect on the underlying image; but when you use

the Dodge tool to lighten the Gray layer, it will lighten the underlying image without affecting the color or texture. The Soft Light mode has a more gentle effect than Overlay and it doesn't tend to increase the saturation as much. Select the Dodge tool in the Tool palette and brush over the wrinkles using a low opacity to gradually lighten them (Figures 6.14 and 6.15).

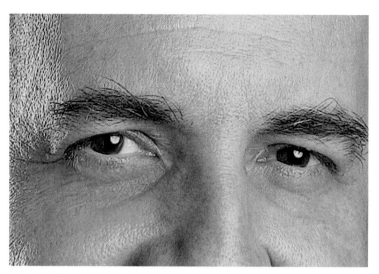

Figure 6.14 The wrinkles before dodging

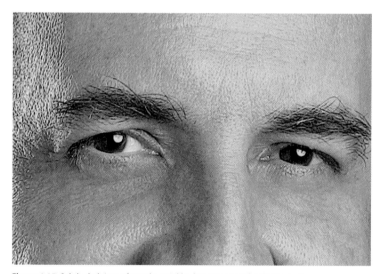

Figure 6.15 Subtle dodging softens the wrinkles but preserves the skin texture.

If you temporarily change the Layer mode back to Normal, you can see the dodge marks clearly in the Gray layer. Just reduce the opacity to see where they line up on the face (Figure 6.16).

Figure 6.16 Use the Dodge and Burn tools to selectively lighten or darken wrinkles.

If you go too far, you can repair the effect by brushing back into the Soft Light layer with 50 percent gray at low opacity. If you need a stronger lightening or darkening effect, you can duplicate the layer by dragging the Layer thumbnail onto the New Layer icon at the bottom of the Layers palette. The final retouching softens and fills in wrinkles and pores without completely eliminating them (Figure 6.17). Wow, I look 10 years younger! (OK, maybe 15 years but who's counting?) Compare the two versions in the chapter opening image.

Figure 6.17 The final retouching should look natural and preserve as much of the original skin texture as possible.

You may have noticed that we haven't really touched the classic retouching tool—the Clone Stamp tool that has been in Photoshop since the beginning (Figure 6.18). The Clone Stamp tool (sometimes called the *rubber stamp* because of the Tool icon in the Tool palette) still has its uses, but the newer tools are easier to use for this type of retouching. One of the biggest problems with the Clone Stamp tool is the tendency to smooth overworked areas. This happens when the soft edges of the Clone Stamp overlap, and multiple strokes tend to smooth out noise and texture.

Figure 6.18
The Clone Stamp looks like a rubber stamp
in the Tool palette.

Prior to Photoshop CS, most experts used really small brush sizes to retouch pore by pore. The new tools make this work much less tedious. The Clone Stamp is very useful, however, for duplicating areas or moving features (Figure 6.19).

Figure 6.19 Are three eyes better than two?

The Patch tool is found under the Bandage icon in the Tool palette (Figure 6.20). It is a special kind of selection tool that is very useful for removing defects in a plain background. Leave the tool options set to Patch: Source (Figure 6.21). We will use it on the CCD dirt spots just to the right of the face.

Figure 6.20
The Patch tool is with the other retouching tools in the Tool palette.

Figure 6.21 Leave the tool options set to Patch: Source.

To use the tool, select it and draw a selection outline around the spot (Figure 6.22). Simply drag the selection to an area that is free of spots. The area inside of the selection outline changes to the area to which you dragged. You can clean up lots of spots very quickly.

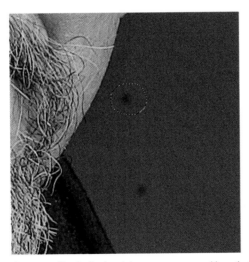 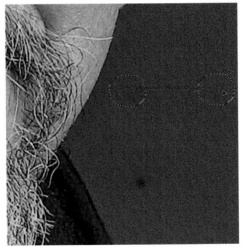

Figure 6.22 Use the Patch tool the same way you would use the Lasso and draw a selection around the spot you want to remove. Then drag the selection to an area that is clean.

Hue/Saturation Color Repair

The retouching we just did on my photo was relatively straightforward because the skin color was mostly uniform. What can we do with this image from Ken Chernus (Figure 6.23)?

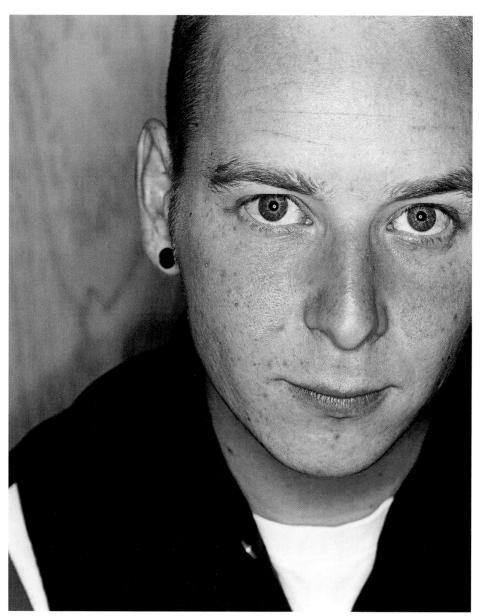

Figure 6.23 Red blotchy skin is a classic problem. (Photo by Ken Chernus)

Red blotchy skin can look worse in digital capture because of the tendency for Bayer pattern imaging systems to overemphasize the red component in skin color. Pimples and red blotches tend to go nuclear. Fortunately, there is a relatively simple fix that utilizes a Hue/Saturation adjustment layer. To perform this fix, call up the dialog by clicking and selecting from the Adjustment Layer icon at the bottom of the Layers palette, and change the Edit drop-down menu to Reds (Figure 6.24). The left Eyedropper toward the bottom should be selected. Move the cursor (the Eyedropper sampler) into the image and click the brightest red pimple. The selected range (at the bottom of the dialog in the rainbow gradient) will move slightly to center over the selected color. Select the right Minus Eyedropper tool and click an area of good skin color. The sample region will shrink somewhat to indicate the more constrained sample area (Figure 6.25).

Figure 6.24 Change the Edit drop-down menu to Reds.

Figure 6.25 Use the Eyedroppers to refine the affected color range by clicking in the image.

This part is the trick: we are going to temporarily apply a radical hue shift to help visualize the selected region. Push the Hue slider all the way to the left; the selected reds in the face will turn bright cyan blue. Now you just need to drag the right gray-triangle slider to the left to trim the selected region to limit the effect to those areas that are too red and blotchy (Figure 6.26).

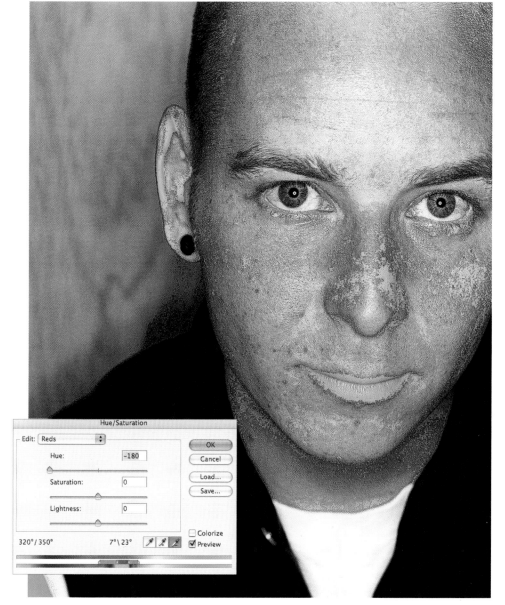

Figure 6.26 Use the Sample Region sliders to trim the selected region.

After you have identified the region that will be affected, you can employ a more attractive color shift. Drag the Hue slider to the right, past zero and toward yellow. Stop when you've killed the red curse. Use the Info palette numbers to determine if the skin values in the pimple regions are in the correct range (move the cursor into the image to get a reading). Because pimples are also darker than normal skin, push the Lightness slider to the right until you get better tonal uniformity (Figure 6.27). Don't go too far with this; it will reduce the saturation of the skin tone and ultimately look unnatural.

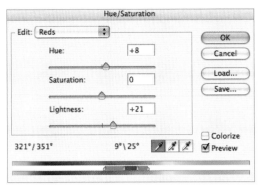

Figure 6.27 Adjust the sliders to bring the red regions into the same color and tonal range as the rest of the face.

Some areas of the face might be too yellow. You can adjust these areas in a similar fashion. Change the Edit drop-down to Yellows, use the Eyedropper tool to select the too-yellow region, subtract the red pimple areas with the Minus Eyedropper tool (these are now already shifted), apply the radical hue shift to trim the area further, and push the slider slightly to the left to make the yellow regions more red (Figure 6.28). The Edit drop-down, which did indicate Yellows, will change to Reds-2 to indicate that you are editing another red region. The Hue/Saturation adjustment has hidden most of the pimples and given the skin a much healthier look (Figure 6.29).

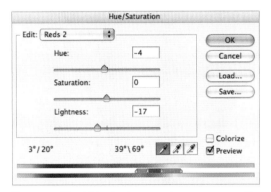

Figure 6.28 Edit additional regions as need to create a more uniform skin tone.

To finish, you can use the Soft Light dodge-and-burn-layer trick to lighten the few remaining darker pimples. You might want to mask off the red to reduce the effect of the Hue/Saturation adjustment from the lips—especially with women. Just paint into the Hue/Saturation adjustment layer with black over the lips. In this image, I also brushed a little blue color into the eyes to relieve some of the monochromatic nature of the shot. In the end, all of the pimples have become soft freckles, and we have not corrupted the skin texture (Figure 6.30).

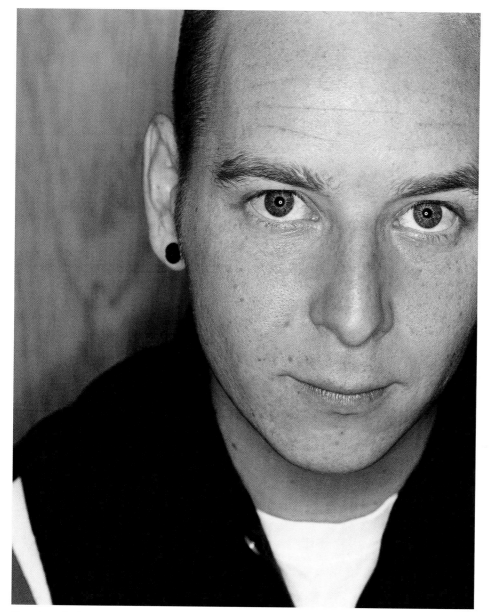

Figure 6.29 The skin appears to be much healthier, and we haven't touched a retouching tool.

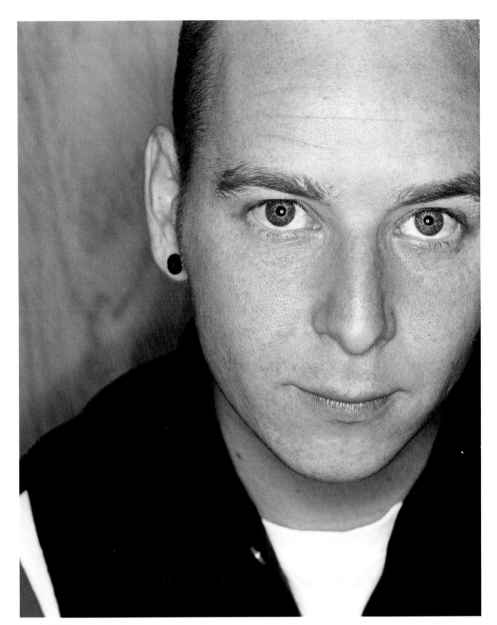

Figure 6.30 The final retouch

Beauty Retouching

When you mention retouching, people often think about the impossibly flawless high-fashion models and cover girls they see in magazines. In this type of photography, there is no real attempt to be realistic. Instead, photographers try to create a believable impossibility. Flawless skin is expected; but at the same time, the skin shouldn't look like plastic. Often, the challenge is to create this effect with subjects that are not even close to ideal raw material. You'll need to know how to completely reconstruct the skin if an assignment calls for it. Of course, nothing is impossible nowadays.

In this example, we will work with the shot of an attractive woman in her fifties (Figure 6.31).

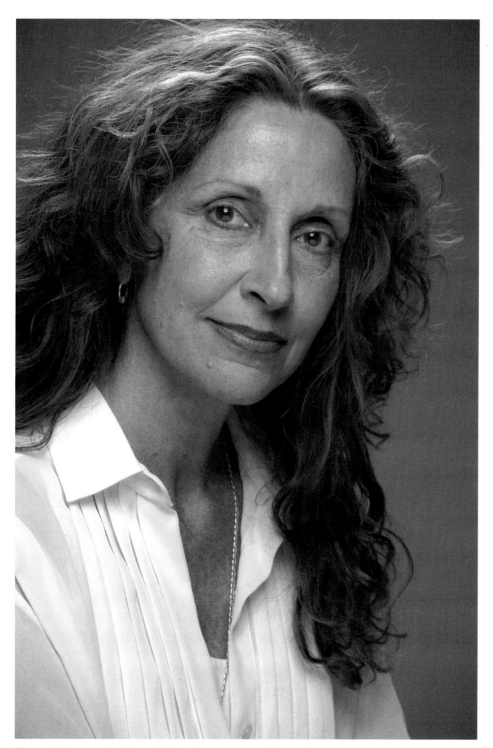

Figure 6.31 This woman is still beautiful. She is, however, no longer 20 years old.

In our youth-obsessed culture, it is not surprising that photographers are asked to take 30 years off the faces of various authors, musicians, actors, and actresses. Because television and movies are still such low resolution, people often are unaware just how old some of their favorite idols are. I'm not about to burst anyone's bubble here, so we are going to completely rebuild this woman's skin.

As always, we'll start by making a new layer. In this case, we are going to duplicate the background image by dragging the thumbnail in the Layers palette to the New Layer icon. The strategy here is to blur this copy as the basis for the new skin, so let's rename the layer (by double-clicking the Background Copy name next to the new thumbnail) and call it Surface Blur (Figure 6.32).

Figure 6.32
Duplicate the background to a new layer by dragging to the New Layer icon.

Choose Filter > Blur > Surface Blur (Figure 6.33). Surface Blur is a new Photoshop CS2 filter that is especially useful in this application. This blur maintains the major edge transitions, but it also manages to create a very smooth blur. The Radius slider controls the intensity of the blur, and the Threshold slider controls how much of the image stays sharp. Unlike other blur filters, higher Threshold settings have a greater blurring effect. You'll want to adjust the sliders so that you can completely smooth the wrinkles and skin texture while leaving major features intact (Figure 6.34).

Figure 6.33 The Surface Blur filter is perfect for smoothing the skin.

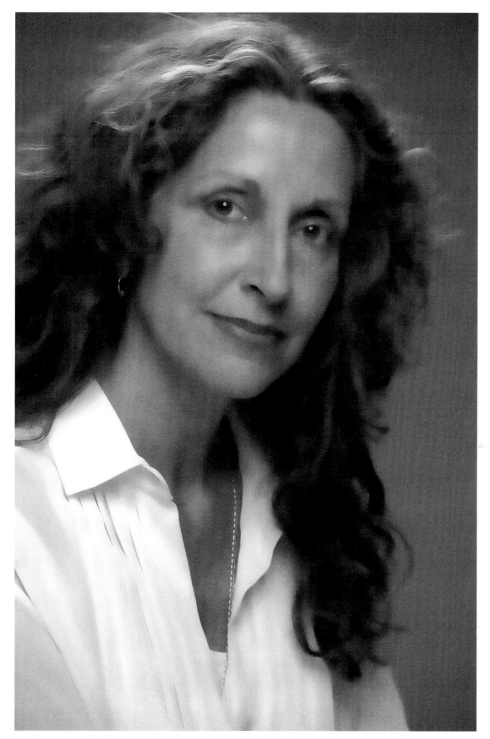

Figure 6.34 Skin and other textures are completely smoothed with the application of Surface Blur.

Note: For Photoshop CS users, the next best choice is the Median filter (Filter > Noise > Median). This filter has only one slider, but you can get a similar, although not quite as good, smoothing effect.

We will hide this Blur layer with a layer mask. Hold down the Option/Alt key and click the Layer Mask icon at the bottom of the Layers palette (Figure 6.35). This action creates a Black layer mask and hides the Blur layer while revealing the original image.

Figure 6.35
Option/Alt+click the Layer Mask icon to create a Black layer mask.

Now simply paint into the layer mask with white to cover the areas of skin that you want to smooth (Figure 6.36). The area you are working on can be difficult to see if you've covered everything. You can toggle off the visibility of the Background layer to see if there are any *holes*. To do so, click the Eye icon next to the Background thumbnail in the Layer palette (Figure 6.37).

Carefully paint around all the areas you need to keep—the eyes, lips, etc.—until you've covered up all the "bad" skin. At this point, you should have something that looks like Figure 6.38.

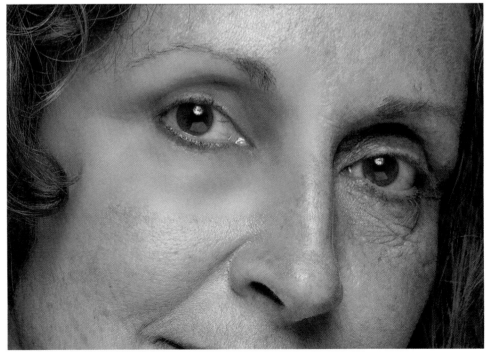

Figure 6.36 Paint into the layer mask with white to cover the skin with the blurred copy.

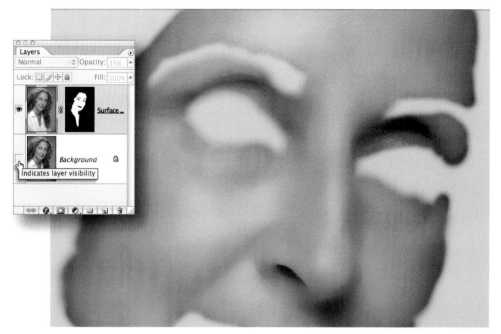

Figure 6.37 To check for holes, toggle the visibility of the Background layer.

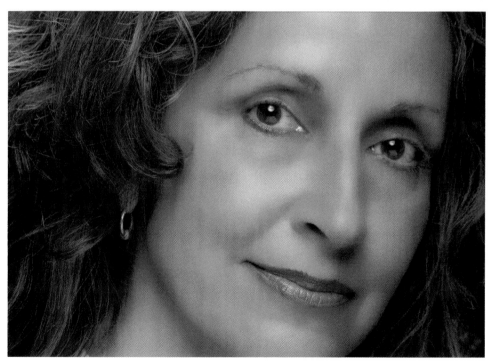

Figure 6.38 Work carefully so that you smooth the wrinkled skin, but keep other features sharp.

The skin will be smooth, but the colors and tone might be a little blotchy looking. To fix this, make a new layer, but Option/Alt+click the New Layer icon to bring up the New Layer Options dialog. Check the Use Previous Layer To Create Clipping Mask box (Figure 6.39). This will allow the mask in the underlying layer to control the new Paint layer.

Figure 6.39

Check the Use Previous Layer To Create Clipping Mask box when you create the new Paint layer.

Take a large soft brush, sample colors from the blurred skin (Option/Alt+click to turn the cursor into an Eyedropper and sample a color), and paint with a very low opacity to gradually smooth out the color and tones (Figure 6.40).

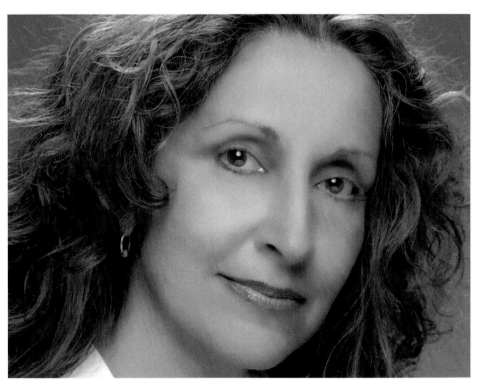

Figure 6.40 Use a large paint brush at low opacity to smooth the colors and even the tones.

At this point, you'll want to bring back some hint of the underlying skin. Select the Blur layer by clicking the thumbnail in the Layers palette. Push the Opacity slider to the left a bit to bring back some of the underlying layer (Figure 6.41).

This technique is similar to the one we used on my face. However, this time we covered the original skin with a blurred copy and paint. Now we want to create a Dodge And Burn layer and dodge out any unattractive wrinkles that are left—this is very similar to what we did before. Option/Alt+click the New Layer icon at the bottom

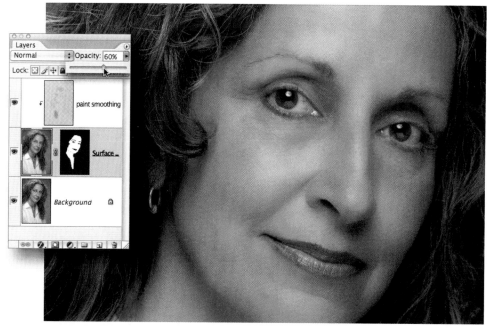

Figure 6.41 Reduce the opacity of the Blur layer to bring back some of the original texture.

of the Layers palette. This will bring up the New Layer dialog. Change the Mode to Soft Light, and then check the Fill With Soft-Light-Neutral Color box. Make sure you check Use Previous Layer To Create Clipping Mask. This will fill the New Layer with 50 percent gray. You want to keep using the mask you created with the Blur layer. Use the Dodge tool to dodge away wrinkles. In Figure 6.42, you can see what Soft Light looks like if it is applied as a Normal layer.

At this point, the subject's skin appears to be very smooth with just a hint of its original skin texture. To keep the image from looking too plastic, you'll need to add more texture to the skin. I've experimented with all kinds of different approaches. Although I'm not completely satisfied with the following technique, it is my current favorite technique for adding artificial skin texture. I'll continue to experiment until I find one I like better.

Once again, create a new Gray Overlay layer. Option/Alt+click the New Layer icon at the bottom of the Layers palette to bring up the New Layer dialog. Check the Use Previous Layer To Create Clipping Mask box, select Overlay from the Mode drop-down, and check the Fill With Overlay Neutral Color (50% gray) box (Figure 6.43).

The Layers palette should look like Figure 6.44. The last three layers created are being controlled by the opacity and layer mask of the Surface Blur layer. To get a better idea of how the Texture layer is going to affect things, temporarily push the Opacity slider for the Blur layer back to 100 percent. You won't see any of the original texture, but you will be able to see the new texture you are about to create. You will also see the dodge lines where you lightened the wrinkles; you can temporarily turn off the visibility of this layer if you find it distracting.

Select the Overlay Texture layer and run the Noise filter on it (Filter > Noise > Add Noise). Check the Uniform and Monochromatic boxes, and add enough noise to make the image begin to look as if it were shot with Tri-X film (Figure 6.45).

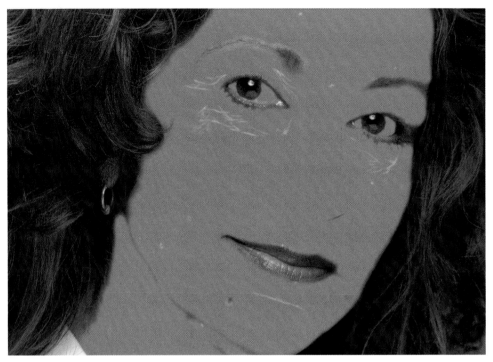

Figure 6.42 The gray Soft Light layer can be used to iron away wrinkles.

Figure 6.43 The Gray Overlay layer will have no effect on the image until you add texture to it.

Figure 6.44
After you create the Overlay Texture layer, change the opacity of the Surface Blur Layer back to 100 percent.

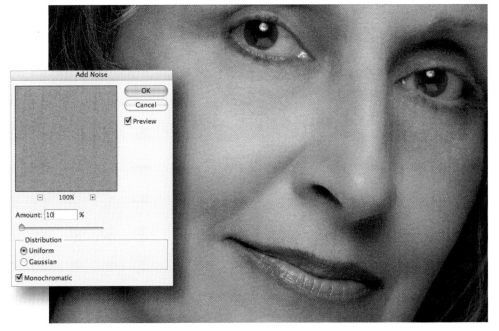

Figure 6.45 Add obvious noise.

The ideal value in the filter dialogs depends on the size and resolution of the file. As such, no hard rules can apply to all images. You have to develop a feel for this, and sometimes you have to make a test print to judge a subtle effect such as noise.

Many photographers would stop here, but this noise is too sharp for our purposes. With the Gray Overlay Texture still selected, run a Blur filter (Filter > Blur > Gaussian Blur), use just enough Blur to soften the edges of the noise without completely smoothing it out (Figure 6.46).

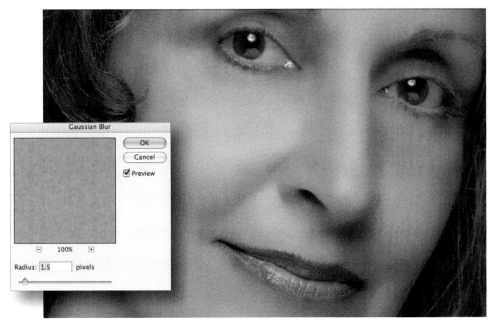

Figure 6.46 Soften the noise with a Gaussian Blur filter.

Sometimes this is all you really need to do, but I usually like to create a slightly more complex texture to simulate real skin. To do so, run the Emboss filter (Filter > Stylize > Emboss). See Figure 6.47.

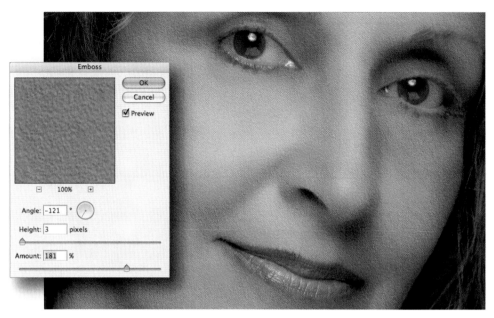

Figure 6.47 Run the Emboss filter to get a more three-dimensional effect.

This still looks too fake, so you need to soften it a bit. You can modify any filter right after you've run it by using the Fade command. Go to the Edit menu (immediately after running the filter) and choose Edit > Fade Emboss (Figure 6.48).

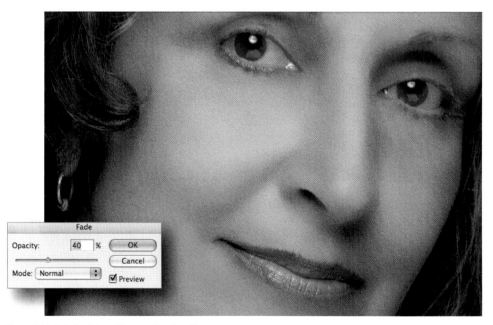

Figure 6.48 Fade the Emboss filter to soften the effect.

Return to the Surface Blur layer and reduce the opacity to 70 percent or so. You should have something similar to Figure 6.49; compare this with the skin that hasn't been retouched (Figure 6.50).

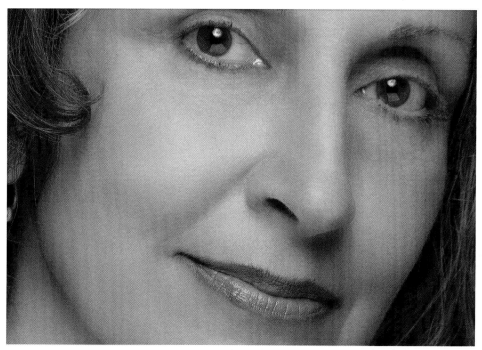

Figure 6.49 The artificial texture combined with a hint of the original texture creates a convincing effect.

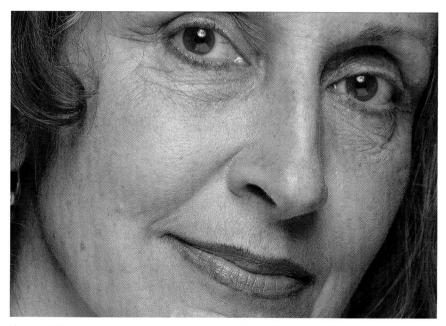

Figure 6.50 The original photo reveals that the subject has had a long life with a lot of sunshine.

For the final retouched version, I brightened the eyes (enlarged the pupils), brushed in some subtle eye shadow color, and performed a little edge burning (Figure 6.51). Because all of the retouching was performed in layers that are controlled by the Surface Blur layer, you can reduce the opacity of that layer a little more if you want a more realistic rendering (Figure 6.52).

Figure 6.51 The final retouched version has some edge burning and a little eye makeup added.

Figure 6.52 Reducing the opacity of the Surface Blur layer brings back some of the real skin and still manages to hide most of the wrinkles.

This example shows what is possible. Professional photographers are frequently asked to take the same sort of approach for even young and beautiful models, as you can see in the next example (Figure 6.53).

Figure 6.53a Sometimes the application calls for highly idealized glamour retouching, even with young beautiful models.

Figure 6.53b

Figure Thinning Techniques

"Make me look thinner!" Depending on the nature of the shot, a number of different techniques can be used for this very common request. Extreme cases involve a lot of re-illustrating, but the most common problems can be fixed very easily. Most people don't have perfect bodies; even attractive models can be captured in less-than-flattering angles and need some amount of corrective retouching.

One very simple approach can be illustrated by the example in Figure 6.54. This blackmail photo was taken on the occasion of my fiftieth-birthday party. I am making a fool of myself dancing with my daughter (yes, that's really my daughter). I look a little wide in the hips here. It's been quite a while since I had a 30-inch waist, and I'd like to look a little thinner in this shot. This sort of situation, where you have a subject who isn't too bad but who wants to look thinner anyway, is very common.

Figure 6.54 I'd like to look a little thinner here.

To begin the digital makeover, make a simple rectangle selection around the figure and press ⌘+J/Ctrl+J to copy the figure into a new layer. Reselect it by ⌘/Ctrl+clicking the thumbnail in the Layers palette. Then do a free transform (Image > Transform > Free Transform). Squish and stretch the figure by pushing and pulling on the middle handles so that the figure becomes taller and thinner. A little bit goes a long way (Figure 6.55).

Figure 6.55 Stretch and squeeze the figure.

The only thing that really gives away the trick is how squashed the head looks. To correct it, select the original head in the underlying layer and copy it into a new layer at the top. (Press ⌘+Option+J/Ctrl+Alt+J and drag to the top.) Position the original unsquashed head over the squashed body, and voilà! You have a thinner me (Figure 6.56). Clone a little bit around the background to clean it up, and you'll get Figure 6.57.

Figure 6.56 Copy the original head and place it above the squashed figure.

Figure 6.57 The final retouch

The next example is more complex, but it is just as common (Figure 6.58). A simple *x-y* stretch will not correct the problem. The dancer really needs a tummy tuck. This type of retouching used to require a lot of careful work with the Clone Stamp tool, but fortunately Photoshop CS and Photoshop CS2 have the Liquify tool, which works much better. The Liquify tool is actually a kind of super-filter with its own interface and set of tools.

Figure 6.58 This beautiful dancer just had a baby and needs just a little help with a tummy tuck.

Copy the background to a new layer and choose Filter > Liquify. A new window will appear with a preview of the image, a set of tools in the upper left, and a panel of controls at the right (Figure 6.59). By default, the Forward Warp tool is selected. We will use this tool to literally push in the tummy.

Figure 6.59 The Liquify filter has its own self-contained interface.

Adjust the brush size in the right-hand panel until it is big enough to, more or less, cover the stomach area. Reduce the Brush Density and Pressure to about 30 or even less; this will cause the tool to work more slowly and give us more control. Brush the stomach in, and you can magically push the image around as if it were plastic gel (Figure 6.60). If you work slowly and gradually push things into the final shape, you can avoid lumpy bumpy effects.

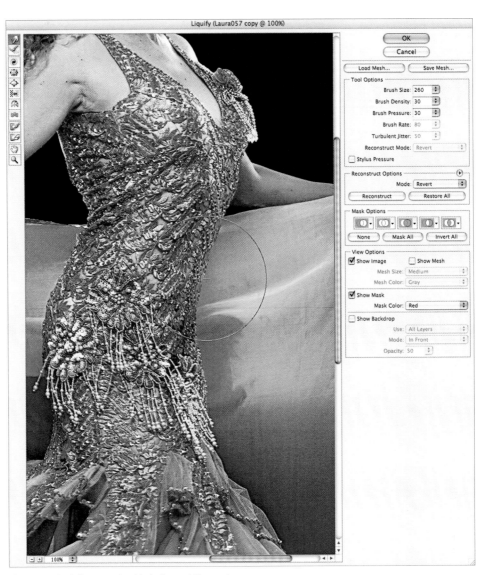

Figure 6.60 Push the tummy in with the Forward Warp tool.

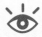

Note: The normal keyboard navigation commands work inside the Liquify interface, so you can zoom in by holding the spacebar+⌘/spacebar+Ctrl and clicking.

You can do a lot of detailed reshaping using this technique. When you are satisfied with the results, press OK. That's it. For the final version (Figure 6.61), I also flipped the hair and trimmed her arm a bit; I did it all using the same Liquify brush.

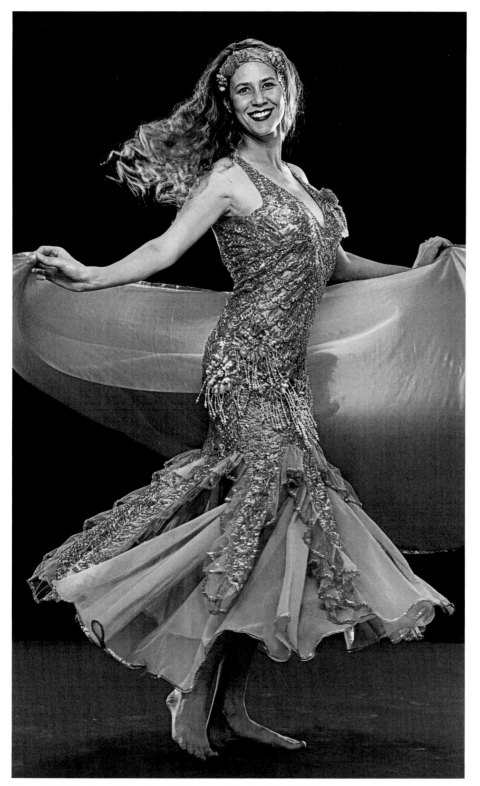

Figure 6.61 The final retouch has slimmed the dancer and given back her girlish figure.

This kind of retouch is so easy that I don't charge for it if my client is the subject. In fact, I often just go ahead and do this sort of thing without telling them. Your subjects will always be happy with the flattering version and typically compliment you on your excellent photography. (There is no need to spoil their illusions by showing them the unretouched version.) Of course, if the client is an ad agency, you should make sure they know you are doing the retouching. You can charge for it and get input on any other changes they might want. The more people who are involved in the decision making, the more nit-picky the retouching demands will be.

Figure 6.62 is another example that demonstrates how much figure slimming you can perform with the Liquify tool.

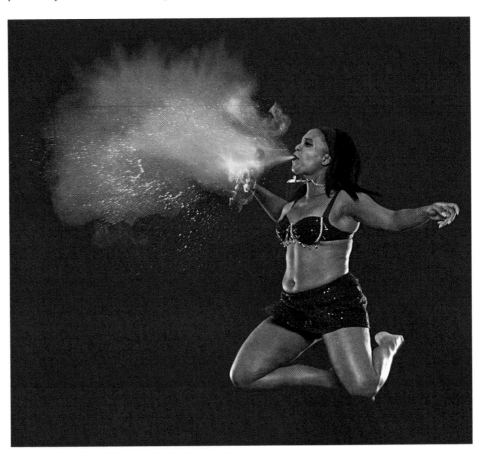

Figure 6.62a The original fire-eater could be slimmer; the Liquify tool can work wonders.

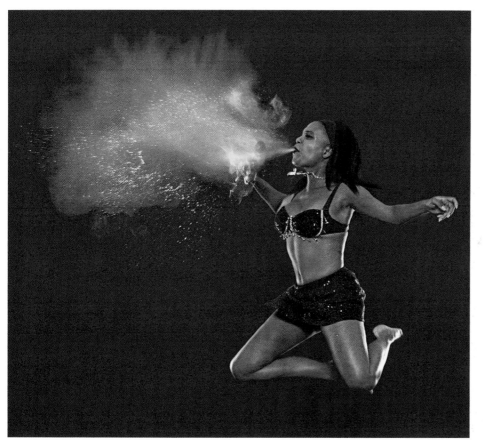

Figure 6.62b

Subtle Retouching

Extensive retouching is not always appropriate. For example, we aren't going to turn the sweet old lady in Figure 6.63 into a 20-year-old babe. We can enhance this image, but we certainly must resist any urge to remove wrinkles or any other signs of aging because it would be perceived as undignified. In cases such as this, I prefer to simply adjust the skin color to give it a somewhat healthier tone. I might work on the makeup a bit and liven up the eyes by enlarging the pupils and catch lights; however, I don't want to make her look like anything other than what she is.

Figure 6.63 This sweet old lady is never going to look like a 20-year-old.

For the final version (Figure 6.64), I used a Hue/Saturation adjustment layer to equalize the skin color and increase the saturation in the skin and hair a bit to give it a healthy glow. I put a little light into her eyes, and I *very* slightly worked the wrinkles with a Soft Light layer. The finishing touch was the blur of the background. I did this by drag-copying the background into a new layer, running a Blur filter (you can use Gaussian Blur or even Lens Blur) and then hiding the blurred layer with a Black layer mask (Option/Alt+click the Layer Mask icon at the bottom of the Layers palette). I painted the blurred background over the underlying layer (use white to paint into the Black layer mask). We'll do more of this background blurring in Chapter 7, "Special Effects."

Figure 6.64 The final version enhances the overall image without looking obvious.

When you are preparing this type of retouch for final printing, you should avoid sharpening the skin. We will go over sharpening techniques in Chapter 8, "Preparing for Print." For now, just be aware that you want to avoid sharpening wrinkled skin; this goes a long way toward minimizing the wrinkled look. In most cases for natural portraiture, less is more. Simple things, such as enlarging the pupils and working catch lights into the eyes (as discussed in Chapter 3), can work wonders without *looking* as though things were altered.

Subtlety is especially important for shots of mature men. Wrinkles are like war scars, a badge of honor for someone who has lived a good life. Be very careful about removing them. The gentleman in Figure 6.65 has earned his wrinkles, and you might want to emphasize them.

Figure 6.65 This gentleman is an athlete who has spent a lot of time in the sun. (Photo by Ken Chernus)

When in doubt, ask. Some people are vainer than others, and even older men sometimes want to look younger. For the most part, however, you'll want to concentrate on obvious defects, such as red blotchy skin, and subtly minimize wrinkles.

Skin Smoothing

Our final example is a shot of Dr. Doug (Figure 6.66). Doug is an acupuncturist, author, and longevity researcher. We would like him to look as healthy as he truly is. The digital camera has emphasized the red tones in his skin, so we'll use the Hue/Saturation adjustment techniques to equalize the skin tone (Figure 6.67). Next, we'd like to soften the wrinkles. Doug is an outdoor-sports enthusiast, and he has some unavoidable wrinkles and freckles due to sun exposure. We don't want to eliminate them, just soften them slightly. We will use a new technique to apply a global softening effect.

Figure 6.66 The original shot of Dr. Doug shows the typical overly red skin from a digital camera file.

Figure 6.67 The Hue/Saturation technique equalizes the skin color and eliminates most of the problem.

First, flatten the image (applying the Hue/Saturation adjustment layer in the process) by selecting Flatten Image from the Layers Palette Options menu. Duplicate the background by dragging the thumbnail to the New Layer icon at the bottom of the Layers palette. Now, run the Surface Blur filter (Filter > Blur > Surface Blur), using a large Radius and Threshold to blur all the skin texture (Figure 6.68). Much as we did for the beauty-retouching technique, make a layer mask that covers all the areas of skin except for the eyes, lips, and teeth (Figure 6.69).

Figure 6.68 Make a blurred copy of the background image.

Now, duplicate the Blur layer so that you have two identical Blur layers. You are going to use one layer to darken and the other layer to lighten the wrinkles in the original, background image. Turn off the visibility of the top Blur layer (click the Eye icon in the Layers palette), and rename it to Blur-dark; then select the first Blur layer, rename it to Blur-light, and change the mode to Lighten (Figure 6.70).

Figure 6.69 Mask off the blur from the eyes, lips, and hair.

Lighten mode applies the layer only where it can make the underlying image lighter. Because you applied blurred shadows into highlights, the highlights in the Lighten Blur layer are not as bright, so you can see the light lines from the original. The blur covers only the darker parts of the image. Now, you'll want to lighten the Blur Light

layer so that it hides more of the light wrinkles. Bring up a levels adjustment (Image > Adjustments > Levels) for this Blur layer. Push the middle slider to the left a little bit, so that more (but not all) of the light wrinkles are hidden (Figure 6.71).

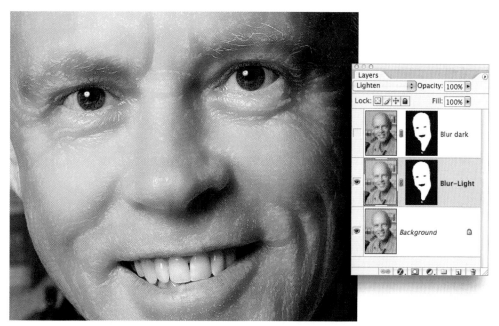

Figure 6.70 I've added a second Blur layer, this one in Lighten mode.

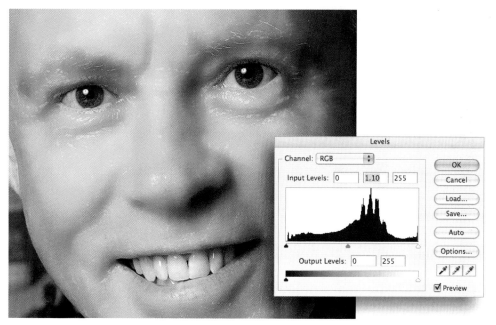

Figure 6.71 More of the lighter wrinkles are hidden.

Now, we will reverse things for the other Blur layer. Turn off the visibility for the first Blur layer. Turn on and select the top Blur layer. Change the mode to Darken (Figure 6.72).

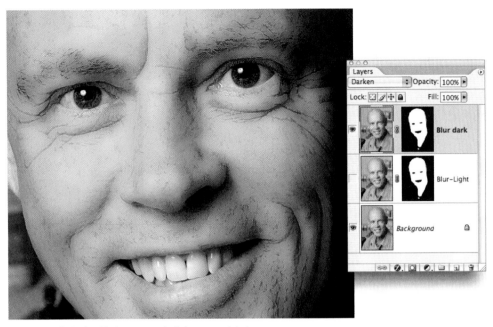

Figure 6.72 The Darken Blur layer covers the lighter parts of the image.

We need to do something similar to darken the Blur Dark layer to hide more of the dark wrinkles. As before, select Image > Adjustments > Levels. This time, push the middle slider to the right to darken the layer slightly and cover up more of the dark wrinkles (Figure 6.73).

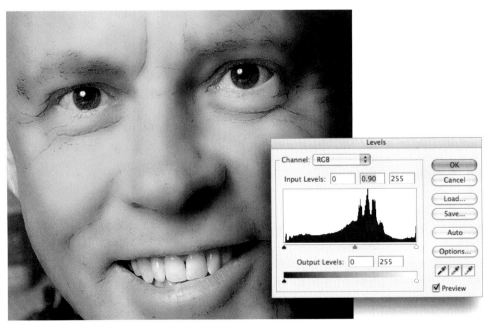

Figure 6.73 Darken the layer with levels to hide more dark wrinkles.

When the two Blur layers are set up, you can adjust the opacity of Lighten and Darken blurs independently to get the desired skin-smoothing effect. The final version uses an opacity of 45 percent for the Lighten Blur and 30 percent for the Darken Blur layers (Figure 6.74). The overall skin texture is lightened slightly, and the wrinkles are smoothed without being removed. No cloning or healing was done. If you are ambitious enough, you can record all the steps to generate this effect. Compare the new version with the unsmoothed version to see just how far we've taken the photo (Figure 6.75).

Figure 6.74 The final skin-smoothing detail

Figure 6.75 The unsmoothed version shows a lot of texture even after the Hue/Saturation adjustment for the red skin.

The final retouched version (Figure 6.76) achieves a skin-smoothing effect without obliterating the actual skin texture. This effect makes no attempt to remove wrinkles, but instead focuses on smoothing the texture of the skin in a subtle way; every detail is still there, just slightly less intense.

Figure 6.76 The final retouched version

We've examined a number of different techniques using examples that are particularly suited to a specific technique. Most of the time, in the course of our regular work, we will need to utilize multiple techniques in different combinations for different parts of the image. Be on the lookout for novel solutions to unique problems. Perhaps the Liquify tools could be used to adjust an expression slightly, Curl the lips subtly or open a sleepy eye. Combine techniques in different ways. Adjust opacities more or less to suit a particular image. Use different kinds of noise or embossing effects in skin texture layers. Don't just apply the steps outlined here in a formulaic way. Keep experimenting and you'll discover your own techniques.

Special Effects

Ever since the movie Jurassic Park, *the general public has associated digital imagery of any kind with special effects. This is true with digital photography as well, and often people assume that some trick is involved just because an image was shot with a digital camera. Not all digital imagery involves trickery, but I certainly don't want to disappoint anyone hoping to learn a few special effects. This chapter will explore a few techniques that are uniquely digital, even though they may simulate traditional photographic effects. The focus will be on useful photographic effects commonly used with people photography.*

Chapter Contents

Soft Focus

Film Grain and Mezzotint

Cross-Processing

Tattoos

Soft Focus

Soft focus or diffusion effects have been used in photography since the earliest days when photographers sought to emulate impressionistic paintings (which was, in turn, influenced by the perspective rendering of the camera). Soft focus became very popular with people photography because it hid skin defects and suggested a sense of glamour and romance. Some Hollywood stars insisted on always being photographed with a diffusion filter. Photoshop has several ways to simulate the look of traditional diffusion filters, as well as some other soft-focus effects that go beyond what is possible with traditional methods. The biggest advantage to the digital approach, of course, is that you don't have to commit to a particular look at the time of exposure. Instead, you have the luxury of experimenting with different looks at your leisure after the shoot in a nondestructive way. We will explore a number of effects using the image in Figure 7.1.

Basic Diffusion Effect

All of the following soft-focus effects start with this basic technique.

1. Duplicate the background into a new layer by dragging the thumbnail to the New Layer icon at the bottom of the Layers palette (Figure 7.2).

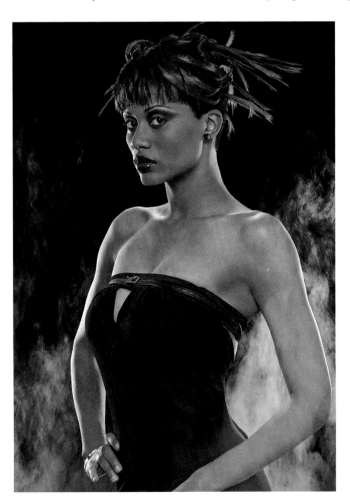

Figure 7.1

This sultry-model shot is the perfect starting point for glamour-enhancing soft-focus effects.

Figure 7.2
Duplicate the background into a new layer.

2. With this layer selected, choose Filter > Blur > Gaussian Blur. Set the radius high enough to get a good blur and still be able to identify the major features—eyes, lips, and general silhouette (Figure 7.3).

Figure 7.3 Run the Gaussian Blur filter on the duplicate layer.

3. Reduce the opacity of the blurred layer to bring back some of the sharp image underneath (Figure 7.4). This is very similar to what happens when you shoot with a diffusion filter on the lens. The only problem with this is that the blur also reduces the contrast of the image because shadows are blurred into highlights and highlights are blurred into shadows.

You can compensate for this with a contrast-enhancing Curves adjustment layer on top of the Blur layer (Figure 7.5). Be careful with the curve; you don't want to eliminate the glow effect that the Blur layer gives you. In this example, returning the highlights to white is more important. If you try to bring the midtones back down to where they were, the glow effect of the blur would be hidden.

Figure 7.4 Reduce the opacity of the blurred layer.

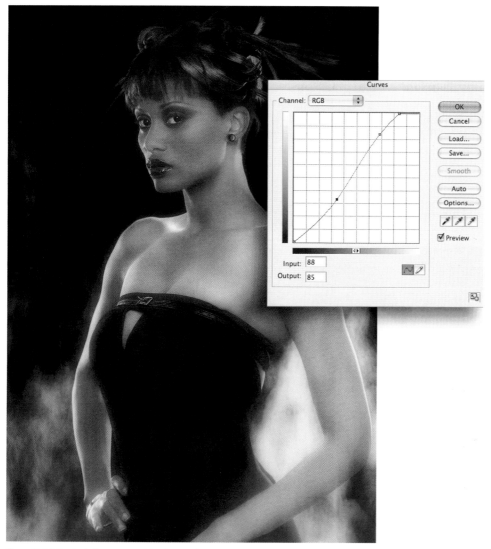

Figure 7.5 Bring back the contrast with a Curves adjustment.

Steep S-curves such as this will also increase saturation in RGB. You might want to change the Layer mode for the curve to Luminosity (Figure 7.6). This will affect only the contrast of the image without affecting the color.

If you would like to keep some of the increased saturation, you can duplicate the Curves layer, change the first one back to normal, and reduce the opacity to 40 percent. Reduce the duplicate to 60 percent; now you'll have the same contrast with just a little bit of the increased saturation (Figure 7.7).

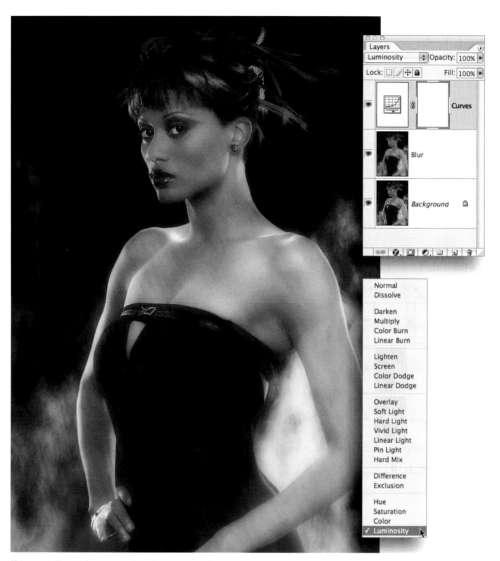

Figure 7.6 Change the Layer mode to Luminosity to eliminate the oversaturated look.

Screen Diffusion

Let's return to the original two-layer version without Curves adjustment layers. Changing the mode of the blurred layer to Screen creates an interesting variation. Screen lightens the values in the underlying layer with the blur so you can change the opacity back to 100 percent and the sharp underlying image will be clearly visible. All the values are elevated with the highlights bleeding into the shadows (Figure 7.8).

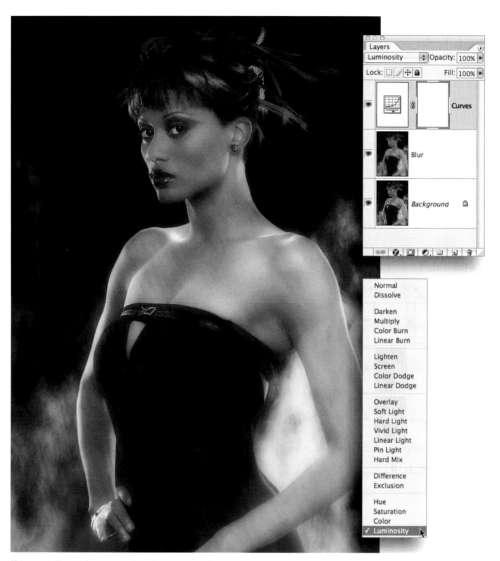

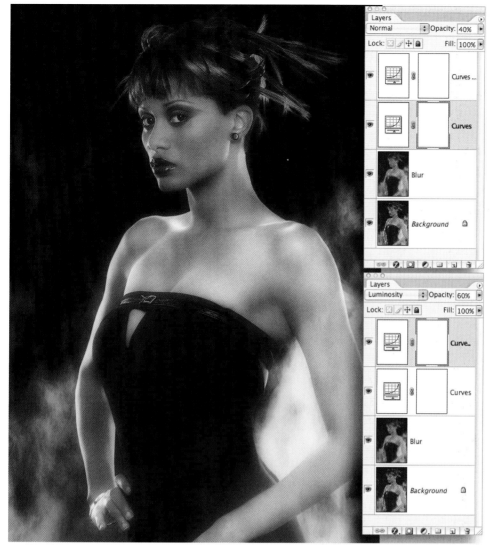

Figure 7.7 Duplicate the curve and reduce the opacities of each so that part of the correction is applied normally (with increased saturation) and part of the correction is applied in Luminosity mode.

A Curves adjustment is necessary to bring back the screen-lightened values. This time, to preserve the impact of the blurred highlights, place the Curves adjustment underneath the blurred layer: select the Background thumbnail in the Layers palette before creating the Curves adjustment layer (Figure 7.9).

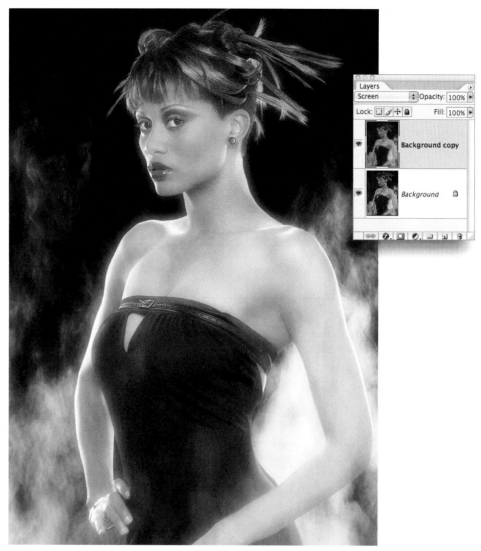

Figure 7.8 When the Blur Layer mode is changed to Screen mode, all values are lightened.

Screen diffusion creates a more intense highlight glow than normal blur diffusion, and this can be quite attractive with certain images. However, achieving enough contrast by using a simple Curves adjustment can be difficult. You might need to mask off the effect from areas where you want detail to show. To accomplish this, put the blur and the curve adjustment into a group:

1. Select the Blur Layer thumbnail in the Layers palette. Hold down the Shift key and select the Curves adjustment layer. Both layers should be highlighted in the Layers palette.

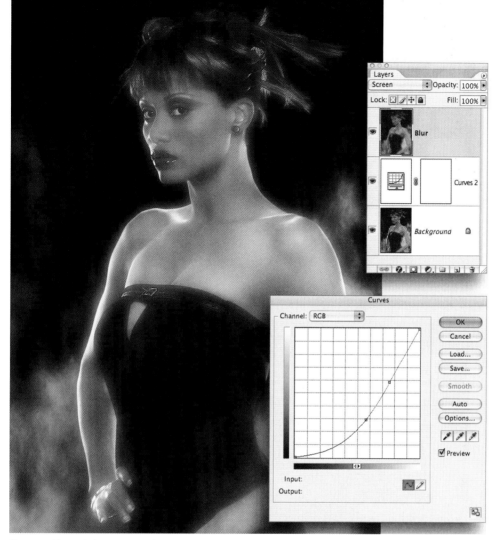

Figure 7.9 Place a darkening Curves adjustment layer beneath the Blur layer.

2. Select New Group From Layers in the Layer Options flyaway menu at the upper right of the Layers palette (Figure 7.10). The two layers will be placed into a folder in the palette; this container can be treated as one unit in the Layers palette as if it were a single layer.

3. With the group selected, click the New Layer icon at the bottom of the Layers palette (Figure 7.11).

Figure 7.10 Place the blur and the adjustment layers into a group.

Figure 7.11 Make a layer mask for
the group.

Once this layer mask is in place, paint into the mask with black over the areas
through which you want the original sharp layer to show. In this example, I've masked
off the eyes, lips, hair highlights, and other small details (Figure 7.12).

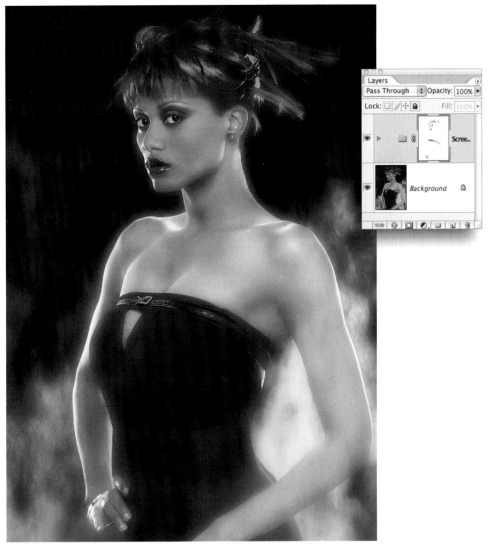

Figure 7.12 Paint into the mask with black where you want details to show through from the underlying Sharp layer.

Multiply Diffusion

You may have guessed that you can also change the Apply mode to Multiply. This, of course, has the opposite effect of Screen. The shadows bleed into highlights and all values are darkened. In this example, the subject is fairly *low key*, meaning that dark tones dominate the image. A Multiply blur would not have the same impact on such a dark image.

It is worth experimenting with Multiply blur on lighter images where the subject is against a lighter background, such as the one in Figure 7.13. However, you would need to apply a lightening Curves adjustment to compensate for the darkening effect of Multiply.

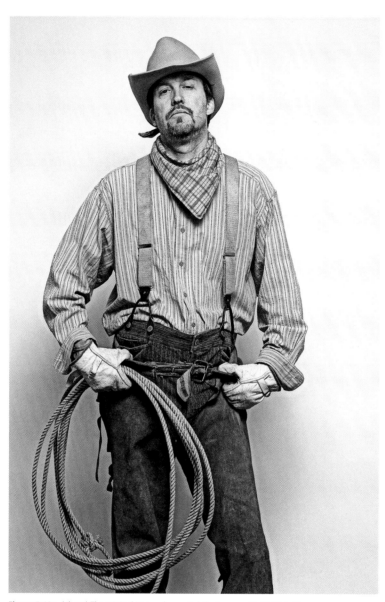

Figure 7.13a (above) The original image; (opposite) the image with Multiply blur

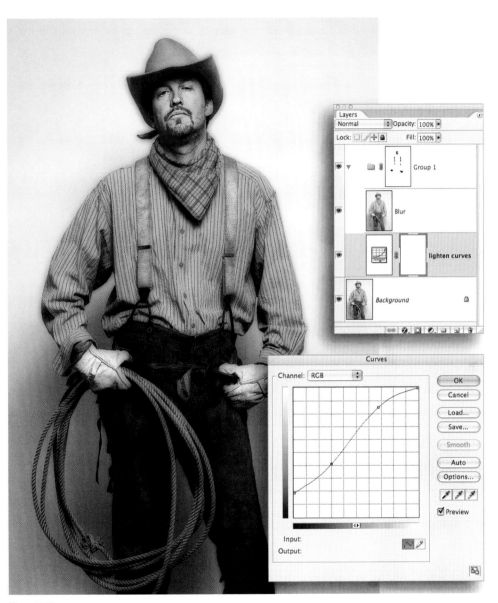

Figure 7.13b

Overlay Diffusion

Let's return to our original example for something a little different. We'll return to a two-layer version without Curves adjustments. All of the diffusion effects we've looked at have had a contrast-reducing effect. Something different happens when you change the Blur Layer mode to Overlay (Figure 7.14). You can see an increase in contrast and color saturation. The blur is now a very subtle glow.

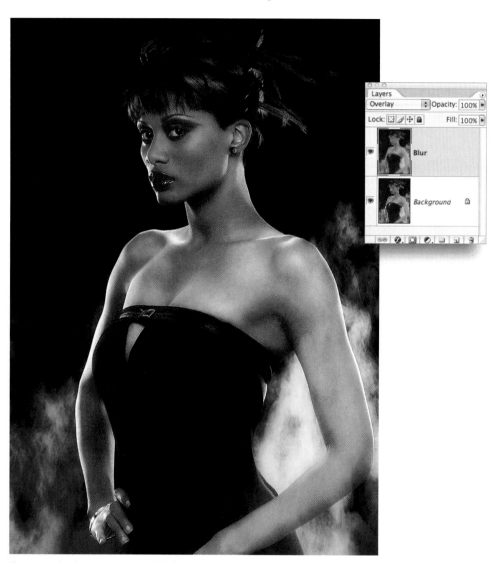

Figure 7.14 Overlay increases contrast by lightening with lighter blurs and darkening with darker blurs.

Curves are called for again, but this time we need to reduce the contrast. To maximize the impact of the Overlay blur, place the Curves adjustment layer underneath the Blur layer. You can work the curve while you watch the combined result with the Overlay on top. The inverse S-curve shape shown in the example reduces the midtone contrast and raises the low values to combat the increase in contrast that the Overlay layer supplies (Figure 7.15).

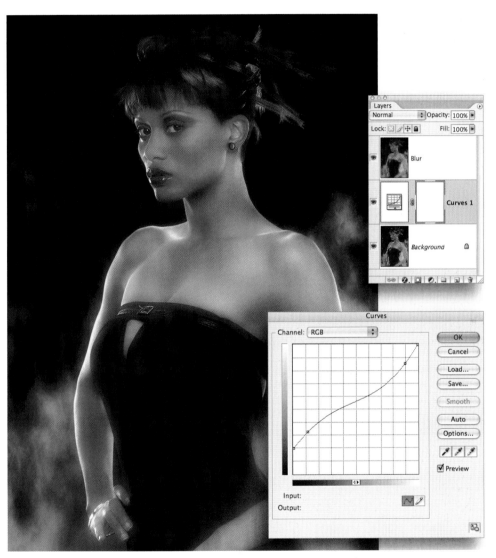

Figure 7.15 Reduce the contrast underneath the Overlay layer to return the image to a normal range.

You can see how much contrast reduction is being applied by turning off the Overlay layer visibility (click the Eye icon next to the thumbnail in the Layers palette). The image should look something like Figure 7.16.

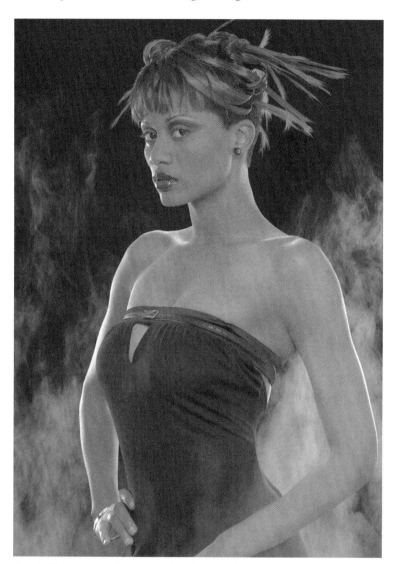

Figure 7.16 Use a Curves adjustment to reduce the contrast but preserve the blur-glow effect.

For the final version, I placed a Hue/Saturation adjustment layer above the Blur layer to reduce the saturation a little. Then all the layers above the background were "grouped" and a layer mask was used to bring back sharp details from the original background image (Figure 7.17).

Overlay blur creates a subtle glow effect that doesn't look blurred and has an interesting glamour-enhancing glow to it.

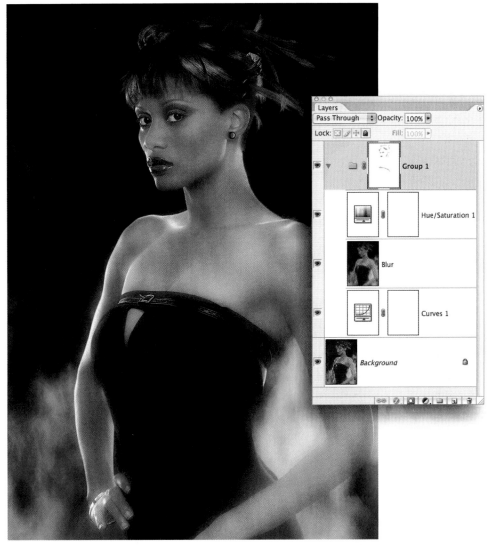

Figure 7.17 The final version reduces the saturation and brings back some sharp details from the original image.

Linear Light Diffusion

There are a number of different apply modes with which you can experiment. I'll show you one more that has a very interesting variation. Return to the basic layers (background with Blur layer on top) and change the mode of the Blur layer to Linear Light (Figure 7.18). This creates a lot of contrast with a saturation boost. The result is pretty interesting but definitely out of control.

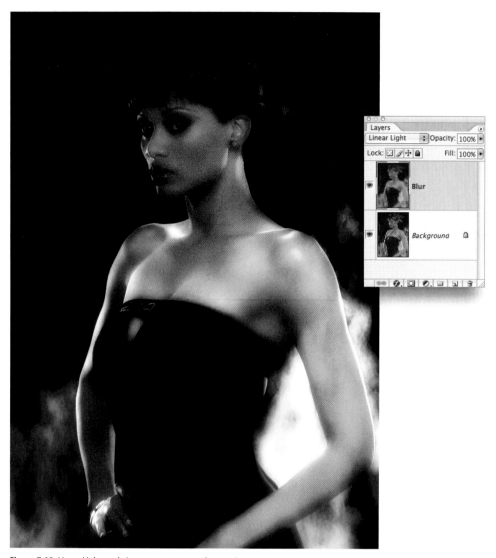

Figure 7.18 Linear Light mode increases contrast and saturation.

The biggest problem with the image at this point is that all the low values have been crushed to black. Using Blending Options, you can ramp off the effect of the Linear Light blur from the shadows:

1. Double-click the Blur Layer thumbnail (or select from the Layer Options flyaway) to bring up the Layer Style/Blending Options dialog (Figure 7.19).

2. Hold down the Option/Alt key and click the black-triangle slider in the Blend If: Gray area in the underlying layer to "split" it. Slide the right half of the triangle all the way to the right. This ramps the effect out of the low values and produces the image in Figure 7.20.

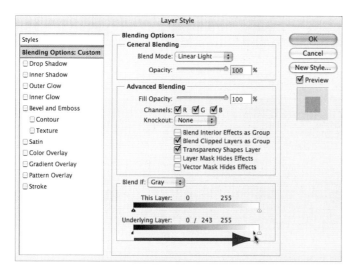

Figure 7.19
Use Blending Options to take
the effect off of the low values
by splitting the Black slider all
the way to the right.

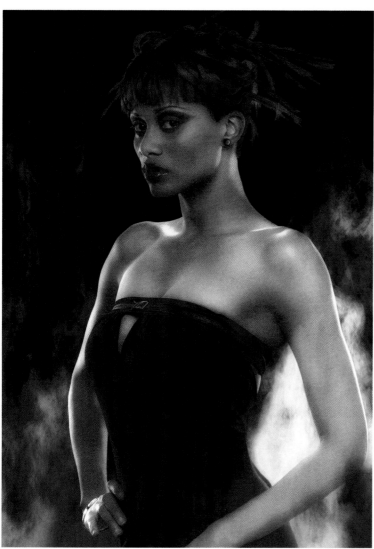

Figure 7.20 The shadow detail is back.

3. The biggest problem with the image is the pumpkin-colored skin. Let's take the saturation out of the Blur layer: select the Blur layer, hold down the Option/Alt key, and click the New Adjustment Layer icon. Choose Hue/Saturation and check Use Previous Layer To Create Clipping Mask (Figure 7.21). This causes the Hue/Saturation adjustment to be applied to the Blur layer before the Blur layer is applied to the background.

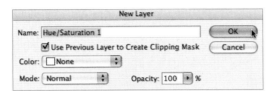

Figure 7.21 Create a clipping mask for the Hue/Saturation adjustment.

4. When the Hue/Saturation adjustment dialog appears, move the Saturation slider all the way to the left to −100. The result is the same as desaturating the Blur layer directly, but it allows you to fine-tune the effect while you are looking at the result combined with the Linear Light blur.

The final version uses a layer mask for the Blur layer to bring back the snappier highlight details in the original image (Figure 7.22).

The possibilities of this basic diffusion approach are limitless. Clearly, you can use it to go well beyond simulating traditional filter effects using digital techniques. The power of layers and Layer Apply modes can be utilized in many different ways. Let's look once again at some traditional blur effects for more inspiration.

Depth of Field Effects

Limited depth of field, where a very narrow plane of focus is used to provide visual interest, has a long tradition in portrait photography (Figure 7.23). The Japanese refer to the special quality of out-of-focus areas in a defocused lens as *bokeh*, and the subtle bokeh of certain lenses is very hard to simulate successfully with digital techniques. This portrait by Anthony Nex shows the bokeh effect most strongly at the upper-right corner in the hair and ear.

Figure 7.22 The Linear Light Blur layer has been desaturated, and the result has a fabulous tonal-modeling effect in the skin

A very common use for the limited depth-of-field bokeh is to throw a background out of focus to help separate the subject from a busy background. This shot of a young man has a background that's slightly out of focus (Figure 7.24). Ideally, it should be a little more out of focus, so we will use digital techniques to achieve this rather than reshoot.

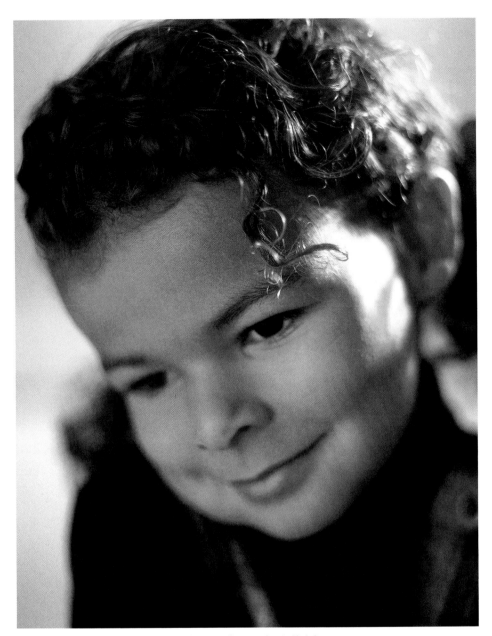

Figure 7.23 This beautiful child portrait by Anthony Nex shows true optical bokeh.

The basic strategy is to duplicate the background into a new layer, as we did for the diffusion techniques, blur this duplicate, and use a layer mask to hide the areas of the image that we'd like to keep sharp:

1. Duplicate the background to a new layer by dragging the Background thumbnail to the New Layer icon at the bottom of the Layers palette (Figure 7.25).

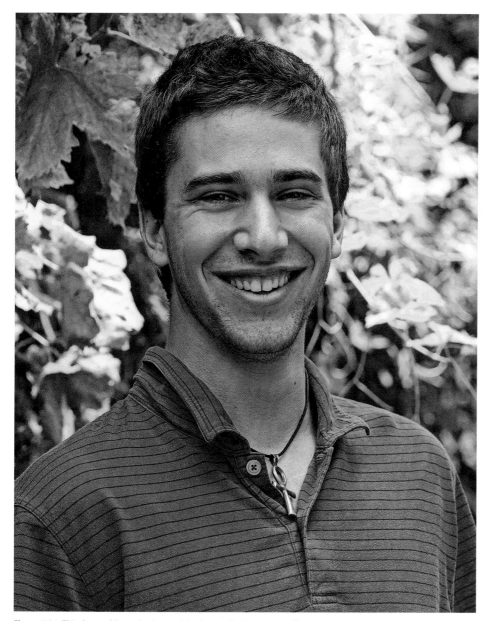

Figure 7.24 This shot could use a background that's just a little more out of focus.

Figure 7.25
Duplicate the background to
prepare for the blur.

2. Select a blur filter. You could use the venerable Gaussian Blur filter (Figure 7.26), but this blur effect has no sense of bokeh. Everything is blurred in a uniform manner; it doesn't look like an out-of-focus lens capture.

Gaussian Blur would serve the purpose, but we are looking for more than just utility here. Let's stop for a moment and examine the other possibilities. The Lens Blur dialog (Filter > Blur > Lens Blur, Figure 7.27) has a very large preview and a number of advanced options that help simulate a lens blur effect.

Faster and More Accurate check boxes provide an option for slower machines or especially large files where you might not want to wait the extra time for the effect to render. The difference between the two options is subtle; however, if you have a fast machine, there's no reason not to use More Accurate.

Figure 7.26 Gaussian Blur

Figure 7.27 Lens Blur creates a better simulation of lens blur.

Depth Map allows you to load an Alpha Channel mask to control where the blur is applied. This is sometimes a good option, but we're not going to take the time to build a mask for this example.

Iris is where you control the intensity and look of the effect; you can load different shapes meant to simulate the diffraction effects of the f-stop iris in a lens. This effect is most visible when there are small points of white highlights. The radius controls the intensity of the blur (higher radius = more blur). Blade Curvature and Rotation affect how the iris image is rendered when it is visible in the effect.

Specular Highlights allows you to keep the brightness level up in highlights. Digital blur effects combine all pixel values together such that shadows bleed into highlights, reducing the brightness. Real lens optical blurs do not do this because the dynamic range of the real world is thousands and sometimes millions of levels, whereas the 256 levels of a digital image cause highlights to absorb the blurred shadows and appear duller. The Brightness slider introduces brightness back into the highlights; Threshold sets the level at which this brightness is reintroduced.

Finally, because digital blurs can introduce banding, there is a **Noise** section where you can add banding-killing noise to the effect.

Despite all the sophistication of the Lens Blur filter, it still falls short of the subtle bokeh of real lens blur. Part of the magic of bokeh is the way real lens blur creates abstract geometrics and subtle double images. Notice the overlapping octagonal shapes in the real blur of Figure 7.28.

Figure 7.28 Real lens blur is not just soft; it contains lots of abstract shapes and double images.

Adobe introduced a number of new blur filters in Photoshop CS2, and one of the most interesting has great potential for simulating lens bokeh. The Shape Blur filter (Filter > Blur > Shape Blur) allows you to load a library of shapes to create abstract geometrics and double imagery based on a specific shape. The result can be used to

approximate bokeh (Figure 7.29). Experiment with the various shapes to find a look that works with your specific image. Outline shapes have a more pronounced effect than solid shapes.

You can also use Motion Blur (Filter > Blur > Motion Blur); this filter creates an effect more like camera shake, but it is still a bit more interesting than Gaussian blur (Figure 7.30).

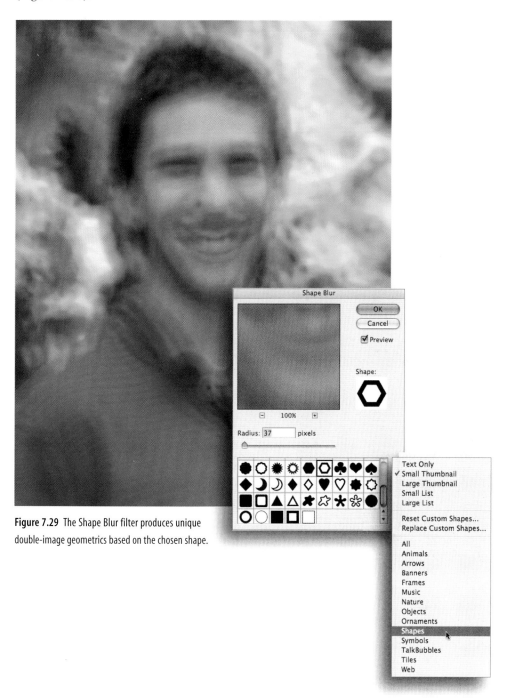

Figure 7.29 The Shape Blur filter produces unique double-image geometrics based on the chosen shape.

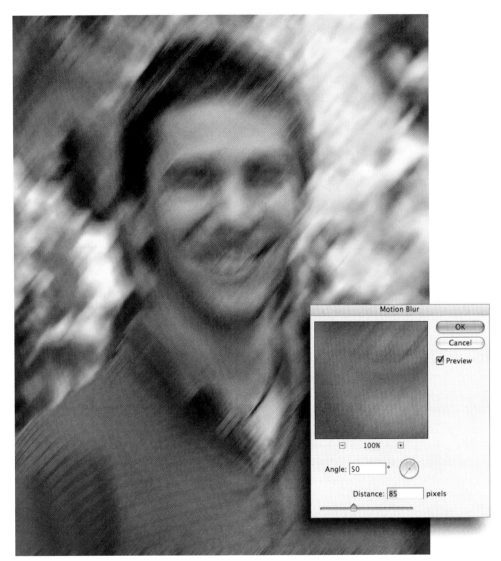

Figure 7.30 Motion Blur looks more like camera shake.

Let's return to the process of adding bokeh to your image.

3. Add a Blur layer, using your chosen blur method.

4. Make a mask for the Blur layer by clicking the Layer Mask icon at the bottom of the Layers palette. Then paint into the mask with black over the subject to hide the blur and reveal the sharp underlying image (Figure 7.31).

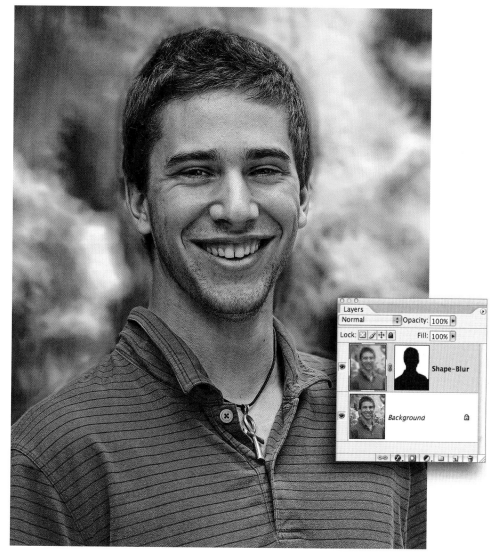

Figure 7.31 Use a layer mask to hide the blur on the subject.

5. At this point, the image exhibits a problem that is common when the background is artificially blurred: there is a faint dark halo around the subject's head where the subject has been blurred and has spread into the background. You can fix this by cloning into this halo from the blurred background. Although this correction is a bit more involved, you can also make a mask for the subject to separate it from the background before you blur the duplicate. I used a path to generate a selection before clicking the New Layer Mask icon at the bottom of the Layers palette. You now have a duplicate layer with the subject masked in the top layer (Figure 7.32).

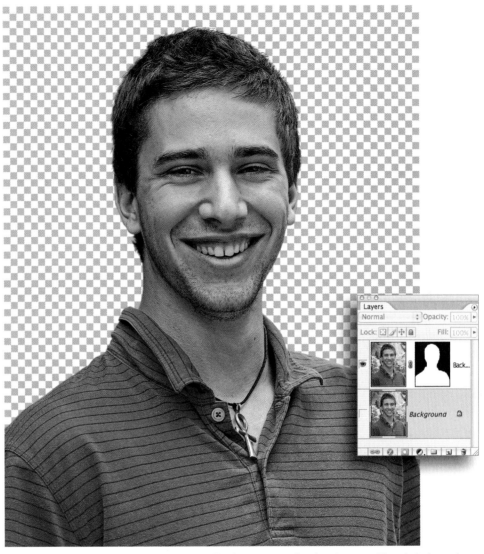

Figure 7.32 The background visibility has been turned off so that you can see the subject is separated from the background.

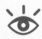

Note: For readers who might have a hard time with basic masking, I supplied this image on the companion CD with an alpha channel mask already prepared for use in a layer mask. To use this as a mask, go to the Channels palette and locate the alpha channel at the bottom (it is called mask), hold down the ⌘/Ctrl key, and click the alpha channel to load it as a selection. I also included the path that you can find in the Paths palette.

6. Turn off the visibility of the top layer (with your masked subject) and select the Background layer. You will blur the background rather than the top layer; but before you do, clone into the edge of the subject. You want to make sure its edge won't bleed into the background once you blur it (Figure 7.33). You don't have to be extremely careful because you're going to blur the background anyway.

7. When you finish cloning, blur the background and turn on the top layer (Figure 7.34).

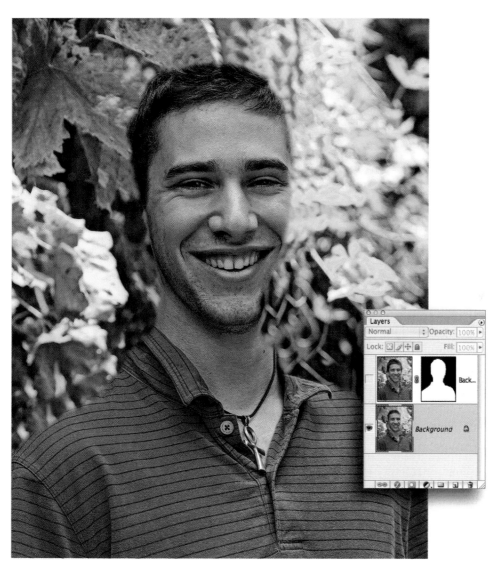

Figure 7.33 Clone into the edge of the figure to prepare for the blur.

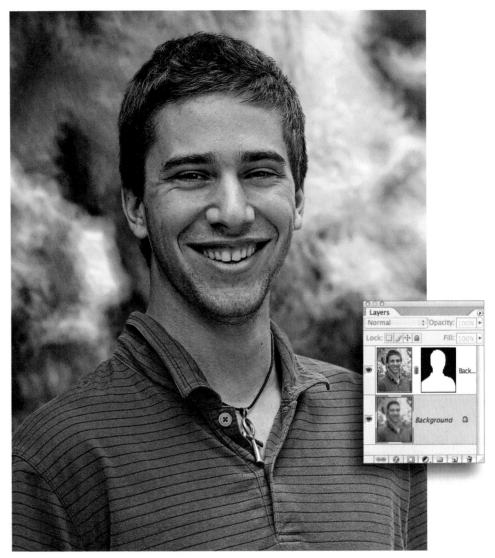

Figure 7.34 The Masked Subject layer sits on top of the blurred background.

My final version (Figure 7.35) combines several different blurs, blending parts together to create a more complex bokeh. I blended back some parts of the original background (I saved the original in the Background layer and only blurred duplicates) as well as Lens Blur, Shape Blur, and Motion Blur.

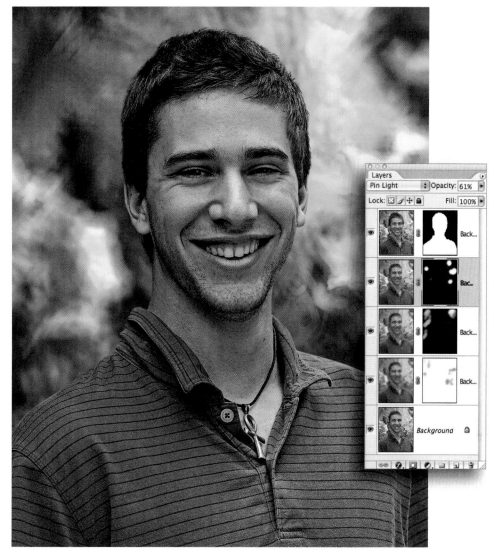

Figure 7.35 The final version has a more complex background.

This might seem like a lot of trouble to go through just to blur the background—and it is. However, I still feel that the digital bokeh version is more beautiful than if I simply ran a Gaussian Blur on the background (Figure 7.36).

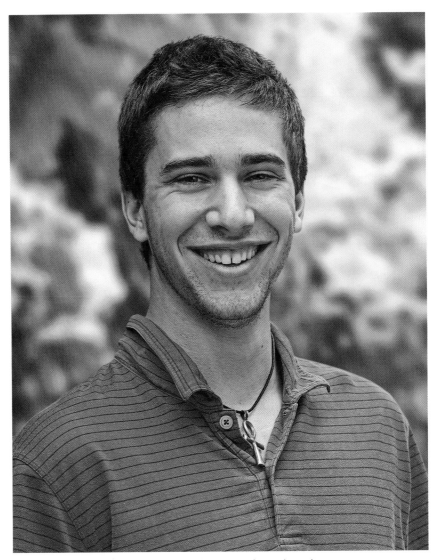

Figure 7.36 The Gaussian Blur background looks fake: it's too uniform and smooth.

Lens Tilt Effect

Another popular traditional technique to achieve a limited plane of focus is a lens tilt effect. Usually done with a view camera, it involves deliberately tilting the lens to place the plane of focus through a narrow area, such as the eyes, and throwing other areas more seriously out of focus than limited depth of field would normally accomplish. This is another effect that is difficult to simulate digitally. Figure 7.37 is an example of a digitally simulated lens tilt effect by Anthony Nex.

Figure 7.37 The focus was placed on the eyes and mouth by selectively blurring the rest of the image. (Photo by Anthony Nex)

Let's use the image in Figure 7.38 to look at one method to achieve this effect. I'd like to place the plane of focus through her eyes. If I were using a view camera, I would tilt the lens forward and adjust the focus until only the eyes were sharp. The top of her head would go out slightly, and the focus would fall off gradually down her body until it was very soft by her waist.

Again, the basic approach to digital blurs is to duplicate the background and blur the copy so you can blend back to the original if necessary (Figure 7.39).

Figure 7.38 Original sharp image

Figure 7.39
Duplicate the background
to prepare for the blur.

We want to achieve a gradual transition from sharp to blurry; Lens Blur has the tools to create this effect using only one dialog box. To prepare for the effect, however, you'll need to make a special gradient mask. Add a layer mask to the duplicate layer by clicking the Layer Mask icon at the bottom of the Layers palette. The idea is to create a gradient in the mask that is black where the eyes are and gradually transitions to white at the lower third and lightens toward the top of the head (Figure 7.40). The black area will be protected from the application of the blur, white will receive the full blur, and gray areas will be partially blurred.

Figure 7.40 The gradient to be used for the layer mask

To create the gradient, first make sure the layer mask is selected, and then select the Gradient tool in the Tool palette (Figure 7.41). Set the Tool options with black as the foreground color and choose the Foreground To Transparent gradient (Figure 7.42).

Figure 7.41 Select the Gradient tool.

Figure 7.42 Choose the Gradient options.

Place the cursor at the eyes, hold down the Shift key (to constrain the direction to 90 degrees), and drag down to about her waist. Switch the foreground and background colors so that white is the foreground color (press the X key) and drag from the top of her head to her eyes (Figure 7.43).

You can turn off the bottom layer to visualize the parts of the image that will receive the blur (Figure 7.44). The more transparent areas will receive less blur. If you think some areas should be blurrier, you can revise the mask by painting into it with white. The more visible an area is, the more it will be affected.

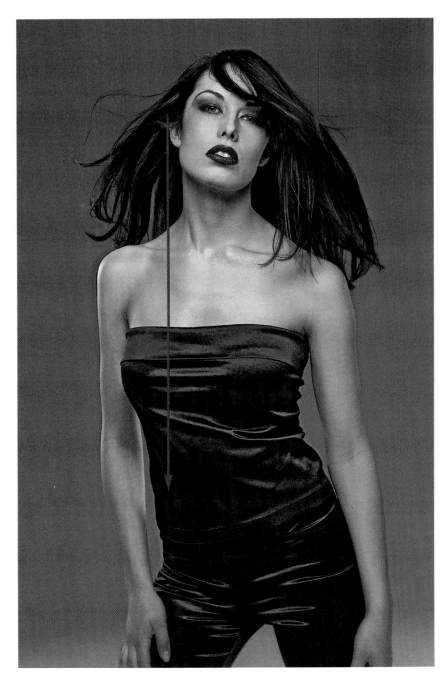

Figure 7.43 To create the gradient, drag into the layer mask in the direction of the arrows.

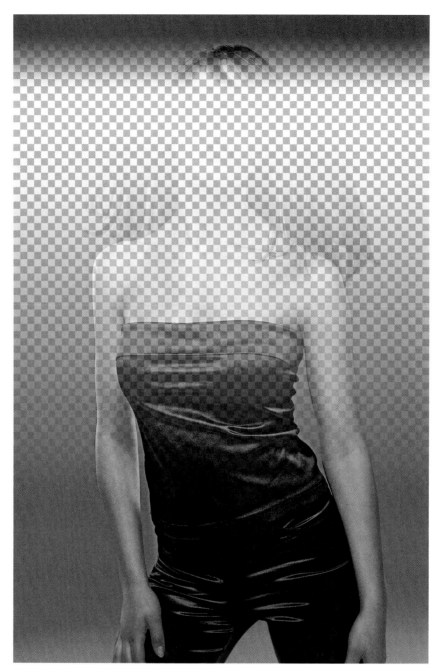

Figure 7.44 The more visible parts of the image will be more strongly affected by the Lens Blur filter.

Select the Image thumbnail in the Layers palette (so that the mask is no longer selected) and select the Lens Blur filter (Filter > Blur > Lens Blur). See Figure 7.45.

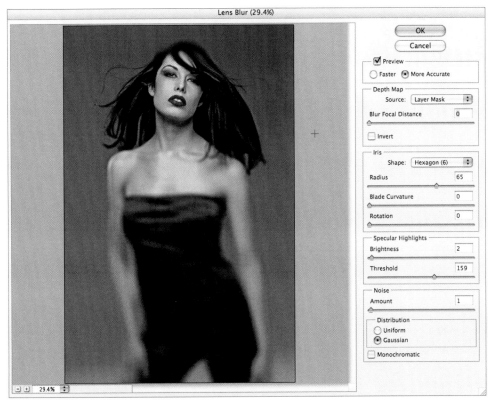

Figure 7.45 The Lens Blur dialog controls the blur effect.

Select Layer Mask in the Depth Map drop-down menu. The gradient you just created will be used to control where the blur is applied to the image. The Blur Focal Distance slider determines the value where the blur will start; leave it set at zero (black in the mask) to begin and gradually increase the blur until it's at full strength at 255 (white in the mask). Different settings will push the blur into different areas of the mask and can lead to unexpected results. You can use this to fine-tune where the blur starts and stops in the image. In this example, because there are essentially two gradients in the mask, the blur will be difficult to control successfully, so you should leave the slider at zero. Set the Radius slider to the desired blur strength and add a small amount of noise to the image to control possible banding. Click OK when everything is set and you're happy with the preview.

When you return to the image, you can throw away the layer mask—it is unnecessarily masking part of the effect. Drag the layer mask from the top Blur layer to the Trash icon at the bottom of the Layers palette, and select Delete when you are asked to apply the mask. Now you can see the full extent of the blur (Figure 7.46). Unlike using the layer mask to partially hide a one-level blur in the layer, the Lens Blur is applied at progressively higher intensity depending on the value in the mask.

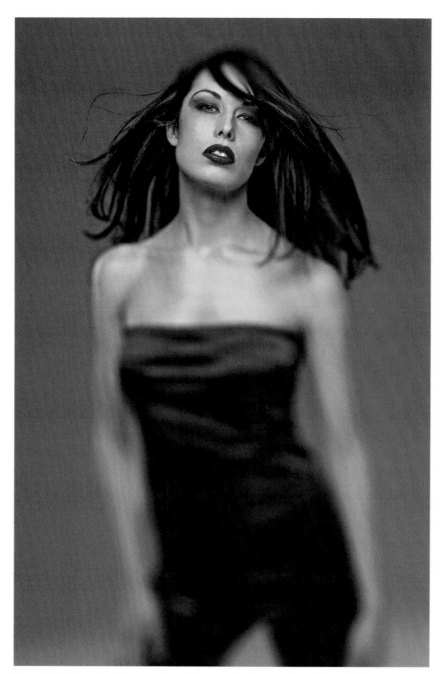

Figure 7.46 The Lens Blur filter was used to apply a progressive blur to simulate the lens tilt effect.

If any areas in the image are too blurry, you can selectively mask them off with a New Layer mask to reveal the sharp image underneath; I did this with the lips. Reduce the opacity of this progressive Blur layer to generate a progressive diffusion effect. You can combine diffusion with the progressive blur for all kinds of interesting variations. Here is one that uses Overlay blur diffusion (Figure 7.47).

Figure 7.47 Overlay Diffusion adds another dimension to the effect.

Film Grain and Mezzotint

Digital photography is known for being smooth and grainless. Mostly this is considered to be an advantage. Still, there is something to be said for the subtle pointillist quality of film grain, and there are times when grain or noise can be used for artistic effects. Grain or noise can also be handy for eliminating banding and smoothing gradients. I'm going to look at a few examples to illustrate the best techniques for adding grain to a digital image.

The image in Figure 7.48 was captured digitally using a special Lensbaby soft-focus lens. The selective focus of the image enhances the mood and conveys a sense of mystery, but it still seems just a little too soft to me. Some selective sharpening helps (we'll go over sharpening in Chapter 8, "Preparing for Print"), but the image could still use something else (Figure 7.49).

Figure 7.48 This shot of an oud player is just a little soft.

Figure 7.49 The sharper version still needs some help.

Grain can also enhance the apparent sharpness of an image, so let's add some to this image and see what happens. Noise is the digital equivalent of grain, and most people would simply use the Noise filter (Filter > Noise > Add Noise). However, film grain does not look the same as digital noise. If you simply run an Add Noise filter on the image, you'll get Figure 7.50—a sort of dirty haze that reduces the image contrast because light noise covers the shadows and dark noise covers the highlights.

Figure 7.50 If you run the Noise filter directly on the image, you'll get a haze that reduces the contrast of the image.

To combat this, use the following technique. Hold down the Option/Alt key and click the New Layer icon at the bottom of the Layers palette. This will bring up the New Layer Options dialog (Figure 7.51). Make sure you change the Mode to Overlay and check the Fill With Overlay-Neutral Color (50% Gray) check box.

Figure 7.51

Set the New Layer Mode to Overlay and Fill With Overlay-neutral color.

There will be no change in the image because Overlay will affect the image only when values in the layer deviate from gray. Now, run the Add Noise filter on this gray Overlay layer. Zoom the image to 50 percent magnification to get a better sense of how the noise level will look in print.

Overlay noise looks a lot more like film grain: the noise ramps off in the shadows and highlights. This approximates what happens when grain plugs up in the shadows

and thins out in the clear highlights. The Noise Dialog options control the character and intensity of the noise. The Amount slider controls the intensity, but the radio buttons have a large impact on the look of the noise. Uniform noise is smoother and more even (Figure 7.52).

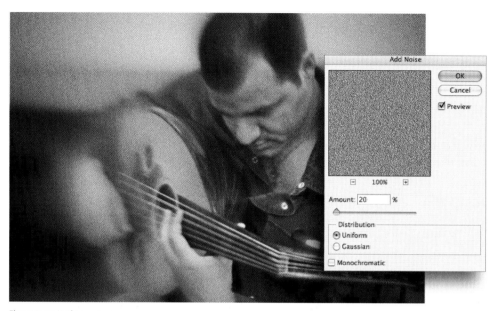

Figure 7.52 Uniform noise is more even.

Gaussian noise is clumpy and more organic looking (Figure 7.53).

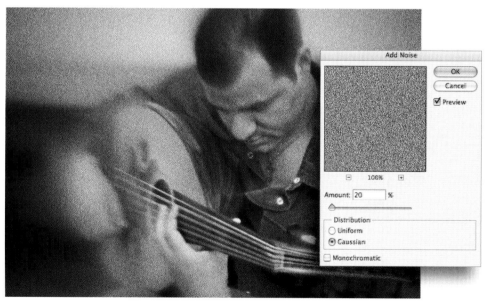

Figure 7.53 Gaussian noise is clumpy and looks a little more like high-speed film grain.

The Monochromatic check box creates noise that is even clumpier and doesn't have the random color component. Perhaps best suited to B+W imagery, it has a more-intense contrast quality (Figure 7.54).

Another strategy is to add a high level of noise but reduce the opacity of the Overlay layer (Figure 7.55).

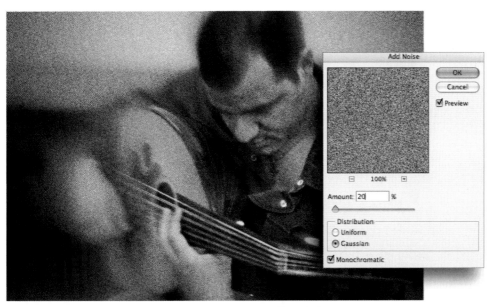

Figure 7.54 Monochromatic noise has a more aggressive look without additional color.

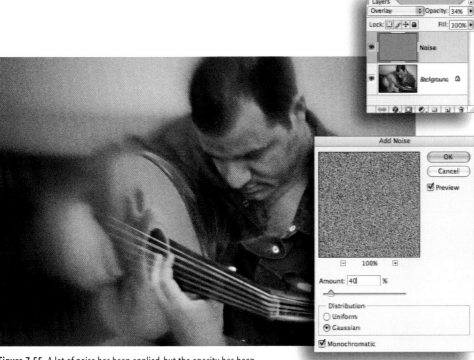

Figure 7.55 A lot of noise has been applied, but the opacity has been reduced to bring the noise level down.

Let's look at some more noise techniques with this colorful image by Aaron Rapoport (Figure 7.56).

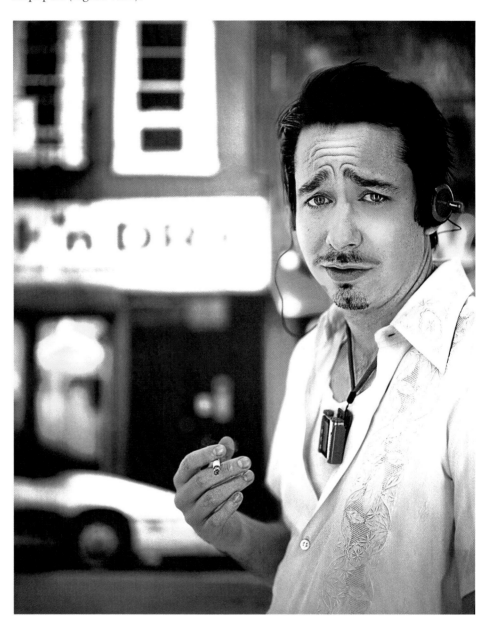

Figure 7.56 The original image by Aaron Rapoport has a low level of noise.

Sharp Uniform color noise gives the image the look of a fine art mezzotint (Figure 7.57).

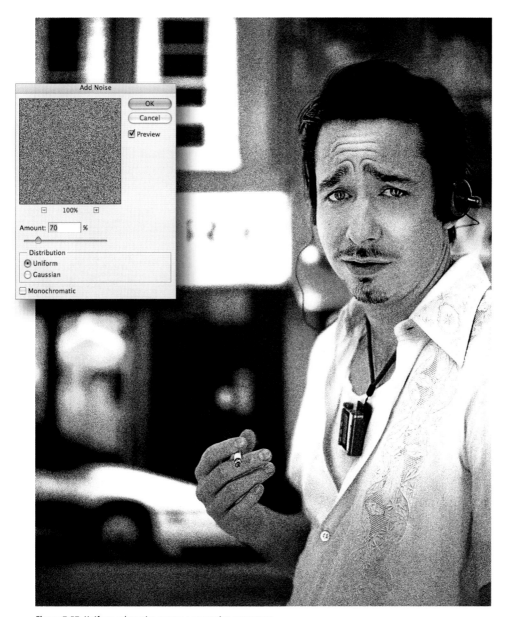

Figure 7.57 Uniform color noise creates a mezzotint appearance.

If you want something more like color negative noise, you can blur the noise slightly. To take the edge off the noise, run the Gaussian Blur filter at less than 1 pixel (Figure 7.58).

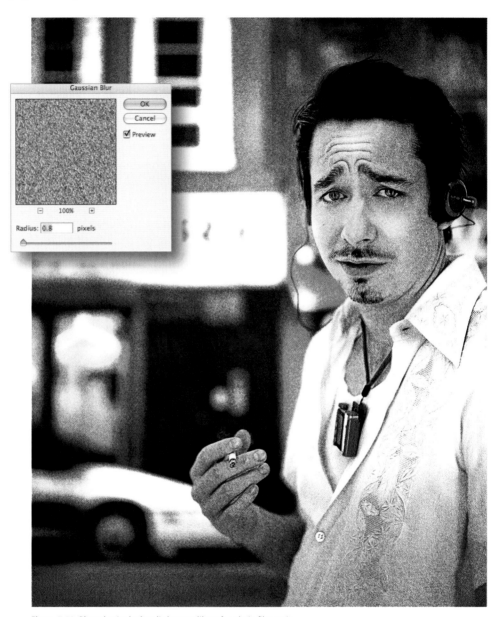

Figure 7.58 Blurred noise looks a little more like soft-gelatin film grain.

Change the Layer mode from Overlay to Soft Light for a more subdued effect (Figure 7.59).

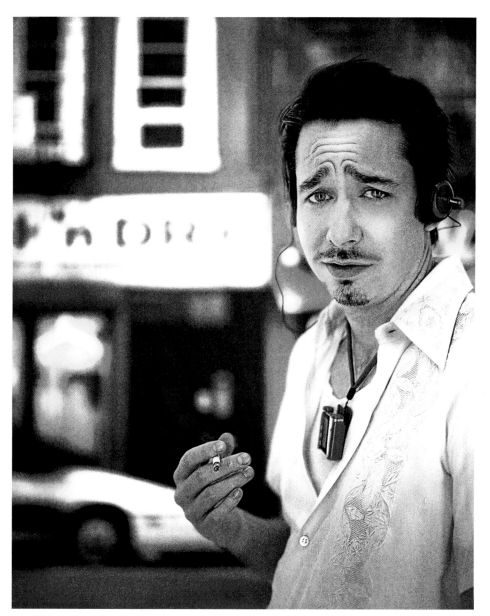

Figure 7.59 Soft Light gives a more subdued effect.

Apply a Motion Blur on the Noise layer to create an interesting illustration variation. Choose Filter > Blur > Motion Blur and apply a 100-pixel diagonal blur. Then apply Unsharp Mask (Filter > Sharpen > Unsharp Mask) to increase the contrast for an interesting texture effect.

Figure 7.60 Sharpened Motion Blur noise creates an interesting illustrative effect.

Noise Patterns

A very convenient way to apply noise is to use saved patterns. If you use noise effects a lot, make a noise pattern and save it for later use. Create a new document with 1000×1000 pixels. Fill the document with 50 percent gray and run a noise filter directly on the document. This will be the basis for a repeating pattern. You'll have to make sure the edges tile together so that the pattern repeats seamlessly. Select Filter > Other > Offset. Enter **500** for Horizontal Pixels Right and **500** for Vertical Pixels Down (Figure 7.61).

Figure 7.61

Use Offset to place the edges of the document in the center, where you can check for seams.

This will place the original frame edges in a cross through the center of the image. If you are lucky, you won't see the edges as a seam. If you do, you'll have to clone into the seam to break it up so the transition is invisible. Run the Offset again to return the image to its starting configuration. Select All (⌘+A/Ctrl+A) and choose Edit > Define Pattern. Name the new pattern something meaningful so you can use it later.

To use this pattern for grain/noise effects, simply create a new Pattern adjustment layer (click the Adjustment Layer icon at the bottom of the Layers palette), select your noise pattern, and change the Mode to Overlay (Figures 7.62 and 7.63).

Figure 7.62

Patterns can be used as adjustment layers.

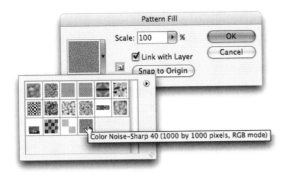

Figure 7.63

Select your pattern from the Pattern Fill dialog by clicking the triangle next to the pattern thumbnail.

The beauty of adjustment-layer patterns is that you can scale the noise at any time by double-clicking the Adjustment Layer thumbnail in the Layers palette to bring up the Pattern Fill dialog (Figure 7.64).

Figure 7.64

Patterns can be scaled up or down at any time.

Once you've made a collection of different noise patterns, remember to save them as a set. This will ensure that they won't be lost after a crash and can be reloaded and transferred to a new version of Photoshop. Choose Edit > Preset Manager, choose Patterns in the drop-down, click one of the Pattern thumbnails, and click Save Set (Figure 7.65).

Figure 7.65

Remember to save your patterns.

Cross-Processing

Another traditional technique comes from the world of chemistry. *Cross-processing*, a technique that is very popular with fashion photographers, involves processing either transparency or negative film in the opposite type of chemistry. The most popular type of cross-processing uses transparency or slide film processed as a negative. With this technique, photographers rate their slide film at high ISO (plus two stops or so) and then process the film in C-41 or color negative chemistry. This results in a grainy negative with very saturated colors and no orange base color. When printed, the images have lurid colors with odd crossover colors in the shadows and lots of contrast. The exact effect is very hard to predict, and many photographers have their own secret way of exposing and printing the cross-process look.

This is another difficult effect to simulate digitally, but I have developed a method that gives you a lot of flexibility and control with the same kind of happy accident discovery as the traditional wet chemistry technique. This technique is fairly involved, so follow along closely as we go over the technique using this image (Figure 7.66).

1. Duplicate the background to a new layer by dragging the thumbnail to the New Layer icon at the bottom of the Layers palette (Figure 7.67).

Figure 7.66 The original digitally captured image

Figure 7.67
Duplicate the background to a layer.

2. We're going to mimic slide film processed in negative chemistry, so let's turn the image into a negative. With the new layer selected, press ⌘+I/Ctrl+I to invert the values in the image (Figure 7.68).

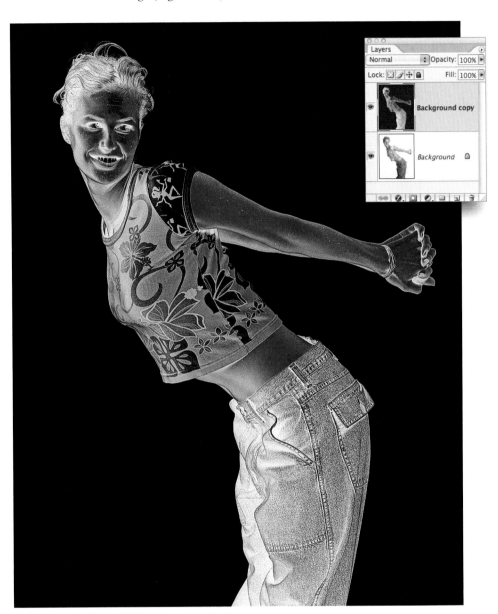

Figure 7.68 Invert the image in the top layer.

Figure 7.69 Set the Layer options to create a clipping mask for the Levels adjustment.

3. To make it look more like a real color negative, hold down the Option/Alt key and click the Adjustment Layer icon to select a Levels adjustment. In the resulting Layer Options dialog, check the Use Previous Layer To Create Clipping Mask (Figure 7.69) box. When the Levels dialog opens, set the Output Levels in the Red channel, Black slider to 90, in the Green channel, Black slider to 40, and in the Blue channel, White slider to 180. This results in a good approximation of a color negative (Figure 7.70).

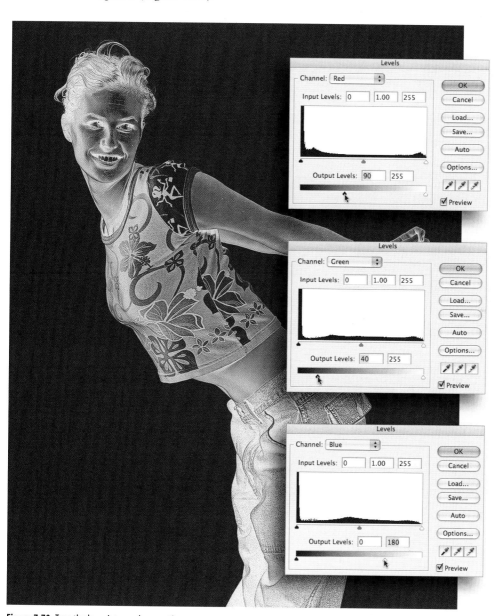

Figure 7.70 Turn the layer into a color negative.

4. Reselect the Background Copy layer, rename it **Negative,** and change the Mode to Difference (Figure 7.71).

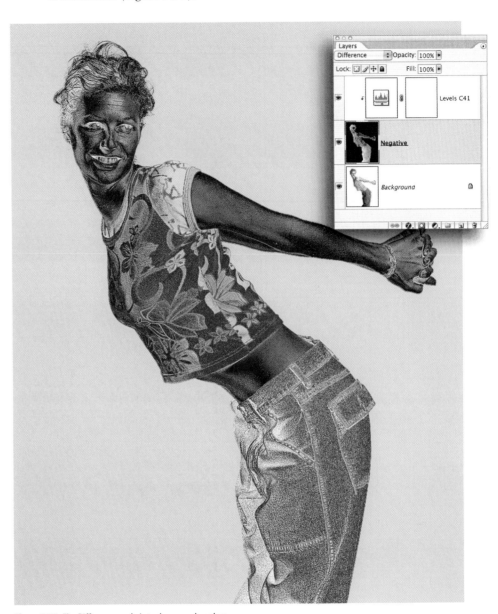

Figure 7.71 The Difference mode introduces wacky colors.

5. Duplicate the Background layer again, drag it to the top of the layer stack, and change the Mode to Luminosity (Figure 7.72). The original tonal values are restored, but with odd color crossovers.

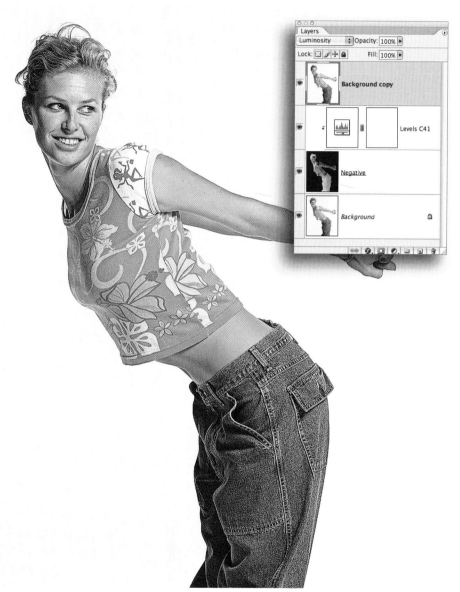

Figure 7.72 Duplicate the background again and apply its luminosity to the underlying layers.

6. Make a Curves adjustment layer on top of everything, but simply click OK without changing anything. Change the Mode to Overlay (Figure 7.73). Overlay applies the normal image on top of itself, resulting in the enhanced contrast that is typical of the cross-processed look. The image is a little light, but we'll fix that in the next step.

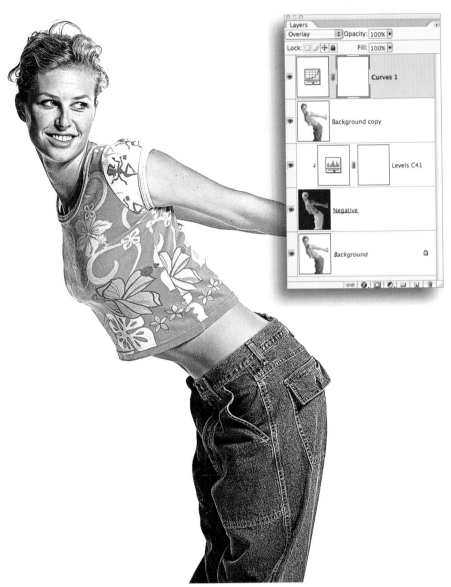

Figure 7.73 By overlaying normal (unaltered) Curves, you can enhance the contrast.

7. At this point, you can play around with the Overlay Curves to get the tone, color, and contrast you want for the effect (Figure 7.74).

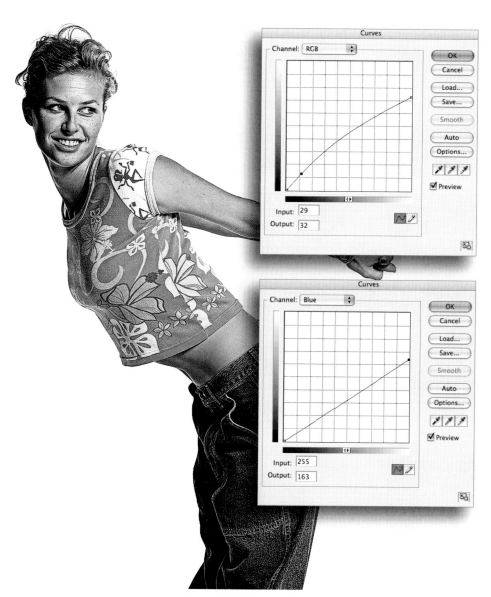

Figure 7.74 Adjust the Overlay Curves to get the look you're after.

8. You can also return to the Levels layer and tweak the effect of the color negative to modify the colors. Everything is available for revision—you can change layer opacities, change the Overlay layer to Soft Light, Hard Light, or whatever, and watch what happens. You can put a Hue/Saturation adjustment layer at the top to further modify the color (Figure 7.75).

9. Because the effect is created in layers, you can mask off specific parts of the image. Select the top layers and place them in a group (Figure 7.76). Add a layer mask for the group and paint out the effect where you want to bring back the original image, as I did for her face and arms (Figure 7.77). The chapter opener is another example where a cross-process look was masked from the face.

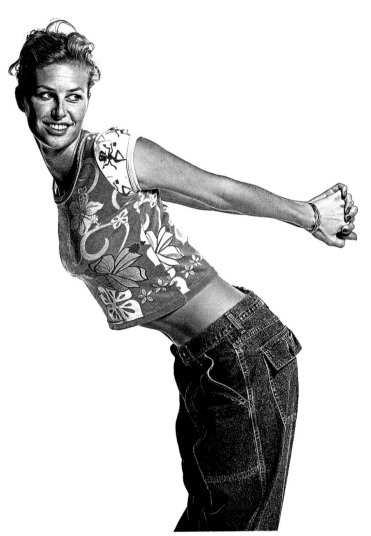

Figure 7.75 Tweak the Overlay Curves and the Levels layer; change the Modes to create different looks.

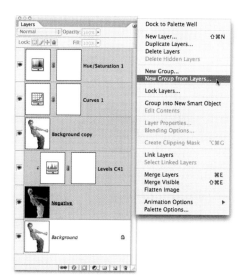

Figure 7.76
Group the layers in order to
mask them.

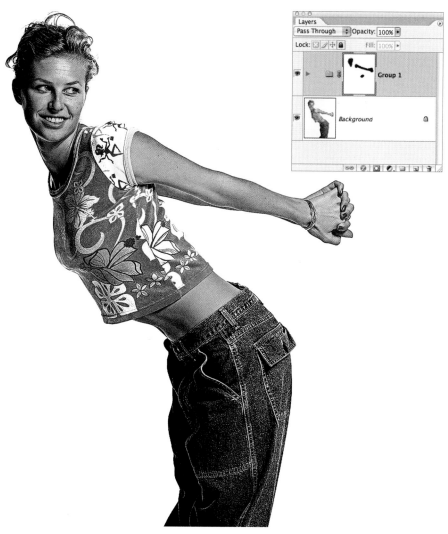

Figure 7.77 The effect has been masked from the face and arms.

The cross-process look doesn't have to be extreme; you can use it to simply generate some cross-over shadow colors and subtly alter hues for an interesting look (Figures 7.78 and 7.79).

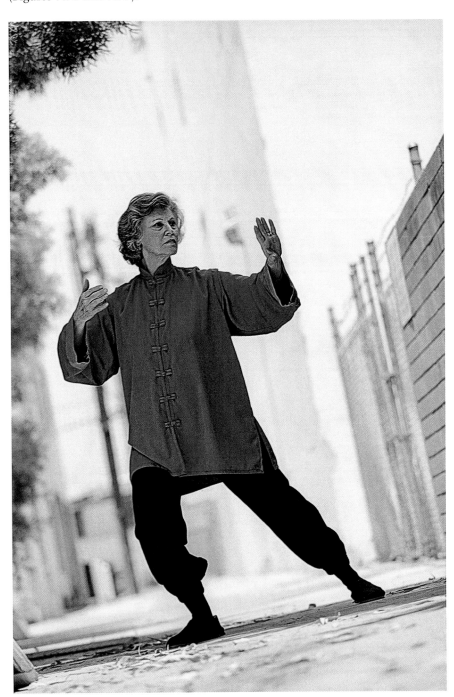

Figure 7.78 The original tai chi lady by Ken Chernus

Figure 7.79 The cross-process version shifts the colors in the background and on the jacket.

Tattoos

Tattoos can provide some interesting challenges. In many cases, photographers simply accept what the camera captures. Photographing tattoos is just like photographing a normal subject (Figure 7.80). Making sure the tattoos have as much color and contrast as possible becomes very important when the clients are the ones with the tattoos. They are often more interested in how the tattoos render rather than the overall impression of the photographs. Let's look at a few tricks to enhance the tattoos on this subject.

Figure 7.80 The tattooed subject is treated just like any other portrait model.

First, duplicate the background into a new layer. Tattoos almost always look more faded than their owner would like. For this project, the black lines of the tattoo need to appear darker. Change the Mode to Multiply to get the changes in Figure 7.81.

The tattoos are darker, but so is everything else. We need to keep the un-tattooed skin from getting darker. Double-click the Multiply layer to bring up the Layer Styles/ Blending Options dialog. Change the Blend If drop-down to Red and move the White slider (in either layer) to the left until the lighter skin from the underlying layer starts to appear (Figure 7.82).

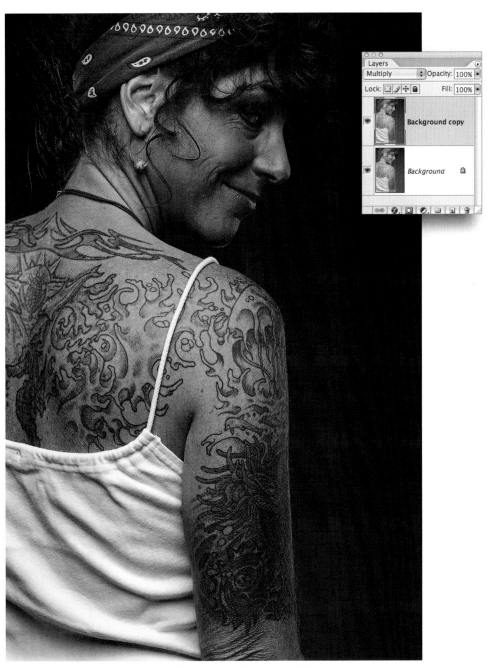

Figure 7.81 Duplicate the background and multiply it over itself. Everything will darken.

To soften the harsh transitions, reduce the posterized look, and bring back more of the lighter skin, split the slider. Hold down the Option/Alt key and push the left half of the slider to the left until most of the lighter skin appears (Figure 7.83).

Hide this whole layer with a layer mask: hold down the Option/Alt key and click the Layer Mask icon at the bottom of the Layers palette. This will create a Black Layer mask and hide the effects of this layer. Select the Brush tool and, using a low opacity, gradually brush over the tattoo with white (into the mask) to darken the lines. Some

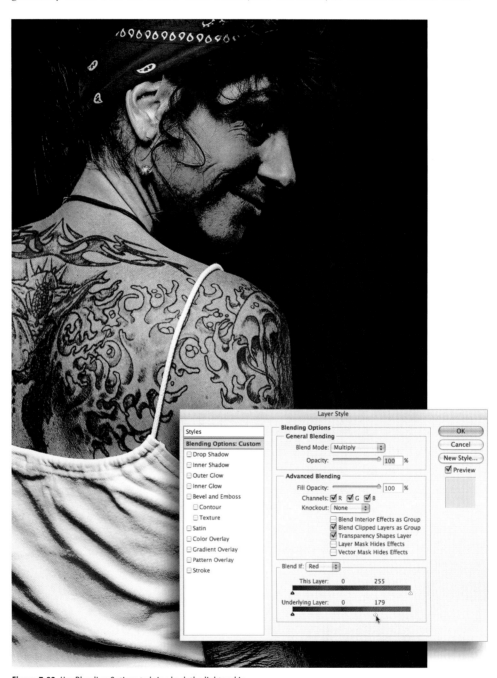

Figure 7.82 Use Blending Options to bring back the lighter skin.

areas will need to be darkened more than others; the more solidly colored section on her arm won't need to be darkened as much. Build up slowly and try to even out the darkness in the lines (Figure 7.84).

If you want more darkening, you can apply a darkening Curves adjustment to the layer as you look at the combined result. The lines are certainly darker now, but I'd also like to enhance the colors and add more saturation. I don't want to add any saturation to the skin color, however. To achieve this, we'll use a trick in the LAB color space. Choose Image > Duplicate and check Duplicate Merged Layers Only in the dialog (Figure 7.85).

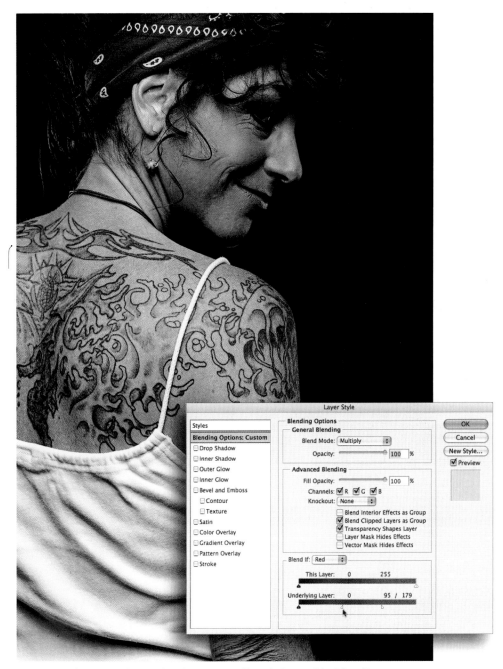

Figure 7.83 Split the Blend slider to soften the transition and bring back more of the lighter skin..

You'll get a duplicate document that is the result of the work done so far. Change this document to LAB (Image > Mode > Color). LAB is a great color space for manipulating color saturation. Make a Curves adjustment layer by selecting from the Adjustment Layer icon at the bottom of the Layers palette. Select the *a* channel in the

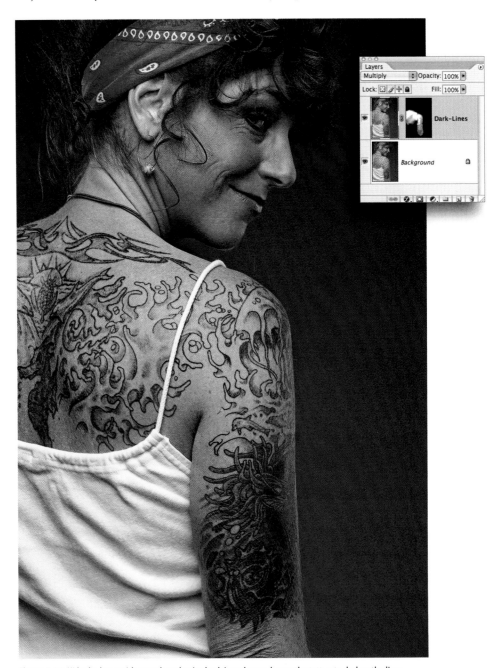

Figure 7.84 Hide the layer with a mask, and paint back into the mask over the tattoo to darken the lines.

Figure 7.85

Duplicate the document and check Duplicate Merged Layers Only.

Channel drop-down. Hold down the ⌘/Ctrl key and click in the image on an area of light skin; this will place a point on the *a* curve where the color of skin lives. We will leave this point unchanged and steepen the curve above and below that point to increase the saturation in every color that is different than the color of skin. Pull the curve into a pronounced S-shape without moving the original point (Figure 7.86).

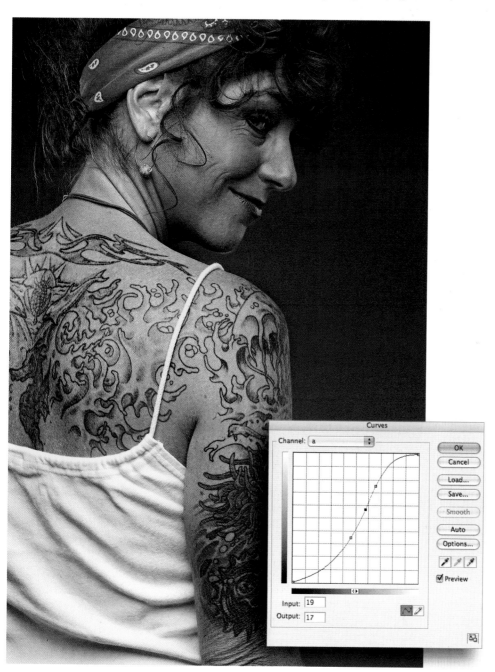

Figure 7.86 Make a Curves adjustment in the *a* channel to increase saturation in the reds and greens. The center point in the curve is the anchored skin color.

Increasing the contrast in the *a* channel amplified the saturation in the reds and greens. Even though you anchored the skin color with a point, some additional red crept into the skin color. To remedy this, you need to flatten the curve through that center point. Place two more points on the curve near the original anchor point and drag them to flatten the line near that point (Figure 7.87).

Repeat the procedure for the *b* channel and to produce Figure 7.88.

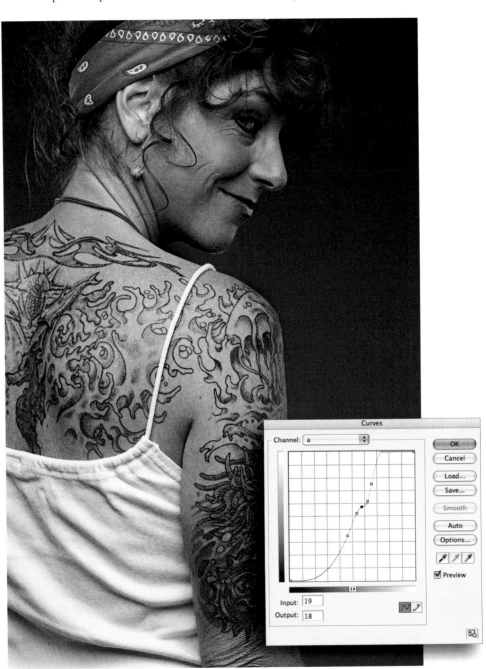

Figure 7.87 Flatten the curve through the anchor point to fix the skin color.

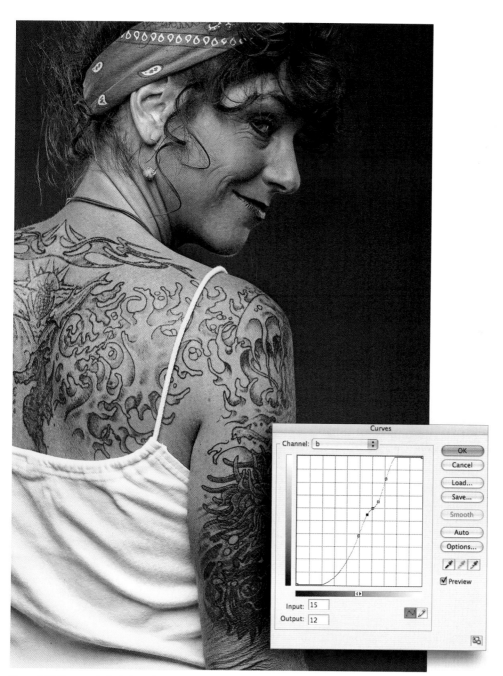

Figure 7.88 The curve in the *b* channel amplifies the saturation of the blues and yellows.

This amount of saturation is needed only in the tattoos, not everywhere. Hide the Curves adjustment by inverting the layer mask. Make sure the mask for the Curves adjustment is selected in the Layers palette, then press ⌘+I/Ctrl+I. This changes the layer mask for the Curves adjustment to black. All you have to do is paint white over the colored areas of the tattoo in the mask (Figure 7.89).

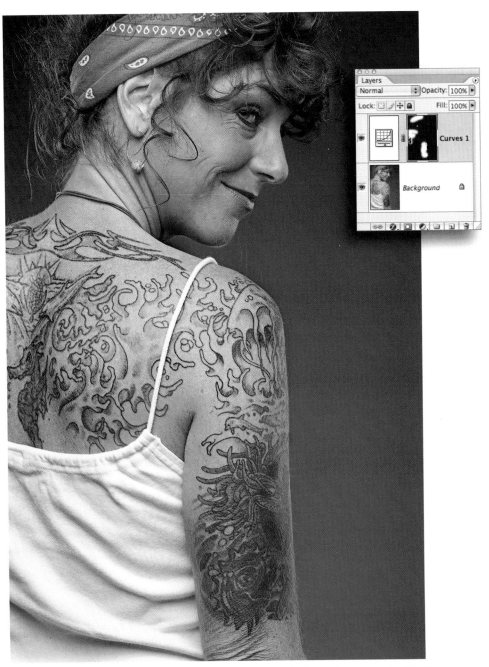

Figure 7.89 Normal color is restored everywhere except where you paint in the Curves adjustment mask with white.

At this point, you could stop, convert the LAB document back into your regular RGB workspace, and call it a day. I like to save a layered version with everything in it so I can revise things later if necessary. For maximize flexibility, put everything into one document with all layers intact. First, save the LAB document with the Curve. Then flatten the LAB document, hold down the Shift key (this ensures that the documents will be aligned properly), and drag this document on top of the original RGB document. Change the Mode to Color so you can reduce the opacity of the top layer if the saturation is too much or revise the interaction of the underlying layers if you need different contrast (Figure 7.90).

Figure 7.90
This layer structure allows for maximum flexibility.

Sometimes, even after these steps, you might want to add just a bit more color to a specific area. This detail shows the tattoo before enhancement (Figure 7.91).

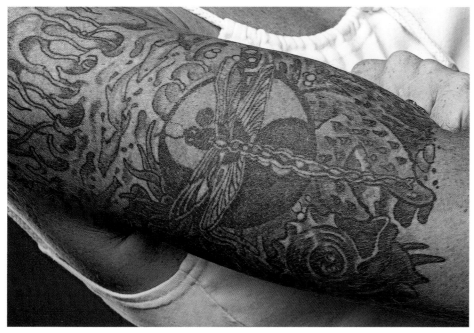

Figure 7.91 The tattoo before enhancement

After contrast and LAB color saturation, the tattoo could still use a little more green in the yin-yang design (Figure 7.92).

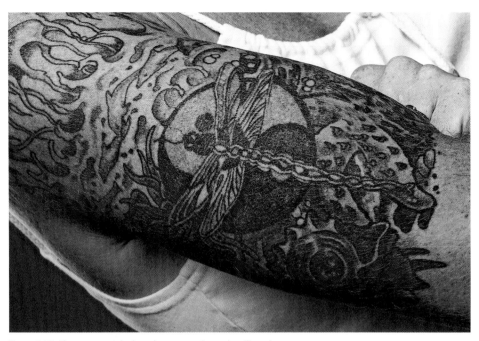

Figure 7.92 After contrast and color enhancement, the tattoo still needs more.

You can make a new, empty Color layer on top of everything else and paint into that layer with color to add more color to the image (Figure 7.93).

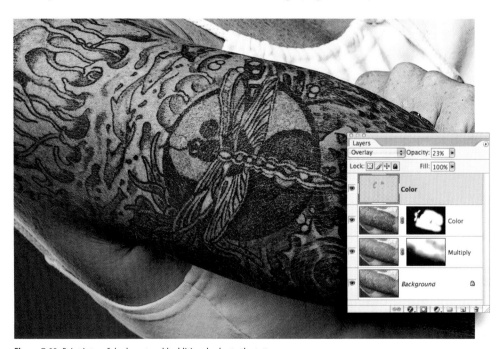

Figure 7.93 Paint into a Color layer to add additional color to the tattoo.

Faking Tattoos

What if you want to know what a tattoo would look like before you go to all the trouble (and pain) of having one applied for real? Yes, you could have a henna tattoo, but you couldn't necessarily see the tattoo the way others could. There are other uses for fake tattoos in photographs as well; fake tattoos have been used in movie posters. It is actually easier to blend a tattoo image into a photograph than it is to enhance an existing tattoo.

We'll start with this shot of a young woman's back (Figure 7.94).

There are many sources for tattoo designs, including some online. This dragon design was downloaded as a JPEG file (Figure 7.95). I applied a small amount of Overlay noise to smooth it out and add a sense of skin texture.

Figure 7.94 Ready for the application of a tattoo

Figure 7.95 A tattoo design (©2005 TattooJohnny.com)

Drag the dragon-design document on top of the woman's back and change the mode to Multiply (Figure 7.96). The tattoo ink only makes skin darker; therefore, multiplying anything darker than white in the Tattoo layer makes the underlying image darker too. As a result, the tattoo automatically blends in with the image.

Reduce the Layer opacity a bit, and resize the Tattoo layer: choose Edit > Free Transform (or press ⌘+T/Ctrl+T) and drag the corner handles until the tattoo is sized correctly. At this point, the wings of the dragon will extend past the woman's right shoulder (Figure 7.97).

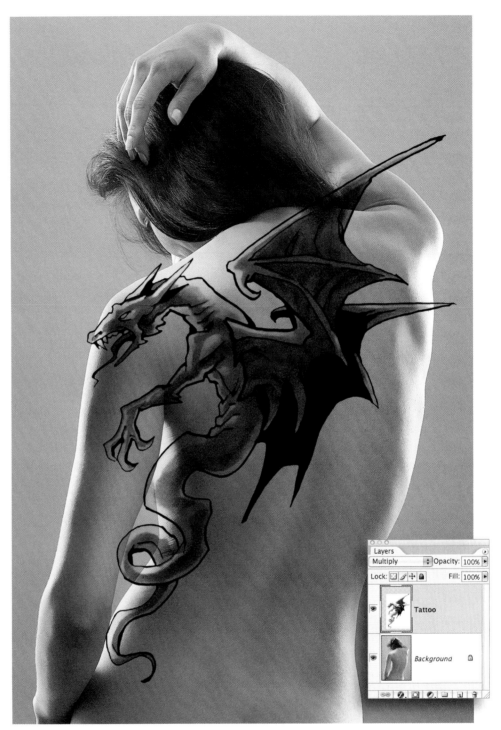

Figure 7.96 The tattoo is placed in a Multiply layer.

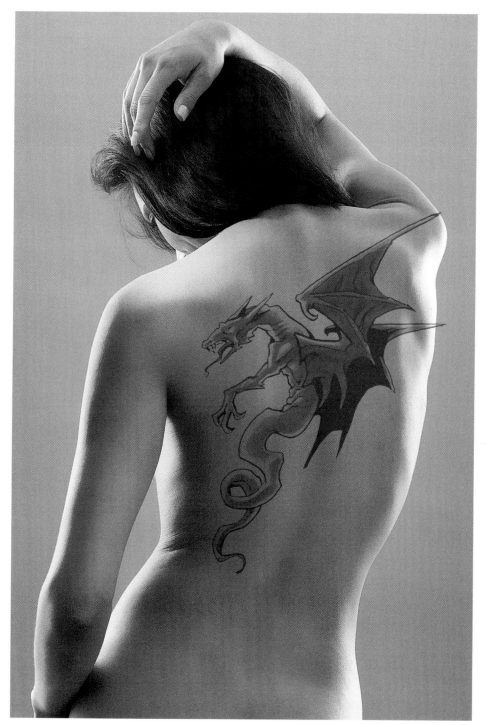

Figure 7.97 Resize the design.

If the tattoo were really on the woman's body, the design would curve toward the shoulder and dip at the shoulder blade. You can use Liquify to shape the tattoo to follow the contours of the body. Choose Filter > Liquify. When the dialog comes up, make sure you check Show Backdrop at the bottom right so you can see how the design fits on the body. Use the Distort Brush to push the dragon design to fit (Figure 7.98).

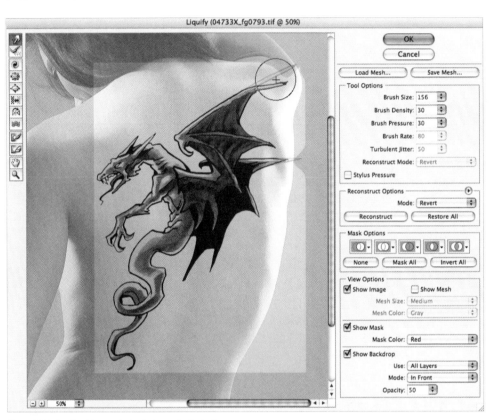

Figure 7.98 Use Liquify to push the design to fit the body.

To finish, I added a White layer mask (click the Layer Mask icon at the bottom of the Layers palette) and added some blurred noise to add texture to the black areas of the tattoo. I also blurred the dragon design slightly to suggest the way tattoo ink bleeds into skin (Figure 7.99). You can adjust the Layer opacity to give you a freshly inked or a faded-and-aged look.

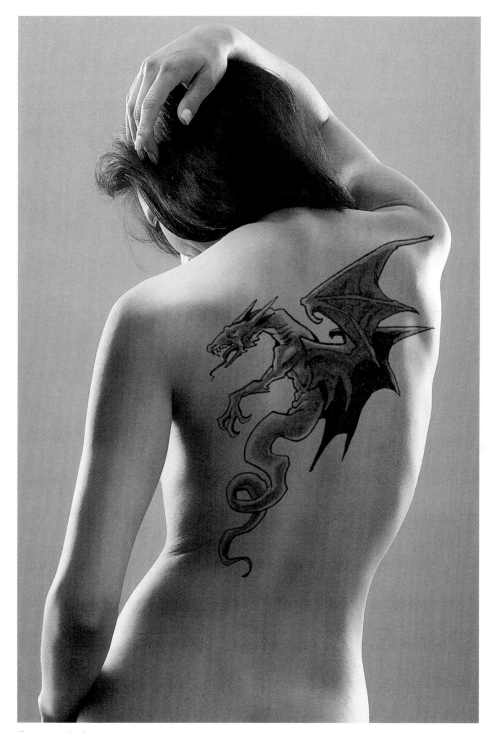

Figure 7.99 The final version

Capoeira 3 Lee Varis 2000

Preparing for Print

The final form of a digital image is usually a print of some kind. To prepare for this eventuality, digital photographers must do a number of things aside from using all the creative techniques employed when working with the image on the monitor. Last minute tweaks frequently make the difference between a great print and a mediocre one. This chapter covers techniques that are particularly important in people pictures including:

Chapter Contents
Sharpening
Color Management for Print
Soft Proofing
Desktop Printing
Creative Print Finishing

Sharpening

Whether they are scans from film or direct digital captures from a digital camera, all digital images require some level of sharpening. Often, some sharpening is applied automatically by the scanning software or in-camera processing. Sharpening is critical for CMYK offset lithography because the line screen has a fairly drastic diffusing effect on photographic imagery. People photographs printed with high-quality inkjet printers often don't need as much sharpening as other photographs, and many times the soft effect is desirable to hide skin texture. Perhaps because of this, most photographers of people tend to ignore sharpening or, at best, treat it as an afterthought, applied as some kind of default setting based on camera model.

Sharpening is an art in itself. Good sharpening techniques can enhance almost any image and elevate an ordinary photo to an arresting image that jumps off the page. Really sharp images have a three-dimensional quality that is almost impossible to achieve without using some kind of edge-enhancing technique. Sharpening techniques were employed by the old master painters of the Renaissance. They placed dark lines next to light edge highlights to visually carve important detail into an image. Modern photographers use Unsharp Mask, a technique pioneered by astrophotographers, whereby a blurred negative was sandwiched with a positive to enhance edge details in images of distant galaxies. Although the modern version of this technique involves complex digital-image-processing algorithms, the principle is the same. Sharpening is best done after the image is sized for final output, often as the last step before printing. We will examine a couple of the best Photoshop sharpening techniques that are the most pertinent for our work with people in digital photography.

Unsharp Mask

Let's begin our exploration of sharpening from the Filter menu with Unsharp Mask—rather than Sharpen, Sharpen More, or Sharpen Edges—because Unsharp Mask offers useful adjustable parameters that the others don't.

The Unsharp Mask filter detects edge transitions and applies dark and light halos around these edges. Most beginners simply run the filter directly on the image. This often results in enhanced saturation in dark and light halos around colored edges, and it makes the artificial sharpening more obvious. You can see this saturation effect in this image (Figure 8.1) in the direct-apply version on the left. The version on the right was applied to affect luminosity only. In order to avoid the saturation enhancement, some experts advise you to convert the image to LAB and sharpen the L channel. Others say, "Just fade to luminance (Edit > Fade > Unsharp Mask, choose Luminosity in the dialog) right after running the filter." The best overall approach is to run your sharpening filter in a duplicate layer set to Luminosity. This allows for the most interactive view of your sharpening effect, and it prevents sharpening halos from acquiring saturated colors. Also, when you sharpen in a separate layer, you gain the benefit of extra control over how that sharpening is applied through the use of layer masks.

Figure 8.1 The close-up in the center is unsharpened. Unsharp Mask was applied to the versions on both sides.

Let's set up a basic sharpening routine for this image of a jazz musician (Figure 8.2). First, let's set up a Luminosity Sharpen layer—drag the Background thumbnail to the New Layer icon at the bottom of the Layers palette to duplicate it—and then select Luminosity from the Blending mode drop-down menu just under the Layers tab (Figure 8.3). After doing that, we will zoom to the best magnification to judge our sharpening effect.

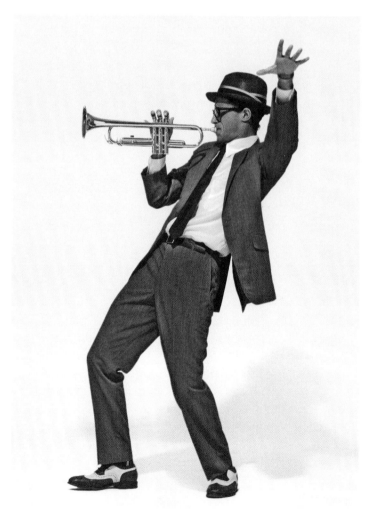

Figure 8.2
The original
unsharpened image

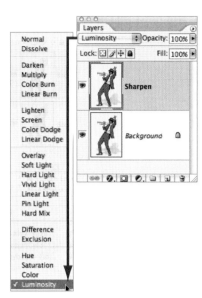

Figure 8.3
To set up sharpening, place a
duplicate in a layer and change
the Layer Blending mode to
Luminosity.

Many experts will advise you to view the effect of the Sharpen filter at 100 percent—I used to do this myself. The sharpening effect at this magnification will appear at lot more drastic than it will appear at the final printed size. I prefer to judge the effect of sharpening at 50 percent.

Note: Because the image appears so much bigger than it will actually print, most photographers tend to undersharpen when they view an image at 100 percent onscreen. When you zoom to 50 percent, you are viewing the image at approximately 150 pixels per inch. Most of the time, you will be sharpening for size at 300 pixels per inch. By viewing the effect of sharpening at the 150 ppi size, you can compensate for the lower screen resolution of 72 ppi, which is the best compromise to view the intensity of the effect.

Once you've zoomed to a 50 percent view, select the Unsharp Mask filter (Filter > Sharpen > Unsharp Mask). Compare the effect inside the dialog (where it is displayed at 100 percent) with the 50 percent zoomed view (Figure 8.4).

Unsharp Mask works by enhancing the contrast of tonal transitions; we perceive these transitions as light and dark halos around edges. The sliders in the Unsharp Mask dialog give you some level of control over the size and intensity of these halos. The Threshold slider sets the value change necessary before sharpening halos are applied. Due to the amount of grain visible in film images, this technique is primarily useful with images scanned from film. For most digitally captured images, grain is a nonissue,

so you can leave the Threshold slider set at zero. Noise, however, can be present in digital files, especially when the camera was set to a high ISO. Therefore, the Threshold slider can be used to minimize sharpening of noise (push the slider to the right until you reach a setting where noise isn't impacted). You can set the amount slider all the way to 500 percent because you are applying the sharpening to a duplicate layer, and you can use the layer opacity to control the amount. At this intensity, you can clearly see what the halos are doing to the image.

The whole trick with using the Unsharp Mask filter is to set the Radius high enough to adequately sharpen without being obvious at the desired print size. You might be surprised by how much you can get away with; I almost always sharpen more than what I think looks good onscreen. Adjust the layer opacity to bring the intensity down so the effect doesn't overpower the image. A uniform level of sharpening everywhere in the image often looks unnatural; you can use a layer mask on the Sharpen layer to refine how the sharpening is applied across the image. Try painting with black into the mask to remove sharpening from skin texture. To really appreciate the effect of sharpening, you should make test prints. It is often quite amazing how even a small amount of sharpening can enhance an image. Compare this sharpened version (Figure 8.5) to the original unsharpened version (shown back in Figure 8.2).

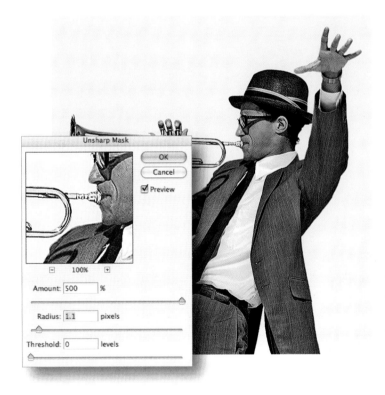

Figure 8.4
The dialog allows you to
view sharpening at 100
percent, but always check
the effect at 50 percent
as well

Figure 8.5 The final sharpened version

Smart Sharpen

Sharpening can supply a lot of sparkle to an image. This effect is the result of the lightening halos. Unfortunately, if an image contains a lot of high-frequency transitions such as tiny details, texture, or fine lines (hair), this "sparkle" can be distracting. The shot of the belly dancer in Figure 8.6 has this issue. If we apply regular Unsharp Mask, we run the risk of turning the sequins into a riot of white speckles, as in Figure 8.7. Ideally, we want to apply more dark halos than light. Photoshop CS2 introduced a new Smart

Sharpen filter that allows us to do just that. As always, make a duplicate layer to use to apply the sharpening. Choose Filter > Sharpen > Smart Sharpen, and you will be presented with a larger dialog that contains some additional features (Figure 8.8).

Figure 8.6 Original unsharpened version

Figure 8.7 Notice the distracting white halos that appear when regular Unsharp Mask is used.

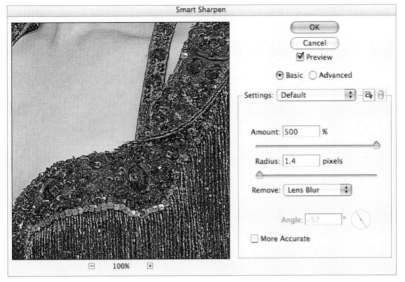

Figure 8.8 The Smart Sharpen dialog presents a large preview.

When the Basic radio button is selected, you can access the Amount and Radius sliders that control intensity and halo width, respectively. Just below these sliders, the Remove drop-down changes the sharpening effect to accommodate Gaussian Blur, Lens Blur, and Motion Blur. Gaussian Blur gives you very much the same effect as straight Unsharp Mask. Lens Blur offers a tighter halo with some built-in Threshold to minimize texture sharpening in a subtle way. Motion Blur activates the angle control and applies the Sharpen halos along the axis perpendicular to the angle setting; line up the angle with the direction of the Motion Blur to remove the blur. Finally, at the bottom of the dialog is a More Accurate check box. This is perhaps a misnomer; checking this changes the sharpening algorithm to generate an intense edge sharpening that has the tendency to introduce double edges and strange texture effects. I am still looking for an image that is suited to the More Accurate approach. So far, I've found that leaving this box unchecked yields the most natural-looking effects.

The big advantage of Smart Sharpen appears when you check the Advanced radio button; this option adds a Shadow and Highlight tab. Selecting the Shadow tab reveals three sliders: Fade Amount, Tonal Width, and Radius (Figure 8.9). The interaction of these sliders is not obvious. Fade determines by how much the darken halos are reduced in intensity. Tonal Width determines the degree of darkening to remove; if your Tonal Width setting is low, only very subtle darkening halos will be removed. This works kind of like the Threshold slider in Unsharp Mask. Higher Width settings remove darker halos; lower Width settings leave the darker halos alone and remove halos that are less dark. Setting the Fade Amount to 100 and the Tonal Width to zero will have no effect, neither will setting the Fade Amount to zero and Tonal Width to 100. Radius appears to work relative to the basic Sharpen radius, and determining exactly what it's doing is difficult. The Highlight tab works the same way with lightening halos (Figure 8.10). The best results for our example are seen with the Shadow

Fade at zero and the Highlight Fade at 100. This doesn't seem to remove all the lightening halos, but it reduces the ratio of lighten to darken halos by half. We still get significant sharpening with this approach, but the light "sparkle" doesn't overwhelm the image.

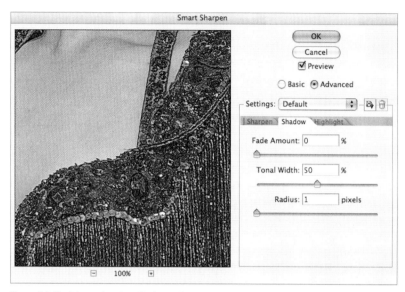

Figure 8.9 The Advanced settings Shadow options

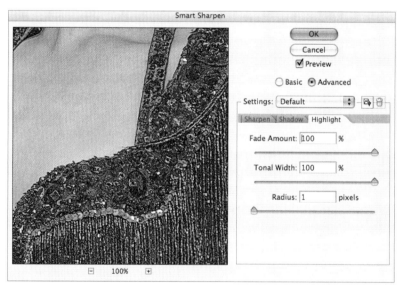

Figure 8.10 The Highlight option sliders

Multiple Sharpening Layers

Although it is convenient to control darkening and lightening halos in one dialog, I find it much more flexible to achieve similar results using two Sharpen layers with different blending modes. The idea is to apply regular Unsharp Mask to a duplicate layer, copy the sharpened layer, and use Lighten and Darken modes on these layers. The Sharpen effect will then be in two layers that can be controlled separately. This approach preserves the ability to apply sharpening with a Threshold slider, as well as Lighten and Darken.

1. Return to our unsharpened version and again duplicate the background into a layer. Run Unsharp Mask: Amount 500, Radius 1.3, Threshold 6 (Figure 8.11). This Threshold setting is just enough to keep the skin smooth.

Figure 8.11

The regular Unsharp Mask dialog settings with a Threshold set to minimize skin texture

2. Immediately after running the filter, choose Edit > Fade Unsharp Mask. You will be presented with a small dialog where you can change the Blending mode of the filter to Luminosity (Figure 8.12).

Figure 8.12

The Fade dialog set at Luminosity

3. Now you can use the Layer Blending modes to control Lighten and Darken effects. Duplicate the sharpened layer and turn off its visibility by clicking the Eye icon in the Layers palette. Target the original Sharpen layer and change the Layer Blending mode to Darken (Figure 8.13). The image will now have only darkening halos.

4. Turn on the top layer and change the Blending mode to Lighten; reduce the layer opacity to 50 percent (Figure 8.14).

The resulting version of the image is very similar to the Smart Sharpen version, but you can more easily modify the balance of lighten to darken without having to run the filter again.

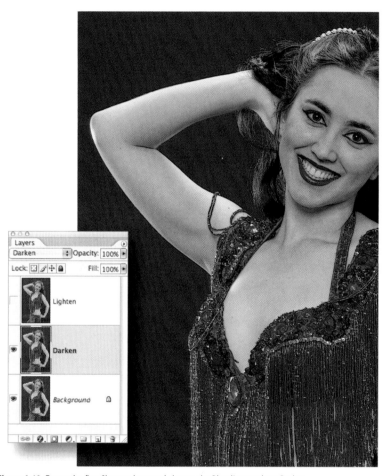

Figure 8.13 Target the first Sharpen layer and change the Blending mode to Darken.

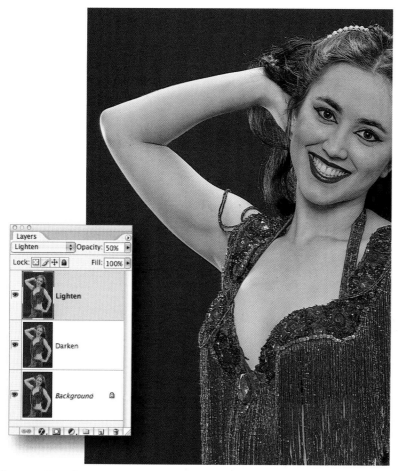

Figure 8.14 Target the second Sharpen layer and change the Blending mode to Lighten.

Octave Sharpening

The idea of multiple Sharpen layers has a unique application when you need a more intense Sharpen effect and need to minimize the visibility of wide halos. I call this technique "octave sharpening" because it applies ever-widening Sharpen halos in diminishing opacities similar to the overtones of a musical note. The net effect of this approach is to create ramped halos that fade as they move away from the edge.

My sample image is from a session I conducted with swing dancers. Focusing on moving subjects is difficult, and the dancers managed to move just outside of the ideal focus range (Figure 8.15). We'll begin this example the same way we began all the other examples. First, zoom in to 50 percent to evaluate the sharpening. Make a duplicate layer and change the Blending mode to Luminosity. Now make three additional duplicates (Figure 8.16).

The idea is to apply progressively wider radius sharpening in successive layers with decreasing opacity. Wide-radius sharpening gets low layer opacity, and as the Sharpen halos get tighter, opacity increases until the tightest halo is at 100 percent. We will start with the first duplicate layer and the tightest halo. Turn off the other duplicates above this layer by clicking the Eye icon to the left of the Layer thumbnail. Make sure the Blending mode is set to Luminosity and call up the Unsharp Mask filter. Set the Amount to 500 percent, Radius to 0.5, and Threshold to 0. This creates a very small but intense halo that will increase the sharpening effect but be almost imperceptible at print size. Leave the Opacity slider for this layer at 100 percent (Figure 8.17).

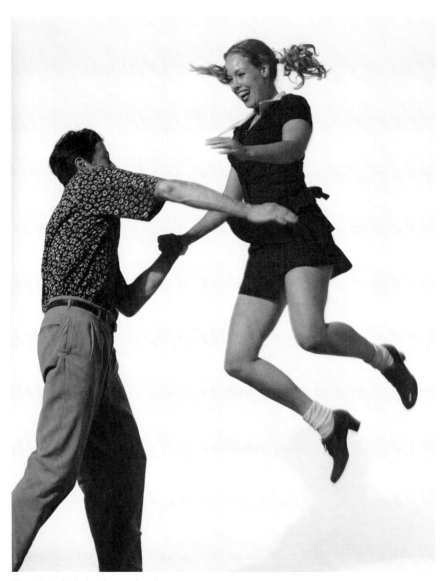

Figure 8.15 Original unsharpened version

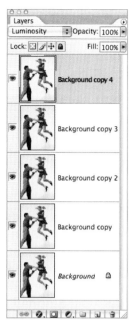

Figure 8.16
Four duplicate layers are
used to sharpen successively.

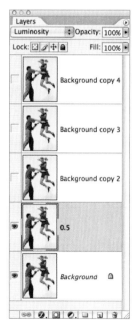

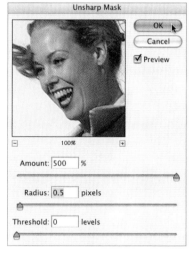

Figure 8.17
The first Sharpen layer is
at a 0.5 Radius.

The next layer up gets an Unsharp Mask Radius of 1 pixel, but you should reduce the opacity of the layer to 50 percent (Figure 8.18). The next layer gets a Radius of 2 pixels with an opacity of 25 percent (Figure 8.19).

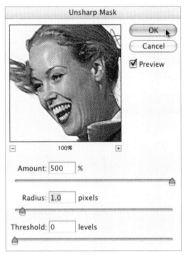

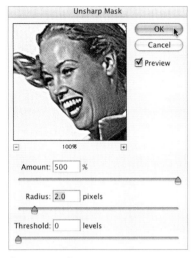

Figure 8.18 Radius at 1.0

Figure 8.19 Radius at 2.0

The last layer gets an Unsharp Mask Radius of 4 pixels, but you should reduce the opacity of the layer to 13 percent (Figure 8.20).

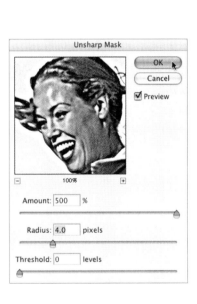

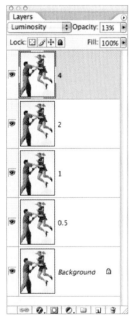

Figure 8.20

The last Sharpen layer, at Radius 4.0, has the lowest opacity in the layer stack.

Masking for Sharpening

At this point, you would normally be done, but this particular image suffers from a common sharpening problem. The dark-edge halos around the figures are exposed against the white background, lending a cutout appearance to the figures (Figure 8.21). You will need to use a layer mask trick to *trim off* the edge. The problem is that you have four layers to mask. There is a solution, however. You can use one mask to control all four layers if you put the layers into a group. Start by selecting all the sharpened layers (shift-click all the Sharpen layers). Once this is done, choose New Group From Layers from the Layer Options menu at the upper-right corner of the Layers palette (Figure 8.22).

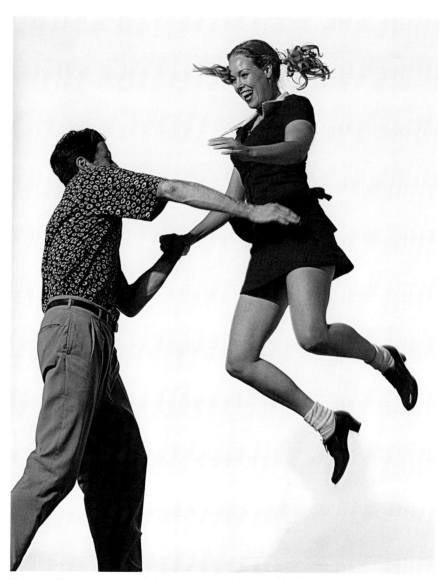

Figure 8.21 The sharpened version looks extra sharp around the edge of the figures and has a cutout look.

Figure 8.22
Select all the Sharpen layers and group them.

Name the new group **Octave-Sharpen**, leave the Blending mode at Pass Through and the Opacity at 100 percent. All the linked layers are now contained in a folder in the Layers palette (Figure 8.23). This Sharpen folder can be treated as an individual layer by adding a layer mask to it.

Figure 8.23
The Sharpen group

Now, we will create a selection for the models in preparation for the layer mask:

1. Using the Lasso tool, draw a loose selection around the people (Figure 8.24).

2. Use the Magic Wand tool, hold down Option/Alt, and click into the background around the subjects to subtract the white background from the selection. The selection should "hug" the dancers (Figure 8.25).

Figure 8.24 Make a loose lasso selection around the figures

Figure 8.25 Subtract the white background inside the selection with the Magic Wand tool

3. Choose Select > Feather and select 3 pixels. You'll need to shrink the selection to come just inside the edge.

4. Choose Select > Modify > Contract and enter 3 pixels. The edge of the selection will shrink inside the edge of the models (Figure 8.26).

Figure 8.26 After shrinking, the selection is just inside the edge of the figures.

Now, simply target the Sharpen Group and click the New Mask icon at the bottom of the Layers palette to create a mask that trims off the outer dark edge of the Sharpen effect (Figure 8.27). The mask can be further refined and extra-dark or light halos can be *painted out* using black in the mask. Compare the result in Figure 8.28 with the original sharpened version in Figure 8.21. The difference is subtle, but now the model seems to be more part of the background.

Figure 8.27
The Group mask trims off the Sharpen halos at the outer edge of the figures.

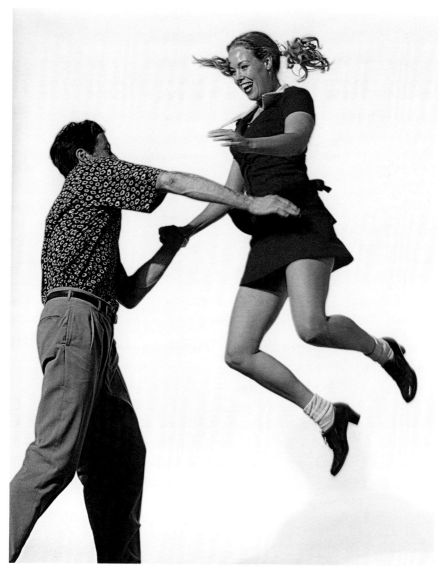

Figure 8.28 The final Sharpen version blends into the background in a more natural way.

You'll be amazed at what you can do to rescue some out-of-focus images using this technique. The image in Figure 8.29 was taken using a Lensbaby soft-focus lens. Using the octave-sharpening techniques, much of the apparent detail is restored.

Figure 8.29a This Middle Eastern drummer is a little too soft. Octave Sharpening restores a more detailed look (opposite).

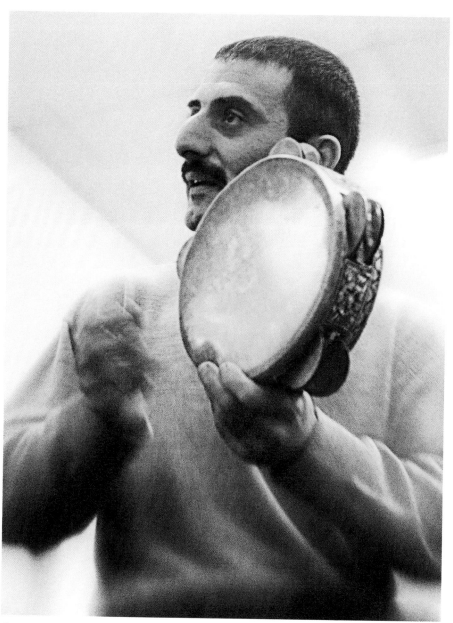

Figure 8.29b

Overlay Sharpening and High-Radius Effects

There is one more sharpening technique I'd like to cover. There are two basic kinds of Unsharp Mask sharpening. The first, low-Radius Unsharp Mask applied with a relatively high Amount, is what we've been practicing. The second kind, high Radius with a low Amount, is the inverse. This second type is what Dan Margulis has called *HIRALOAM sharpening* in his books and magazine articles. The nature of this effect is different from regular sharpening. It tends to create a sculpted light, almost three-dimensional effect that can add shape and form to an image with relatively flat lighting.

Rather than use regular Unsharp Mask for this effect, I like to use a special Overlay Sharpening technique that achieves a similar but better result. Let's examine this technique using this image of a swordsman in period costume at a Society for Creative Anachronism event (Figure 8.30). We will gradually build up the sharpening, bring the figure away from the background, and create some stronger shape to prepare for final printing. The first few steps are similar to what we did in the previous examples.

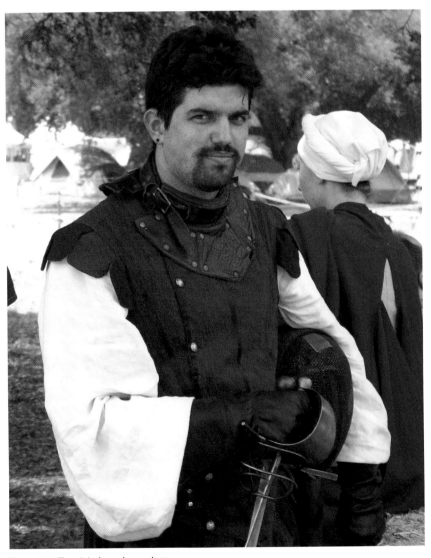

Figure 8.30 The original swordsman photo

First, create a Lighten and Darken sharpening group (similar to what we did for Figure 8.23) and mask the sharpening effect from the background (Figure 8.31).

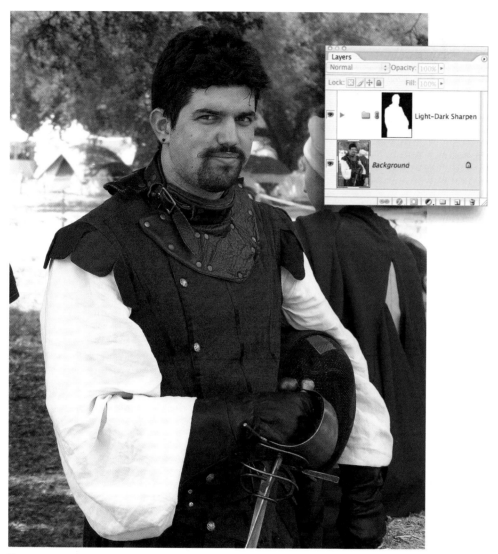

Figure 8.31 A Lighten-Darken sharpening group adds a basic level of sharpening.

Next, create a contrast-reducing Curves adjustment layer with a mask that applies the effect only to the background (Figure 8.32). This helps to bring the figure forward, but I'd still like more contrast and shape in the face and hair. The soft open-shade lighting doesn't help here.

For the Overlay Sharpen technique, create a new empty layer by Option/Alt+clicking the New Layer icon at the bottom of the Layers palette and choosing Merge Visible to place a copy of the image into this empty layer (Figure 8.33). We will use this layer to sharpen the model only so, to prepare for this, we will copy the mask from the Sharpening Layer group.

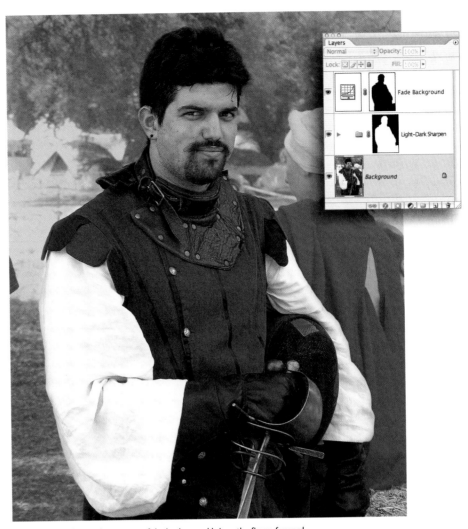

Figure 8.32 Reducing the contrast of the background brings the figure forward.

Figure 8.33
Merge a composite into
the top layer.

Hold down the Option/Alt key and drag the Layer Mask thumbnail from the Sharpen group to the merged layer. This duplicates the mask into this layer. Select the image thumbnail and choose Image > Adjustments > Hue/Saturation; desaturate the image by pushing the Saturation slider all the way to the left. You'll end up with Figure 8.34. The reason we're doing this will become clear in a moment.

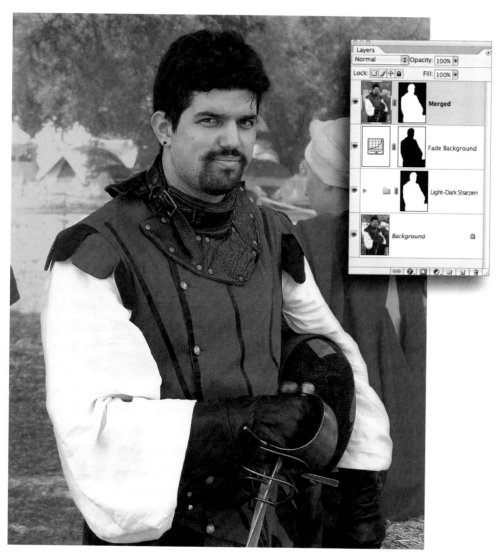

Figure 8.34 Mask the layer from the background and desaturate.

With the image thumbnail still highlighted, select Filter > Other > High Pass (Figure 8.35).

Figure 8.35
Select the High Pass filter.

High Pass is an odd filter that reduces contrast to medium gray everywhere except where there is an edge transition based on the Radius setting in the dialog. Low Radius settings preserve contrast only at narrow edges. The effect will be very similar to Unsharp Mask when we change the Layer mode to Overlay. In this case, we'll use a high Radius setting to produce an almost *bas-relief* effect (Figure 8.36). The High Pass filter has a built-in soft ramping effect that helps hide the edge halos most visible around the shirt. By de-saturating the layer before you apply the High Pass filter, you avoid enhancing the saturation of the colored areas in the image.

Change the Layer mode to Overlay and you'll finally be able to see the sharpening effect (Figure 8.37). Notice the increase in contrast and shape in the face and hair. There is a better sense of texture in the neck protector and the clothing in general. In this example, the Overlay layer is used at 100 percent; however, you might need to reduce the opacity so the effect doesn't overpower the image.

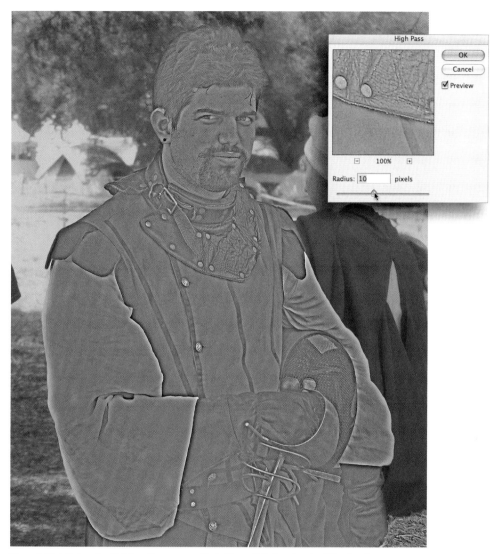

Figure 8.36 A high-radius High Pass filter creates a kind of bas-relief effect that simplifies the edge contrast.

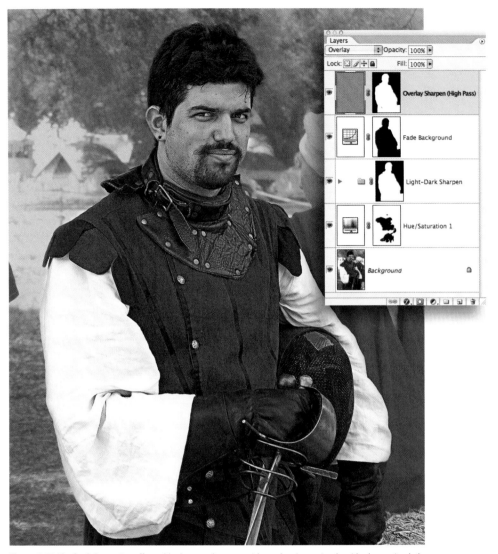

Figure 8.37 The final sharpening effect adds shape and texture without showing seriously wide sharpening halos.

Let's look at another example of this method. Remember the skin-lightening corrections we applied in Chapter 5, "Tone and Contrast: Color and B+W"? Figure 8.38 is the next-to-last step in the process, after luminosity-blending lightened the skin. After duplicating the background into a new layer, desaturating, and running a 20-pixel Radius High Pass filter, we get Figure 8.39.

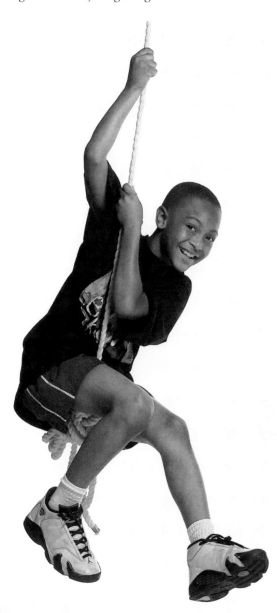

Figure 8.38
The shot before High Pass
Overlay sharpening.

Change the Layer mode to Overlay to get Figure 8.40. The highlights on the face and arms are strengthened, but so are the shadows—and we don't want to make anything darker than it already is. By selecting Blending Options from the Layer Options flyaway menu, you can set the Blend If sliders to blend back the original shadow values so you get only the lightening effect of the High Pass Overlay layer (Figure 8.41).

Figure 8.39
The duplicate layer is desaturated, and a 20-pixel Radius High Pass filter is applied.

Blending back the low values using this technique works the same as applying lighten-only Sharpen halos. The final result adds highlight shape to the image without also darkening it (Figure 8.42).

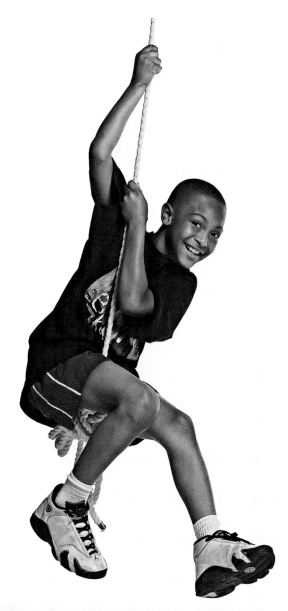

Figure 8.40
The High Pass Overlay
effect lightens *and* darkens
the image.

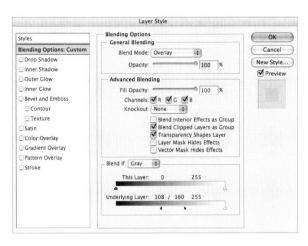

Figure 8.41
Blending Options are used to bring back the original shadow values.

Figure 8.42
High Pass Overlay now supplies only enhanced highlights.

Color Management for Print

After your image is sized and sharpened, it is ready for you to make a print. So far, we have been working with a backlit display with vivid RGB colors that exceed the saturation and brightness of anything we can put on paper. Now the moment of truth arrives, and you need to translate what you see on the monitor to a print that can convey the same feeling. The problem is much the same as it was when photographers shot transparency film: there is still a huge discrepancy between the dynamic range and color gamut that can be represented with a glowing backlit monitor image and what can be printed on paper, where the brightest thing is the white paper. Another major issue is the way images are constructed in the two different media. RGB images on the monitor exist in an additive color space: red, green, and blue light is added together to make white. CMYK images, which form the bulk of paper-based output, use cyan, magenta, yellow, and black to subtract from paper white to make a color image.

Note: Tim Grey explains this well in *Color Confidence: The Digital Photographer's Guide to Color Management, Second Edition* (Wiley, 2006).

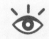

Typically, all of our corrections and edits are made in RGB, and the majority of printed outputs are in CMYK. This includes desktop inkjet printers that are designed to receive RGB files. These printers internally transform RGB input into some kind of CcMmYKk-type color for the specific inkset that the printer uses. Even true RGB output devices, such as a LightJet printer, do not actually have a standard RGB workspace color gamut. Therefore, all prints require a color transformation to occur from the workspace (editing color space) to the output (printing color space) for optimum results. All such transformations are handled by the color management system. Photoshop uses ICC (International Color Consortium) profiles to manage color inside the application. Effective color management requires profiles that describe every device used in the image creation workflow from workspace to monitor to printer. I selected default profiles for my RGB workspace and CMYK workspace in Photoshop color settings. Frequently, the default CMYK workspace is used for generic CMYK output. Ideally, the color transformations necessary for printing to a specific printer utilize a profile for that specific device. Fortunately, most modern desktop printers provide reasonable profiles that are installed with the device drivers, and we can use these profiles to control the color transforms for printing.

Profiles and Look-Up Tables

Understanding what a profile is will help you fully comprehend what happens in color-managed transformations. An ICC profile is a standard way of numerically defining the way a particular device (a scanner, camera, printer, or monitor) renders color for a human observer under average daylight conditions. Color management involves linking these various device profiles together in a way that allows us to control the appearance of colors from one device to another. In order for this to work, a profile must reference

the observable colors from a device to a device-independent model, a sort of absolute definition of color. Profiles are static definitions, and the dynamic calculations that move an image file through various profiles to arrive at the final output are handled by a color management module (CMM) that is the mathematical engine for all the transforms.

Therefore, a profile is a special number transformer, a kind of black box called a *look-up table* (LUT) or more often a *color look-up table* (CLUT), that takes a set of numbers and returns another set of numbers. The first set of numbers can be from any kind of color device (RGB, CMYK, or grayscale); the second set of numbers is the LAB definition of the color represented by the first set (Figure 8.43).

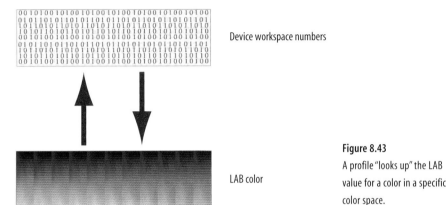

Device workspace numbers

LAB color

Figure 8.43
A profile "looks up" the LAB value for a color in a specific color space.

You can think of LAB numbers as being independent of any particular device but representative of colors observable under D50 graphics industry standard lighting. Therefore, a profile gives us a real color definition of the numbers from a digital file—in D50 light.

Some profiles are relatively simple rules based on a matrix with a few points defining a larger set of colors. Other profiles are larger plots of all possible colors in a particular set. Matrix profiles are commonly used for Photoshop's working spaces and monitor profiles. Printer profiles are most commonly larger CLUTs, sometimes referred to as table-based profiles. The math surrounding all this is staggering. For the artist, a profile is merely a definition of the color rendered by a device translated into LAB. When photographers need to transform one set of device numbers into numbers for another device, they use profiles to "look up" the LAB colors and generate new numbers for the next device based on those colors (Figure 8.44).

When the profiles for the devices you are using are installed, you simply have to select the appropriate profile at the right time to manage the necessary color transforms. The rest of this chapter will go over the steps necessary to get the most out of profiles in your color management system.

First device

LAB colors

Second device

Figure 8.44
LAB color is the link between
the two device numbers.

Soft Proofing

Photoshop includes a method for previsualizing the effect that gamut reduction in the
output has on the image. You can find this preview, often referred to as a *soft proof*,
under the View menu. Select Proof Colors under the View menu or press ⌘+Y/Ctrl+Y
to toggle the soft proof on or off (Figure 8.45). This changes the screen to simulate the
appearance of the print. The default proof color is Working CMYK; you can select
your CMYK color space in Photoshop Color Settings.

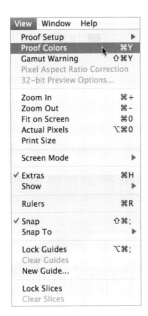

Figure 8.45
Select Proof Colors to
change the screen to
simulate the output.

You can change the proof colors to match the output you are going to use. Go
to View > Proof Setup > Custom. You will get a dialog that allows you to select a pro-
file for a printer and a rendering intent for your transformation (Figure 8.46). You can
select any output profile you want; you aren't restricted to working with CMYK or any

of the default selections such as Monitor RGB or Windows/Macintosh RGB. If you have a profile for your Epson printer, you can select it here.

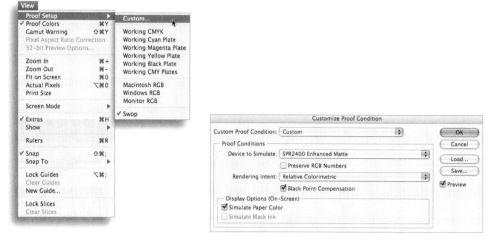

Figure 8.46 Select View > Proof Setup to change the output device you want to simulate.

The Simulate check boxes at the bottom of this dialog are particularly interesting. The Simulate options allow you to see a more accurate preview and force an absolute color match to the screen. However, evaluating the color this way requires a little practice. When you select Proof Setup and check the Preview box, you might observe a very slight change in appearance depending on the color gamut of the original. Normally, you'll see very little change. When you select Ink Black, the preview changes to reflect the actual intensity of the black ink on the paper to be printed. This can make the image seem a little dull, but it still is not entirely accurate. (Toggle back to the previous page to compare.) To be accurate, you need to select Paper White. This often results in a very dull rendition—yuck! (Figure 8.47).

Figure 8.47 The version on the left shows the original RGB (Adobe RGB) screen version. The right shows a Paper White simulation of CMYK (U.S. Web Coated—SWOP v2).

Note: When all the options for your soft proof are set up, click Save. You can recall the setup from the drop-down at the top of the dialog or go right to it from the Proof Setup menu.

Paper White is not as white as a backlight monitor. Once you understand that, you can begin to see how this simulation might be useful. The problem is that our eyes are confused by all the white in the interface visible on the monitor. You can mitigate the effect of all this white by toggling to Full Screen mode. Press the F key to hide the desktop and place the image on a gray background. Press the F key again to get a black background, and press the Tab key to hide the palettes. Without the white reference of the interface, the duller image doesn't look that bad. In many cases, with desktop inkjet printers, the simulation will be only slightly duller; however, it can give you a heads-up warning about how the contrast will change—low values might get muddy and highlights might get less intense.

To most people, the screen simulation looks worse than the final print because matching the visual context of the print for screen viewing is very difficult. However, the simulation is still quite useful because it helps you get enough contrast in the image to produce a good print. You can leave Proof Colors on and use any adjustment tools to optimize the image for your output. Usually, simple Curves can be used to add extra contrast to punch up the image for the more-limited dynamic range of the typical output. Many photographers leave the simulation on when they display images on the monitor to their clients. This reduces the clients' expectations and they have fewer problems accepting a final print.

Note: By working with the print corrections in a layer, you can save the adjustment for your printer and apply it to other documents. You can simply drag it onto the new documents. You can keep saved corrections available for different printer outputs and apply them at the last minute before printing.

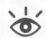

Desktop Printing

After sharpening, previewing, and adjusting, the moment of truth will finally arrive when you have to make an actual print. Even if you are sending the file to a commercial printer, you'll want to make a desktop print to use as a *rough proof* or *aim print*. As a digital photographer, you'll probably be printing from Photoshop. For your first step in the final sequence, go to the File menu (File > Print with Preview).

The first time you see the Print With Preview dialog, it will probably be set up with Output options selected in the drop-down menu below the large preview at the

left of the dialog. We'll get back to this later. Most of the important printing options for our purposes are in the Color Management options (Figure 8.48).

Figure 8.48 Select Color Management in the drop-down just below the preview.

This is where you set up all the Profile options for your prints. At the top of the dialog, Position controls how the image lays out on the page. The Center Image check box provides a quick way to place the image. Directly below that is the Scaled Print Size area; by default, this is set up for 100 percent. If the image is way too small or way too big on the page preview, click the Page Setup button and make sure you're using the right size paper. Checking the Scale To Fit Media check box is a quick and dirty method of sizing the image to fit the paper—just beware that your quality will suffer if the reported Scale percentage is overly high. It is far better to set the size properly in Photoshop before using the dialog. The Show Bounding Box check box is useful when you have an area of white canvas in your image and you want to see how much of this canvas will be cropped if the image is too big.

The important color settings reside in the lower half of the dialog box. Print identifies whether you are going to print the document directly or generate a simulation proof; if you are making prints for your portfolio or to sell to a client, you probably will check Document. This sets the profile to the document color space and determines where the color starts from in its journey to the print. (We'll cover the Proof setting later.)

Next, is the Options area. For RGB images, the Color Handling drop-down shows Let Photoshop Determine Colors, Let Printer Determine Colors, or No Color Management.

- Selecting **Let Photoshop Determine Colors** allows you to select the Printer Profile in the drop-down menu just below this one. This is the most straightforward way to set up color management for the print.

- If you select **Let Printer Determine Colors**, the Print Profile option is grayed out and you will have to set the Color Management options in the printer driver. The Printer Driver dialogs are usually a lot more confusing in this regard, so you'd be wise to stick with Photoshop. The Printer Profile drop-down shows all the profiles installed on your system to which you have access. If the printer driver is installed properly, a profile for your printer and media can be selected here.

- You should choose **No Color Management** only when you are printing color patches to create a custom profile.

The last choice is Rendering Intent. Here you can choose: Perceptual, Saturation, Relative Colorimetric, or Absolute Colorimetric. Ninety percent of the time Relative Colorimetric will give you the best result. Occasionally, certain very saturated colors will tend to posterize and lose detail in the print. If this is the case, you can try to solve the problem with Perceptual rendering. Generally though, Perceptual rendering will give a less saturated color in the print and your skin tones could become dull. The other renderings are applicable for custom profiles and unusual circumstances; however, for the most part, you can ignore them with people images.

Note: The Color Management options generated a lot of confusion in past versions of Photoshop. Adobe changed the user interface and the terminology used in the most recent version of the Print With Preview dialog. The Source Space area in previous versions has become Print, and the Print Space area has become Options in CS2. No Color Management in CS2 has much the same effect as Same As Source in previous versions. Proofing options are selected in the "Print" area of the dialog, and the Proof Setup Preset profile is selected in the "Options" area. Once you get used to the changes, the current method makes more sense.

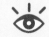

Once all your options are set, you are free to click Print. The only additional thing you need to remember is that because your color management options are being set in Photoshop, you have to turn off any such options in the Printer Driver dialog. All of the color transformations will have already taken place in Photoshop before the data hits the printer driver, so make sure you do not "double color manage" and introduce an additional transformation. Every printer driver is a little different, but yours will have some option to select "no color management" in the printer driver.

Output Simulations

Moving directly from the document color space to the printer will give you the most faithful rendering of your image file. Sometimes you might want to simulate another kind of output with your desktop printer. The final use for the image may be in offset lithography or some other type of commercial output, but you will be delivering an RGB file and you may need to know how it will look in the final output. By selecting the Proof radio button in the Print section of the dialog, you have the option of setting up this kind of output simulation for your desktop printer (Figure 8.49).

Figure 8.49 Use the Proof option to simulate another type of output on your desktop printer.

Once this is selected, the Proof Setup Preset drop-down is activated and you can select any of your saved Proof Setup simulations. The check boxes below the drop-down override the same settings in your presets. Most of the time, even though you may want to view the effect of paper white in your screen simulation, the Simulate Paper Color option is not desirable because it will print a tone into the white portions

of your image and cause the image to look duller than it really is. However, Simulate Black Ink will generally offer a better idea of the depth and contrast of the final output as long as your printer has a darker black—I leave this checked for CMYK offset simulations.

Creative Print Finishing

Let's return to the Output options in the Print With Preview dialog. When you select Output from the drop-down directly below the Preview, a number of different options appear. Most of these are only of interest to commercial printers, but two of the options can provide some print enhancement features. Before you explore these options, uncheck the Center Image check box and enter a smaller value in the Top position. If you are going to print with page space around the image, you might want to have the image just above center on the page. Sometimes called the *visual center*, placing images in this area prevents the image from looking as if it is falling off the page (Figure 8.50).

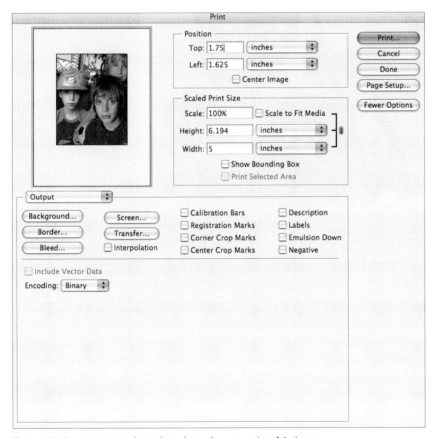

Figure 8.50 Output options can be used to enhance the presentation of the image.

Click on the Border button to bring up a dialog where you can create a thin, black *keyline* around the image on the page (Figure 8.51).

Figure 8.51 A thin keyline contains the edge of the image.

The Background button calls up the Color Picker. With it, you can set a color value to print into the page background (Figure 8.52). You can achieve a very subtle effect with this option. By selecting a tone just slightly grayer than white (L=95 is a good starting place), you create the illusion that the paper white areas inside the image are brighter than they really are. Your eye catches the surrounding matte area as the white point, and small areas of white in the image appear as light sources. This is a subtle but real optical illusion. If your printer does not print to the edge of the paper, trim off any border before displaying the print.

Figure 8.52
Use the Background button to pick a color slightly darker than white for the image matte.

The image at the beginning of this chapter utilizes this effect in a slightly different way. The area surrounding the three figures at first appears to be the paper white, but it actually has a slight gray tone. The white clothing and highlights on the instruments look just a little brighter, and this gives the image a little more snap. The surround was created using Canvas Size in Photoshop (Image > Canvas Size). Set the Canvas Extension in the resulting dialog (Figure 8.53) and click the small square to the right of the Canvas Extension Color drop-down to select a gray color in the Color Picker. You can generate many different rough-edge effects when you have some canvas area with which to work. You can also "sign" your work with the Text tool in the matte area just below the image.

Figure 8.53
You can add space around the image with the Canvas Size dialog.

Here is a simple technique to create a rough-edge effect. After creating your canvas area matte, as in the preceding steps, select the Pen tool or the Rectangle Path tool and draw a path just inside the edge of the image (Figure 8.54). Now, select the Brush tool. You are going to stroke the path with a rough brush.

Figure 8.54 Draw a path just inside the edge of the image.

You can use any brush you want; I used one in the Dry Media Brushes preset. To load these brushes, go to the Tool Options bar and click the Brush drop-down. Then click the triangle at the upper right of the Brush Selector menu to load the preset brushes, select Dry Media Brushes from the drop-down menu, and click Append in the resulting dialog (Figure 8.55). Scroll down until you find the Soft Pastel Large brush. Set a diameter large enough to create a rough edge—in this example, I used 60 pixels.

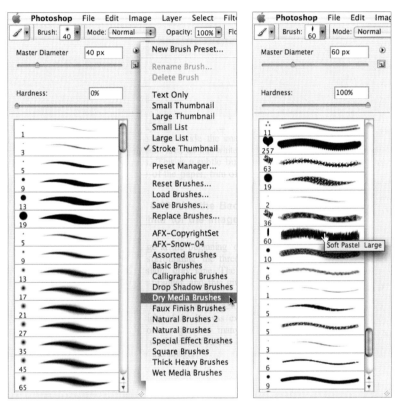

Figure 8.55 Find the Dry Media Brushes in the Presets drop-down, and choose the Soft Pastel Large brush.

Option/Alt+click the matte area and make sure the off-white color of the matte is the foreground color for the brush. Next, make a new empty layer in the Layers palette. Now you are ready to stroke!

Select Stroke Path from the Paths palette by clicking on the Palette Options triangle at the upper right of the Paths palette. You will get a dialog where you can select a Painting tool; make sure the brush is selected and click OK. The selected brush is *stroked* along the path, obscuring the hard edge of the original image (Figure 8.56).

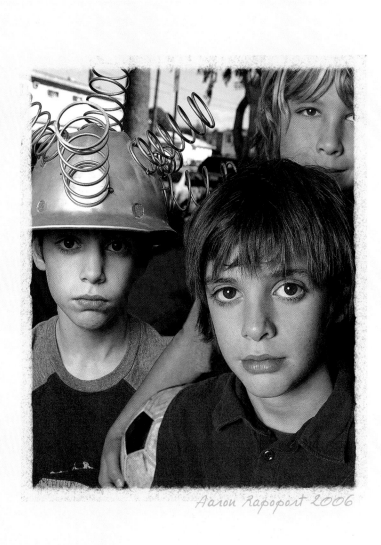

Figure 8.56 The rough edge look gives the image a hand-made appearance.

To complete the fine-art print look, you can sign the print using the Text tool and a handwriting font, as Aaron did in the example. The rough-edge look is very popular with portrait photographers, and it looks especially good when the print is done on watercolor paper. Figure 8.57 was created using three different brushes to build a more complex edge.

A few of the third-party plug-ins offer easy ways to get a wide variety of rough-edge looks, as you can see in the following examples. Figure 8.58 was created using the PhotoFrame Pro 3 plug-in from onOne Software.

Extreme Edges, a library of mask images from GraphicAuthority.com, was utilized to create the complex edge effect in Figure 8.59.

Figure 8.57 Different brushes in a light-dark-light application yield a more complex edge.

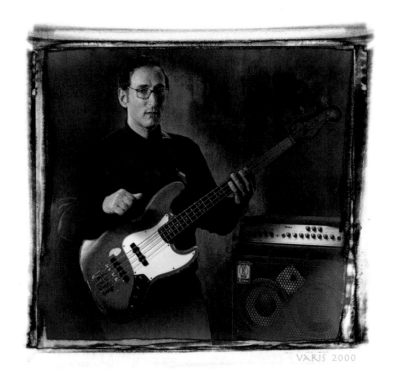

Figure 8.58
Two photo edges
were applied to
create this effect.

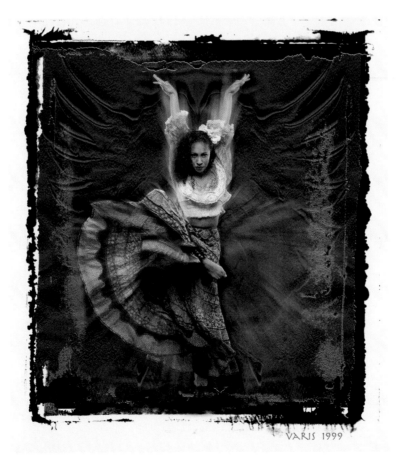

Figure 8.59
Complex shapes
used in layer masks
created the wet-
darkroom edge
effect.

Sometimes simple is the best. You can create thin keylines of any color by using the canvas feature with small pixel dimensions. In Figure 8.60, I set a canvas using Relative checked and adding 10 pixels in each dimension with a blue canvas color. Then I added an additional white canvas so I could sign my name under the image.

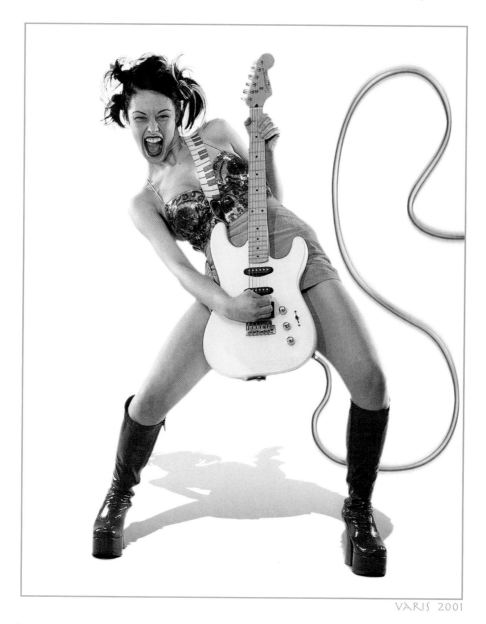

VARIS 2001

Figure 8.60 A simple keyline sometimes works better than a complex edge.

Edge treatments can do a lot to dress up the presentation of an image, and presentation can be important for portraits and fine-art imagery that will be displayed in a portfolio rather than in a frame on the wall. Explore the possibilities when you start printing your work, even if you decide that the particular image doesn't need anything extra.

Last Minute Fixes

Final tweaking is often necessary before you can be happy with a print. Let's step through the final corrections for this image by Aaron Rapoport (Figure 8.61).

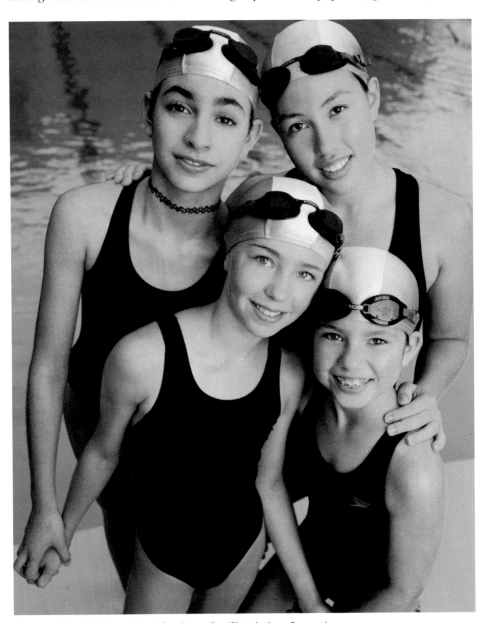

Figure 8.61 The original image directly from Camera Raw (Photo by Aaron Rapoport)

Aaron opted for a lot of contrast and saturation. The bathing suits are very dark, with values down to a level of 5 in some areas. The detail in the suits is not important, so we'll leave them alone and concentrate on the faces. The skin color is not bad, although the highlights read a little on the pink side and the shadows read a tad on the yellow side. The blue water is way out of gamut for CMYK, so we would lose tonal variation when the color clips into CMYK.

First, make some basic Curves and Hue/Saturation adjustments to equalize the skin color and reduce the blue saturation a bit (Figure 8.62).

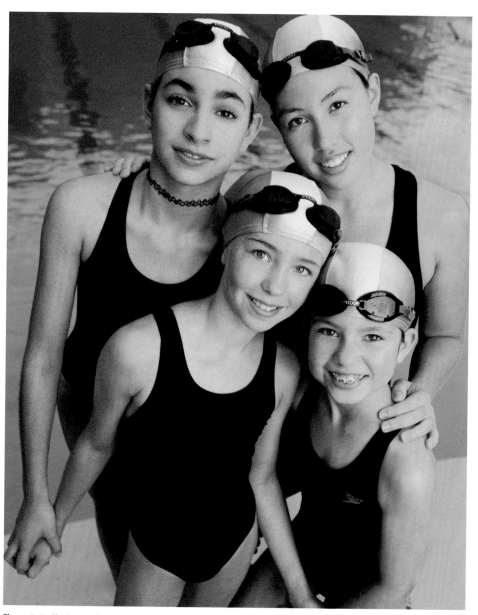

Figure 8.62 The image after Curves and Hue/Saturation adjustments

Next, blend the Luminosity with the Channel Mixer (check Monochrome, set Green to 70 percent, and set Blue to 30 percent) to put some added shape into the skin (Figure 8.63).

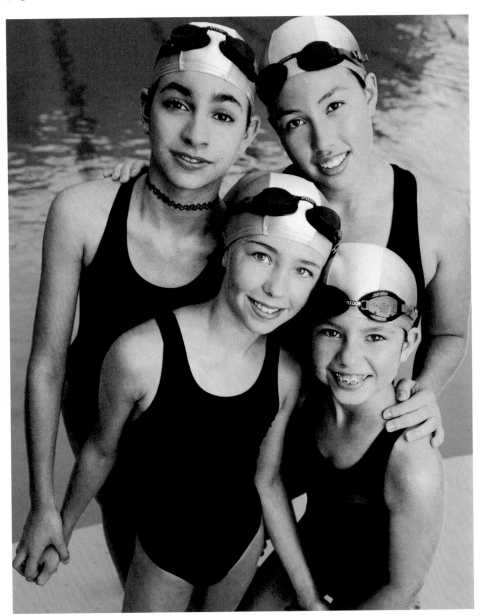

Figure 8.63 Luminosity Blending adds shape.

Now, add a little sharpening and some High Pass Overlay to further enhance the shape (Figure 8.64). The image is starting to look pretty good.

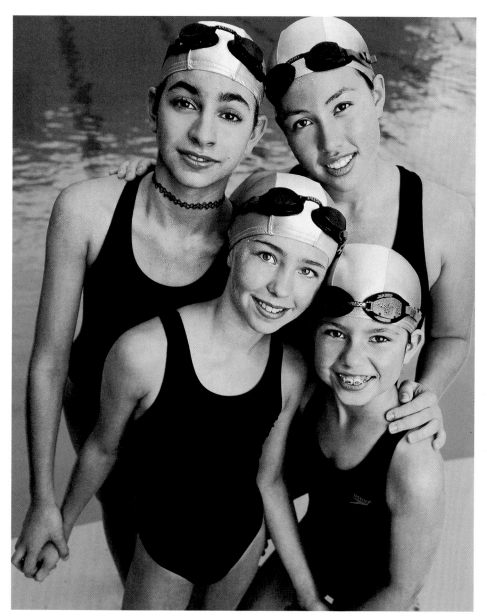

Figure 8.64 Sharpening and a high-radius High Pass Overlay layer add some final shape.

There is one last subtle problem. It may be too subtle to see at the print size in this book, but it is a common defect that often appears in inkjet portfolio prints from digital camera files. Look at a close-up of the most offensive areas (Figure 8.65).

The shadow values, which are most noticeable along the arm, have become too saturated. As colors approach black, they should become less saturated, not more saturated. This kind of oversaturated shadow value is quite common in digital camera files that are processed with a saturation boost. The result is often a posterized tone in the dark skin that creates harsh breaks instead of smooth transitions.

Figure 8.65 Shadow values in the skin tone are too saturated.

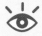

To remedy the situation, you can employ a little blending options trick. Create a Hue/Saturation adjustment layer and push the Saturation slider all the way to the left; you will end up with a B+W version of the image. Select Blending Options from the Flyaway Layer Options menu and set Blend If Blue sliders, as shown in Figure 8.66.

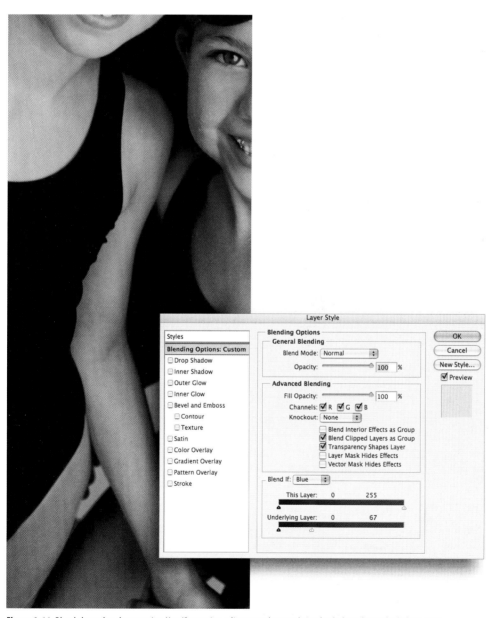

Figure 8.66 Blend through a desaturating Hue/Saturation adjustment layer to bring back the color in the lighter areas.

The oversaturated, dark skin color is first noticeable as a dark tone in the Blue channel, so use that channel to control the blend. Split the Blend slider to smooth the transition, and you'll end up with Figure 8.67.

Figure 8.67 Split the Blend slider to soften the transition.

The final image has a more natural look in the shadow areas and is less likely to exhibit ugly posterized transitions in the shadow values of the skin (Figure 8.68).

Look back at Figure 8.61. You'll see that we've achieved a more three-dimensional look—the figures have greater presence and better contrast and sharpness. The first version by itself doesn't seem so bad. On the computer monitor, this image may seem

to be just fine. The color is vibrant and you won't notice how soft it is. Digital images are so seductive that we often don't push images hard enough, and we settle for less than we could. Sometimes we don't know if we've gone far enough until we've gone too far; when we do, it is a simple matter to reduce a layer's opacity and try another print to find the sweet spot. Often, these subtle tweaks in color, sharpening, blending, and print presentation make the difference between a good image and a great image.

I hope you try some of these techniques on your favorite images and find the hidden treasures that lurk there. May we all create more great images!

Figure 8.68 The final has more natural shadow transitions in the dark skin mostly noticeable as less red in the shadows. Compare this to Figure 8.64.

Parting Shots

9

Digital cameras have given us more control over the images we capture, and they have opened up new possibilities for creative expression. We have explored numerous tools and techniques for using those tools to capture and enhance photographs of the human subject. I hope this material has been a catalyst for your own explorations and that you continue to refine these techniques and develop your own personal approaches to people photography in the digital age. For this final chapter, I will leave you with some additional food for thought.

Chapter Contents
Digital Photo Workflow
Companion CD Contents
Future Developments

Digital Photo Workflow

The digital workflow has changed the way photographers interact with their subjects, creative collaborators, clients, and their own creative instincts. Examine the symbolic flow chart in Figure 9.1.

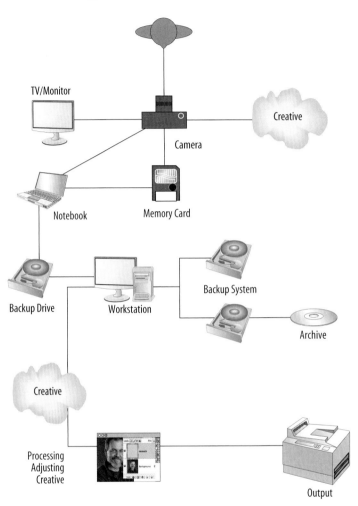

Figure 9.1 Digital photo workflow

Starting with the camera and subject, the instantaneous preview of the captured image has enhanced the interaction between photographer, subject, client, and other creative collaborators. This primary creative area allows for greater participation in the act of image capture and opens the process to more people. This is certainly a double-edged sword: it can improve communication between collaborators, and it can also stifle spontaneity by introducing a design-by-committee mentality. The challenge for the photographer is to manage the creative environment while maintaining control and encouraging participation.

After this stage, the images, captured to a memory card or directly to a computer, move through a system of checks and balances, temporary backups, and duplicate copies

until they arrive at the next creative stage. Interpretive rendering is applied to the original captured data—RAW files are processed, color corrected, retouched, and creatively manipulated to present the photographer's vision.

Finally, the images are archived and delivered, either as prints or digital data. At this point, the images become publicly consumable: the vision can be shared, transferred at the speed of light around the world on the Internet as well as in tangible form such as a print or projected image.

Two main areas of creative work in the digital workflow are heavily impacted by digital technology. The first stage, image capture, has been radically altered by the change of the capture medium and instant feedback. The economics and speed of digital capture have also changed the amount of imagery that is typically captured during a shoot. The cost of film and processing used to impose a monetary limit on how many images we could capture. Now, the limiting factor is the amount of storage space available, and it seems like we'll see no end to economies of scale with continuing improvements in density and declining cost of memory. The increased speed at which we can capture, review, and capture again has opened the floodgates to more and more images—we capture more just because we can! As with most changes, there are negative consequences too. More captures encourage the first creative evil: image gluttony. Rather than stop and carefully consider an image, we can be tempted to take the easy way and capture many more images—just in case. Instead of capturing the decisive moment, the undisciplined photographer captures *all* the moments and selects from the multitude. This leads to sloppy thinking, and it is something to guard against.

The second creative stage occurs after the image has been captured and selected. The post-production stage has become just as important as the image-capture stage. The image can be crafted, enhanced, corrected, and "re-imagined" in the digital darkroom in ways that go far beyond Ansel Adams' wildest dreams. These über-photos can be magnificent or grotesque, depending on the sensibilities of the artist. Some photographers succumb to the temptation to Photoshop everything to death, again just because we can. The second creative evil is image vanity. Just how much special trickery does an image deserve? Should we retouch everything to some godly perfection? Should we transform something simple into a Spielberg extravaganza? Sometimes it is hard to know when you've crossed the line until you actually cross it.

It all really comes down to you. The creative artist is the most important part of the process. Not the technology, not the workflow, not the special techniques. They are just tools in service of the vision. These digital tools give you great power. As Spider-Man says, "With great power comes great responsibility." Use the power wisely.

Companion CD Contents

To help you with the material presented in this book, I've provided the image files for most of the tutorials. These image files are copyrighted; they are intended for your private use in learning the techniques presented in this book. You are permitted to manipulate them and print them to check how well you did. You may not publish them in any way, including them posting online, sharing them, or allowing any reproduction beyond what you need for your own private use.

The companion CD is organized by chapter starting with Chapter 2. Most image files are already sharpened for output at the intended size—roughly 5″×7″. The Chapter 8 images for the sharpening tutorials are the only exception. These image files will look good onscreen at 50 percent magnification, but they will probably look oversharpened at 100 percent. Try to make any onscreen evaluations at even percentages—25, 50, and 100 percent. All of the files are RGB and supplied with embedded profiles that should be honored for best results. The following sections provide a breakdown of the files on the companion CD.

Chapter 2

The material in this chapter is intended for use with your own camera files. However, I've placed a folder with RAW test files from my cameras (mostly Canon 1Ds Mark II) in with the rest of the material. You'll find three RGB files of the Color Checker processed from the test files as an uncalibrated Adobe RGB default rendering, general-calibrated Adobe RGB rendering, and skin-calibrated Adobe RGB rendering. These files are provided as references to the screenshots in the book only. Obviously, you can't use them to calibrate your own camera, but you can practice the calibration procedure with these files before you shoot your own test.

In addition to the image files, I've provided some bonus PDF tutorials relating to general RAW file workflow and digital-camera post processing. These tutorials are supplemental materials that are not covered in detail elsewhere in the book, and they go beyond the specific topic of the book. Nevertheless, I think you'll find them useful.

Chapter 3

There are no tutorial images in this chapter. However, I've made the basic portrait-lighting diagrams available that you can print as reference cards.

Chapter 4

Tutorial and sample images are provided. They are referenced by the figure numbers in the book, so you will see filenames such as f0433.tif for Figure 4.33. This naming scheme will be used for the remaining chapters as well.

Chapter 5

Tutorial images for grayscale conversion, luminosity blending, and toning effects are provided. The original starting-point images are TIFF files, and the finished versions are provided as layered PSD files. In most cases, only the last, most-complex layered version is provided so you can deconstruct and compare it to versions that you create from the original starting point.

Chapter 6

Tutorial images for basic image repair, beauty retouching, figure thinning, and skin-smoothing techniques are provided. In most cases, the full PSD layers contain the original unretouched version in the background. The skin-smoothing image of Dr. Doug can

be used for the hue/saturation anti–red skin technique. (I don't have permission to give away the other image.)

Chapter 7

The finished soft-focus tutorial image contains all the different diffusion effects as layer groups, clearly labeled, which you can turn on or off.

The Blur background *bokeh* starting-point image has an Alpha Channel mask already prepared, as well as the path that was used to make the mask. You can examine them for clues to determine how the mask was constructed. You can also simply load the mask as a selection to generate the layer mask that is called for later in the tutorial.

The finished version of the lens-tilt image contains an Overlay Blur layer on top for the final effect; you can turn this off to see the regular version.

Chapter 8

The tutorial images for sharpening technique are included with the full layered versions. All of the correction layers for the swordsman are included. Even though I don't specifically go through all the steps, you can deconstruct the layers to see how I made the corrections.

> **Note:** To get an accurate idea of the sharpening level, you must make a print. In almost all cases, the onscreen image will seem oversharpened. Try to evaluate the onscreen image at 25 or 50 percent magnification rather than 100 percent.

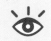

If you prefer to work from a TIFF starting point rather than a JPEG, here's how: For the CD images in Chapters 4 through 8, open the PSD version from the Finish_Files folder, set all layers but the Background to invisible, and then Save As > TIFF.

> **Note:** Many files are collected in ZIP format to save space; use a utility such as StuffIt Expander or WinZip to unpack them and save the uncompressed files to your own drive.

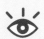

Future Developments

Digital-capture technology is slowly coming out of an early "film emulation" stage of development. The adoption process has focused on making picture-taking familiar to people who have had experience with film-based capture systems. Camera and lens systems have followed the form factors dictated by film cameras. We are just now starting to see experiments with new ergonomic designs unencumbered by the constraints of film-transport mechanisms and large-format film. DSLRs will probably be replaced by direct-view chip designs and cameras will be smaller, lighter, and have sharper optics. Resolutions in the range of 12 to 20 megapixels will be common for consumer-level

cameras within three years. Radical new optical designs will deliver focus selection after capture, so there will be no need for autofocusing and you'll never misfocus a shot. These advances are working in prototypes today.

This means that there will continue to be major upheavals in the infrastructure devoted to image making. Support services are changing. The needs of the imaging industry require different services than we've been used to, and the instant delivery of information demands faster and faster turnaround in image capture and delivery. The demand for images will continue to increase, and images will become more and more a commodity, the value dependent on context. Computer-generated imagery will replace many applications for photographic imagery in advertising and commercial areas. Niche markets will rule, and personalized imagery will become more important.

Communication between creative people will demand standards—standard vocabulary, standard tools, and standard file formats. The concept introduced by the digital camera RAW file has major implications for imaging, but new developments will be stifled unless a standard RAW format is adopted. At the moment, the only prospective standard format is DNG and, hopefully, this will be rapidly adopted throughout the industry.

The application of metadata to image files introduces the possibility for metadata-based image editing. This would separate edits from the RAW data and color correction, retouching, and compositing. With it, just about any kind of image enhancement could be stored as a set of instructions that would take up much less space and could be applied to original captured RAW data faster across networks or rendered later at the point of image consumption.

The one thing that will remain constant is the need for pictures of people. I mean real people, not CGI-rendered illustrations of people (which will be a novelty with narrow applications). People will always respond to pictures of real people in ways that differ significantly from images of other subjects. This means that skill in capturing pictures of people will still be important no matter what other changes occur in image-making technology. We are likely to see improvements in color control and image-enhancement software. The improvements will also likely require more complex skills to apply with any creative integrity.

Another thing that is clear is that improvements in technology will likely build on things that are in place today. Image-making skills acquired in using today's technology will be useful with tomorrow's technology. Even paradigm-shifting technology, such as the personal computer, is built on existing language and organizing structures. Image-making skills still require basic training in lighting, knowledge of color theory, and knowledge of optics to be fully utilized no matter how radical the new imaging technology is. You have seen how the digital tone-control techniques used in this book evolved from conceptual work done by Ansel Adams with film. Continuing education will be mandatory just to keep up with the increasing speed of change.

With these things in mind, be aware that everything in this book will be obsolete in a fairly short time. Certain techniques will still work, but new tools will replace the need for complicated procedures, and new techniques will make things easier and better than ever. The only way to stay competitive is to keep learning. The information in

this book will become outdated, so you should be flexible and not take this material to be the ultimate statement on the subject. The concepts introduced here do have value, however, and by mastering the techniques presented here you will be preparing for a future with many rewards.

Thank you for making the effort. I will leave you now with one last personal image of my family in Greece. Live long and prosper.

Index

Note to the Reader: Throughout this index **boldfaced** page numbers indicate primary discussions of a topic. *Italicized* page numbers indicate illustrations.

R

S

INDEX ■

INDEX